Velvet Curtains and Gilded Frames

Edinburgh Studies in Film and Intermediality

Series editors: Martine Beugnet and Kriss Ravetto
Founding editor: John Orr

A series of scholarly research intended to challenge and expand on the various approaches to film studies, bringing together film theory and film aesthetics with the intermedial aspects of the field. The volumes combine critical theoretical interventions with a consideration of specific contexts, aesthetic qualities, and a strong sense of the medium's ability to appropriate current technological developments in its practice and form as well as in its distribution.

Advisory board
Duncan Petrie (University of Auckland)
John Caughie (University of Glasgow)
Dina Iordanova (University of St Andrews)
Elizabeth Ezra (University of Stirling)

Gina Marchetti (University of Hong Kong)
Jolyon Mitchell (University of Edinburgh)
Judith Mayne (The Ohio State University)
Dominique Bluher (Harvard University)

Titles in the series include:

Romantics and Modernists in British Cinema
John Orr

Framing Pictures: Film and the Visual Arts
Steven Jacobs

The Sense of Film Narration
Ian Garwood

The Feel-Bad Film
Nikolaj Lübecker

American Independent Cinema: Rites of Passage and the Crisis Image
Anna Backman Rogers

The Incurable-Image: Curating Post-Mexican Film and Media Arts
Tarek Elhaik

Screen Presence: Cinema Culture and the Art of Warhol, Rauschenberg, Hatoum and Gordon
Stephen Monteiro

Indefinite Visions: Cinema and the Attractions of Uncertainty
Martine Beugnet, Allan Cameron and Arild Fetveit (eds)

Screening Statues: Sculpture and Cinema
Steven Jacobs, Susan Felleman, Vito Adriaensens and Lisa Colpaert

Drawn From Life: Issues and Themes in Animated Documentary Cinema
Jonathan Murray and Nea Ehrlich (eds)

Intermedial Dialogues: The French New Wave and the Other Arts
Marion Schmid

The Museum as a Cinematic Space: The Display of Moving Images in Exhibitions
Elisa Mandelli

Theatre Through the Camera Eye: The Poetics of an Intermedial Encounter
Laura Sava

Caught In-Between: Intermediality in Contemporary Eastern Europe and Russian Cinema
Ágnes Pethő

No Power Without an Image: Icons Between Photography and Film
Libby Saxton

Cinematic Intermediality: Theory and Practice
Kim Knowles and Marion Schmid (eds)

Animating Truth: Documentary and Visual Culture in the 21st Century
Nea Ehrlich

Derivative Images: Financial Derivatives in French Film, Literature and Thought
Calum Watt

Towards an Intermedial History of Brazilian Cinema
Lúcia Nagib, Luciana Corrêa de Araújo, and Tiago de Luca (eds)

Velvet Curtains and Gilded Frames: The Art of Early European Cinema
Vito Adriaensens

www.edinburghuniversitypress.com/series/esif

Velvet Curtains and Gilded Frames
The Art of Early European Cinema

Vito Adriaensens

EDINBURGH
University Press

Edinburgh University Press is one of the leading university presses in the UK. We publish academic books and journals in our selected subject areas across the humanities and social sciences, combining cutting-edge scholarship with high editorial and production values to produce academic works of lasting importance. For more information visit our website: edinburghuniversitypress.com

© Vito Adriaensens, 2024, 2025

Edinburgh University Press Ltd
13 Infirmary Street,
Edinburgh, EH1 1LT

First published in hardback by Edinburgh University Press 2024

Typeset in Garamond MT Pro
by Cheshire Typesetting Ltd, Cuddington, Cheshire

A CIP record for this book is available from the British Library

ISBN 978 1 4744 0698 7 (hardback)
ISBN 978 1 3995 5417 6 (paperback)
ISBN 978 1 4744 0699 4 (webready PDF)
ISBN 978 1 4744 0700 7 (epub)

The right of Vito Adriaensens to be identified as the author of this work has been asserted in accordance with the Copyright, Designs and Patents Act 1988, and the Copyright and Related Rights Regulations 2003 (SI No. 2498).

Contents

List of Figures	vi
Acknowledgements	xiii
Introduction: History, Intermediality, and Early European Cinema	1
1. The Birth of a Sixth Art: The Art Film and the Film-as-Art Discourse	22
2. Behind the Velvet Curtain: The Cultural Communion between Stage and Screen	54
3. An Actress for Our Age: Betty Nansen, Modern Media Icon	78
4. In Another Light: Academic Painting, Pictorial Photography, Bourgeois Cinema	104
5. Old Masters Endure: Victor Sjöström's Netherlandish Tableaux	140
Conclusion: Towards a Cultural Poetics of Early European Cinema	167
Bibliography	174
Filmography	190
About the Author	194
Index	195

Figures

ABBREVIATIONS

DFI – Danish Film Institute
EYE – Eye Filmmuseum
GPA – Gaumont Pathé Archives
HG – Jean-François Heim Gallery
IA – Internet Archive
KB – The Royal Danish Library
MHDL – Media History Digital Library
PS – PhotoSeed
SFI – Swedish Film Institute
WC – Wikimedia Commons

FIGURES

1.1 *L'Assassinat du Duc de Guise* (*The Assassination of the Duke de Guise*; André Calmettes and Charles Le Bargy, 1908, Le Film d'Art). Film poster (WC). 26
1.2 Louis Feuillade, "Scènes de la vie telle qu'elle est," *Ciné-Journal* 4, 139 (22 April 1911), 19 (MHDL). 32
1.3 Louis Feuillade, "Le Film Esthétique," *Ciné-Journal* 3, 92 (28 May 1910), 3 (MHDL). 32
1.4 *Kameliadamen* (*The Lady of the Camellias*; Viggo Larsen, 1907, Nordisk Films Kompagni). Film production still (DFI). 34
1.5 *Tyven* (*The Thief*; Unknown, 1910, Nordisk Films Kompagni). Film program excerpt (DFI). 35
1.6 *Dødsspring til Hest fra Cirkuskuplen* (*The Great Circus Catastrophe*; Eduard Schnedler-Sørensen, 1912, Nordisk Films Kompagni). Film program cover (DFI). 35
1.7 Robert Storm Petersen, "Filmens Muse," *Filmen* 2, 3 (15 November 1913), 44. 38

List of Figures vii

1.8 *Tyven* (*The Thief*; Unknown, 1910, Nordisk Films Kompagni). Film production still (DFI). 43
2.1 *Den hvide Slavehandel* (*The White Slave Trade*; Alfred Cohn, 1910, Fotorama). Film program cover (DFI). 58
2.2 *Dansen paa Koldinghus* (*The Dance of Death*; Viggo Larsen, 1908, Nordisk Films Kompagni). Film program (DFI). 60
2.3 *Dansen paa Koldinghus* (*The Dance of Death*; Viggo Larsen, 1908, Nordisk Films Kompagni). Film production still (DFI). 61
2.4 *En Kvinde af Folket* (*A Woman of the People*; Viggo Larsen, 1909, Nordisk Films Kompagni). Film program cover (DFI). 61
2.5 "A Woman of the People," *The Moving Picture World* 4, 26 (26 June 1909), 892 (MHDL). 62
2.6 *Hamlet* (August Blom, 1911, Nordisk Films Kompagni). English film program (DFI). 64
2.7 *Heltemod forsoner* (*Courage Reconciled*; Viggo Larsen, 1909, Nordisk Films Kompagni). Film program excerpt (DFI). 64
2.8 *Hvem er Hun?* (*Madame X*; Holger Rasmussen, 1910, Nordisk Films Kompagni). German film program excerpt (DFI). 67
2.9 "Le Vertige," *Ciné-Journal* 4, 142 (13 May 1911), 20 (MHDL). 70
2.10 H.F.H., "The Asta Neilsen (sic) Pictures," *The Moving Picture World* 11, 12 (23 March 1912), 1055 (MHDL). 70
2.11 "Some of the Celebrated Actors from the Denmark Theatres Who Have Helped to Make the Great Northern Films Famous," *The Moving Picture News* 4, 38 (23 September 1911), 12–13 (MHDL). 73
3.1 Betty Nansen as Victorien Sardou's *Dora* (Casino Theatre, 1893). Theatre production still (KB). 78
3.2 Betty Nansen as Tora in Bjørnstjerne Bjørnson's *Paul Lange og Tora Parsberg* (Dagmarteatret, 1901). Theatre production still (KB). 83
3.3 Betty Nansen as *Prinsesse Elena* (*Princess Elena's Prisoner*; Holger-Madsen, 1913, Nordisk Films Kompagni). Film production still (DFI). 88
3.4 Chiaroscuro in *Prinsesse Elena* (*Princess Elena's Prisoner*; Holger-Madsen,1913, Nordisk Films Kompagni). Digital film grab (DFI). 90
3.5 Betty Nansen in *The Celebrated Scandal* (J. Gordon Edwards and James Durkin, 1915, Fox). Film production still (KB). 93
3.6 *Betty Nansen Teatret aabner i September* (*The Betty Nansen Theatre Opens in September*, 1917). Theatre poster (KB). 97
4.1 L-shaped set at Nordisk's Valby studio c. 1912 from Ole

Olsen, *Filmens Eventyr og Mit Eget* (*Film's Adventure and My Own*; Copenhagen: Jespersen & Pios Verlag, 1940), 128b. 107

4.2 Asta Nielsen & Urban Gad's Berlin Studio c. 1913 from Paul Sarauw, "Levende billeder. Danske instruktører i Berlin. Arbejdsvilkaar og Gager." *Masken* 3, 32 (11 May 1913), 210 (DFI). 107

4.3 *Onkel og Nevø* (*Uncle and Nephew*; August Blom, 1912, Nordisk Films Kompagni). Film production still (DFI). 108

4.4 Nordisk's prop department at Valby c. 1908–1912 from Ole Olsen, *Filmens Eventyr og Mit Eget* (*Film's Adventure and My Own*; Copenhagen: Jespersen & Pios Verlag, 1940), 88b. 109

4.5 Vigorously reused prop painting in *En Lektion* (*The Aviator and the Journalist's Wife*; August Blom, 1911, Nordisk Films Kompagni). Film production still (DFI). 109

4.6 *They Had Given up Waiting for Him* (*They Did Not Expect Him*; Ilya Repin, c. 1884–1888). Painting, oil on canvas. State Tretyakov Gallery, Moscow (WC). 114

4.7 *Never more to hear that silent voice, Her smile to meet no more* (John Henry Frederick Bacon, 1889). Painting, oil on canvas. Private Collection (WC). 116

4.8 *A Parisian Ball* (*Scène de Bal*; Jean Béraud, 1880). Painting, oil on canvas. Jean-François Heim Gallery, Basel (HG). 116

4.9 *Artists in Finck's Coffee House in Munich* (*Kunstnere i Fincks Kaffehus i München*; Wilhelm Bendz, 1832). Painting, oil on canvas. Thorvaldsen Museum, Copenhagen (WC). 116

4.10 *Woman Lacing Her Bodice Beside a Cradle* (*Interieur met vrouw zittend naast een wieg*; Pieter de Hooch, c. 1661–1663). Painting, oil on canvas. Gemäldegalerie, Berlin (WC). 118

4.11 *Easy Come, Easy Go* (*Soo gewonne, soo verteert*; Jan Steen, c. 1661). Painting, oil on canvas. Museum Boijmans van Beuningen, Rotterdam (WC). 118

4.12 *Old Man in an Interior with Winding Staircase* (*Mediterende filosoof*; Rembrandt, c. 1632). Painting, oil on canvas. The Louvre, Paris (WC). 118

4.13 *A Conversation Piece* (Solomon Joseph Solomon, 1884). Painting, oil on canvas. Leighton House Museum, London (WC). 119

4.14 *Den hvide Slavehandels sidste Offer* (*In The Hands of Impostors no. 2*; August Blom, 1911, Nordisk Films Kompagni). Film production still (DFI). 119

4.15 *Den farlige Alder* (*The Price of Beauty*; August Blom, 1911, Nordisk Films Kompagni). Film production still (DFI) 119

4.16	*Diamantbedrageren* (*The Diamond Swindler*; Unknown, 1910, Nordisk Films Kompagni). Film production still (DFI).	121
4.17	*Gadeoriginalen* (*A Dream with a Lesson*; August Blom, 1911, Nordisk Films Kompagni). Film production still (DFI).	121
4.18	*Sønnen fra Rullekælderen* (*The Adopted Son*; Unknown, 1911, Nordisk Films Kompagni). Film production still (DFI).	121
4.19	*Det bødes der for* (*Love and Money*; August Blom, 1911, Nordisk Films Kompagni). Film production still (DFI).	121
4.20	*Kærlighedens Styrke* (*The Power of Love*; August Blom, 1911, Nordisk Films Kompagni). Film production still (DFI).	122
4.21	*Dyrekøbt Glimmer* (*When Passion Blinds Honesty*; Urban Gad, 1911, Nordisk Films Kompagni). Film production still (DFI).	122
4.22	*Kærlighed og Venskab* (*Love and Friendship*; Eduard Schnedler-Sørensen, 1912, Nordisk Films Kompagni). Film production still (DFI).	122
4.23	*Tropisk Kærlighed* (*Love in the Tropics*; August Blom, 1912, Nordisk Films Kompagni). Film production still (DFI).	122
4.24	*Det gamle Købmandshus* (*Midsummer-tide*; August Blom, 1912, Nordisk Films Kompagni). Film production still (DFI).	123
4.25	*Guvernørens Datter* (*The Governor's Daughter*; August Blom, 1912, Nordisk Films Kompagni). Film production still (DFI).	123
4.26	*Den tredie Magt* (*The Stolen Treaty*; August Blom, 1913, Nordisk Films Kompagni). Film production still (DFI).	123
4.27	*Et Kærlighedsoffer* (*I Will Avenge*; Robert Dinesen, 1914, Nordisk Films Kompagni). Film production still (DFI).	123
4.28	*Past and Present, No.1* (Augustus Leopold Egg, 1858). Painting, oil on canvas. Tate Gallery, London (WC).	125
4.29	*Past and Present No.2* (Augustus Leopold Egg, 1858). Painting, oil on canvas. Tate Gallery, London (WC).	125
4.30	*Past and Present No.3* (Augustus Leopold Egg, 1858). Painting, oil on canvas. Tate Gallery, London (WC).	125
4.31	*Fiskerliv i Norden / Ved Havet* (*Fishermen's Life in the North / By the Sea*; Viggo Larsen / Ole Olsen, 1906/1909, Nordisk Films Kompagni). Digital film grab (DFI).	125
4.32	*Fiskerliv i Norden / Ved Havet* (*Fishermen's Life in the North / By the Sea*; Viggo Larsen / Ole Olsen, 1906/1909, Nordisk Films Kompagni). Digital film grab (DFI).	125
4.33	*Le Tic* (*The Twitch*; Étienne Arnaud, 1908, Gaumont). Digital film grab (IA).	126
4.34	*La Fille de Jephté* (*The Vow; or, Jephthah's Daughter*; Léonce Perret 1910, Gaumont). Digital film grab (GPA).	126

4.35 *Fading Away* (Henry Peach Robinson, 1858). Photograph, albumen silver print from glass negatives. The Royal Photographic Society at the National Media Museum, Bradford (WC). 127

4.36 *Salon de Photographie – Photo-Club de Paris* (1898). Lithographic print (Private Collection) (WC). 128

4.37 *The Manger* (Gertrude Käsebier, 1899). Photograph, platinum print. The Museum of Modern Art, New York (WC). 131

4.38 *Den hvide Slavehandels sidste Offer* (*In the Hands of Impostors no. 2*; August Blom, 1911, Nordisk Films Kompagni). Film production still (DFI). 131

4.39 *Mont St. Michel* (Robert Demachy, 1907). Photograph, autotype (halftone) from Franz Goerke (ed.), *Die Kunst in der Photographie* (Halle: Verlag von Wilhelm Knapp, 1907) (PS). 133

4.40 *De molens die juichen en weenen* (*The Mills in Joy and Sorrow*; Alfred Machin, 1912). Two-frame photograph (EYE). 133

4.41 *Det hemmelighedsfulde X* (*Sealed Orders*; Benjamin Christensen, 1914, Dansk Biograf Compagni). Digital film grab (DFI). 133

4.42 *Clair de lune sur la mer* (A. Rutot, 1896), photogravure from *Troisième Exposition d'Art Photographique* (Paris: Photo-Club de Paris, 1896), 46 (PS). 134

4.43 *Le Roman d'un mousse* (*The Curse of Greed*; Léonce Perret, 1913, Gaumont). Digital film grab (IA). 134

5.1 Victor Sjöström on the cover of *Cinéa*. "Les Merveilles du Cinéma Suédois," *Cinéa* 11 (special issue) (15 July 1921), cover. Production still from *Berg-Ejvind och hans hustru* (*The Outlaw and His Wife*; Victor Sjöström, 1918) (MHDL). 142

5.2 Caricature of Victor Sjöström. E. Nerman, "Victor Sjostrom [sic]," *Cinéa* 11 (special issue) (15 July 1921), 21 (MHDL). 143

5.3 Caricature of Jenny Hasselqvist. E. Nerman, "Jenny Hasselquist [sic]," *Cinéa* 11 (special issue) (15 July 1921), 7 (MHDL). 143

5.4 Caricature of Gösta Ekman. E. Nerman, "Gosta Ekmann [sic]," *Cinéa* 11 (special issue) (15 July 1921), 10 (MHDL). 143

5.5 Little Theatre Films presents *Vem dömer*. Helen V. Swenson, "Is There an Undiscovered Picture Audience?" *Exhibitors Trade Review* 14, 23 (3 November 1923), 1031 (MHDL). 146

5.6 Don Ryan attempting to interview Victor Sjöström. K.R. Chamberlain, "Don Ryan, about to lay siege upon the subject of this interview, encounters some resistance on the part of

the press agents," *Picture-Play Magazine* 20, 1 (March 1924), 23 (MHDL). 147

5.7 The art department working on the Ursula sculpture – in the Coronation of the Virgin pose. *Vem dömer* (Victor Sjöström, 1922). Production still (SFI). 148

5.8 Christ, ready for his close-up. *Vem dömer* (Victor Sjöström, 1922). Production still (SFI). 150

5.9 Christ Crucified transformed into the ghost of Master Anton. *Vem dömer* (Victor Sjöström, 1922). Digital Film Grab (SFI). 151

5.10 Ursula, guided through the fire. *Vem dömer* (Victor Sjöström, 1922). Digital film grab (SFI). 151

5.11 Ursula, pious in her wedding gown. *Vem dömer* (Victor Sjöström, 1922). Film production still (SFI). 153

5.12 Jenny Hasselqvist and Ivan Hedqvist in a key pose in *Vem dömer* (Victor Sjöström, 1922). Production still. Lionel Landry, "L'Epreuve du Feu." *Cinéa* 2, 81 (15 December 1922), 16 (MHDL). 154

5.13 The same key pose as painted advertising for *Vem dömer* (Victor Sjöström, 1922). (SFI). 154

5.14 Assembling the stake. *Vem dömer* (Victor Sjöström, 1922). Film production still (SFI). 155

5.15 The Dance of Death in *Det sjunde inseglet* (*The Seventh Seal*; Ingmar Bergman, 1957, AB Svensk Filmindustri, Gunnar Fischer). Film production still (SFI). 155

5.16 Orans posture. 13th-Century Icon of Our Lady of the Sign from Yaroslavl. Kiev School, c. 1114. Tretiakov Gallery, Moscow (WC). 156

5.17 Ursula at the stake. *Vem dömer* (Victor Sjöström, 1922). Digital Film Grab (SFI). 156

5.18 Ursula and Bertram kneeling before the statue of Christ Crucified. *Vem dömer* (Victor Sjöström, 1922). Digital film grab (SFI). 156

5.19 *Een stel wandelt door het Stadhuis van Amsterdam* (*A Couple Walking in the Citizens' Hall of Amsterdam Town Hall*; Pieter de Hooch, c. 1663–5). Painting, oil on canvas. Musée des Beaux-Arts, Strasbourg (WC). 158

5.20 Sjöström's subdivision of the frame – 1. establishing shot. *Vem dömer* (Victor Sjöström, 1922). Digital film grab (SFI). 159

5.21 Sjöström's subdivision of the frame – 2. cut closer on the axis. *Vem dömer* (Victor Sjöström, 1922). Digital film grab (SFI). 159

5.22 Sjöström's subdivision of the frame – 3. re-establishing shot.
Vem dömer (Victor Sjöström, 1922). Digital film grab (SFI). 159
5.23 Sjöström's subdivision of the frame – 4. final reframing. *Vem dömer* (Victor Sjöström, 1922). Digital film grab (SFI). 159
5.24 Ursula's tightly framed position on the church set. *Vem dömer* (Victor Sjöström, 1922). Film production still (SFI). 161
5.25 Ursula and the monk grieving in a subdivided frame. *Vem dömer* (Victor Sjöström, 1922). Film production still (SFI). 161
5.26 *Afluisterend dienstmeisje naast een half weggeschoven gordijn* (*Eavesdropper with a Scolding Woman*; Nicolaes Maes, c. 1655). Painting, oil on panel and mixed media. Private Collection (WC). 161
5.27 *De pantoffels* (*The Slippers*; Samuel van Hoogstraten, c. 1660). Painting, oil on canvas. The Louvre, Paris (WC). 161
5.28–5.31 Ursula caught in a Scandinavian dissolve. *Vem dömer* (Love's Crucible; Victor Sjöström, 1922). Digital film grab (SFI). 162

Acknowledgements

This book first took shape a good fifteen years ago, when I was a young and impressionable student with a burning passion for cinema at the University of Antwerp. With a first-year paper on George Romero's lesser-known vampiric masterpiece *Martin* (1977), I managed to stand out in what must have been a large number of papers about Jean-Pierre Jeunet's *Le fabuleux destin d'Amélie Poulain* (2001) – a film that was still going strong in Belgium and inspired many a Flemish teenager to get a bob cut. Incidentally, my closest friends today are people who I met then, and whose papers equally reflected their singular tastes. I remember vying for the attention of the department's sole film professor, Tom Paulus, and was lucky enough to receive his guidance early on for a BA thesis on the interaction between David Belasco's stage Naturalism and American cinema of the 1910s, and a co-authored MA thesis on theatrical and pictorial strategies in the work of Maurice Tourneur – it was the beginning of a beautiful friendship. It is not hard to grasp where this book stems from, then, as the manifold relationships between cinema and visual and performing arts have always fascinated me. Exploring it from an academic perspective, I was surprised to find that there still existed such a gap between film and theatre research; the twain seldom met, and if they did, they were not exactly on congenial terms. Luckily, the work of authors such as Martin Meisel, David Mayer, Ben Brewster and Lea Jacobs, and Victoria Duckett has lit the way, and intermedial research on the whole has been on the rise. For taking me on as a part-time PhD student and allowing me to further develop my interest in the field, and for being a great mentor and a dear friend for more than ten years, I can never thank Tom Paulus enough.

I was richer a second mentor when Steven Jacobs joined our faculty and went on to hire me as a part-time research assistant on a project of epic proportions centered on the cinematic visualization of visual arts at the School of Arts (KASK), University College in Ghent. Among others, the project has since spawned the Cinémathèque royale de Belgique's *Art & Cinema* DVD collection with Belgian art documentaries of the 1940s and 1950s; Steven Jacobs and Lisa Colpaert's *The Dark Galleries: A Museum Guide to Painted Portraits in Film Noir Gothic Melodramas and Ghost Stories of the 1940s*

and 1950s (Ghent: AraMER, 2013); and, of course, *Screening Statues: Sculpture and Cinema* (Edinburgh University Press, 2017), authored by myself, Steven Jacobs, Susan Felleman and Lisa Colpaert. I am infinitely indebted to Steven for teaching me how to be a consummate professional, inspiring me with his deep-rooted passion for film and encyclopedic knowledge of visual arts, and including me in what has been, and will continue to be, a fruitful collaboration.

I would also like to thank my close colleagues at the Research Centre for Visual Poetics at the University of Antwerp and former colleagues at the School of Arts (KASK), University College Ghent for their ongoing support and welcome distractions, with special mention for my partners in cinematic crime Anke Brouwers and Katja Geerts at the University of Antwerp; Lisa Colpaert and Hilde D'haeyere at the School of Arts; and of course Susan Felleman, co-sponsor of the School of Arts project, at the University of South Carolina. Thanks are also in place here for my close colleague in the field of film and media studies at the Department of Communication Studies at the University of Antwerp, Philippe Meers, and my former colleagues at the VU University in Amsterdam, singling out Ginette Verstraete and Ivo Blom for graciously imbuing me with educational wisdom and sharing their experience. In the same breath I would like to mention my colleagues in the cultural field and the media, generously providing me with platforms on which I have been able to disseminate my expertise to broader audiences, in particular Stef Franck and Bart Versteirt at what used to be the Flemish Service for Film Culture (VDFC) and is now Cinea, the crew at the Cinémathèque royale de Belgique, Mayke Vermeren at Zebracinema, Frank Van der Kinderen and Jos Van den Bergh at the former Cinema Zuid (now Cinema Lumière), Evelien van Vessem at Cinemagie, and Sabeth Snijders and Peter de Bruijn at NRC Handelsblad.

I also owe a deep debt of gratitude to the like-minded scholars I have discussed my work with over the years at various conferences, with a number of whom I have since forged interesting alliances that have led to stimulating debates, exciting publications, plans for future endeavors, and generous support. These are Charlie Keil and Victoria Duckett, who have graciously shared their knowledge, given me feedback and supported my projects, topping it off by being all-round good eggs and great people to share a glass of wine with. My past and present friends at Domitor, the international society for the study of early cinema: Kaveh Askari, Scott Curtis, Tami Williams, Valentine Robert, Sarah Keller, Clara Auclair, Ian Christie, Joshua Yumibe, Viva Paci, Grazia Ingravalle, Dimitrios Latsis, Louis Pelletier, Michael Cowan, Camille Blot-Wellens, and Colin Williams. Connoisseurs and friends in the field that cannot be forgotten are Angela Dalle Vacche, Brigitte Peucker, David Bordwell, Kristin Thompson, Paolo Cherchi Usai,

C. Claire Thomson, Giovanna Fossati and Elif Rongen-Kaynakçi at the Eye Filmmuseum, Nathalie Morris, Agnès Bertola at the Gaumont Pathé Archives, Jörg Schweinitz, Daniel Wiegand and Casper Tybjerg. The bighearted support of my newest colleagues at Columbia University's School of the Arts should also be recognized here, where I have been a visiting scholar and Adjunct Associate Professor. I am fortunate enough to have roamed the same halls as Jane Gaines and Rob King, whose keen intellect and sharp analytical skills have already proven invaluable, and their unwavering support means a lot. I am also grateful for the friendship and support of Kate Saccone, and her generous feedback on this book.

Much of my research was made possible by generous scholarships, awards, and grants. A three-year seat on the young scholars' Collegium awarded to me at Le Giornate del Cinema Muto Silent Film Festival in Pordenone has allowed me to combine complete absorption into the world of early cinema with wonderful Italian food, a dangerous Pavlovian cocktail. The Rosa Blanckaert Fund Grant for Young Researchers combined with the support of the Research Foundation Flanders (FWO), the Antwerp Doctoral School, the Erasmus Program, and, most notably, a Research Scholarship from the Danish Agency for Universities and Internationalization, permitted me to spend six wonderful months in Copenhagen as a visiting scholar at the Department of Media, Cognition, and Communication at the University of Copenhagen. My first year at Columbia University as a visiting scholar was made possible by the generous support of the Belgian American Educational Foundation and its Luc Wauters-Fernand Collin Postdoctoral Fellowship, and for this opportunity I wish to especially thank the Foundation's President, Professor Emile Boulpaep. I was, furthermore, grateful to have been a [PEGASUS][2] Marie Skłodowska-Curie Postdoctoral Fellow, supported by the European Union's Horizon 2020 Project, and a Chargé de recherche through Le Fonds de la Recherche Scientifique (FNRS) and the Université libre de Bruxelles and its wonderful CiASp, or Centre de recherche en Cinéma et Arts du spectacle. I am indebted here especially to Muriel Andrin, Dominique Nasta, and Karel Vanhaesebrouck. It is here that I also wish to gratefully acknowledge the sincere interest and gracious support of Gillian Leslie, Richard Strachan, and Sam Johnson, my spirited editors at Edinburgh University Press, whose enthusiasm and enduring patience was important in bringing about this book, and to series editors Martine Beugnet and Kriss Ravetto, whose insightful feedback has strengthened it.

Most of the chapters in this book were presented in more rudimentary forms at international conferences over the last fifteen years, particularly at NECS and Domitor. A version of chapter three on Danish actress Betty Nansen was published in *Nineteenth Century Theatre and Film* (vol. 45, no. 1,

2018). Chapters four and five, on the intermedial aesthetics of European cinema in the 1910s and early 1920s, were featured in *Kosmorama*, the journal of the Danish Film Institute (no. 259, 2015; and 269, 2017).

In pursuit of the Nordisk Films Kompagni's secrets, I passed all of my waking and some of my sleeping hours performing research at the Danish Film Institute in Copenhagen. For those who haven't been, the Danish Film Institute is a piece of archival heaven and an excellently run institute where I was welcomed with open arms. For all of their assistance, trust, friendship, and tea, I would like to sincerely extend *"tusind tak"* to Thomas Christensen, Tobias Lynge Herler, Madeleine Schlawitz, Pernille Schütz, Lisbeth Richter Larsen, Lars-Martin Sørensen, Henrik Fuglsang, Birgit Granhøj Dam, Karina de Freitas Olesen, Christian Hansen, Uffe Smed, Juri Olsen, and any other Great Danes I may have forgotten. The Swedes are not so bad either, and in fact I should go on record here to say that Scandinavians have been very kind to me across the board. I am greatly indebted to the Swedish Film Institute for their generosity, and in particular to Magnus Rosborn, Clara Gustavsson, Krister Collin, and Jon Wengström.

Last but not least, I would like to thank my family and my dearest friends for their support and love. My mother, for naming me after *The Godfather*, to begin with. For stimulating my intellectual interests from a young age and for never questioning my path. My parents-in-law, for strongly supporting me and making their home mine. And, of course, my wife, my number one supporter and greatest love. I am unremittingly grateful to her for making our lives a romantic comedy directed by Preston Sturges, and I intend to slowly take over the globe with her, one city at a time. In the final words of Calvin and Hobbes, "it's a magical world, ol' buddy, let's go exploring."

*For my mother
and in loving memory of my father*

INTRODUCTION

History, Intermediality, and Early European Cinema

In 2015, the history of cinema was the subject of at least two conferences, the XXII International Film Studies Conference in Udine on "A History of Cinema Without Names" and the History of Moviegoing, Exhibition and Reception (HoMER) Network conference on "What is Cinema History?" at the University of Glasgow. These investigations of the process and philosophy of history writing demonstrate that this issue is ever pertinent. A few years ago, the yearly Udine gathering, organized by the Museo Nazionale del Cinema, reoriented itself to become the Permanent Seminar on the History of Film Theories. Its 2015 conference set out to become a research project that (re)defines the investigation of film history by eliminating possible auteurist readings – hence "without names" – instead choosing to focus on "creating a new 'topography' of the basic stylistic elements that, while common to both authors and genres, can also find independent and diverse modes of connection."[1]

To rejuvenate historiographical inquiry pertaining to the medium of cinema, the organizers drew from late-nineteenth- and early-twentieth-century art historians and cultural intellectuals such as Aby Warburg (1866–1929), Henri Focillon (1881–1943), and Erwin Panofsky (1892–1968), and more contemporary literary theorists in the guise of Nelson Goodman (1906–98) and Antoine Compagnon (b. 1950).[2] The organizers further proposed analogies for their project with Heinrich Wölfflin's (1864–1945) history of art without names and Paul Valéry's (1871–1945) concept of a history of literature without authors.[3]

The HoMER conference looked to evaluate cinema history's method and rhetoric, taking Robert C. Allen and Douglas Gomery's 1985 *Film History: Theory and Practice* as an important benchmark. It acknowledged the various epistemological "turns" or directions that cinema studies have taken since the 1970s – such as spatial, visual, historical, and digital – and set out to "investigate the shifting positions and imperatives of cinema history and its relationships with other approaches and disciplines."[4] As per HoMER's main emphases, exhibition and reception, we should also see this conference as targeting absent investigations into the history of moviegoing and audiences, building on open-ended efforts in the past.[5]

These conferences are a testament to the fact that there is no unified method to historical research in the field of cinema studies, and that it is very much an inter- and multidisciplinary affair. The questions that were raised at the HoMER conference have been tackled before in a number of books or special journal issues dedicated to the subject, and they often echo general concerns vis-à-vis history writing and the narrativization of history, as already expressed by historians like E.H. Carr, Hayden White, Karl Löwith, Marc Bloch, Michel Foucault, Sande Cohen, and Frank R. Ankersmit.[6] And by the first wave of academic film historians such as Charles F. (Rick) Altman, Patrick Griffin, Robert C. Allen, or Robert A. Rosenstone (and Hayden White's response to Rosenstone).[7] Most of these film historians developed ideas already put forward by reflexive historians such as E.H. Carr, for instance Altman and Allen's critical consideration that there does not exist a "single" film history, but many film histories, and that history is a continuously dynamic process rather than inert matter, points also elaborated by film historians David Bordwell and Kristin Thompson in their prologue to the film history textbook of textbooks, *Film History: an Introduction* (2003).[8] The consideration that Bordwell and Thompson give their choice of historical narrative and perspective is very salient, and their focus on the process of history writing, or historiography, is often overlooked in other histories of film.

Another example of a historiographical reflection put forward by cultural theorists and taken up by film studies is Allen's dialectic opposition between historical narrative and narrative history. Allen told his students to be critical and keep in mind that the historian at hand inevitably imposes organizational structures onto history, conveying also the difference between the "how and what" that historical narrative details and the "how, what and why" that narrative history tries to get across.[9] Rosenstone and White, then, anticipated new media environments by weighing in on the possibilities and pitfalls that presenting history on film brings forth; White invoked the medium of film's specificity to represent historical events to coin the practice of "writing" history on film as "historiophoty" – as opposed to the process of writing history on paper known as "historiography."[10]

One can say that the field of cinema history has expanded its horizons. Not only "as cinema itself unravels or merges into a diversity of media forms and reception contexts," as the HoMER call for papers puts it, but also looking back to the 1910s.[11] From an interdisciplinary and intermedial perspective, interactions with performing and visual arts were part and parcel of cinema's cultural fabric. Bearing this in mind, the Udine conference's outspoken formalist stance seems somewhat counterproductive and antiquated: for though its Wölfflin-inspired call to focus more on the historical persistence of stylistic

"systems" or patterns certainly merits being heeded, its seemingly avid rejection of human agency and cultural context does not.[12] My own research into the transferability of certain schemas from visual and performing arts to Scandinavian cinema of the 1910s and 1920s has demonstrated the importance of grounding formalist findings in a geographic and cultural context.[13]

Udine's position also went against recent (re)considerations of the field's "historical turn(s)." In the 2004 special issue of *Cinema Journal* on the historical turn, Charles Musser came forth to situate the label of "film historian" as a reductive one at best. Musser stated that he "found it productive to imagine cinema as an element (typically a crucial element) of other histories" and writes of his pursuit of alternative models in "two areas of cultural practice that cross media boundaries," namely cinema as part of a theatrical framework, on the one hand, and investigating the shared legacy of early documentary and photography, on the other hand.[14]

Sumiko Higashi set out similar lines in her introduction to the special issue, hoping for the proliferation of dialogue between scholars across different scientific disciplines to enrich cinema studies in an academic environment "more hierarchical than the military."[15] This is also the central tenet of the issue, with case studies such as Lee Grieveson's on censorship and regulation, for instance. In his "Woof, Warp, History," Grieveson expresses "the continuing need for cultural historians of cinema to carefully track the complex traffic between aesthetic and cultural spheres." He argues for an expansive interpretation of David Bordwell's valuable "historical poetics" to one that not only fleshes out "the functions of the mode of production and [discloses] referential meaning but also [situates] institutional and textual pressures in a broader social, political, and cultural history."[16]

Richard Abel and Robert Sklar concur with Grieveson in the arguments they present in their pieces, while Janet Staiger and Jane Gaines make a case for the inclusion of theory to enrich historical research and get away from the descriptive nature that narrative history tends to take on.[17] In this regard, Gaines also recently problematized the narrativization of early cinema history in her 2013 question-ridden look at the philosophy of film history. She proposes a tongue-in-cheek "what happened in the tunnel" metaphor to describe the necessity of early cinema historians to fill in the substantial number of blind spots brought about by an estimated 70 to 80 per cent of silent films being irretrievably lost. Gaines rightly argues that this inevitably leads to a tension between "what happened" and "what is said to have happened."[18]

It is indeed important to remain critical of one's methods when performing historical research and to be aware that a historical narrative, and history itself, is always a construct. It is nevertheless an essential and unavoidable construct if we aim to better understand the mechanisms that govern society

and culture at large. Looking at early cinema in response to Jane Gaines's challenge, I am a proponent of culturally mapping the case at hand and crossing disciplinary boundaries in the process, as I believe it promotes a better understanding of the performative as well as substantive aspects of the medium. My own research into the cultural context of the early European feature film between 1908 and 1914 builds on film history, theatre history, art history, and the history of photography, all of which I argue are entwined in the late nineteenth and early twentieth centuries.

Early European Cinema

This book focuses mostly on the period between 1908 and 1914, from when the European feature film first came into its own – fueled by the *film d'art* or art film movement – until it ground to a halt at the start of the Great War. We will delve into the work of two international market leaders in film production that were additionally renowned for their artistic quality: the French Gaumont film company and the Danish Nordisk Films Kompagni. These two companies were aided in their pursuit of both "commerce" and "art" by Le Film d'Art, the company that produced the "first" art film in 1908, *L'Assassinat du duc de Guise* (André Calmettes and Charles Le Bargy). Le Film d'Art was a fairly small company backed by French giant Pathé Frères and was not able to make financial ends meet in the short-lived period that it was active with its founding members. While its pioneering role is symbolically an important one, especially with regard to early cinema history, the company was immediately overrun by both small and large companies from all over Europe that set out to produce and market "artistic" films in exactly the same way; Gaumont and Nordisk are a case in point, achieving more financial success than Le Film d'Art ever did. As we will see, there was little that the company could do legally or discursively to stop the proliferation of *films d'art*, since it turned into a genre rather than a trademark, and then from a genre into a strategy.

The choice for a French company as a case study will not surprise anyone. France is seen as cinema's birthplace and subsequent cradle, and its production companies dominated the international market from the beginning of film history up until the start of the Great War in 1914. It was Pathé Frères and Gaumont, trademarked by the images of the rooster and the daisy, respectively, that consolidated production, distribution, and exhibition from 1906 onwards. Their many international offices ensured that the French gospel was amply preached. Charles Pathé held a slight market advantage over Léon Gaumont, but the trajectory of both was overall very similar, and with Ferdinand Zecca and Albert Capellani at Pathé's and Louis Feuillade

and Léonce Perret at Gaumont's, both companies could boast excellent (artistic) directors. The work of Feuillade has become an integral part of the silent French canon and the ensuing historiography of French cinema, due in no small part to historians marveling at Feuillade's serials, *Fantômas* (1913–14) and *Les Vampires* (1915–16). Influential French cinema historians such as Francis Lacassin profiled the director as early as 1964, and AFRHC (Association Française de Recherche sur l'Histoire du Cinéma)-sponsored works sparked a resurgence of Feuillade and Gaumont research from the 2000s onwards.[19]

More recently, Albert Capellani's work has become more available through Bologna's Il Cinema Ritrovato festival programming and accompanying DVDs, leading to two important publications.[20] My own research on the subject has also contributed to the growing body of work on the French director.[21] Feuillade, artistic director at Gaumont from 1907, has grown to be, and consistently remains, one of the great directors of early European cinema. Furthermore, there are two artistic endeavors that Feuillade orchestrated at Gaumont in the wake of the art film wave that are interesting to explore, namely *Le Film Esthétique* (or "the aesthetic film") in 1910, and *Scènes de la vie telle qu'elle est* (or "scenes of life the way it is") in 1911. Both of these series of films are noteworthy because of the outspoken cultural stance that they seem to take: art for art's sake and social realism, respectively. These series were publicized by means of short manifestos written by Feuillade and published in Georges Dureau's influential film magazine *Ciné-Journal*. Gaumont and Feuillade's stories and surviving films have thus largely been well-documented and described in secondary sources. Most of these works are in French, with the notable exception of Richard Abel's important research on French film history, such as *The Ciné Goes to Town*.[22] The Gaumont-Pathé Archives provide access to primary source materials, complemented by Gaumont's investment in a curated DVD collection with regard to their legacy.

A case study counterpart to the French hegemony of early cinema can be found in the Nordisk Films Kompagni. While Denmark was a much smaller country, the same economic and internationally expansionist decisions that had propelled Gaumont forward would work for Nordisk. The Danish film company was founded by Ole Olsen in 1906, after Olsen had started running one of the first film theatres in Copenhagen in 1905, called "Biografteatret" (or "the cinema theatre"). Nordisk Films Kompagni literally translates to the "Nordic Film Company," but after establishing affiliates in Europe early on, the company already arrived in New York in 1908 under the moniker The Great Northern Film Company. The expansive nature of Ole Olsen and the excellent communication and marketing skills of his colleagues quickly made the company an important international player. The choice for a Danish case

study was further informed by research that has been going on since silent film studies' humble academic beginnings in the 1970s. Film historians were quick to point to the high visual and narrative quality of films from a number of European countries, most notably France, Italy, and Denmark, though a lot of archival groundwork was only just being undertaken.

In his groundbreaking study of early American cinema, *American Silent Film* (1978), William K. Everson was thus impressed by the Danish silent films he had seen that he even deemed it necessary to take a detour from his object of study to sing the many praises of the great Danes. His book was published right on the heels of Marguerite Engberg's pioneering treatise on Danish silent film, *Dansk Stumfilm*, which was the first book to take stock of Denmark's silent cinema legacy in a comprehensive manner.[23] In *American Silent Film*, Everson referred to Denmark's 1910s output as "the most *advanced* feature films" of the time.[24] He not only complimented the creative and technical talent of directors such as Benjamin Christensen, August Blom, and Holger-Madsen – who orchestrated the "maturity of content, [. . .] strong psychological themes, and [. . .] smooth lyricism of the camerawork"[25] – but he also merited what he believed to be a Danish national atmosphere in which artistic interests prevailed over commercial ones, a view that I will nuance.

Though decades worth of film studies have since grounded Everson's comments on the Danish silent film in a rich and varied discourse that has demonstrated the visual and narrative wealth of other early European cinema, it must be stated that much of that original excitement remains when researching Denmark's cinematic legacy of the 1910s. For the period at hand, however, its treasures still benefit from thorough archival investigation and reevaluation. Research on the history of Danish silent cinema has been few in number, not so widespread, mostly in Danish, and usually part of a larger historical framework, such as Casper Tybjerg's dissertation on Danish silent film from its beginning until 1920 and Lisbeth Richter Larsen and Dan Nissen's edited volume *100 Years of Nordisk Film*.[26]

By contrast, the Italian silent film has been studied much more extensively these last few years, with excellent research by for instance Angela Dalle Vacche and Giorgio Bertellini.[27] Much like my own approach, these scholars seek to reevaluate historical works and historical narratives of past research. They have revisited archival research performed by pioneering historians in the 1970s and 1980s, or sometimes much earlier, and complemented and contrasted it with the primary archival materials we have at hand today. We have certainly come a long way with the availability of primary source material. The digitization and searchability of many of them, in the wake of the digital humanities revolution, has aided ascertaining and revising long-standing notions on the history of film. Much praise in this arena should be

directed at the Media History Digital Library, spearheaded by the University of Wisconsin-Madison's Wisconsin Center for Film and Theater Research.

In the case of the Nordisk Films Kompagni, this reevaluation means revisiting the mostly descriptive analyses of Engberg and Ron Mottram and digging into the Nordisk archives at the Danish Film Institute. The Danish language presents an important barrier for most, but a large amount of Nordisk material from the silent period has been excellently preserved by and at the Danish Film Institute, making it a highly interesting case study.[28] This material includes films, programs, stills, credits, promotional materials in several languages, and screenplays, also for many of the films that were itself lost. Going through Nordisk's filmography with an eye on dramatic output, 282 films were released between 1908 and 1914, of which 185 films (65 per cent) are currently lost. For most of these films, however, extra archival material exists in the form of the aforementioned stills, programs, and more. This archival wealth allowed for a close analysis of Nordisk's production strategies, and allowed me to see how Nordisk, like Gaumont, responded in kind to the "art film revolution" that the Film d'Art had instigated, with a series labeled "Dansk Kunstfilm," or the "Danish Art Film."

Class over Country

It is perhaps counterintuitive to steer clear of a national or regional model when researching late-nineteenth- and early-twentieth-century Europe. The French Revolutionary Wars (1792–1802) and subsequent Napoleonic Wars (1803–15) kicked off a war-ridden nineteenth century, and the Great War (1914–18) reduced Europe to rubble once again at the start of the twentieth or the end of the long nineteenth century. This resulted in an estimated fifteen million deaths and the establishment of national borders anew. According to Eric Hobsbawm, the word "nationalism" only entered the vocabulary towards the end of the nineteenth century to specifically describe the ideological right wing, and nationalism itself took "a dramatic leap forward" from 1880 to 1914.[29] Aggressive expansionism and right-wing sentiment did not translate immediately into the cultural realm, however, except if one counts the period leading up to the Great War as one in which the medium of cinema forcefully transcended international borders, with European film companies leading the charge. It was the European art academies that functioned as *the* nervous systems of artistic education and influence from the sixteenth and seventeenth century onwards, and as art historian Sir Nikolaus Pevsner (1940) has noted, there was a strong connection between state and art until the latter had sought to emancipate itself at the end of the seventeenth century, resulting in a break between the two.

Strong States had made and developed the idea of the academy of art. Their legitimate reason had been to issue a certain quantity and a certain quality of art, useful to, and desired by, court or government. Now art had emancipated itself since about 1800, first through Schiller and then through the Romantic movement. After this the artist regarded himself as the bearer of a message superior to that of State and society. Independence was consequently his sacred privilege.[30]

These academies did not only educate their own nationals – de facto fostering the idea of a national aesthetic – but sent them out and received foreigners as well. Almost every self-respecting painter and sculptor spent one to several years in either Paris, France, or one of the great art cities of Italy, such as Rome or Florence, as part of their education. This is also reflected in numerous paintings portraying foreign artist colonies; exemplified by artists such as Danish sculptor Thorvaldsen (1770–1844), who spent most of his life in Rome after being sent there for his education by the Danish academy; and evidenced by the notorious Americans in Paris. The presence of the latter actually led to a printed directory by Albert Sutliffe in 1887. These artistic yellow pages contained their names, addresses, and sketches, for, as the author notes, "the aggregate of American travelers who come to France every year is only excelled by that of England for which there are geographical reasons."[31]

From the end of the sixteenth century, artists and members of the upper class had also been embarking on cultural tourism in what came to be known as the Grand Tour. The itinerary of this European voyage varied, but Paris and the foremost Italian cities were a constant, with popular stops in Antwerp, Berlin, and Geneva. The demographic makeup of these Grand Tourists changed parallel with the growth of the middle classes in the nineteenth century and corresponding technological advances in transport, making it easier and cheaper to reach these destinations. The Grand Tour was not so much about gaining art historical expertise as it was about making good on one's social status and cultural capital. It was these countries' receptive European academies that set out the artistic guidelines. I will argue that these were geared towards a figurative realism that went over well with their target demographic, the middle class or bourgeoisie.

As scholars such as Kocka and Mitchell, Beckert, and many others have demonstrated, the nineteenth century was the century of the middle classes coming into their own as the most important social class in Europe.[32] The push for realism in the arts saw artists, usually a part of this class themselves, pandering to bourgeois tastes and reflecting their importance as patrons. An important part of this movement was the revival of genre painting, or "*petit genre,*" portraying everyday life with a focus on both leisure and domesticity.

From the 1880s onwards, however, art histories tend to suffer from a bias towards innovation and experiment. Many more pages have been dedicated to the innovations of Impressionism, Symbolism, and Expressionism, for instance, and the popularity and prevalence of "academic art" has been negated, underplayed, and made to become synonymous with "kitsch." The newer tendencies in art started to become represented at the salons as well, most notably at the Salon des Refusés founded in 1863. It was the figurative academic art, however, the style that art historian Aleksa Čelebonović dubbed "Bourgeois Realism," that would remain most popular for a long time.[33] The theatrical stage was similarly marked by waves of innovation in this period, but its naturalism (or hyperrealism) soon became blended with the popular social melodramas, and more innovative experiments took a little longer to catch on than they had in painting.

Hobsbawm recognized this as a period of identity crisis for both the arts as well as the bourgeoisie. Where the former increasingly sought out innovation and experiment, he stated, the majority of the latter "'didn't know about art, but they knew what they liked,' or retreated into the sphere of 'classic' works whose excellence was guaranteed by the consensus of generations."[34]

In cinema, figurative realism was unquestionably the norm when approaching dramatic content. Popular classics from literature and the stage were adapted to the screen early on, because their excellence and audience were as good as guaranteed. Cinema was also far better equipped to serve middle-class audiences all over Europe than its stage counterpart because it was silent. Films traveled freely all across the globe and especially in Europe, as distributors made light work of replacing the intertitles to fit a respective country's language(s). The big French film corporations strongly dominated the market from the medium's beginning until the Great War. They scored with border-crossing popular genres rather than content that was tailored to fit national or regional tastes. From a commercial standpoint, nation-specific content was not interesting at all. Internal and external communication shows us that production companies were trying to stay away from content that was too specific to a certain region or country because it could alienate audiences. For a company like the Danish Nordisk, for instance, the numbers did not lie: Scandinavia represented only 2 per cent of the company's sales.[35] This demonstrates that they were entirely invested in an international market and would surely not benefit much from catering to local tastes and interests. They were also careful not to shoot in locations that could be perceived as too "foreign" in other countries.

This is not to say that research into a production context does not benefit from a close analysis of the nation's cultural context, or that such a division cannot be functional and workable. In fact, one is most commonly forced to

reckon with socio-cultural or socio-political parameters. At the same time, however, the emphases, needs, and possibilities from 1908 to 1914 clearly lay in targeting a broad European and even international audience with popular and recognizable content.

This book may therefore come across as being solely against a reading in terms of the "national." Defined by Joseph Garncarz, however, "national film culture [...] aims to define popular culture according to neither a canon of films nor simply the films produced in a country but rather the films most favorably received."[36] In his line of reasoning, Garncarz follows Andrew Higson's definition in "The Concept of National Cinema." From this perspective, early European cinema's dramatic feature films were not cut from the same cloth in terms of their origin, irrespective of where they were screened, and a good case can be made for an analysis that focuses on understanding the phenomenon as one that saw producers concerned with reeling in middle-class audiences, matching their content to fit the demands of the time. Richard Butsch's research into American stage and film audiences, for example, has shown that the conversion of nickelodeon storefronts to cinema palaces that simulated the opulence and prestige of the theatre played a big part in this as well.[37] Whether these strategies effectively reached the right demographic or not, I will demonstrate that there was a definite method to the madness of early cinema production, and one that easily transcended national boundaries at that.[38] Tom Gunning put it most eloquently when he stated that "cinema was international before it was national."[39]

An Intermedial Framework

Film theorist Ágnes Pethő has noted that the term "intermediality" has emerged as one of the "most challenging concepts in media theory," prompting a wide variety of interpretations, taxonomies, and definitions.[40] This book tackles the concept "intermedial" as a set of relationships that flow broadly *between* media and that are thus often reciprocal. By definition, this concept is more apt to describe the intricate web of cultural correlations that can be spun between visual arts, performing arts, and screen arts, than, for instance, "transmedial." The latter's prefix implies a narrower relationship that simply flows from one point to another and leaves little room for what is "in-between." At the same time, an intermedial approach is stimulating because it questions cinematic mediality and rightly problematizes a take on film history that blissfully excludes influences from other media. This opens the floor to historical revisionism, or "the history of cinema not as a linear progress in time, but as a set of paradigms that can be re-visited and refashioned."[41]

Film historian Donald Crafton takes a critical stance to past intermedial research, especially the kind of ruminations concerned with viewing cinema as if it were painting or sculpture. Crafton is clearly concerned with the preservation of cinema's medium-specificity and points to French-Italian film theorist Ricciotto Canudo (1877–1923) as an example of early film historical writing that sought to represent cinema as an autonomous form of art. He implies that he sees Canudo's work as a pejorative case that simply mapped "a cinematic convention over an aesthetic formula," rather than the interdisciplinary synthesis of art forms that Canudo suggests cinema represents.[42] The French-Italian theorist was very cautious and reticent in declaring cinema a new art form precisely because of the perceived absence of medium-specific characteristics. I will argue that Canudo's work was not simply a compilation of superficial comparisons between film and other art forms, but a discourse that was distinctly representative of both the period and early film theory. Furthermore, Canudo took medium-specificity seriously and approached it from an art historical perspective. Later theoretical work on film as art such as that by Rudolf Arnheim (1904–2007), with his 1932 *Film als Kunst*, or Erwin Panofsky (1892–1968) and his 1934 *Style and Medium in the Motion Pictures*, is more commonly invoked, but Canudo published his first considerations on film as an art form in the midst of the art film wave that swept Europe in 1908. His text was published in 1908 in Italian and 1911 in French, respectively, and provides a unique inside perspective on the matter in line with concerns voiced by other contemporary theorists.

Still, Crafton is right in stating that, as far as academic film studies is concerned, "the field has only slowly meshed with art-historical practice, compared to the ways film studies has meshed with other disciplines for the past two decades." He believes that the difference between the two is largely a semantic one and "the result of academic contrivance."[43] More than a decade has now passed since the release of Dalle Vacche's *The Visual Turn*. Though it is still a niche of sorts, one can surely detect a further increase in intermedial research, both in early cinema and beyond; whether it be through investigating the cinematic visualization of fine arts, the symbiotic relationship between film and performing arts, shared stylistic patterns and strategies, or a larger discursive-theoretical framework.

Recently, work by Dalle Vacche, Brigitte Peucker, Susan Felleman, Steven Jacobs (with Lisa Colpaert), and Ágnes Pethő has contributed greatly to the field of intermediality. It is only Dalle Vacche and Peucker that deal with the context of early cinema, however, which in this respect is certainly still an understudied field.[44] Luckily, efforts by scholars such as Ivo Blom, investigating interdisciplinary crossroads in Italian silent cinema, and Kaveh Askari, digging into the intersections between early American cinema, art education,

and the art studio, among others, have led the way.[45] Furthermore, studies on theatre and (early) cinema can also be considered part of this field. With an eye on the period covered by this book, Ben Brewster and Lea Jacobs' 1997 book *Theatre to Cinema: Stage Pictorialism and the Early Feature Film* is a seminal work. It builds on that of A. Nicholas Vardac, and is further complemented in the field by Jon Burrows, Christine Gledhill, David Mayer, and Victoria Duckett, to name a few.[46]

Like Gledhill, I am interested in fashioning a "cultural poetics" of the period at hand. Taking early European cinema as a starting point to find that a thorough investigation of the relationships with its artistic counterparts is a crucial part of understanding the medium in its proper societal context. The idea of a "cultural poetics" stems from the historiographical move towards New Historicism in the 1980s, spearheaded by historian Stephen Greenblatt. He argued for a move away from the autonomy of the text and to an understanding of cultural phenomena in their proper historical context, being aware that history can be an unreliable narrator. In Greenblatt's own words,

> the general question addressed by Jameson and Lyotard – what is the historical relation between art and society or between one institutionally demarcated discursive practice and another? – does not lend itself to a single, theoretically satisfactory answer of the kind that Jameson and Lyotard are trying to provide.[47]

Film historians were quick to catch on to this concept in what came to be known as "new film history." David Bordwell states that this new historicism in film studies not only meant a further exploration of other aspects of cinema, such as its economics, exhibition, narratology, or style, but also a focus on primary materials. This entails the combination of "traditionally distinct spheres of inquiry." The international inquiry into pre-1920s cinema, for instance, "has generated questions which treat industry, audience, narrative, and style together."[48]

Looking at the makeup of the formative years of early European cinema between 1908 and 1914 and how it relates to society, then, I follow Greenblatt and Bordwell in proposing that there are a multitude of answers to the overarching question of the relationship between art and society. I will argue that these can be found in the medium's relationships with visual and performing arts – with an emphasis on painting, theatre, and photography – and its appeal to middle-class audiences. This means that I will analyze productional, promotional, discursive, and aesthetic elements within a broader socio-cultural framework.

In chapter two, for instance, this focus will be channeled into a case study on the fluidity between stage and screen, culminating in a case study

on Danish actress Betty Nansen in chapter three. In chapter four, Nordisk and Gaumont's pre-war output is placed onto the broader cultural spectrum, tracing pre-modern trends from photography and painting as key influences, which culminates in an in-depth analysis of how Swedish director Victor Sjöström's 1922 film *Vem dömer* (*Love's Crucible*) still reflects this mid-1910s approach and aesthetic in the early 1920s in chapter five. This book can therefore be seen as jumping off from new historicism into the more recent "intermedial turn" of film studies. It joins scholars such as Askari in a field of early cinema studies that tries to avoid an evolutionary model. Rather, it reveals "a media ecology in which fluid conceptions of image and address persist or reemerge," laying bare connections between different artistic media and across periods of time.[49]

TRANSITIONAL CINEMA AND THE LONG NINETEENTH CENTURY

I would like to propose considering early European cinema up to 1914 part of what historians have defined as a long nineteenth century (c. 1789–1914), rather than it being a uniquely twentieth-century phenomenon. Mapping early European cinema in this way not only aims to indicate the important cultural continuation that I argue exists between nineteenth-century artistic modes in painting, theatre, photography, and early-twentieth-century cinema, it also hopes to problematize the application of "modernism" and the "modernity thesis" to a period in which cinema underwent considerable change. As any sensible historian will tell you, imposing organizational schemas upon the unorganized and often seemingly unconnected array of events that is history is a necessary evil. It is unavoidable when one wants to make sense of a certain context, but nevertheless contributory to the narrative construct that is history writing.

For my own research purposes, I will be applying several labels and subdivisions to early European cinema from 1908 to 1914. It is in this period that the art film was "born" out of a large-scale strategy to reel in middle-class audiences with subject matter that they could relate to. What we see resulting from that is a quick development towards longer, story-driven narratives, from a single-reel to a multi-reel format. This multi-reel format also became known as the "feature(d)" film around 1910. Nordisk's president Ole Olsen notoriously promoted the heck out of his company's *Den hvide Slavehandel* (*The White Slave Trade*; August Blom, 1910) as being the "first" feature film, with a length of 603 meters, but in fact his film intricately plagiarized the now lost eponymous film by Alfred Cohn for the Fotorama company, which was released four months earlier and boasted a length of 706 meters.[50]

I will designate this period of change between 1908 and 1914 as one of Bourgeois Realism, after Aleksa Čelebonović's designation of nineteenth-century genre painting. I see a clear and rapid shift away from the one-reel adaptations of popular classics from theatre, literature, painting, and opera, that were the bread and butter of the art film from 1908 to around 1910, to the equally popular social (melo)drama, which dominated the scene in a multi-reel, or feature-length format from 1910 to 1914. While I use the First World War as a cut-off point, one could certainly argue that this trend continued beyond this boundary. For one, films were still being produced during the Great War by countries such as Denmark and Sweden, two of the few countries that had managed to maintain neutrality throughout. This allowed them to thrive and benefit from the dramatic collapse of the French market. Furthermore, many European production companies tried to pick up where they left off when the Great War ended. This is exemplified by the gradual shift in focus, tone, and production models in the late 1910s and early 1920s.

In his research on early American fiction filmmaking, Charlie Keil recognized the period from 1907 to 1913 as a "transitional cinema," signifying a process of change effectuated by, among others, "changes to production practices, altered industry standards regarding film formats and release schedules [and] increased monitoring of films by the trade press."[51] This period was later broadened by Keil to encompass 1908 to 1917, which is also the period that Bordwell, Staiger, and Thompson identify as the start of a Classical Hollywood style.[52] They argue that this period represents the dominance of a classical model "in the sense that most American fiction films since that moment employed fundamentally similar narrative, temporal, and spatial systems. At the same time the studio mode of production had become organized."[53]

This periodization has willingly been transplanted to a European context, but the question is whether the same parameters truly hold up there? The European film industry underwent different changes at different periods and was subject to great upheaval from July 1914 to November 1918, which was also the period in which American cinema rose to dominance and further developed its stylistic system. American cinema, furthermore, employed a more cutting-based style, whereas the European cinema tended towards a more mise-en-scène based aesthetic. As Bordwell has noted, this functional dialectic was already being recognized by contemporary film writers, but it is still good not to distinguish too sharply between the two, for while "analytical cutting and lengthy takes can be seen as logical alternatives, historically they often functioned as flexible, nonexclusive options."[54] While this is certainly true, the split was nevertheless present and quite noticeable, especially from 1908 to 1914. The example that Bordwell uses, furthermore, is Victor

Sjöström's *Ingmarssönerna* (*Ingmar's Sons*) from 1919, which dates from after the war and stands in contrast with the depth-staging examples Bordwell describes from Sjöström's 1913 *Ingeborg Holm* and Louis Feuillade's *Fantômas* series (1913–14). In chapter five, we will see that Sjöström returns to his earlier strategies in the 1922 *Vem dömer*, which relies heavily on long takes and staging.

From a production angle, Pathé-Frères had already initiated their move towards vertical integration in 1906, with other large European companies following suit quickly. A director-unit system, as well as the efficient compartmentalization of labor, seems to have been implemented around the same time. The standardization of length was accomplished around 1911 with the establishment and propagation of the multi-reel film. Many early cinema scholars seem to be in agreement, furthermore, that 1913 constituted an absolute peak year in terms of qualitative European output. From Italy to Russia and Sweden, the intelligent application of mise-en-scène communicated intricate narratives, and breathtakingly beautiful pictorial cinematography strikingly conveyed emotion, as described in greater detail in chapters one and four. It seems unlikely that the tableau aesthetic, which boasted mise-en-scène in longer takes, was already put in place around 1910, and reached critical highs in 1913, would have evolved to a similar "classical" end goal as American cinema. It might therefore be more useful to argue for a European transitional period dating from 1905 to 1910, leading up to an integrated industrial approach and a consistent set of stylistic parameters.

In broader art historical and cultural terms, the timeframe of early European cinema I am working in is often considered to be part of modernity, but one can say that there is a dialectic relation between artistic "modernism" and the more interrelated "modernization" and "modernity." Here we follow Daniel Biltereyst, Richard Maltby, and Philippe Meers, cued by Elsaesser.[55] First, it is useful to make distinctions between *modernism* as "an artistic avant-garde;" *modernization* in the sense of industrial innovation in the fields of "technology, industry and science;" and *modernity* "as a practice of lifestyle, fashion and sexual mores [as well as] a particular attitude to life [. . .] usually associated with increased leisure time and new patterns of consumption" in Western societies.[56]

These distinctions are not always delineated so clearly with regard to the late nineteenth and early twentieth century. From a broader historical standpoint, the modern era has not necessarily ceased to exist, starting with efforts of globalization at the end of the Middle Ages (c. 1500). It is precisely this tension between "modernism" and the larger societal forces of "modernity" that scholars such as Charlie Keil and Ben Singer have addressed, questioning the one-on-one causal approach that is applied between modernity (cause)

and early cinema (effect). Ben Singer summarized the modernity thesis as "an interest in unearthing or rethinking cinema's emergence within the sensory environment of urban modernity, its relationship to late nineteenth-century technologies of space and time, and its interactions with adjacent elements in the new visual culture of advanced capitalism" with cinema representing a product "quintessential of fin-de-siècle society" and standing out as "an emblem of modernity."[57] We will elaborate on this in subsequent chapters, but studying the continuation of the so-called "blood and thunder" melodramas, for instance, a sensational stage form popular from the mid-Victorian period onwards, Singer argues that this type of melodrama was wed with urban modernity in the creation of the highly popular thrill-ridden serials such as *The Perils of Pauline* (1914) or *The Hazards of Helen* (1914–17), enforcing the modernity thesis.

In the same vein, Tom Gunning and André Gaudreault developed the idea of a "cinema of attraction(s)" in 1985 to culturally define the style of cinema before 1906–7. Gunning considered this type of cinema as strongly exhibitionist and related it to the work of avant-garde writer-directors, such as Abel Gance (1889–1981), Fernand Léger (1881–1951) and Sergei Eisenstein (1898–1948), arguing that they shared the practice of "exhibitionist confrontation" over "diegetic absorption."[58] Bordwell objects with Gunning's proposal of coupling this style to a Benjaminian view of modernity, meaning one in which the shocks, jolts, sensations, and fragmentation of modern urban life "created a new perceptual 'mode' specific to modernity," a fragmentation that per Gunning and others is reflected in both editing and the "aesthetic of astonishment." But if there was indeed such "a radical and pervasive change in the ways of seeing," Bordwell posits, then why didn't more films before 1907 bare traces of this, and why did this stop after 1907, assuming that "modernity and its mode of perception did not cease around 1910," to be replaced by "traditional, even 'bourgeois' modes of storytelling."[59] Furthermore, Keil states that this approach has led to a "modernity-spawned canon for cinema's early years" that privileges "films made prior to the transitional period."[60] As will become apparent in subsequent chapters, I follow Bordwell and Keil in thoughtfully questioning the "modernity thesis" and its far-reaching implications. Proposing a view of early European cinema as part of a long nineteenth century does not exclude it from being "modern" in a historical sense, but it certainly aims to preclude it from being seen as modernist. Rather, I will argue, especially in chapters one and four, that the dramatic feature films of this period were Bourgeois Realist in their style and content, building on popular artistic conventions and strategies from theatre, painting, and photography.

Notes

1. Anon. "A History of Cinema Without Names: A Research Project" Call for Papers (2014), *XXII Udine International Film Studies Conference*, Udine (18–20 March 2015).
2. E.g. Aby Warburg's visual history project *Mnemosyne*, or *Atlas of Images* (1927–1929), Aby Warburg with Martin Warnke and Claudia Brink (eds.), *Der Bilderatlas MNEMOSYNE* (Berlin: De Gruyter, 2000); Henri Focillon, *Vie des forms* (Paris: Ernst Leroux, 1934); Erwin Panofsky, "On Movies," *Bulletin of the Department of Art and Archaeology of Princeton University* (June 1936), 5–15, and *Studien zur Ikonologie. Humanistische Themen in der Kunst der Renaissance* (Cologne: Dumont, 1980); Nelson Goodman, *Languages of Art: An Approach to a Theory of Symbols* (Indianapolis: Bobbs-Merrill, 1968); and Antoine Compagnon, *Le démon de la théorie: littérature et sens commun* (Paris: Éditions du Seuil, 1998).
3. Heinrich Wölfflin, *Kunstgeschichtliche Grundbegriffe: Das Problem der Stilentwicklung in der neueren Kunst* (Munich: Bruckmann, 1915) and *Das Erklären von Kunstwerken* (Leipzig: E.A. Seemann, 1921); Paul Valéry, *L'enseignement de la poétique au Collège de France* (Paris: s.n., 1937).
4. Anon. "What is Cinema History?" Call for Papers (2014), *HoMER Network Conference, Glasgow* (22–4 June 2015). Cf. Robert C. Allen and Douglas Gomery, *Film History: Theory and Practice* (New York: McGraw Hill, 1985).
5. E.g. Robert C. Allen, "From Exhibition to Reception: Reflections on the Audience in Film History," *Screen* 31, 4 (1990), 347–56.
6. Edward Hallett Carr, *What is History?* (London: Macmillan, 1961); Hayden White, *Metahistory: The Historical Imagination in Nineteenth-Century Europe* (Baltimore: Johns Hopkins University Press, 1973); Karl Löwith, *Meaning in History* (Chicago and London: The University of Chicago Press, 1949); Marc Bloch, *Apologie pour l'histoire, ou métier d'historien* (Paris: Armand Colin, 1971); Michel Foucault, *L'Archéologie du savoir* (Paris: Gallimard, 1969); Sande Cohen, *History Out of Joint: Essays on the Use and Abuse of History* (Baltimore: Johns Hopkins University Press, 2006); and Frank R. Ankersmit, *Sublime Historical Experience* (Stanford: Stanford University Press, 2005).
7. Charles F. Altman, "Towards a Historiography of American Film," *Cinema Journal* 16, 2 (1977), 1–25; Patrick Griffin, "Film, Document, and the Historian," *Film & History – An Interdisciplinary Journal of Film and Television Studies* 2, 2 (1972), 14–21; Robert C. Allen, "Historiography and the Teaching of Film History," *Film & History – An Interdisciplinary Journal of Film and Television Studies* 10, 2 (1980), 1–6; Robert A. Rosenstone, "History in Images – History in Words – Reflections on the Possibility of Really Putting History onto Film," *The American Historical Review* 93, 5 (1988), 1173–85; Hayden White, "Historiography and Historiophoty," *The American Historical Review* 93, 5 (1988), 1193–9.
8. David Bordwell and Kristin Thompson, *Film History: an Introduction* (Second Edition. New York: McGraw-Hill, 2003).
9. Allen, "Historiography and the Teaching of Film History," 3.

10. White, "Historiography and Historiophoty."
11. Anon. "What is Cinema History?"
12. Anon. "A History of Cinema Without Names: A Research Project."
13. Cf. Vito Adriaensens, "The Bernhardt of Scandinavia: Betty Nansen's Modern Breakthrough," *Nineteenth Century Theatre and Film* 45, 1 (2018), 56–80; "A Swedish Renaissance: Art and Passion in Victor Sjöström's 'Vem dömer' (1922)," *Kosmorama* 269 (2017). https://www.kosmorama.org/en/kosmorama/artikler/swedish-renaissance-art-and-passion-victor-sjostroms-vem-domer-1922; "Malerei in Bewegung: Bürgerlicher Realismus und Piktoralismus im europäischen Kino (1908–1914)," in Jörg Schweinitz and Daniel Wiegand (eds.), *Film Bild Kunst: Visuelle Ästhetik des vorklassischen Stummfilms* (Marburg: Schüren Verlag, 2016), 151–75; "'Kunst og Kino': The Art of Early Danish Drama," *Kosmorama* 259 (2015). https://www.kosmorama.org/en/kosmorama/artikler/kunst-og-kino-art-early-danish-cinema.
14. Charles Musser, "Historiographic Method and the Study of Early Cinema," *Cinema Journal* 44, 1 (2004), 105.
15. Sumiko Higashi, "In Focus: Film History, or a Baedeker Guide to the Historical Turn," *Cinema Journal* 44, 1 (2004), 98.
16. Lee Grieveson, "Woof, Warp, History," *Cinema Journal* 44, 1 (2004), 124.
17. Richard Abel, "History Can Work for You, You Know How to Use it," *Cinema Journal* 44, 1 (2004), 107–12; Robert Sklar, "Does Film History Need a Crisis?," *Cinema Journal* 44, 1 (2004), 134–8; Janet Staiger, "The Future of the Past," *Cinema Journal* 44, 1 (2004), 126–9; Jane Gaines, "Film History and the Two Presents of Feminist Film Theory," *Cinema Journal* 44, 1 (2004), 113–19.
18. Jane Gaines, "What Happened to the Philosophy of Film History?" *Film History: An International Journal* 25, 1–2 (2003), 70–80.
19. Francis Lacassin, Francis, *Louis Feuillade* (Paris: Seghers, 1964); Jacques Champreux and Alain Carou (eds.), "Louis Feuillade," *1895 – Revue d'Histoire du Cinéma* (Hors série, October 2000); Alain Carou and Laurent Le Forestier (eds.), *Louis Feuillade: Retour aux sources – Correspondances et archives* (Paris: Revue de l'Association française de recherché sur l'histoire du cinéma and Gaumont, 2007).
20. Jean Antoine Gili and Eric Le Roy (eds.), "Albert Capellani: De Vincennes à Fort Lee," *1895 – Revue d'Histoire du Cinéma* 68 (Special issue, Fall 2012); Christine Leteux, *Albert Capellani: Cinéaste du Romanesque* (Grandvilliers: La Tour Verte, 2013).
21. Vito Adriaensens, "Albert 'Cap' Capellani," in Stefan Franck (ed.), *To Dazzle the Eye and Stir the Heart: the Red Lantern, Nazimova and the Boxer Rebellion* (Brussels: Cinémathèque Royale de Belgique, 2012), 27–34.
22. Richard Abel, *The Ciné Goes to Town: French Cinema 1896–1914* (Berkeley and Los Angeles: University of California Press, 1998).
23. Marguerite Engberg, *Dansk Stumfilm: De store År I–II* (Copenhagen: Rhodos, 1977).
24. William K. Everson, *American Silent Film* (New York: Da Capo Press, 1978), 60.

25. Everson, *American Silent Film*, 61.
26. Casper Tybjerg, *An Art of Silence and Light: The Development of the Danish Film Drama to 1920* (Copenhagen: University of Copenhagen, Doctoral Dissertation, 1996); Lisbeth Richter Larsen and Dan Nissen (eds.), *100 Years of Nordisk Film* (Copenhagen: Danish Film Institute, 2006).
27. Angela Dalle Vacche, *Diva: Defiance and Passion in Early Italian Cinema* (Austin: University of Texas Press, 2008); Giorgio Bertellini (ed.), *Italian Silent Cinema: a Reader* (New Barnet: John Libbey & Company, 2013).
28. For an overview of what is the available in The Danish Film Institute's Nordisk Films Kompagni collection, cf. Lisbeth Richter Larsen, "The Nordisk Film Collection: An Introduction," in Dan Nissen, Lisbeth Richter Larsen, Jesper Stub Johansen and Thomas C. Christensen (eds.), *Preserve Then Show* (Copenhagen: Det Danske Filminstitut, 2002), 196–206; and Isak Thorsen, "The Nordisk Film Collection," *Early Popular Visual Culture* 14, 3 (2016), 281–7.
29. Eric Hobsbawm, *The Age of Empire: 1875–1914* (London: Abacus, 2003), 142.
30. Nikolaus Pevsner, *Academies of Art: Past and Present* (Cambridge and New York: Cambridge University Press, 2014), 240.
31. Albert Sutliffe, *The Americans in Paris, with Names and Addresses, Sketch of American Art, Lists of Artists and Pictures, and Miscellaneous Matter of Interest to Americans Abroad* (Paris: T. Symonds, 1887), 5.
32. Jürgen Kocka and Allan Mitchell (eds.), *Bourgeois Society in Nineteenth-Century Europe* (Oxford: Berg, 1993); Sven Beckert, "Institution-building and Class Formation: How Nineteenth-century Bourgeois Organized," in Graeme Morton, Boudien de Vries and R.J. Morris (eds.), *Civil Society, Associations and Urban Places: Class, Nation and Culture in Nineteenth-Century Europe* (Aldershot: Ashgate, 2006), 17–38.
33. Aleksa Čelebonović, *The Heyday of Salon Painting: Masterpieces of Bourgeois Realism* (London: Thames & Hudson, 1974).
34. Hobsbawm, *The Age of Empire*, 219–20.
35. Marguerite Engberg, "Plagiarism, and the Birth of the Danish Multi-Reel Film," in Lisbeth Richter Larsen and Dan Nissen (eds.), *100 Years of Nordisk Film* (Copenhagen: Danish Film Institute, 2006), 79.
36. Joseph Garncarz, "The emergence of nationally specific film cultures in Europe, 1911–1914," in Richard Abel, Giorgio Bertellino, and Rob King (eds.), *Early Cinema and the "National"* (New Barnet: John Libbey & Company, 2008), 185; See also Andrew Higson, "The Concept of National Cinema," *Screen* 30, 4 (1989), 36–47.
37. Richard Butsch, *The Making of American Audiences: From Stage to Television, 1750–1990* (Cambridge and New York: Cambridge University Press, 2000), 158–72.
38. Of course, this is not a study into exhibition practices, and works as early as Emilie Altenloh's 1914 *Zur Soziologie des Kino* have already pointed towards the diversity of film audiences, but rather than speaking of an "imagined audience" when referring to the middle classes, or bourgeoisie, in this book, it is important to note that its points of departure are conscientiously dictated by productional, promotional, and stylistic strategies inherent in the corpus, therefore resulting

in what can be construed as a contemporary "target audience" for production companies. Cf. Emilie Altenloh, *Zur Soziologie des Kino: die Kino-Unternehmung und die Sozialen Schichten ihrer Besucher* (Jena: Eugen Diederichs, 1914).

39. Tom Gunning, "Early cinema as global cinema: the encyclopedic ambition," *Early Cinema and the "National,"* 11
40. Ágnes Pethő, *Cinema and Intermediality: The Passion for the In-Between* (Newcastle upon Tyne: Cambridge Scholars Publishing, 2011), 1.
41. Pethő, *Cinema and Intermediality*, 37.
42. Donald Crafton, "Foreword" in Angela Dalle Vacche (ed.), *The Visual Turn: Classical Film Theory and Art History* (New Brunswick and London: Rutgers University Press, 2003), x.
43. Crafton, "Foreword," x.
44. See Angela Dalle Vacche (ed.), *The Visual Turn: Classical Film Theory and Art History* (New Brunswick and London: Rutgers University Press, 2003); Angela Dalle Vacche (ed.), *Film, Art, New Media: Museum without Walls?* (Basingstoke and New York: Palgrave Macmillan, 2012); Brigitte Peucker, *Incorporating Images: Film and the Rival Arts* (Princeton: Princeton University Press, 1995); Brigitte Peucker, *The Material Image: Art and the Real in Film* (Stanford: Stanford University Press, 2007); Susan Felleman, *Art in the Cinematic Imagination* (Austin: University of Texas Press, 2016); Susan Felleman, *Real Objects in Unreal Situations: Modern Art in Fiction Films* (Chicago: Intellect, 2014); Steven Jacobs, *The Wrong House: the Architecture of Alfred Hitchcock* (Rotterdam, 010 Publishers, 2007); Steven Jacobs, *Framing Pictures: Film and the Visual Arts* (Edinburgh: Edinburgh University Press, 2011); Steven Jacobs and Lisa Colpaert, *The Dark Galleries: a Museum Guide to Painted Portraits in Film Noir, Gothic Melodramas and Ghost Stories of the 1940s and 1950s* (Ghent: AraMER, 2013); and Pethő, *Cinema and Intermediality*.
45. See Ivo Blom, "Il Fuoco or the Fatal Portrait: The XIXth Century in the Italian Silent Cinema," *Iris* 14–15 (Autumn 1992), 55–66; Ivo Blom, "Quo vadis? From Painting to Cinema and Everything in Between" in Leonardo Quaresima and Laura Vichi (eds.), *La decima musa. Il cinema e le altre arti/The Tenth Muse: Cinema and other arts* (Udine: Forum, 2001), 281–96; Ivo Blom, "Of Artists and Models: Italian Silent Cinema between Narrative Convention and Artistic Practice" in Ágnes Pethő (ed.), *The Cinema of Sensations* (Newcastle upon Tyne: Cambridge Scholars Publishing, 2015), 121–36; and Kaveh Askari, *Making Movies into Art: Picture Craft from the Magic Lantern to Early Hollywood* (London: British Film Institute, 2014).
46. See Ben Brewster and Lea Jacobs, *Theatre to Cinema: Stage Pictorialism and the Early Feature Film* (Oxford and New York: Oxford University Press, 1997); A. Nicholas Vardac, *Stage to Screen: Theatrical Origins of Early Film from Garrick to Griffith* (Cambridge, MA: Harvard University Press, 1949); Jon Burrows, *Legitimate Cinema: Theatre Stars in Silent British Films 1908–1918* (Exeter: Exeter University Press, 2003); Christine Gledhill, *Reframing British Cinema 1918–1928: Between Restraint and Passion* (London: British Film Institute, 2003); David Mayer, *Stagestruck Filmmaker: D.W. Griffith and the American Theatre* (Iowa City: University

of Iowa Press, 2009); and Victoria Duckett, *Seeing Sarah Bernhardt: Performance and Silent Film* (Urbana, Chicago, and Springfield: University of Illinois Press, 2015).
47. Stephen Greenblatt, "Towards a Poetics of Culture" in H. Aram Veeser (ed.), *The New Historicism* (London and New York: Routledge, 1989), 5.
48. David Bordwell, "Contemporary Film Studies and the Vicissitudes of Grand Theory," in David Bordwell and Noel Carroll (eds.), *Post-Theory: Reconstructing Film Studies* (Madison: The University of Wisconsin Press, 1996), 28–9.
49. Askari, *Making Movies into Art*, 5.
50. Engberg, "Plagiarism and the Birth of the Danish Multi-Reel Film," 72–9.
51. Charlie Keil, *Early American Cinema in Transition: Story, Style, and Filmmaking, 1907–1913* (Madison: The University of Wisconsin Press, 2001), 3.
52. Charlie Keil, "To Here from Modernity: Style, Historiography, and Transitional Cinema" in Charlie Keil and Shelley Stamp (eds.), *American Cinema's Transitional Era: Audiences, Institutions, Practices* (Berkeley and Los Angeles: University of California Press, 2004), 51–65.
53. David Bordwell, "The Classical Hollywood Style, 1917–1960" in David Bordwell, Janet Staiger and Kristin Thompson, *The Classical Hollywood Cinema: Film Style & Mode of Production to 1960* (London and New York: Routledge, 2005), 9.
54. David Bordwell, *On the History of Film Style* (Cambridge, MA and London: Harvard University Press, 1997), 199.
55. Thomas Elsaesser, *Weimar Cinema and After: Germany's Historical Imaginary* (London and New York: Routledge, 2000), 390.
56. Daniel Biltereyst, Richard Maltby, and Philippe Meers (eds.), *Cinema, Audiences and Modernity: New Perspectives on European Cinema History* (London and New York: Routledge, 2012), 15.
57. Ben Singer, *Melodrama and Modernity: Early Sensational cinema and its Contexts* (New York: Columbia University Press, 2001), 102.
58. Tom Gunning, "The Cinema of Attraction: Early Film, Its Spectator and the Avant-Garde" *Wide Angle* 8, 3–4 (1986), 66.
59. Bordwell, *On the History of Film Style*, 142–6.
60. Keil, "To Here from Modernity," 55.

CHAPTER ONE

The Birth of a Sixth Art: The Art Film and the Film-as-Art Discourse

The impact that the year 1908 had on European film history is not to be underestimated. It was the year in which French production company Le Film d'Art united famed l'Académie française playwright Henri Lavedan (1859–1940) with Comédie-Française actor Charles Le Bargy (1858–1936) in an effort to create artistically sound dramatic features that would elevate the cinema by associating it heavily with the legitimate stage. They released what is considered to be the first "art film" with *L'Assassinat du Duc de Guise* (André Calmettes and Charles Le Bargy) and immediately sparked a European art film wave. The first of its kind. It was also more or less the year in which film criticism was born. The first issue of the influential French film magazine *Ciné-Journal* was released and French-Italian film theorist Ricciotto Canudo (1877–1923) put forth the first version of his powerful article pondering the "birth of a sixth art." Building on the important work performed on the subject by film historians such as Richard Abel, Alain Carou, and Béatrice de Pastre, and working with primary source materials, this chapter will first argue that there were two distinct phases to be recognized in the evolution of the European art film. This is exemplified by the directions pursued by two international film giants, the French Gaumont and the Danish Nordisk Films Kompagni. We will then analyze contemporary critical reactions to the phenomenon of the art film, focusing on the heated polemic that dealt with the cultural legitimacy of the medium as an art form. This war of words spearheaded investigations into cinema's medium specificity and its relationship with visual and performing arts. It demonstrated that the inherent intermediality of the new medium was picked up on straight away, but we will see that it was the cinema's mechanical properties that obstructed its legitimization. These arguments will be developed by examining the French *Ciné-Journal*, the Danish *Filmen*, and the American *The Moving Picture World*, as well as texts by contemporary writers and directors. We will employ the critical voice of Ricciotto Canudo as a guide. His paradoxically divergent views ranged from full-blown Romanticism to sedated Futurism, making him a perfect representative of a period caught between two centuries.

LE FILM D'ART AND LES FILMS D'ART

If there is one certainty about the use of the word "art film" in the early years of twentieth-century Europe, it is that it was confusing at best. Taking a look back, one can argue that the problematic nature of the term prevailed on a multitude of levels. It was troublesome for producers, distributors, exhibitors, and audiences, as well as critics, and not just on a generic level. An initial semantic distinction has to be made between "Le Film d'Art," the company; "*films d'art*," or art films; and "*films artistiques*," or artistic films. Film started out as a form of inexpensive mass entertainment that had to struggle for respectability, prestige, and a singular identity, but, in retrospect, these issues were overcome in a very short time span. The solution was found by reworking form and content to fit the needs of the audience, since they could grant the medium the respectability it needed to distinguish itself as a proper art form on a par with the theatre. The middle class had grown in size substantially by the end of the nineteenth century, turning it into the most significant patron audience of the arts in what historians such as Eric Hobsbawm have dubbed "the long nineteenth century," which is dated from the French Revolution in 1789 to the start of the First World War in 1914.[1] In this "bourgeois century," as Roger Magraw also called it, the arts tended to reflect the values and tastes of its chief consumers.[2]

Film companies responded by investing in films that exuded a sense of "quality" at the same time that the medium had logically been evolving into longer, story-driven narratives. It was no coincidence, then, that the advent of the European feature-filling film corresponded with the first wave of art films in 1907–8. The cinema's quest to legitimize itself led to an association with those media that were already artistically legitimate – mainly literature and visual and performing arts – with an emphasis on popular classics. The first phase of cinema's activation of this key middle-class demographic was therefore aimed at earning its cultural capital. It made perfect sense, also, that France would be the country to spawn the art film. The French had ruled the cinematic roost from the very beginning of its history and proved to be the most productive film industry in the world until the Great War. Four major film companies were on top around the turn of the century: Pathé-Frères, Gaumont, Star Films, and Lumière. The latter went off-screen rather quickly, however, and in the same period Georges Méliès' Star Films was unable to keep up with the expansion of Pathé and Gaumont, making them the only remaining major studios by 1905–6.

Abel's research has demonstrated that the French film scene only really rose to dominance in all areas from around 1906–7 onwards, when a large number of small new production companies were founded and hundreds

of permanent cinema theatres were established to exploit the ever-growing output. The rise was so steep that "the French press repeatedly expressed astonishment at the speed with which the cinema was supplanting the café-concerts and music halls and the extent to which it was threatening to displace the theater."[3] For a number of people, a potential displacement of the theater was a genuine concern. In fact, the steep rise of movie theatres did thoroughly shake up the cultural playing field, effectively sounding the death knell for the fairground cinema circuit. The entrepreneurially oriented Pathé-Frères were again instrumental in implementing this strategy, clearly seeing the financial and cultural benefits of such a vertical integration. They set out to construct a circuit of nationwide cinemas as early as November 1906 to "expand its market base beyond the clientele of fairs and to attract a large urban white-collar and bourgeois audience on a more consistent basis;" but close competitor Gaumont waited until 1908 to open their first Paris venue, the Cinéma-Palace.[4] The surge continued into 1909, when Abel's numbers show that Pathé-Frères' nationwide circuit had reached 200 cinema theatres, and Paris alone was host to more than a hundred movie theatres. Construction slowed down for almost two years before exploding once more in 1911, peaking with the September opening of Gaumont's newly renovated Hippodrome. It was aptly renamed the Gaumont-Palace, and with its 3,400 seats it was the largest movie theater in the world.[5]

Compounding the worries of the established stage world, and tightly implanting a feather in cinema's cultural cap, was a series of French lawsuits concerning intellectual property and copyright. Plagiarism and the shameless duping of negatives ran rampant during the earliest years of cinema and so the establishment of a legal framework that saw "film" as intellectual property was crucial. Richard Brown argues that the convincing preference for story films over actualities around 1904 encouraged "increased use of trademarks as a means of gaining added value and promoting brand identification."[6] Onscreen trademarks were usually quite visibly incorporated into the set. Pathé's rooster, Gaumont's daisy, and the American Mutoscope and Biograph Company's "AB" logo, for instance. While these were great at preventing, or at least deterring, the copying of negatives, they did not deal with the content of the film at hand. This was a significant problem in film nations such as France, Great Britain, Denmark, the United States, and most likely elsewhere too.

In France, lawyers Emile Maugras and Maurice Guégan drafted a 142-page document entitled *Le cinématographe devant le droit* (1908) designed to protect producers' rights and put an end to fraudulent counterfeiting and copying. The aim of this document was to establish cinema as an art form, but as Édouard Arnoldy notes, Maugras and Guégan had an elevated moral

and aesthetic ideal of cinema in mind that did not necessarily corroborate with the lowbrow reality of cinema as a popular medium. It did indicate, however, in which direction a number of prominent people wanted it to go.[7] To complicate matters, Maugras and Guégan were also both in the employ of Pathé. They were supported publicly in their pleas by Edmond Benoît-Lévy, a lawyer, journalist, editor of *Phono-Ciné-Gazette* (1905–8), and director of the Omnia-Pathé cinema. Benoît-Lévy reported on all of these court cases in *Phono-Ciné-Gazette*, Pathé's key publicity outlet, and took up a clear position in the matter. He stated that film was not merely a product but "a literary and artistic property in a double sense [. . .] for a film consists of an idea and its application simultaneously. Invention makes it a non-written literary property, and photography makes it incontestably an artistic property."[8] This strategy towards cultural legitimation worked. The Berlin Commission, which was in charge of revising the 1886 Berne Convention on the international protection of scientific, literary, and artistic production, henceforth formalized protection laws that granted protection to authors whose work was reproduced on film, as well as to the film property itself.[9]

When Le Film d'Art went into production in 1908, it therefore seemed as if a number of battles on the cultural front had either already been won or were being won. This also happened against the background of the establishment of cinema theatres nationwide, a legal plea for intellectual property rights close to recognition, and audiences expanding in class and number. Le Film d'Art brought together the famous playwright Henri Lavedan with Comédie Française actor Charles Le Bargy. In a first stage, Lavedan set out to convince other well-known authors to collaborate on scripts for Le Film d'Art. Lavedan already had a stellar reputation as a celebrated playwright and was elected an Académie member at a young age. As Carou notes, Lavedan tried to cultivate a "classical" image to warrant his position, which was strengthened by the critical success of his 1902 Don Juan vehicle *Le Marquis de Priola*; for some critics this success was reason enough to place him on the highest of literary pedestals.[10]

Lavedan managed to get some impressive names around the same table, congregating with the likes of Academicians Victorien Sardou (1831–1908), of *la pièce bien faite*, or the well-made play; neo-romantic poet Edmond Rostand (1868–1918); playwright and vaudeville great Alexandre Bisson (1848–1912); and Georges Courteline (1858–1929), writer of satirical plays such as the popular military comedy *Les Gaietés de l'escadron* (1886).[11] Though this group might be identified as representative of a more classical theatre tradition, as opposed to the newer forms of stagecraft, Lavedan's work was also performed at André Antoine's Théâtre Libre, for example. Carou is right to note something we often take for granted, namely that by 1908 even the teachings

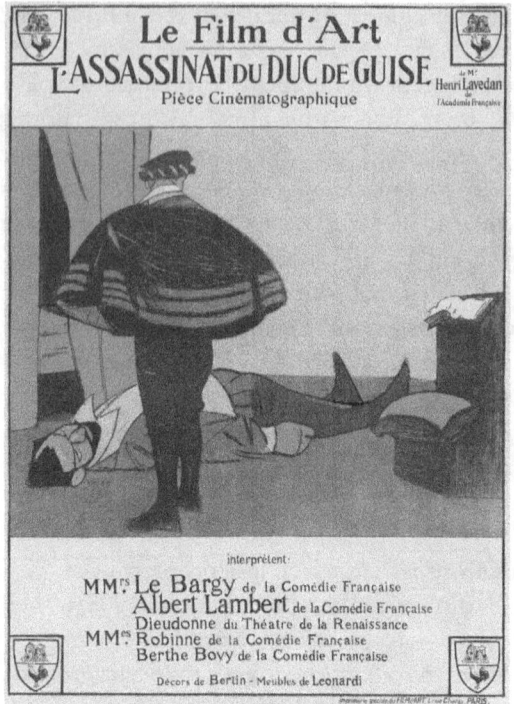

Figure 1.1 *L'Assassinat du Duc de Guise* (*The Assassination of the Duke de Guise*; André Calmettes and Charles Le Bargy, 1908). Film Poster (WC).

of André Antoine (1858–1943) were more than twenty-five years old. This had left plenty of time for osmosis between the boulevard-style melodrama and the socially inspired realism of the naturalist stage.[12]

On 7 March 1908, Le Film d'Art signed a collaborative exclusivity contract with Pathé, who supported them to build a glass studio in Neuilly and had their films developed, stocked, and distributed. Stéphanie Salmon has pointedly observed, however, that Pathé was actually on the better end of the deal because of the industrial and distributional control it could exercise over the company.[13] November 1908 marked Le Film d'Art's launch with the historical film *L'Assassinat du Duc de Guise* (Charles Le Bargy and André Calmettes), accompanied by original music from famous composer Camille Saint-Saëns (1835–1921) (Figure 1.1). The concept was a marketing match made in heaven and immediately became a production trend most European film companies sought to bank on. Everyone started producing their own brand of art films through subsidiaries and series. Notable examples are Pathé's own subsidiary S.C.A.G.L. (Société Cinématographique des Auteurs et Gens de Lettres) and its Italian counterpart Film d'Arte Italiana, Nordisk's Dansk Kunstfilm,

and Gaumont's Grands Films Artistiques. The first program by Le Film d'Art featured several films that were showcased all at once, but in fact you could say that they were beaten to the punch by S.C.A.G.L., also financially backed by Pathé, since it released Albert Capellani's Émile Zola (1840–1902) adaptation *L'Assommoir* a month earlier in October 1908. Pathé was betting on several horses at the same time, and their diversification within the art film world would quickly turn out to be a good bet. The productions mounted by Le Film d'Art proved very expensive, while other art film subsidiaries managed to turn a profit by providing similar "light" versions of the same product. Historical films were generally costly due to the specificity of period costumes, lavish sets, difficult locations, and many extras, so a sustained development of these to turn a profit proved untenable for a number of companies.

Film historian Alan Williams sees the appeal of the French series and subsidiaries in the fact that it was the first time that "the medium presumed to interest elite audiences not in itself as novelty but in the stories it could tell," but this was not entirely accurate, since productions of this sort were certainly not new.[14] In fact, the success of "quality films" released prior to 1907 indicated that there was indeed an exploitable market awaiting them. A list published by the *Views and Film Index* in 1906 laid bare fifty films from 1901 to 1906 that, according to Uricchio and Pearson, "had a pronounced success" and "marked a distinct stage in the business." Examples include *L'Enfant prodigue* (Ferdinand Zecca for Pathé, 1901, released in the States in 1904), *Les Aventures de Robinson Crusoé* (Georges Méliès for Star Films, 1902, released in the States in 1903), and *La Vie du Christ* (Alice Guy for Gaumont, 1906, released in the States in 1907).[15] The difference between these films and the new ones lay not solely in their subject material, but in what Williams calls the "careful exploitation of the publicity channels of bourgeois theatre."[16]

Le Film d'Art was very aware of these channels and of its own brand potential. It arranged to have its rehearsals covered and its films reviewed as if they were stage plays. The company exploited the media in a way that was never before seen for motion pictures. The first few years, these productions were mostly grand and expensive, geared towards adaptations of famous operas, plays, or works from the literary greats, such as Shakespeare and Zola, because these had already proven to be successful. In the case of *L'Assassinat*, well-known historical events formed the basis of the film, namely the murder of Henri I, Duc de Guise (1549–1588) by Henri III (1551–89). This violent historical episode was the subject of Paul Delaroche's 1834 eponymous painting, George Onslow's 1837 opera *Le Duc de Guise*, and at least two previous cinematic adaptations bearing the same name: one by Georges Hatot and Alexandre Promio for Lumière in 1897 and one by Ferdinand Zecca for

Pathé from 1902. The music written for the occasion by composer Camille Saint-Saëns was another added attraction.

GAUMONT

At the Gaumont film company, meanwhile, Louis Feuillade (1873–1925) had just taken over the duties of Alice Guy (1873–1968) as artistic director in 1907. Guy followed her husband Herbert Blaché (1882–1953) to the United States to run the Gaumont foreign office, but they soon started their own studio in New Jersey named the Solax Film Company, which produced over 300 films between 1910 and 1916. Working as an editor at the French newspaper *La Revue Mondiale*, Feuillade only started selling screenplays to Gaumont in 1906. He began directing films almost straight away, before being appointed Guy's successor a mere year later upon her own insistence. From the description of Gaumont director Henri Fescourt (1880–1966), who was active at the company from 1912 onwards, we can tell that Feuillade's duties were those of a real producer: buying screenplays, assigning directors to projects, and maintaining close contact with president Léon Gaumont.[17] Feuillade was a producer who did not interfere with the directorial work of his colleagues, however, since he had enough simultaneous directorial work on his plate. Gaumont historian Philippe d'Hugues compared Feuillade's superhuman productivity to that of author Honoré de Balzac (1799–1850), and with c. 700 films directed in less than twenty years this comparison certainly seems apt if not understated.[18] Feuillade worked in almost every genre imaginable, but is mostly remembered for his historical and artistic features; his comedies with popular screen characters Bébé and Bout-de-Zan; and his spectacular crime serials *Fantômas* (1913–14), *Les Vampires* (1915–16), *Judex* (1916–18), *Tih Minh* (1918), and *Barrabas* (1920).

The artistic ventures that Feuillade overtly embarked upon with Gaumont in the wake of Le Film d'Art and Pathé's S.C.A.G.L. were marketed to audiences under the series labels *Le Film esthétique* (1910), *Scènes de la vie telle qu'elle est* (1911), and *Les Grands Films Artistiques Gaumont* (1912). As Francis Lacassin rightly indicates, however, Feuillade did not wait for the "death of the poor duke" but was already looking into grand universal subjects that would push the cinema in more royal directions than those of the farce or melodrama in 1907. He produced around fifteen films that were mythologically, biblically, or historically inspired before inaugurating the *Le Film esthétique* series. Directed by Feuillade unless indicated otherwise these were: *La Légende de la fileuse* (1908), *La Légende de Narcisse* (1908), *Prométhée* (1908), *L'Amour et Psyché* (1908), *L'Aveugle de Jérusalem* (1909), *Judith et Holopherne* (1909), *Le Voile des nymphes* (1909), *Idylle corinthienne* (1909), *La Légende de Midas* (1910), *La*

Légende de Daphné (1910), *Le Festin de Balthazar* (also known as *Les Derniers jours de Babylone*, 1910), *Lysistrata* (1910), *Hippomène et Atalante* (Étienne Arnaud, 1910), *Esther* (1910), and *La Fille de Jephté* (1910).[19] These titles were cross-checked and corrected by means of the Feuillade filmography provided by Champreux and Carou.[20] This list can be complemented with Feuillade's 1909 *Le Printemps*, an artistic "rites of spring" film inspired by Romantic pictorial motifs and contemporary dance. Gaumont's choice to steer clear of literary and theatrical property was both an artistic and an economic consideration. Artistic because Feuillade was not satisfied with the unimaginative adaptations executed by his competitors, and economic because his boss Léon Gaumont did not care for paying twice for well-known intellectual property – a fee would then go to the original author for the rights, as well as to the screenwriter for adapting it.[21]

Feuillade's predecessor and female pioneer Alice Guy had tried her hand at similar subject matter as well, with the prestigious 1906 production *La Naissance, la vie et la mort du Christ* (also known as *La Vie du Christ*) and the 1907 *Sur la barricade* (also known as *L'Émeute*). *Sur la barricade* was modeled after Victor Hugo's (1802–85) famous poem *Sur une barricade, au milieu des pavés*, from his 1872 *L'Année terrible*. Biblical films had naturally been around since the beginning, too. As research by David J. Shepherd shows, in the early period a good number of these were directed by Ferdinand Zecca for Pathé – most notably the successful *L'Enfant prodigue* (1901) – with a spike in output around 1904–5.[22]

It was with universal "historical" subject matter that Léon Gaumont and Louis Feuillade hoped to reel in audiences internationally. Correspondence between the two Gaumont heavyweights reveals that they were particularly concerned with neighbor Pathé's expansion and with the reception of their films in the United States. In a letter dated 28 January 1910, Feuillade noted that he was impatiently waiting for the American reception of *Le Festin de Balthazar*, because if these grand spectacles with their tableau structure proved to please overseas audiences then this was the path they needed to follow. The director believed that "grand historical scenes are of all times and of all places, giving us the best chance to compete with the Americans in their own country."[23]

Aside from their own noble intentions and principles, it must be noted that Gaumont also invested in a subsidiary in the same way that Pathé backed Le Film d'Art. Théâtro-Film was its name, and it was founded in 1909 and run by Comédie-Française actor Maurice de Féraudy (1859–1932). *Ciné-Journal* described Théâtro-Film as being born of a desire for a "more natural, more lively and more artistic cinema," which they found logical at a time when the cinema could not "escape the theatrical evolution towards life and towards

truth" because audiences were growing tired of the same fast and frantic scenes and wanted something better and more mature.[24] Like other subsidiaries focusing on a single genre, however, Théâtro-Film was a very short-lived venture. Research by Bernard Bastide estimates just about forty films being produced and released between the summer of 1909 and the beginning of 1910; a lot by current standards, but not by silent film standards. While in this regard Bastide does not consider Théâtro-Film a historically noteworthy enterprise, it is interesting to note that the few remaining Théâtro-Film screenplays already indicated the new ground that Gaumont and other European companies were looking to tread. They focused on social issues in historical settings, rather than the "*grand sujets*" that Le Film d'Art was dealing with.[25] D'Hugues confirms this move away from lofty historical productions and notes that this decision was made on economic grounds, leading Gaumont to shift their approach to films that dealt with "daily observations and descriptions of more modest contemporary environments."[26] From the outset the company now loftily aspired to the new standards for Realism set by vanguard talents such as Émile Zola and André Antoine, but it did not hurt that it was a lot easier on their wallet either.

Louis Feuillade announced the beginning of this new series of films explicitly marketed to the public as "artistic" in an April 1911 manifesto that justified Gaumont's intentions. The series was *Scènes de la vie telle qu'elle est*, or "Scenes of life the way it is," the public forum was France's leading film journal, *Ciné-Journal*, and what Feuillade was trying to sell and justify was cinematic realism (Figure 1.2). Promotional articles like Feuillade's were certainly not uncommon in a professional trade journal such as *Ciné-Journal*, and even the term "*scènes de la vie*" had been applied before, both to documentaries and to fiction films.[27] It is nevertheless striking, however, that one of France's leading cinematic figures actively weighed in on the debate concerning cinema's artistic value, albeit in his company's name. More specifically, Feuillade engaged with cinema's coming to terms with the concept of "realism," laying bare some of the discursive issues of the time. He promoted the new series by marking its importance in cinema's history and by associating it with similar artistic strategies in established media:

> providing a new series of films with this title for the public to judge, the Gaumont Company is aware that the release of these films will mark a memorable date in the history of the cinematography of art. The scenes of 'life the way it is' resemble nothing that has been done until now by the various producers all over the world. They are an attempt at projecting realism for the first time onto the screen as it was years ago in literature, theatre, and the arts. It is up to Gaumont to try this for the first time; the public will tell us if we have succeeded.[28]

Feuillade goes on to explain what exactly he understands to be cinematic realism, which, interestingly, he does in terms of both morality and film style. If the audience found itself drawn to these films, it would be because:

> they want to be and are slices of life. If they are interesting, if they are moving, it is because of the virtue that emerges from them after having inspired it. They eschew all fantasy and represent people and things as they are and not as they should be. And in dealing with subjects that can be viewed by all, they spread a moral higher and more meaningful than so many harrowing little stories, falsely tragic or idiotically sentimental, of which not a trace remains in memory or in the heart but on the surface of the projection screen. Lately the taste of the audience has clearly been in favor of "Films" in which we saw excellent artistic craftsmen performing naturally, simply, without emphasis or ridiculous pantomime. [. . .] we have arrived at *les Scènes de la Vie telle qu'elle est* to give an impression of truth unknown until this day [. . .] an innovation that seeks to pull French cinematography away from the influence of Rocambole and towards a higher destiny. [Referring to the first film in the series, *Les Vipères*] Since this subject has never been broached, at least not to our knowledge, we have never taken better care to create the right atmosphere, to strike the right note and to obtain maximum effect without departing from a simplicity that gives it the most accurate significance. And our operators have toned down all of the magic of their photography for *Les Vipères*. Adjusting the light to the necessities of the hour and the composition is but child's play for them and their reputations have been well-established for a long time.[29]

Feuillade set Gaumont's new series apart from histrionic acting and from immoral and fantastic content. He tried to distance it from genres such as the *féerie* and the popular serial detective melodrama, a genre in which he would later excel himself with the *Fantômas* and *Les Vampires* series, and two genres in which their rival Pathé was leading the pack. Feuillade's proselytizing certainly did not mean, however, that Gaumont would suddenly stop producing films in the aforementioned genres. Rather, the cost-effective move can be understood to signify a second phase in the targeting of the bourgeoisie. Gaumont tried to retain a healthy level of prestige by proposing their new series as the latest advance in cinematographic artistry. Contemporary filmmaker Henri Fescourt commented that the public was not exactly thrilled with the series, complaining that it was not only far from verisimilar but that the public was also annoyed by the sheer dullness of the characters.[30] Fescourt's note was taken and the series continued under the same name but very quickly evolved to middle-class melodramas such as *Erreur tragique* (Louis Feuillade, 1912). The film portrays the disintegration of a bourgeois couple after they travel to Paris and, in a strange twist, the husband spots his

Figure 1.2 Louis Feuillade, "Scènes de la vie telle qu'elle est," *Ciné-Journal* 4, 139 (22 April 1911), 19 (MHDL).

Figure 1.3 Louis Feuillade, "Le Film Esthétique," *Ciné-Journal* 3, 92 (28 May 1910), 3 (MHDL).

wife with another man in the background of a comic short film when he's visiting a movie theatre.

Gaumont had already tried their hand at promoting a series with a more artistic bent in *Ciné-Journal* a year earlier, in May 1910 (Figure 1.3). If Feuillade boasted about the novelty of the no-frills realism present in its *Scènes de la vie telle qu'elle est* series in 1911, then he purported to do perhaps the exact opposite with their *Le Film esthétique* series in 1910. Both series were essentially trying to reach the same audience by similarly advocating for their elevated artistry. Pointedly, the Gaumont article praising *Le Film esthétique*, or "the beautiful film," appeared alongside an equally large Vitagraph ad that quite generally promoted their films as "*scènes muettes de la vie réelle*," or "silent scenes of real life."[31] The Gaumont series was explained as being both a definition and a program, "beauty in idea and in form." It strived, on paper, to be the absolute pinnacle in the cinematography of art, comparable to an artist's *chef d'oeuvre*, or masterpiece, showcasing that Gaumont never did shy away from using superlatives in its rhetoric.[32] Though the text is rather vague when describing what the series would actually look like, the reader and future spectator were promised nothing more than a poetic *Gesamtkunstwerk* that would surpass the mere theatrical adaptation that constituted the "common" art film, disregarding that they had themselves established Théâtro-Film in 1909 to stay competitive in the first art film wave. The cinematography of *Le Film esthétique* would combine painting with dramaturgy to create sensations of beauty equal to laying eyes on a painting by Jean-François Millet or a fresco by Puvis de Chavannes. Whether the series was "allegorical, poetical or symbolical [. . .], infused with Christian mysticism [or] making sacrifices to the gods on Olympus [. . .] it promises to be much more a genuine pictorial work of art than a theatrical one."[33]

Nordisk

Nordisk director Ole Olsen was in close contact with French market leaders Pathé-Frères and was as quick as Gaumont to follow up on the trend of the art film. Perhaps Nordisk can even be called the trendsetter, because the company's chief filmmaker, Viggo Larsen, directed a number of noteworthy films that were adaptations of popular literary, theatrical, and musical fare. There was the 1906 adaptation of *Den glade Enke*, based on Austro-Hungarian composer Franz Lehár's operetta *The Merry Widow*. The romantic 1885 play *Der var engang* (*Once Upon a Time*) by Danish dramatist Holger Drachmann, and an update of French author Alexandre Dumas *fils*'s 1848 novel *Kameliadamen* (*La Dame aux Camélias* – Figure 1.4) were both adapted for the screen in 1907. In 1908, Larsen adapted Holger Drachmann's 1895 *Dansen på Koldinghus*, as

Figure 1.4 *Kameliadamen* (*The Lady of the Camellias*; Viggo Larsen, 1907, Nordisk Films Kompagni). Film Production Still (DFI).

well as a take on Shakespeare's *Othello*, and a version of French playwright Victorien Sardou's *La Tosca*. The year 1909 was marked by a rendering of Danish playwright Thomas Overskou's mid-nineteenth-century poem *Capriciosa*. The list goes on.

Though Viggo Larsen's films clearly fit into the art film category when one looks at the surviving film programs that Nordisk distributed, the first film to actually carry the Dansk Kunstfilm or Danish Art Film label was the 1910 film *Tyven* (director unknown – Figure 1.5). In a departure from printed programs that consisted of short descriptions of several films that were going to be screened consecutively, the program for *Tyven* is an "*ekstra nummer*," or extra edition. The program was dedicated solely to the one film and contains a rather long summary of the narrative, spoilers and all (in the end, true love conquers all). *Tyven* was also an adaptation and is described in the printed program as a "cinematographical drama after Bernstein's eponymous play," which refers to French Boulevard theatre playwright Henri Bernstein and his 1906 play *Le Voleur*, or *The Thief*.

No mention is made yet of production company Nordisk or of the film's director on the program, and the latter remained so until around 1912–13. This is when we see Eduard Schnedler-Sørensen's name appear on the

Ekstra Nummer. Dansk Kunstfilm.

Tyven.

Kinematografisk Drama efter Bernsteins
Skuespil af samme Navn.

HOVEDROLLERNE:

Fru Professorinde Oda Nielsen.
Hr. Otto Jacobsen.

Figure 1.5 *Tyven* (*The Thief*; Unknown, 1910, Nordisk Films Kompagni). Film Program Excerpt (DFI).

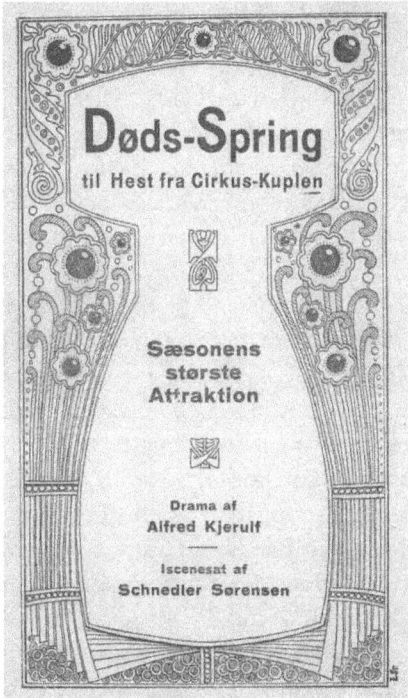

Figure 1.6 *Dødspring til Hest fra Cirkuskuplen* (*The Great Circus Catastrophe*; Eduard Schnedler-Sørensen, 1912, Nordisk Films Kompagni). Film Program Cover (DFI).

program for *Dødspring til Hest fra Cirkuskuplen*, also known as *The Great Circus Catastrophe*, in August 1912 (Figure 1.6). The names that *were* billed in bold underneath playwright Bernstein's name on the *Tyven* program, however, were those of lead actors Oda Nielsen and Otto Jacobsen. Like most figures on the Danish silver screen, Nielsen and Jacobsen were well-known theatre

actors. Clearly, the program's mention of both the French playwright from which the film originated, as well as the two well-seasoned theatrical leads was meant to resonate with audiences familiar with the world of the stage. Better yet, the film program even closely resembled a theatre program. With the expansion and addition of stills in Nordisk programs from 1911–12 on, moviegoers actually received a classy playbill booklet like the ones still handed out for Broadway plays at the time of writing. As we will see in more detail in the following chapter, most directors and actors in the European film industry came from the theatre, and it is interesting to see how the exchange between the two media was quite fluent and reciprocal in Denmark. By analyzing the quintessential contemporary Danish theatre journal *Teatret* (1901–30), we can deduce that almost every actor or director on the Nordisk roster was once active in the theatre industry, or continued to be during their film work. Furthermore, inspired by the quality and international success of Asta Nielsen's *Afgrunden* (Urban Gad, 1910, Kosmorama), *Teatret* also started devoting page space to cinema. Its pages discussed acting for film and heatedly debated whether cinema qualified to be called an art form, the latter being the existential question that also occupied the pages of novice film journals, such as the French *Ciné-Journal* and the Danish *Filmen* (est. 1912).

For one of *Teatret*'s contributors in a piece called "Den stumme Kunst," or "the silent art," the silent theatre that was film could not yet be a form of art because it lacked a crucial ingredient: life. He was referring to the medium's lack of diegetic sound and realistic color, which was one of the foremost arguments against the medium of cinema being recognized as a proper form of art. The commentator was convinced, however, that film would undeniably reach the point of artistry soon, and tried his best not to be patronizing by ending his article with a warning: if you want to put yourself above moving pictures, be sure to take into account the powerful influences the medium has already exerted on thousands of minds.[34]

Interestingly, *Teatret* also allowed plenty of room for response, as it included brief texts on the subject from authors, filmmakers, theatre managers, and actors. Chief Nordisk director August Blom, for instance, felt the need to defend the medium, and downplayed the negative effect it was said to have on people by comparing it to the stage.[35] He pondered whether it was really worth being a staunch opponent of cinema in its early stages of development. Blom recognized that there was a brief period in which film programs were predominantly made up out of nothing but sensationalist murder dramas and silly comedies, but he points to similar issues on the stage, and, relating it to the public's tastes, quipped: "cinema is like the theatre, you can't pay your staff with ideals."[36]

At this point in time, Blom and his fellow directors were almost fully invested in turning out feature-length social dramas, since Nordisk steered the same course as Gaumont and other companies from 1910 onwards. These films approached what Blom called "right" or legitimate theatre. They were mostly released under the "kunstfilm" flag or labels that were comparable, such as "nutids-skuespil," which loosely translates as "contemporary play" or "modern drama"; and "socialt skuespil" or "social drama." As such, Blom did not see why cinema had to get such a bad rap. Its problems were comparable to those of the theatre in that some genres were not as elevated as others. He further believed that cinema was not as powerful as the written or the spoken word and thus entailed fewer (negative or demoralizing) consequences.

In reaction to the same piece in *Teatret*, one of Blom's competitors, Louis von Kohl (1882–1962), painter, author, screenwriter, and director at Det Skandinavisk-Russiske Handelshus, voiced a similarly pragmatic view on the matter. Though von Kohl's stint as a filmmaker was but a brief note in his biography, he must have been a valued cultural voice in Denmark to have been listed first prior to August Blom.[37] Von Kohl thought film to have a great capacity for emotionally stirring audiences, albeit in a fleeting and rather crude sense that made it subpar to art. He did respect the singular genius of Charles Le Bargy in the Film d'Art's historical adaptation of *La Tosca*, however (André Calmettes and Charles Le Bargy, 1909). Himself a director, von Kohl recognized that film was a business, and as such it was dependent upon its customers. The "Kunstfilm label," he wrote, "was cleverly thought up by film companies to give the public a cheap surrogate of an ideal, though it in no way represents a new variety, but rather gives the audience the illusion that they are enjoying something grand."[38]

Von Kohl also believed that the audience should be aware that it was being "tricked," but noted that the people in the film industry were like high priests: they merely interpreted the signs and acted accordingly, following the audience's wishes. Von Kohl was one of those high priests, after all, and the program for his 1911 film *Morfinisten*, described as a "cinematographic drama in two acts," shows that he and Det Skandinavisk-Russiske Handelshus were clearly on the same path as Nordisk in the promotion of their films as art. Furthermore, *Morfinisten* played on a contemporary sensationalist theme – morphine addiction – and most of the company's limited output between 1911 and 1913 eschewed a historical setting. Carl Theodor Dreyer wrote his first three films for Det Skandinavisk-Russiske Handelshus, for example, and they ended with, respectively: a high-speed automobile chase in *Bryggerens Datter* (Rasmus Ottesen, 1912); a hot-air balloon, steamship, and horseback chase in *Dødsridtet* (Rasmus Ottesen, 1912); and a hot-air balloon explosion in *Balloneksplosionen* (Kay van der Aa Kühle, 1913). The inspiration that films of

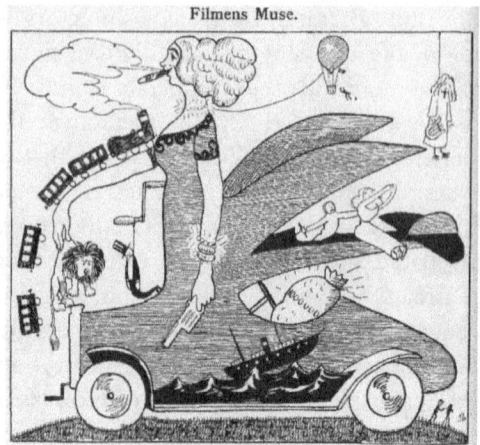

Figure 1.7 Robert Storm Petersen, "Filmens Muse," *Filmen* 2, 3 (15 November 1913), 44.

the time drew from contemporary themes was nicely summed up in cartoonist Robert Storm Petersen's illustration "Filmens Muse," or "film's muse," in a 1913 issue of *Filmen* (Figure 1.7).

Nordisk's move away from historical films undoubtedly stemmed from the same economic considerations as Gaumont's. Complicating the issue on Nordisk's end, however, was a plagiarism suit surrounding its shameless reproduction of Fotorama's popular social melodrama *Den hvide Slavehandel* (Alfred Cohn, 1910). The Fotorama film was one of the first multi-reel films, and an immense hit at that. This case will be discussed in more detail in the next chapter, but suffice it to say that this was the catalyst that made Nordisk dive headlong into the production of multi-reel or feature-length films. Tracing the lineage of the multi-reel film in Europe, Mark B. Sandberg notes that the single-reel format was dominant up until 1910. A single reel was about 300 to 350 meters in length, or up to fifteen minutes screened, and convenient for exhibitors. It was pioneering studios from Denmark, France, and Italy that brought about change.

Longer films do exist from much earlier, but these were usually screened in multiple sessions, or "serialized." Sandberg, like others, defines a "feature" film as a multi-reel film shown in one session. He sees the feature film as the established format by the Great War. It was then that it fully supplanted screenings that contained multiple shorter films. In Denmark, the single-reel film had even become the exception by mid-1911.[39] While pinpointing the exact moment of the cinema's switch to feature-length films is impossible given the large amount of lost output for the period, Denmark played an important role. It was Nordisk president Ole Olsen, moreover, who (falsely) proclaimed that his company had made the first multi-reel film. He promoted

this statement rather aggressively abroad, which led American writers to credit Nordisk with the introduction of the multi-reel, or feature-length film, and the accompanying shift to contemporary issues and environments.[40]

DEBATING, DISCUSSING, AND PROMOTING FILM AS ART

The promotion for these films was done mainly through trade journals, which sprouted and matured alongside the European feature film. Of the French film journals, it was Georges Dureau's *Ciné-Journal*, established in August 1908, that was the most well-known and influential. The journal combined promotional, commercial, and technical aspects of the industry, and was an important forum for producers, filmmakers, and film critics and theorists. The studios' promotional machines had already been established before the rise of trades, primarily by employing catalogues, postcards, and posters. The larger fish in the French filmmaking pond such as Gaumont were vertically integrated before 1908, so one would think that investing in promotion would not make that much of a difference. Gaumont was also a key international player, however, and its owner, Léon Gaumont, was very involved with the company's image and wanted it to exude class.

Analogous to the theatre, Gaumont had been issuing postcards for some of its more important productions from 1903 onwards. These were given up in 1906 when they switched to elaborate catalogues and started working on large color posters. Film posters had already been undertaken on a larger scale by competitor Pathé, and historically we should probably credit Lumière for creating one of the first film posters for their iconic 1898 comedy *L'arroseur arrosé*. Gaumont also vertically integrated the printmaking process for film posters, since building their own print shop would save them money. They are believed to have hired one full-time artist by the name of E. Villefroy to occupy him- or herself with all of their film posters, utilizing different design styles depending on the subject matter or genre of the film. Posters were made for every fictional genre and, under the watchful eye of Louis Feuillade, quality soared at Gaumont even in the poster department. Jean-Louis Capitaine has noted the influence of nineteenth-century academic artists such as James Tissot, Gustave Courbet, and Jean-François Millet in these posters, discerning realist and naturalist as well as more symbolist and art nouveau streaks in them. The result was quality design in line with Gaumont's cinematic work with Feuillade at the helm. At every level, execution was guided by Léon Gaumont's "rules of good taste," which Capitaine sees as a very bourgeois conception of cinema.[41]

Promotion in film journals was different, however, since these film trades served all producers, distributors, and exhibitors, and Gaumont was just

one of them. As such, trade promotion meant vying for attention, although most of them did start out with clear alliances to certain big players. It was in these trades that the confusion surrounding the art film was most noticeable. As mentioned before, the critical success of Film d'Art's *L'Assassinat du Duc de Guise* spawned a large number of series, subsidiaries, and entirely new companies, all banking on the "art film" phenomenon. The polemics in *Ciné-Journal* show that the confusing "art film" label was quickly lamented. At a time fraught with commercial and artistic plagiarism, it is interesting to note that one of the fieriest debates was not about content, per se, but about copyright and trademarking. The answer to the question "can one trademark the art film as a whole?" seems to have been a resounding "no!"

In France, distributors of Le Film d'Art tried to copyright the term in 1910 to ensure their market position. This was not self-evident given that their own financial backers, Pathé, had double-crossed them by starting their own artistic subsidiaries with similar labels. Pathé went so far as to release an art film through S.C.A.G.L. right before the premiere of Le Film d'Art's first film.[42] Furthermore, it is hard to trademark something when there is not a real definition of it. What made a film artistic differed from company to company, be it an adaptation of a famous play or book; a recreation of an historical event; a poetic *féerie*; or even just a film that was "pictorial" in nature – introducing a label that will be discussed in chapter four. It is safe to say, though, that Le Film d'Art's original conception of "famous players in famous plays," to quote a later American company, did not hold up for long in France. In Denmark, on the other hand, we will see in chapter two that famous actors and actresses were exploited much more for their fame.

At any rate, the proliferation of similar labels was such that the editor-in-chief of *Ciné-Journal*, Georges Dureau, felt the need to address the problem. Dureau was spurred on by a few distributors of "Le Film d'Art," who wrote an open letter to *Ciné-Journal* asking him to define the term:

> a certain number of managers, troubled by the denomination "d'art" that all the producers are currently giving their films, are asking you to define "Le Film d'Art" and how we can recognize it.[43]

The distributors quoted an example of what looks like a case of blatant plagiarism. A film by the company Le Film d'Art experienced competition from a film with the same title, by a different company, equally advertised as an art film. The distributors went on to tell Dureau that a simple comparison between the two films would weed out the imposter and "will be enough to define what constitutes the superiority of 'Film d'Art,' the company."[44] The readers' letter from the distributors was a very desperate attempt, it seems, at having one of the industry's largest gatekeepers pick a side and proclaim all

the other companies working in the genre of artistic films to be substandard thieves. It also confirms that the meaning of the term had become vastly diluted in just two years' time. It had become an idea rather than a genre or a style. Dureau's response came swiftly. "The term has become so generalized," he stated, "that confusion reigns among the clientele and audiences, leaving people not knowing how to choose." Dureau identified Le Film d'Art as the one and only company carrying that specific name and quoted some of their recent titles, their distributor, and their address, also indicating that they are no longer part of Pathé but independent now. He continued that it was not for him to say, however, whether the term "film d'art" was the exclusive property of the company, or whether it could be applied to all productions with an "artistic character." He went on to say what he really thought anyway, stating that he personally felt that the specific two-and-a-half words belonged to the company and should not be applied otherwise. He nuanced this immediately, though, by saying: "but I am not a genius, however, and well-willing souls, no doubt more liberal than myself, will be inclined to think otherwise, accepting the generalization."

Dureau also conceded that there were more companies making very decent artistic films. He cited Pathé and Gaumont first, with news of the latter's brand-new *Film Esthétique* series. Dureau apologized for the dryness of his enumeration but did not close the article without leaving the audience on a rather cynical note. "You ask me now," he said,

> which of these is the most artistic of the art films? Do you remember that Musset song "si vous croyez que je vais dire qui j'ose aimer!" [If you think that I will tell who I dare to love] That will be my response. But I will add that, strictly speaking, there are no "art films," only artists who more or less play well with more or less good work. It's a little like the Salon of French Artists, where there are few artists and even less Frenchmen.[45]

A year later, an anonymous Danish critic of the Scandinavian film journal *Biografteaterbladet* similarly lamented the fact that the art film label had lost its original meaning and purpose. Where it used to denote "something special" when the label was given to a picture, he or she wrote, it had now become hard to find a program that did not consist entirely of art films, with even the "wildest farce" being granted the dubious honor.[46] It remains an interesting contradiction that while cinema's status as a form of art would still be heavily debated in the years to come, production companies had essentially proclaimed their place in the artistic pantheon by ways of sheer marketing, since they were already selling art films.

The critics were right. The term had become diluted and widely applied. The many adaptations of the first years of the art film (1907–10) had led to

a more naturalistic acting style, imported from the legitimate stage where Naturalism had caught on in a big way and had merged with the popular melodrama.[47] The excessive usage of artistic labels had seemingly rung in a second wave of art films around 1910–11: films concerned with stories of middle-class life. The courtship of new middle-class audiences had been successful, it seemed, and quite prominently affected both the form and content of the newfangled feature-length films. Marguerite Engberg's substantial research into Danish silent film has shown that middle-class subject matter of feature films went from being most represented on the silver screen in Denmark with 32 per cent in 1910, rising to a whopping 60 per cent in 1911, and remaining more or less constant between 50 and 60 per cent up to 1914.[48] The shift in the art film was essentially a move away from historical costume dramas and classical plays, to social (melo)dramas that dealt with bourgeois households and sensational themes such as adultery, betrayal, and murder. Like the popular bourgeois melodramatic fare on the stage, these films held a mirror up to audiences, reflecting their world, their fears, and their sense of morality.

We can already see this in the aforementioned example of Nordisk's *Tyven*. The film focuses on a domestic setting in a middle- to upper-class household (Figure 1.8), and the core of Bernstein's popular play is melodramatic at its core. This was not to say that this new wave of films was therefore any less artistic in nature. In the pages of theatre journal *Teatret*, a growing number of actors and actresses would come forward to support the artistic merits of film. Most of them had successfully made the leap from stage to screen but remained active in both media. So too Else Frölich, born to well-known Norwegian impressionist painter Frits Thaulow in Paris, and raised in Copenhagen by stepfather Edvard Brandes, a prominent politician and younger brother to famous cultural critic Georg Brandes. Frölich gained her fame on the stage in the popular operetta *Dollarprinsessen* (A.M. Willner and F. Grünbaum with music by Leo Fall, first staged in 1909 at Det ny Teater), before she became one of the leading stars at Nordisk. She made no fewer than sixty-five films for Nordisk between 1911 and 1920. "Film [is] an art that can grip and enthrall just as fully as the theatre," Frölich stated in 1913, as she went on to describe a few laudable performances she recently saw on the theatre stages of Oslo (then Kristiania) and Paris.

> But now film! Yes, how it has brought me an endless many artistic pleasures. I say this without shame, when I remember first and foremost all of Asta Nielsen's films. Every time I went to see them, I was bombarded with Copenhageners' vicious sourness about Asta Nielsen ads, about how she is overrated, about her affectations, and every time I come out it is with a desire to say "thank you" for the expression of real human feelings, so she knows

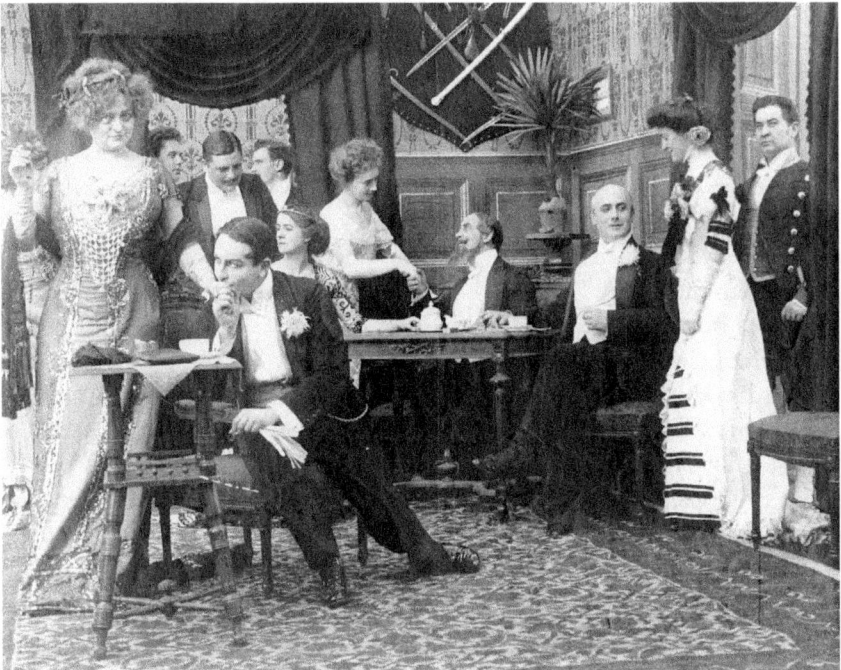

Figure 1.8 *Tyven* (*The Thief*; Unknown, 1910, Nordisk Films Kompagni). Film Production Still (DFI).

how her eyes or her facial expressions have enriched me. And she is not the only one. In a not particularly brilliant film, *Operabranden* [August Blom for Nordisk, 1912], Miss Agnete Blom expresses human suffering in such a genuine and touching way, no actress I have seen on the stage has managed to touch me like she has in a long time.[49]

CANUDO AND COMPANY

Italian theorist Ricciotto Canudo already described cinema's evolution into an art form in his November 1908 piece "Lettere d'arte: Trionfo del Cinematografo," or "Letters of Art: Triumph of the Cinematograph," in the Florence newspaper *Il Nuovo giornale*. The article was expanded and published in France in October 1911 under "La Naissance d'un sixième art: Essai sur le cinématographe," or "The Birth of a sixth art: Essay on the cinema," in *Les Entretiens idéalistes*, a monthly review dealing with art and philosophy. Canudo touched upon a number of issues that were crucial not only to an understanding of the film-as-art debate that arose before the Great War, but to our understanding of the discursive mode of early European film theory

and criticism as a whole. Commercial exploitation aside, it goes without saying that the film-as-art debate was far from self-evident at a time when photography was yet to be recognized for its interpretative artistic qualities. This was notwithstanding longstanding propagation for photography as an art form by the likes of Henry Peach Robinson and the Pictorialist movement, more on whom in chapter four. Erika Balsom concurs, noting that the anti-photographic discourse of the day echoes loudly in Canudo's theory of film.[50] Canudo's voice may not have been singular in the countable sense; the Italian film theorist did seem to be one of the first to quite comprehensively take on a number of contemporary issues in his own celebration of the new medium of cinema as a possible spiritual *Gesamtkunstwerk* – although Canudo referred to this coming together as a "festival" rather than *Gesamtkunstwerk*. His theories led to several important contradictory notions that seemed to live side by side in intellectual rhetoric before the Great War, and we will work from Canudo's expanded 1911 article "La Naissance d'un sixième art: Essai sur le cinématographe"[51] to lay bare some of his theories' most poignant themes and conflicts.

Born in 1877 in the south of Italy, Canudo has often been called the first film aesthetician. In true nineteenth-century fashion, however, he also proclaimed himself a poet, a philosopher, a novelist, an art critic, a literary critic, a musicologist, and an organizer of cultural events. In short, Canudo was a bourgeois cultural polymath, or Renaissance man. By the time of his death in France in 1923, he had left behind five novels, a collection of poetry, three tragedies, a ballet piece, essays on music, four volumes of war impressions, a book on the aesthetics of art and literature, and his work on the cinema. Canudo's spirit even lived on after his death through the conferences and commemorations of the *Club des Amis de Canudo* (the Club of Friends of Canudo), who continued to honor him until World War II. It was his move to France in 1901 that formed the young Canudo, as he rubbed elbows with other intellectual notables of the Parisian avant-garde, a lot of whom were fellow immigrants. Prominent in this group were Igor Stravinsky, Fernand Léger, Marc Chagall, Léon Bakst, Abel Gance, Marcel L'Herbier, Louis Delluc, Jean Cocteau, Pablo Picasso, and Guillaume Apollinaire,[52] the latter of whom became a close friend of Canudo's and nicknamed him "*le Bari-sien très Parisien.*"[53]

Giovanni Dotoli and Jean-Paul Morel describe Canudo as fulfilling a unifying role with regard to the polemically challenged concept of "aesthetics" in the "Parisian world of -isms." For the Italian theorist, the beginning of the twentieth century signified the moment of the biggest artistic liberation, and in his attempt to find a rational explanation for this artistic revolution he also tried to wed the many different perspectives of "the avant-garde." Morel and Dotoli point out that such a synthesis, comprised as it was of impressionists,

cubists, futurists, Dadaists and synchromists, was quite absurd and impossible, but Canudo saw his arguments strengthened as they coalesced in what he considered a symbolic unifier of the arts: the cinema.[54]

Canudo logically published most of his work in France, since he not only moved there but it was also one of the, if not *the*, international cinematic epicenters before the Great War. Paris was not the only breeding ground for critical film theory and criticism, however, and in fact it is telling that Canudo chose to publish his first major article on the cinema in Italian in *Il Nuovo Giornale*, when he had been living in Paris for seven years. As John P. Welle has shown, the Italian "film on paper" market was quite well developed. Welle situates its starting point in 1907, with the publication of writer Giovanni Papini's (1881–1956) article "La Filosofia del Cinematografo" in the widely diffused Turin newspaper *La Stampa*. The beginning of the so called *"cine-letterati,"* or "cine-writers," in Italy coincided with the advent of the trade journals in France and America. The first of these, *Phono-Ciné-Gazette*, saw the light of day two years earlier in 1905 and was edited by the aforementioned Edmond Benoît-Lévy. In America, *The Moving Picture World* sprang up in 1907 and would remain one of the most important film journals in the silent period.

In Italy, no fewer than ninety different film trade journals would appear in the period between 1907 and 1920, with Turin, Naples, Milan, and Rome as the chief centers for these periodicals. Rome alone hosted over forty film journals in this period.[55] Publishing his work "Trionfo del Cinematogrofo" in *Il Nuovo Giornale*, Canudo thus followed Giovanni Papini and would later be joined by more famous *cine-letterati* such as literary greats Gabriele D'Annunzio (1863–1938) and Luigi Pirandello (1867–1936). In 1911, an expanded version of Canudo's text would appear in *Les Entretiens idéalistes*. It is unclear why Canudo waited so long to publish his article in France, since he was well established in intellectual circles by 1908, but it *was* clear that his ties to Italian film culture remained quite strong throughout. He also briefly worked for film production company Ambrosio, adapting several of Gabriele d'Annunzio's works for the screen. Regardless of timing, the main modes of discourse in Italy and France seem to have run along the same lines. One must not overlook the importance of the strong transnationalism that was inherent in the early European film industry, with dominant market players like Gaumont and Pathé opening distribution and production offices in all of the major European countries. They not only controlled the output but also weighed in heavily on the discourse, and they used this to their commercial advantage. Of the French film journals that accommodated this rhetoric, *Ciné-Journal* was the most influential forum for producers, filmmakers, film critics, and theorists.

In his important edited volumes of early film criticism, Richard Abel has already identified the main modes of discourse of the French journals of the time. A first important mode was that of "scientific and technological advance," which was focused on reporting, rather than debating, research into the scientific uses of the cinematograph. It was geared towards three main topics: the reproduction of depth in the image, the reproduction of natural color, and the synchronized reproduction of sound and image. In Abel's words, this research "aimed to fulfill a late nineteenth-century obsession, [namely] the production of a 'true' or 'faithful' analogue to reality."[56]

Secondly, the cinema was deemed a powerful rhetorical device for moral reform and education, as well as propaganda. Writers believing in this cinematographic power had no qualms about uttering bold euphoric statements singing its praises. Yhcam called cinema a universal language with more potential than Esperanto. Pathé engineer Frantz Dussaud pointedly noted that the cinema "will bring peace to the world," foreshadowing Canudo's reading of the cinema as a unifying art form.[57] But this power also triggered less enthusiastic responses, such as that of Louis Haugmard, who prophetically named the medium "the religion of the people; or rather; the irreligion of the future" in 1913, and feared the enslavement of the working class:

> at the movies, bewitched crowds will learn not to think anymore, to resist all desire to reason and construe, faculties which will atrophy little by little; they will know only to open and their large and empty eyes, just to look, look, look... [...] The cinema will be the "amphitheater" of enfeebled civilizations.[58]

This might be the first time that the concept of people enslaved by the screen reared its head. Abel also perceived a third important mode of discourse in the cinema's function as a mass spectacle entertainment. This is a cluster concept that he breaks down as a number of issues that deal with the mass commercial appeal of the cinema, such as: who attends the cinema? Why is the cinema so successful? How does it compare to other forms of popular entertainment? And how does it, or can it, represent modern life? In this mode of discourse, cinema was often portrayed as an inherently contemporary medium that was specific to the Machine Age (c. 1880–1945) and to notions of mass consumption. It was equated with an image factory, while its audience was once accused of possessing the voracious appetite of a "mass Minotaur."[59] Prophetic much?

These kinds of mixed analogies were characteristic of early film writing, in which the modern was often wed with the romantic. This style would persevere in the poetical and philosophical works of the early film theoreticians, Canudo included. It was in this light that a fourth mode of discourse comes

into play for Abel, namely that of "film-as-art." While questions with regard to the legitimacy of the medium arose as soon as 1896, it was not until 1911 that "the attempt to justify the cinema as a new art form [reached] a sustained, polemical level."[60]

Canudo similarly set out to identify different modes in film, weighing the medium against five established art forms that he deemed "manifestations of the aesthetic sense [...] the whole aesthetic life of the world developed itself in these five expressions of Art." They are: music, with its complement poetry; and architecture, complemented by sculpture and painting. Canudo's influential definition of what this new medium is and what it might come to represent will guide us through the following chapters, where we weigh the output and aesthetics of this period against theatre, painting, and photography. Canudo considered the cinema as a new expression of art when he stated that:

> we are witnessing the birth of a sixth art [...] we are living between two twilights: the eve of one world, and the dawn of another. Twilight is vague [...], however, the sixth art imposes itself on the unquiet and scrutinous spirit. It will be a superb conciliation of the Rhythms of Space (the Plastic Arts) and the Rhythms of Time (Music and Poetry).[61]

In his 1923 text "Manifeste des Sept Arts" Canudo would later include dance as a complement of music, labeling cinema the seventh art.[62] In his definition of what this new art form would be, however, one immediately thinks of the theater as a conciliation of the rhythms of space and time. The competition between the theatre and the cinema was, after all, a very hot topic, and critics and intellectuals often pitted the two against each other. Critic and theatre historian René Doumic (1860–1937), for instance, saw the cinema as an inherently theatrical enterprise in 1913, but he nevertheless deemed cinema vastly superior. For him, the cinema was a great equalizer that allowed the masses to consume entertainment quickly, cheaply, brainlessly, and transnationally. Somewhat contradictorily, Doumic also pointed to what he called cinema's "scientific nature" to distinguish the form from the theatre. By doing so, Doumic was more than likely hinting at the cinema's capability to mechanically reproduce the same performance "flawlessly."[63] This was an argument that some critics and theorists specifically used against proclaiming cinema an art form, as a resistance against the mechanization of art via a technological intermediary. This was also a strong argument for those not validating photography as an art form.

While Canudo recognized the theatre's power, he specified that the new manifestation of art should more precisely be "a painting and a sculpture developing in time," or a "Plastic Art in motion." He proclaimed the theatre

performer's mutability – or, "an actor's live performance is always different" – as a very vague and half-hearted argument against recognizing the theatre as a plastic art in motion. Trying to delve into the medium-specific aspects of his own argument, Canudo saw it fit to ascribe two significant components to the cinema: the symbolic and the real. It is here that we meet the writer's Futurist sensibility, or ideology. It was imbued with a sense of nostalgia, melancholy, and mythology that was unbefitting a true Futurist, but it nevertheless formed a combination that seemed to work in the pre-war period. Canudo's symbolic component was that of velocity, to be found in the motion of the images, the speed of representation, and, most importantly, the actions of the characters:

> we see the most tumultuous, the most inverisimilitudinous scenes unfolding with a speed that appears impossible in real life. This precipitation of movement is regulated with such mathematical and mechanical precision that it would satisfy the most fanatical runner. Our age has destroyed most earnestly [. . .] the love of restfulness, symbolized by the smoking of a patriarchal pipe at the domestic hearth. Who is still able to enjoy a pipe by the fire in peace these days, without listening to the jarring noise of cars, animating outside, day and night [. . .] images of life will flicker in front of him with the speed of the distances covered.[64]

It is hard not to read Filippo Tommaso Marinetti's *Manifesto of Futurism* into this excerpt from Canudo. Marinetti's manifesto was written in 1908 and published a year later in 1909, but it must be said that the Futurist's ideas were certainly more programmatic and radical, with statements such as "we are already living in the absolute, since we have already created eternal, omnipresent speed."[65] Marinetti's words were far less applicable to what was actually appearing on screen, and this was also the case for his 1916 *Manifesto of Futurist Cinema*. This manifesto foreshadowed avant-garde cinematic experiments in some of its descriptions of what cinema should do. Marinetti's manifestos were labeled "too ambitious" for their time by scholars such as Wanda Strauven, who deals with it as a "cinema without films."[66] The *Manifesto of Futurist Cinema* described "futurist cinema" in the same terms as Canudo did, however, namely as "Painting + sculpture + plastic dynamism + words-in-freedom + composed noises + architecture + synthetic theatre."

In the "real" aspect of the cinematograph, Canudo engages with the scientific mode of discourse pertaining to the "faithful" representation of reality that the cinema might offer. It is important to emphasize that this mode of discourse clashed with the politics of cinema's legitimization as an art form, which focused on the power of interpretation and subjectivity. The two were nonetheless contradictorily used together in the same discourse. Canudo

was right in stating that the modern audience "actively seeks its own show, the most meaningful representation of its self," but when arguing that "the theater of perennial adultery, the sole theme of the bourgeois stage, is at last being disdained," Canudo did not take a good look at the silver screen of the early 1910s.[67] The rise in bourgeois subject material from 1908 onwards was remarkable and remained dominant throughout the 1910s, more often than not dealing with adultery as a driving plot point. Furthermore, the critical emphasis on realism was being exploited commercially by production companies, with series such as Gaumont's *Les Scènes de la vie telle qu'elle est* and Nordisk's "social plays." In Abel's words, production companies "yoked the discourse of technological innovation to that of a naturalist aesthetic, which itself masked a melodramatic base, as a means of promoting and legitimizing their commercial exploitation of the cinema."[68] Furthermore, even though Canudo praised the cinema for its unbridled "mobility in representation," his hesitation to call it an art form strongly lingers in the text, strengthened by the ever-ubiquitous reproduction argument. "[Cinema] is not yet an art," he argued,

> because it lacks the freedom of choice peculiar to plastic interpretation, conditioned as it is to being the copy of a subject, the condition that prevents photography from becoming an art. [...] Arts are the greater the less they imitate and the more they evoke by means of a synthesis. [...] The cinematograph, therefore, cannot today be an art.[69]

What exactly did Canudo envision for the new medium then? Well, he saw the medium as a possible spiritual *Gesamtkunstwerk* or unifying universal art form, a concept undoubtedly inspired by the ongoing popularity of Richard Wagner (1813–83). Canudo meshed religious rhetoric – the cinema theater as a "temple" for aesthetics – with mythology and social rites, envisioning the cinema's ideal outcome as a form of spectacular "festival." This is, not coincidentally, where Canudo seems to go off the rails a little, mistaking aesthetic organization and melodramatic interpretation for a representation of "total life," as he calls it. He also offered an anthropological reading of cinema akin to the work of Sir James George Frazer (1854–1941), whose *The Golden Bough: a Study in Magic and Religion* was a controversial success at the end of the nineteenth and the beginning of the twentieth century. A quote from Canudo elucidates his alliance with Romantic anthropology:

> The cinematograph as it is today will evoke for historians of the future the image of the first extremely rudimentary wooden theaters, where goats have their throats slashed and the primitive "goat song" and "tragedy" were danced, before the stone apotheosis consecrated by Lycurgus, even before Aeschylus' birth, to the Dionysian theater.[70]

As one can tell, and as Abel reiterates, on the surface of things this conceptual notion of a pagan *Gesamtkunstwerk* does not go well with the "Futurist faith in machine dynamism."[71] Oddly enough, however, Filippo Tommaso Marinetti combined the two in one sentence in his Futurist manifesto, claiming at once, "at last Mythology and the mystic cult of the ideal have been left behind," and then right after, "we are going to be present at the birth of the centaur and we shall soon see the first angels fly!"[72] Elements of this mystical, Wagnerian Romanticism are retained in the aesthetic of the films of the 1910s that we will discuss in the next chapters. It is not until the formal experiments of the 1920s, however, that we see a purer interpretation of these winged notions.

Notes

1. Eric Hobsbawm, *The Age of Empire 1875–1914* (London: Abacus, 2003).
2. Roger Magraw, *France 1815–1914: The Bourgeois Century* (Oxford and New York: Oxford University Press, 1986).
3. Richard Abel, *The Ciné Goes to Town: French Cinema 1896–1914* (Berkeley and Los Angeles: University of California Press, 1998), 25.
4. Abel, *The Ciné Goes to Town*, 30.
5. Abel, *The Ciné Goes to Town*, 31.
6. Richard Brown, "Trade Marks" in Richard Abel (ed.), *Encyclopedia of Early Cinema* (London and New York: Routledge, 2005), 636.
7. Édouard Arnoldy, *Pour une histoire culturelle de cinéma – au-devant de "scènes filmées," de "films chantants et parlants" et de comédies musicales* (Liège: Éditions du Céfal, 2004), 48.
8. Edmond Benoît-Lévy, "Le Droit d'auteur cinématographique," *Phono-Ciné-Gazette* 62 (15 October 1907), 365.
9. Abel, *The Ciné Goes to Town*, 28–9.
10. Alain Carou, "Le Film d'Art ou la difficile invention d'une literature pour l'écran (1908–1909)" in Alain Carou and Béatrice de Pastre (eds.), "Le Film d'art et les films d'art en Europe (1908–1911)," *1895 – Revue d'Histoire du Cinéma* 56 (Special issue, December 2008), 15.
11. Under the title *Les Gaîtés de l'escadron*, the piece was adapted to the screen twice by Maurice Tourneur, once in 1913 for Éclair and again in 1932 for Pathé, uniting Raimu, Jean Gabin and Fernandel.
12. Carou, "Le Film d'Art," 16.
13. Stéphanie Salmon, "Le Film d'Art et Pathé: une relation éphémère et fondatrice" in Alain Carou and Béatrice de Pastre (eds.), "Le Film d'art et les films d'art en Europe (1908–1911)," *1895 – Revue d'Histoire du Cinéma* 56 (Special issue, December 2008), 71–2.
14. Alan Williams, *Republic of Images: A History of French Filmmaking* (Cambridge, MA and London: Harvard University Press, 1992), 63.

15. William Uricchio and Roberta E. Pearson, *Reframing Culture: The Case of the Vitagraph Quality Films* (Princeton: Princeton University Press, 1993), 50.
16. Williams, *Republic of Images*, 64.
17. Henri Fescourt, *La foi et les montagnes; ou, Le septième art au passé* (Paris: P. Montel, 1959), 83–9.
18. Philippe d'Hugues, "Louis Feuillade le précurseur" in Philippe d'Hugues and Dominique Muller (eds.), *Gaumont: 90 ans de cinéma* (Paris: Editions Ramsay and La Cinémathèque Française, 1986), 46–8.
19. Francis Lacassin, *Louis Feuillade Maître des lions et des vampires* (Paris: Pierre Bordas and fils. 1995), 105–6.
20. Jacques Champreux and Alain Carou (eds.), "Louis Feuillade," *1895 – Revue d'Histoire du Cinéma* (Hors série, October 2000), 364–91.
21. Lacassin, *Louis Feuillade*, 105.
22. David J. Shepherd, *The Bible on Silent Film: Spectacle, Story and Scripture in the Early Cinema* (Cambridge and New York: Cambridge University Press, 2013), 295–6
23. Louis Feuillade, quoted in Alain Carou and Laruent Le Forestier (eds.), *Louis Feuillade: Retour aux sources – Correspondances et archives* (Paris: Revue de l'Association française de recherché sur l'histoire du cinéma and Gaumont, 2007), 52. (Author's translation).
24. Anon., "Le Théatro-Film," *Ciné-Journal* 2, 46 (4–10 July 1909), 5. (Author's translation).
25. Bernard Bastide, "Les 'séries d'art' Gaumont: Des 'sujets de toute première classe'" in Alain Carou and Béatrice de Pastre (eds.), "Le Film d'art et les films d'art en Europe (1908–1911)," *1895 – Revue d'Histoire du Cinéma* 56 (Special issue, December 2008), 309.
26. d'Hugues, "Louis Feuillade le précurseur," 49. (Author's translation).
27. E.g., Anon., "Lux – Un Drame dans une Carrière," in Georges Dureau (ed.), *Ciné-Journal* 4 (8 September 1908), 6. The specific reference is found just below the title, "*Scènes de la vie ouvrière*," or "scenes of working life." The American Vitagraph Company was especially active in promoting their films on the French market with the label "*Scènes muettes de la vie réelle*," or "silent scenes of real life," from 1910 onwards, as in Anon., "Scènes muettes de la vie réelle," *Ciné-Journal* 3, 89 (7 May 1910), ii.
28. Louis Feuillade, "Les Scènes de la vie telle qu'elle est," *Ciné-Journal* 4, 139 (22 April 1911), 19. (Author's translation).
29. Feuillade, "Les Scènes de la vie telle qu'elle est," 19.
30. Henri Frescourt, quoted in d'Hugues, "Louis Feuillade le précurseur," 50.
31. Anon., "Scènes muettes de la vie réelle," *Ciné-Journal* 3, 89 (7 May 1910), ii.
32. Louis Feuillade, "Le Film esthétique," *Ciné-Journal* 3, 92 (28 May 1910), 3. (Author's translation).
33. ibid.
34. Sven Lauw, "Den Stumme Kunst," *Teatret: Illustreret Maanedsskrift for Teater og Skuespilkunst* 11, 7 (January 1912), 55.

35. August Blom, "Instruktør ved Nordisk Films Co., August Blom," *Teatret: Illustreret Maanedsskrift for Teater og Skuespilkunst* 11, 7 (January 1912), 55–6.
36. Blom, "Instruktør ved Nordisk Films Co.," 56. (Author's translation).
37. Uffe Andreasen, "Louis v. Kohl," *Dansk Biografisk Leksikon (3rd edition)* (Copenhagen: Gyldendal online). <http://denstoredanske.dk/index.php?sideId=298832> (last accessed on 15 February 2015).
38. Louis von Kohl, "Forfatteren og Maleren Louis v. Kohl," *Teatret: Illustreret Maanedsskrift for Teater og Skuespilkunst* 11, 7 (January 1912), 55. (Author's translation).
39. Mark B. Sandberg, "Multiple-reel/feature films: Europe" in Richard Abel (ed.), *Encyclopedia of Early Cinema* (London and New York: Routledge, 2005), 452–6.
40. Ron Mottram, *The Danish Cinema before Dreyer* (Metuchen and London: The Scarecrow Press, 1988), 93.
41. Jean-Louis Capitaine, *Les premières feuilles de la marguerite: Affiches Gaumont, 1905–1914* (Paris: Gallimard, 1994), 70–9.
42. Abel, *The Ciné Goes to Town,* 40.
43. Astaix, Kastor & Lallement, "Le Film d'Art," *Ciné-Journal* 3, 93 (4 June 1910), 7. (Author's translation).
44. Astaix, Kastor & Lallement, "Le Film d'Art,", 7.
45. Georges Dureau, "Films d'Art et 'Film d'Art," *Ciné-Journal* 3, 94 (11 June 1910), 3–4.
46. Anon., "Norden – Danmark," *Biografteaterbladet – Danmark, Norge, Sverige* 1 (January 1911), 7–8. (Author's translation).
47. Frederick J. Marker and Lise-Lone Marker, *A History of Scandinavian Theatre* (Cambridge: Cambridge University Press, 1996), 162.
48. Marguerite Engberg, *Dansk Stumfilm: De store År I-II* (Copenhagen: Rhodos, 1977), 421–3.
49. Else Frölich, "Film," *Teatret: Illustreret Maanedsskrift for Teater og Skuespilkunst* 12, 14 (April 1913), 107. (Author's translation).
50. Erika Balsom, "One Hundred Years of Low Definition," in Martine Beugnet, Allan Cameron, and Arild Fetveit (eds.), *Indefinite Visions: Cinema and the Attractions of Uncertainty* (Edinburgh: Edinburgh University Press, 2017), 77.
51. Ricciotto Canudo, "The Birth of a Six Art," reproduced in Ricciotto Canudo, *L'Usine aux Images (édition intégrale établie par Jean-Paul Morel)* (Paris: Nouvelles Éditions Séguier & Arte Éditions, 1995); See also Ricciotto Canudo, "The Birth of a Sixth Art" in Richard Abel (ed.), *French Film Theory and Criticism: A History/Anthology 1907–1939 – Volume I: 1907–1929* (Princeton: Princeton University Press, 1993), 58–66.
52. Giovanni Dotoli and Jean-Paul Morel, "Présentation Générale" in Ricciotto Canudo, *L'Usine aux Images (Édition intégrale établie par Jean-Paul Morel)* (Paris: Nouvelles Éditions Séguier & Arte Éditions, 1995), 7–10.
53. John P. Welle, "Film on Paper: Early Italian Cinema Literature, 1907–1920," *Film History: an International Journal* 12, 3 (2000), 295.

54. Dotoli and Morel, "Présentation Générale," 9–11. (Author's translation).
55. Welle, "Film on Paper," 288–99.
56. Richard Abel, (ed.), *French Film Theory and Criticism: A History/Anthology 1907–1939 – Volume I: 1907–1929* (Princeton: Princeton University Press, 1993), 8–10.
57. Abel, *French Film Theory and Criticism* vol. 1, 10–14.
58. Louis Haugmard, "The 'Aesthetic' of the Cinematograph" in Richard Abel (ed.), *French Film Theory and Criticism: A History/Anthology 1907–1939 – Volume I: 1907–1929* (Princeton: Princeton University Press, 1993), 85.
59. Abel, *French Film Theory and Criticism* vol. 1, 14–17.
60. Abel, *French Film Theory and Criticism* vol. 1, 18.
61. Canudo quoted in Abel, *French Film Theory and Criticism* vol. 1, 59.
62. Riccioto Canudo, "Manifeste des Sept Arts," *Gazette des sept arts* no. 2 (23 January 1923), 2.
63. René Doumic, "Drama Review: the Cinema Age" in Richard Abel (ed.), *French Film Theory and Criticism: A History/Anthology 1907–1939 – Volume I: 1907–1929* (Princeton: Princeton University Press, 1993), 86–9.
64. Canudo, "The Birth of a Sixth Art," 59–60.
65. Filippo Tommaso Marinetti, "Manifesto of Futurism" quoted in John Pollard, *The Fascist Experience in Italy* (London and New York: Routledge, 2005), 15.
66. Wanda Strauven, "Futurist Poetics and the Cinematic Imagination: Marinetti's Cinema without Films" in Günter Berghaus (ed.), *Futurism and the Technological Imagination* (Amsterdam and New York: Rodopi, 2009), 225.
67. Canudo, "The Birth of a Sixth Art," 60.
68. Abel, *French Film Theory and Criticism* vol. 1, 10.
69. Canudo, "The Birth of a Sixth Art," 61–2.
70. Canudo, "The Birth of a Sixth Art," 65.
71. Abel, *French Film Theory and Criticism* vol. 1, 21.
72. Filippo Tommaso Marinetti, "The Futurist Manifesto" quoted in Stanislao G. Pugliese (ed.), *Fascism, Anti-Fascism, and the Resistance in Italy – 1919 to the Present* (Lanham and Oxford: Rowman and Littlefield Publishers, 2004), 26.

CHAPTER TWO

Behind the Velvet Curtain: The Cultural Communion between Stage and Screen

The rivalry between film and theatre seemed fierce at the advent of the feature-length film in Europe around 1910. Critics extensively compared the two media, and stage directors took sharp aim at the new art form out of fear that it would render the theatre obsolete. As I will argue, however, the relationship between the two media was far more intricate and reciprocal than discursive trysts in journals and newspapers suggest. Many early cinema directors and actors came from a stage background, and a large number of these directors successfully switched back and forth between stage and screen. In addition, European film companies started seeking explicit partnerships with established theatres around 1908 to heighten the quality of their pictures and invoke the stage's prestige by association. This chapter will explore the intermedial connections between theatre and early cinema in the late nineteenth and early twentieth century. It will focus mostly on Denmark, since the Nordisk Films Kompagni was not only artistically renowned but also one of the undisputed commercial international market leaders between 1908 and 1914.

The Danish production context provides an especially close and well-communicated continuation between the two media. By carefully analyzing and bringing together for the first time primary textual and contextual archival material in the form of domestic and foreign programs, theatre and film journals, interviews and (auto)biographies, I am building on and engaging with important film historical work by Danish silent cinema scholars such as Marguerite Engberg and Ron Mottram, and essential theatre historical work done by Marvin Carlson, Michael R. Booth, and others. I am expanding their discourse in making a case for an intermedial performance sphere, mapping the theatre's overwhelming cultural presence in early narrative cinema. There are clear lines of continuation between a late-nineteenth-century theatrical model and the development of the European feature film into the 1910s, in terms of production, exhibition practices, promotional approaches, and the creation of a transmedial star system. This chapter establishes that interconnected performative world, with the Danish context as a representative for many other countries. The following chapter will focus more intently on the

case of actress Betty Nansen (1873–1943), whose fame hoisted this Danish sense of intermediality to an international level.

THE THESPIAN CONNECTION

When the inaugural issue of Denmark's first proper film trade journal, *Filmen* (1912–19), was released on 15 October 1912, it wasted very little time before addressing the medium's perennial rivalry with the stage. In its editorial, the editors stated that they felt the time was right for a journal devoted to all the aspects of *"den stumme Scene,"* or "the silent stage," because it had such an impact on a large part of the public and had simultaneously garnered the attention of a steadily growing number of artists and other interested parties. "Time and time again," the editors stated, "have scolding voices predicted that film would do away with the art of the stage, but we don't believe that there is the slightest danger of such a thing."[1] They argued that film would never replace the theatre since the two art forms were so inherently different from one another, and that when the newest art was allowed to develop and find its own way, time would reveal it to be entirely independent of the stage. In their belief that this was the case, the editors of *Filmen* pledged to do everything in their power to preserve the good relations between the silent and the talking stage, by, for instance, including recent theatrical news among their film coverage. It was their hope that the "two art forms may thrive side by side to each other's contentment, and that *Filmen* may be the connection that seems to have been missing for some time."[2] Ironically, however, the editors' sweeping reconciliatory gesture was accompanied by a small note in the *"Stumper og Strimler,"* or "bits and strips" section in the back, noting that, unfortunately, there was no stage content in this first number of Denmark's first film journal, due to both the space taken up by advertising and the lack of big theatrical premières.[3]

Filmen's editorial attests to the special relationship that existed between the stage and the screen in Denmark. This connection was implicitly present in most European countries, as well as in the United States. One would be hard pressed to find actors, directors, supporting personnel, or producers that did not have any ties to, or previous experience in, the theatrical world. At Gaumont, for instance, star actor-director Léonce Perret (1880–1935) played alongside the great actress Réjane (1856–1920) at the Vaudeville theatre (1903–5). He then moved on to classic repertoire at l'Odéon (1906–7), the most important French theatre after the Comédie Française, where he acted with future fellow directors Maurice Tourneur and Émile Chautard.[4] When Perret joined Gaumont in 1910, he would make over 350 films for the company and played second fiddle only to director and artistic supervisor

Louis Feuillade (1873–1925). According to Perret, Feuillade hired him on the spot at his first meeting after Feuillade had had a falling out with an actor. He shoved a toga and a beard in Perret's hands for a role in the historical film *Esther* (1910), about the eponymous biblical Jewish queen.[5] Feuillade was no stranger to the theatre either when he started at Gaumont in 1905. A poet with a passion for cycling and bullfighting, Feuillade became a journalist at a young age and started writing plays in diverse genres before and during his time at Gaumont. With his stage colleague and future Gaumont director Étienne Arnaud (1879–1955), for example, Feuillade wrote, among others, the 1905 one-act viticulture drama *Le Clos*. Future Pathé director André Heuzé (1880–1942), then, was one of Feuillade's writing partners on the 1909 vaudeville comedy *Tous Papas*.[6]

In Denmark, at the Nordisk Films Kompagni, correspondence shows us that both actors and directors moved freely between the stage and the screen during their careers as well. In a French context, actors' biographies usually speak of their graduating from theatre to film, not mixing the two worlds at the same time. Whether or not this is statistically rooted in fact for the French, the Danes were open and proud of playing an active role in both, and as we will see it added to their credibility internationally. For Nordisk company president Ole Olsen, actors and directors even moved a little too freely between the two. Olsen was courting Folketeatret actor August Blom (1869–1947), for example, who had also been appearing in Nordisk films since 1909.[7] Blom was to be the heir apparent to artistic director Viggo Larsen (1880–1957), because his first successor, Holger Rasmussen (1870–1926), was too busy with his theatre work.

Rasmussen was a successful actor at the Dagmarteatret and Casino theatre, who would presume artistic control of the latter from 1914 to 1919, and started working for Nordisk in 1908.[8] As Engberg notes, Olsen was keen to tie down Rasmussen because of his theatrical connections and success, especially since Rasmussen had been able to convince famous theatre actor Martinius Nielsen (1859–1928) and his equally famous wife Oda Nielsen (1851–1936) to work on some films for Nordisk.[9] Martinius acted at the Casino, Dagmarteatret, and Folketeatret before becoming a director at both Det kongelige Teater and the Casino simultaneously, while his wife Oda was a prima donna at the Casino, Dagmarteatret, and Det kongelige Teater, and had studied drama in France.[10] Holger Rasmussen directed Martinius Nielsen in Nordisk's 1910 *Kean*, a theatrical film par excellence, based on Alexandre Dumas *père*'s (1802–70) eponymous 1836 dramatic account of the life of iconic but maligned English actor Edmund Kean (1787–1833). The film also starred fellow thespians Einar Zangenberg (1882–1918) and Thilda Fønss (1888–1952). Olsen had already indicated to Blom in late 1909 that they

were becoming dissatisfied with Rasmussen as an artistic director because of his theatrical commitments. In 1911, Blom took over Rasmussen's duties as artistic director, after Blom had directed the three biggest box-office hits on record at Nordisk: *Den hvide Slavehandel* (1910); *Den Dødes Halsbaand* (1910), after Danish poet and playwright Adam Oehlenschläger and starring Det kongelige Teater great and Nordisk regular Thorkild Roose (1874–1961); and *Hamlet* (1911), after William Shakespeare and filmed on location in castle Kronborg in Helsingør, or Elsinore.[11]

While Olsen worried about Blom's double commitment, Nordisk did see the benefit of doubling down on their actors' and directors' connection to the theatre in advertising because it provided them with instant cultural respectability. The campaign for *Den hvide Slavehandel*, the sensational white-slave melodrama that Nordisk shamelessly plagiarized from a popular Fotorama film by Alfred Cohn with the same name, provides a good example.[12] Nordisk had already shot a film with a similar theme in 1907, *Den hvide Slavinde* (Viggo Larsen), most likely because "white slavery" had become a hot topic after the highly successful release of Norwegian author Elisabeth Schøyen's (1852–1936) semi-fictional 1905 novel *Den hvide Slavinde – Det XX Aarhundredes Skændsel (The White Slave – The Twentieth-Century's Scandal)*.[13] With a length of 706 meters the Fotorama film lasted more than half an hour, which was double the size of other contemporary films. It was therefore released with a separate printed program (Figure 2.1), on which the film was billed as a "*Socialt Skuespil*," or "social drama," in forty "parts," which stood for scenes.

The program was nine pages long and described the film in great detail, including no fewer than sixteen photographic stills of key dramatic moments. Lead actress Christel Holch (1887–1969) graced the cover as her character Anna, the young girl who moves to London to help support her family financially but falls into the hands of a prostitution ring. Holch made her debut at Det kongelige Teater in 1908 and moved on to the Aarhus Teater, where she married theatre manager Jacob Jacobsen (1865–1955). It was there that she starred in the Aarhus-based Fotorama's (then still named A/S Th. S. Hermansen) first film, *Den lille Hornblæser* (Eduard Schnedler-Sørensen, 1909), based on a popular nineteenth-century war poem by H.P. Holst (1811–93) and Hans Christian Andersen (1805–75).[14] Holch was not mentioned by name in the program, but is described on the cover as the lead of the previous *Den lille Hornblæser*, which had done very well at the box office.[15] Furthermore, the cover lets the audience know that all of the lead parts are performed by "genuinely first-rate artists." Slave trader Gunnar Helsengreen (1880–1939) was, for instance, a prolific theatre actor who went back and forth between stage and screen, and between Copenhagen and Aarhus. He acted and directed for Fotorama as well as for other film

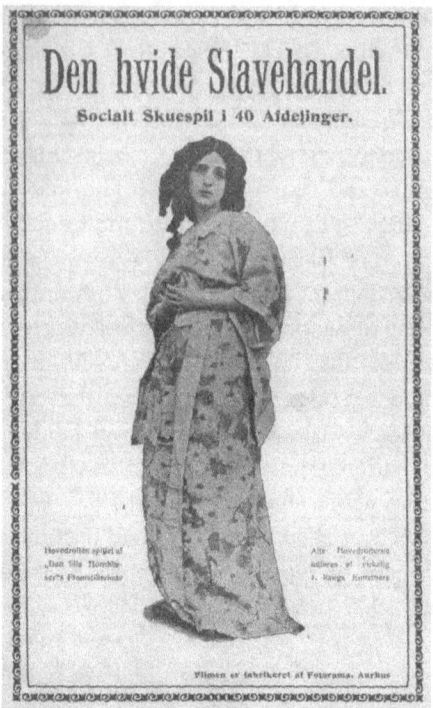

Figure 2.1 *Den hvide Slavehandel* (*The White Slave Trade*; Alfred Cohn, 1910, Fotorama). Film Program Cover (DFI).

companies like Nordisk and Dansk Filmfabrik, worked at the Casino theatre, and also did repertory theatre in the provinces.[16]

In Nordisk's version of *Den hvide Slavehandel*, which came out four months later, Anna was portrayed by actress Ellen Diedrich (1877–1922). She played in five films for Nordisk in 1910 before marrying actor and author Svend Rindom (1884–1960) the next year and devoting her full attention to the stage. Diedrich started out in the Folketeatret, was one of the principal actors in the Aarhus Theatre, and became one of the most well-liked actresses in the Copenhagen theatre scene until her death.[17]

Mutual Marketing Strategies

The program that Fotorama had printed for *Den hvide Slavehandel* is a key example of how film companies followed theatrical models, appropriating its designs for both promotional and cultural gains. Fotorama was not the first to do so, however, as film exhibitors had them printed on single-sheet playbills before 1909–10. This showcased their programs and made it easy for

people to keep track of the many different short films that were being shown. Research by Carlson demonstrates that the "terms program, playbill and bill of the play were all used more or less interchangeably throughout the late nineteenth century."[18] There was nonetheless a clear evolution in the theatre world towards a "magazine-program." This type of program was essentially a little booklet that included information about the programs, the actors and creative team, advertisements, and even transportation information. It was first introduced at the St. James Theatre in London in 1869, where it was called the "Bill of the Play." Subsequently more lavish cardboard programs began appearing in the 1880s, often in color, and London theatres provided their own customized programs varying in size and color until contractors were hired and imposed a certain uniformity from around 1910 onwards.[19] We can still recognize this terminology and evolution today, for instance in the famous New York Broadway stage Playbill booklets that are issued for each show. While its name refers back to single-sheet bills, it is essentially a small magazine, and in 2018, it had a run of 3.5 million copies per month.[20]

What is apparent from the many Danish film programs that survive, the programs' appearance also evolved along with its exhibition practices. Before the introduction of the multi-reel format in 1910, a bill usually consisted of about five films from different companies, countries, and in different genres, forming an afternoon or evening's worth of entertainment. This is apparent, for instance, in the 1908 program containing Nordisk's adaptation of Danish poet and playwright Holger Drachmann's (1846–1908) *Dansen paa Koldinghus* (*Dansen på Koldinghus* in the new spelling; also known as *The Dance of Death*). The film was the dramatic headliner (Figure 2.2) and played alongside three other unknown short films that seem to have been produced by other studios in- or outside of Denmark.

The first film on the program is *Prompte Levering*, or "prompt delivery," a slapstick short about a messenger who has to deliver a silk garment but has some mishaps on the way there. This is followed by a scenic non-fiction film entitled *Fidji-Øerne*, or "Fiji Islands," before we move on to *Dansen paa Koldinghus*. The film is very clearly the headliner, since its title type is larger than the rest's and its description takes up more space than the others' combined. The program further indicates that the main attraction is based on Holger Drachmann's work, and judging by the remaining production stills (Figure 2.3) it was a prestigious period film shot in the *film d'art* tradition. The closing short, *Grimasse-Væddekamp*, or "grimace contest," seems to have been meant to lighten the mood, as it involves nothing more than a man pulling funny faces, according to its description. Exclusive programs for a single film seem to have made their entry slightly before the onset of the feature-filling film. Certain one-reel films were accompanied by an exclusive

Figure 2.2 Dansen paa Koldinghus (*The Dance of Death*; Viggo Larsen, 1908, Nordisk Films Kompagni). Film Program (DFI).

program depending on their artistic status; or, in keeping with our elaborate discussion of the subject in the previous chapter, depending on companies' explicit branding of "artistic status" to give audiences the sense that they were watching high-brow content.

It comes as no surprise, then, that it was Nordisk's first art film, or *Kunstfilm*, *En Kvinde af Folket* (Unknown, 1909; also *Paulines Skæbne*, or "Pauline's fate") which merited a single-feature program (Figure 2.4). It ran for only 345 meters but was billed as a three-act *Folkeskuespil*, or "people play," in fifty-nine scenes. It was described in eight pages and seven production stills but without yet any mention of the principal actors. *Kvinde af Folket* deals with love and class difference, in a plot that sees a rich factory owner fall in love with one of his employees only to quickly cast her off. It was an exponent of the new, more realist direction that Nordisk was taking. Once again, this film's cast consisted of seasoned stage players. The principal lead was taken up by Petrine Sonne (1870–1946), one of Nordisk's pioneering players and a prolific Danish stage and screen actress well into the 1940s. She acted in such Danish classics as Carl Theodor Dreyer's *Du skal ære din Hustru* (1925) and Bodil Ipsen's *Mordets Melodi* (1944). Sonne started at the Folketeatret, and then played at the Frederiksberg theatre and Casino theatre, before spending sixteen years

Behind the Velvet Curtain: The Cultural Communion between Stage and Screen 61

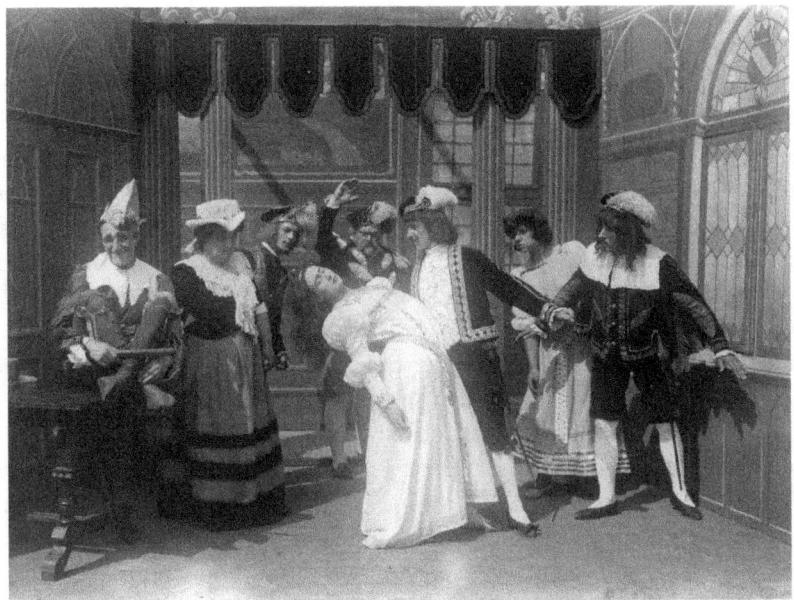

Figure 2.3 *Dansen paa Koldinghus* (*The Dance of Death*; Viggo Larsen, 1908, Nordisk Films Kompagni). Film Production Still (DFI).

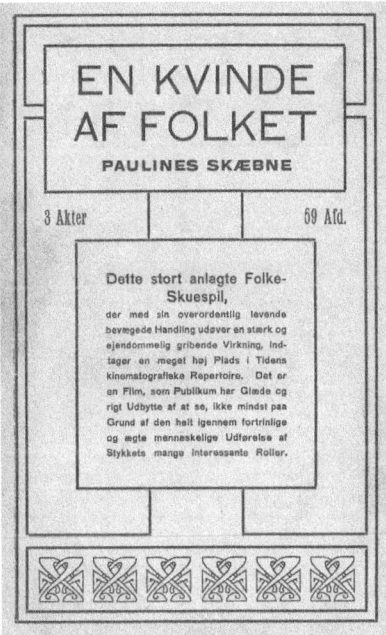

Figure 2.4 *En Kvinde af Folket* (*A Woman of the People*; Viggo Larsen, 1909, Nordisk Films Kompagni). Film Program Cover (DFI).

at Det ny Teater (1911–27). At Det ny Teater she was praised for her sense of imagination and empathy, as well as her broad expressive face with deep-set twinkling eyes.[21] Amongst others, Sonne was joined on the screen in 1909 by August Blom and Elith Pio (1887–1983). The latter was a young up-and-comer who began his career touring in 1907. He spent some time working at various Copenhagen theatres before settling at the Dagmarteatret in 1914 and joining the royal ranks at Det kongelige Teater from 1931 to 1974.[22] In the end, Pio had an impressive sixty-year career on stage, screen, and television, working with renowned directors such as Benjamin Christensen, in *Hævnens Nat* (1916) and *Häxan* (1922); Carl Theodor Dreyer, in *Præsidenten* (1919) and *Blade af Satans Bog* (1921); and appearing in the first Danish sound film, George Schnéevoigt's *Hotel Paradis* (1931).

International as they were, Nordisk released *Kvinde af Folket* through their American branch, the Great Northern Film Company. An ad in *Moving Picture World* (Figure 2.5) shows the aggressive artistic marketing they undertook. It led with the headline "Quality Films" and their polar bear logo was flanked with the slogans: "manufacturers of meritorious productions" and "photographic excellence unexcelled." The ad described the film as a "feature film of the highest order."[23] Normally Nordisk took out half-page ads that incorporated several films, but this was a full-page ad for a single film. *Moving*

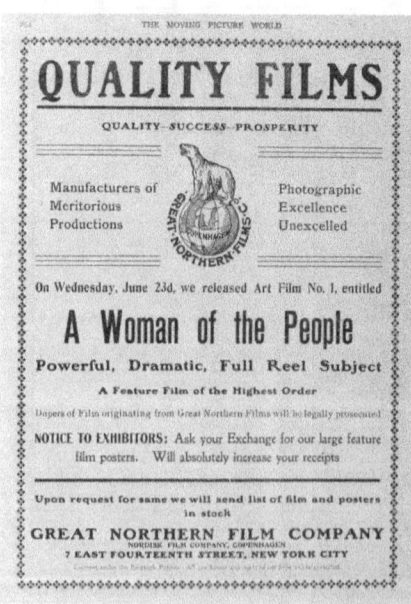

Figure 2.5 "A Woman of the People," *The Moving Picture* World 4, 26 (26 June 1909), 892 (MHDL).

Picture World writers seemed to agree or buy into the high quality of the pictures, for in the same number they sang the praises of the Great Northern's latest achievement. The authors argued that the production company excelled internationally in no small part thanks to their stellar, stage-trained actors:

> a good story, simply and clearly told and well photographed. Therein lies the secret of success; therein lies the secret of the creation of an international moving picture drama. In other words, the preparation and production of plays which are understood at a glance by people in all parts of the world. Think of it now! This Great Northern picture was made in far off Copenhagen, the capital city of Denmark, and, to us, in the ultra modern metropolis of the New World, the action of the piece is as clear as daylight. [. . .] The photography of this picture is up to the fine standard which the Great Northern Company have set for themselves, the tints and tones being judiciously chosen. What we like about it, however, is the intense realism of the acting. Every word, every gesture of the principal characters in this piece is a masterpiece of carefully studied histrionics. This is another case where the illusion is so perfect that one seems, as it were, to be looking at scenes from life itself. Great Northern films, which are going from success to success, have a polish and finish about them which give them that distinction of quality which lifts the moving picture onto the plane of the pictorial.[24]

Most of the printed film programs that were provided for Nordisk films from *En Kvinde af Folket* onwards took on the booklet format. Sandberg also called these programs "pocket movies," and considered them a part of the inherently performative and exhibitory realm of Danish cinema at this time.[25] These "pocket movies" were widespread and issued for films that were either feature length (meaning multi-reel) or deemed prestigious enough to be marketed by themselves, such as Nordisk's series of (Dansk) Kunstfilm, or (Danish) art films, or variants of these like August Blom's *Hamlet* (Figure 2.6). Though *Hamlet* gives Shakespeare top billing, it naturally refers to its own hyper-shortened adaptation as the best one yet, and to be fair its historical Danish locations do help make that point.

A quick and natural addition, then, were the names of the principal actors. The multi-act program for "*Jernbanedrama*," or railroad drama, *Heltemod forsoner* (1909) (Figure 2.7) already mentioned that its parts were played by actors from Copenhagen theatres. It was Dansk Kunstfilm *Tyven* (1910), however, that seems to have been the first Nordisk film to make these parts explicit in its program (cf. Figure 1.5). *Tyven* was an adaptation of French boulevard theatre playwright Henri Bernstein's (1876–1953) 1906 *Le Voleur*, a fact that was mentioned on the program, which also featured the names of aforementioned theatrical star Oda Nielsen and her fellow protagonist Otto Jacobsen (1870–1939). It is clear that Nordisk, especially at this stage before the international

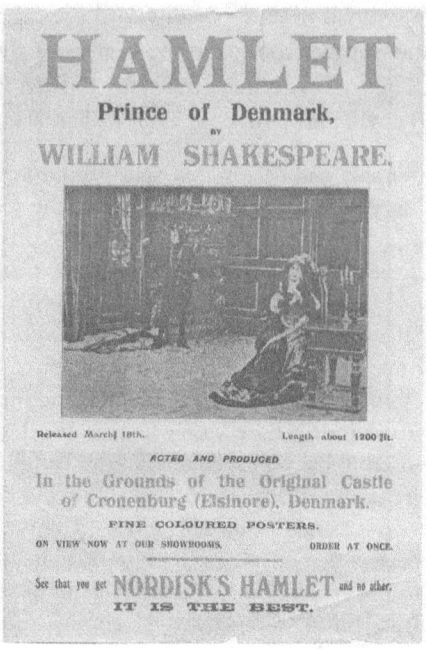

Figure 2.6 Hamlet (August Blom, 1911, Nordisk Films Kompagni). English Film Program (DFI).

Heltemod forsoner
Et Jernbanedrama.
Spillet af Skuespillere fra de københavnske Teatre.

Figure 2.7 *Heltemod forsoner* (*Courage Reconciled*; Viggo Larsen, 1909, Nordisk Films Kompagni). Film Program Excerpt (DFI).

successes of their feature films, was courting audiences with the name recognition that their actors would engender. Nielsen and Jacobsen would have been known around the country. Jacobsen was an actor, teacher and manager who started out at the Dagmarteatret and actively toured Denmark and Norway. He became a stage manager in the provinces and at the Dagmarteatret, and by all accounts he was an excellent manager. His well-planned and high-quality provincial tours attracted the biggest names in the business, and his touring companies had a lasting impact on provincial theatre.[26]

A Transmedial Star System

The decision to add photographs, stills, and names to film programs had far-reaching consequences, since it effectively enabled and maintained a star system. Film producers had successfully taken another page from the theatre's rulebook, providing a clear interdisciplinary continuation of name and status recognition in Denmark as well as other European countries. As the early programs indicate, the actors' presence was more important from a marketing and cultural capital standpoint than that of the company or the director. This was especially true for "artistic features," which made up the bulk of the dramatic European output from around 1911. The absence of directorial credits carried over from the stage as well. The directing position as we know it today was virtually non-existent until the late nineteenth century, more specifically around the 1880s. As theatre historian Michael R. Booth has demonstrated, "the nineteenth-century actor was his or her own master." Classical acting styles were codified, actors generally played parts in set "lines of business" or "types," and quick turnovers in repertory gave little time for rehearsal. Experienced actors had therefore played an immense number of parts in repertory in a short period of time, being responsible for interpreting all of these roles.[27]

For a better understanding of the theatrical star system we need to turn to France. Paris was very much the nineteenth century's cultural and intellectual capital, which held true for both the theatre as well as for early cinema. Carlson rightly states that the Parisian stage not only brought forth "great innovators such as Hugo, Antoine, and Lugné-Poe, but many of those dramatists ignored by literary historians yet beloved by the public and [who] produced far more frequently throughout Europe than the literary giants – dramatists such as de Pixérécourt, Scribe, and Sardou."[28] The latter trio's lack of a similar scale of recognition is possibly due to the fact they were not as daringly innovative, but perhaps also due to the idea that these were popular plays that could safely be adapted by and for a diverging set of audiences.

The impact of the French stage was certainly noticeable in Europe, as French playwrights were widely adapted in many different countries. Equally well known, and less neglected, were their great actors and actresses, from François-Joseph Talma (1763–1826) to Sarah Bernhardt (1844–1923). The fluidity of their work between stage and screen often goes underrecognized as well.[29] Theatre historian Lenard R. Berlanstein has argued that the star system was on the rise in the nineteenth century but that it was not sharply opposed to the ensemble or "troupe" organization that was commonly in place. Rather the two coexisted and cohabited, with company managers eager to pick up on and exploit audience preferences for certain actors and, more often, actresses.

Mademoiselle Mars (1779–1847) had set an important precedent in the 1820s and 1830s, willing the sacred Comédie-Française to place her name above the title of the play. This was a stunt that the popular mononymous Rachel (1821–58) would later repeat. Furthermore, with the government freeing theatres from certain regulations in 1864, the commercialization of the stage set in, reinforcing "a polarization of financial rewards between haves and have-nots."[30]

The next generation of famous French actresses thus took matters into their own hands. They acted as free agents and were so successful as to even be able to open their own theatres at the height of their success, so that they could produce their own plays. Réjane and Sarah Bernhardt are a case in point. The famous French actresses toured the world extensively and profitably, later running the Théâtre Réjane (1906–18) and Théâtre Sarah-Bernhardt (1899–1923) respectively. These actresses and their contemporaries were greatly admired abroad, and the French actresses were especially well regarded in England. This adoration is evidenced by John Stokes in his excellent reception study of French actresses Mademoiselle Mars, Rachel, Plessy (1819–97), Déjazet (1798–1875), Aimée Desclée (1836–74), Réjane, Sarah Bernhardt, and Edwige Feuillère (1907–98).[31] Moving from the late nineteenth into the early twentieth century, Bernhardt seems to have been in a class of her own, however. She remains the most well-documented nineteenth-century actress, known for being a great talent as well as for being the first actress that was shamelessly self-promoting.[32] She is ranked along with the likes of the internationally respected British Ellen Terry (1847–1928) and Italian Eleonora Duse (1858–1924), both of whom also appeared on film.

It seems quite logical, then, that film companies started making use of the drawing power of theatrical stars. French production company Le Film d'Art was naturally one of the first to do so. This decision to credit and promote a film's cast in turn led to the creation of a cinematic star system. I hope to have demonstrated by now that Denmark was characterized by an especially fluid interdisciplinary context when it comes to connections between stage and screen. Copenhagen even had its own Sarah Bernhardt in Betty Nansen, discussed more elaborately in the next chapter. Nansen enjoyed a great career on the stage at Det kongelige Teater, Dagmarteatret, and Folketeatret, before elevating a number of Nordisk's prestigious productions. She additionally made five films for the Fox Film Corporation in the United States, and started her own successful theatre in 1917, Betty Nansen Teatret. The theatre became a home for those on the theatrical cutting edge, and Nansen led it until her death in 1943.[33]

At Nordisk, internal correspondence already cited by Engberg clearly shows that the company was aware of the marketing potential their actors and actresses could have. This was no doubt inspired by the European art

Behind the Velvet Curtain: The Cultural Communion between Stage and Screen 67

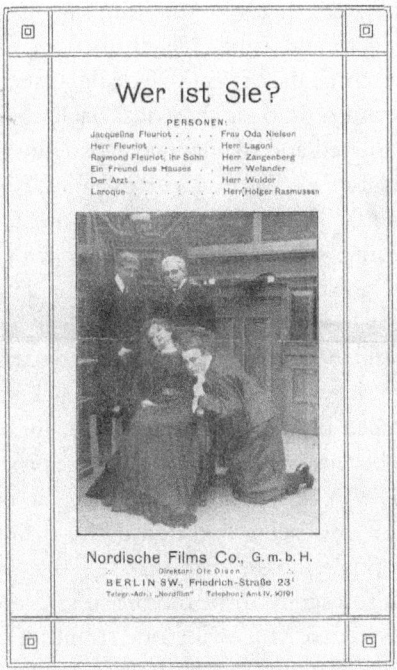

Figure 2.8 Hvem er Hun? (Madame X; Holger Rasmussen, 1910, Nordisk Films Kompagni). German Film Program Excerpt (DFI).

film movement, and perhaps also by the recently founded but very short-lived Danish company Regia Kunstfilms Kompagni (1910–11). Nordisk also started communicating the need to invest in this type of promotion to their foreign offices on 8 September 1910: "We ask you to make customers aware of the great actors and actresses that appear in our films, for example Miss Oda Nielsen in *Hvem er Hun?* [Holger Rasmussen, 1910; after French playwright Alexandre Bisson's highly popular and much-adapted *La Femme X* (1908, also known as *Madame X*)]."[34] This advice was followed up right away judging from the actor marketing in the German program for the film (Figure 2.8). The memo was sent about five months after Nordisk started implementing these strategies in Denmark (*Tyven* was released on 7 April 1910), but since the Scandinavian market only represented a mere 2 per cent of Nordisk's sales, this course of action was best pursued internationally.[35] The strategy proves that Nordisk was not concerned at all with the geographic proximity the stage had to the screen in Denmark, or the actors' limited recognition radius, but rather that they set out to promote the prestige that the connection between the two media brought forth. They were able to turn Danish theatre stars into international film stars.

Tracing the star system in early American cinema, Richard deCordova made some interesting, though debatable, distinctions for navigating between these different artistic contexts. deCordova distinguished between actors that were well known because of their theatrical background and those whose identities were constructed and maintained mostly by the forces of cinema. He referred to the latter as "picture personalities," one step down from full-blown "movie stars." In an international context, however, the divide between the two becomes very fluid since the audience's knowledge is entirely subject to national context and/or promotional manipulation. Furthermore, deCordova's spectator-based approach entails a distinction between a passive spectator who receives knowledge because they construct an actor's identity by navigating "an intertextual path that moves back from the film directly to a discourse produced by the institution of the theater;" and a spectator who becomes active because they participate in the process of constructing a picture personality by watching films and following up on cinematic advertising, the intertextuality thus being "produced and maintained largely by the cinema itself [. . .] empowering the spectator."[36]

Given deCordova's description of the process, "intertextual" might best be replaced by "transtextual," following one strand of established discourse to another in a different context; or simply "transmedial," if we think of this process as existing to and between media. Though the "picture personality" was certainly on the rise quickly, and stars such as Sarah Bernhardt belonged mostly to the theatrical realm, there was also a very large midfield. This included everyone from barely known theatrical actors to internationally or regionally respected thespians that were on a different level than the Bernhardts of this world. It is also unclear why a spectator's cognitive associational, or, per deCordova, "intertextual" process should be considered passive if it is rerouted to a discourse produced by the theatre? Or why indeed a theatrical association necessarily leads to a theatrical discourse, when the cinematic promotional machine could just as easily play this out, as it did. If a screen actor is truly recognized from the plays they have been in without any promotional aid from the film's producers, then logically the transmedial processes are much more interesting and richer in comparison with those built up by solely watching films.

Given the expansive globalization that took place in the film industry between 1910 and 1914, it seems more likely that actors' theatrical backgrounds were amped up by film studios. They ladled souped-up reputations into the minds of spectators who were perhaps wholly unfamiliar with, in this case, a European theatre context, and used actors' theatrical backgrounds as cultural currency to sell their product. As we have seen and will see, this did not keep stage actors from becoming picture personalities,

however, regardless of spectatorial mental processes. Though I believe the denominations "picture personality" and "movie star" to be very workable concepts, it should be recognized that the interplay between actors and star systems in theatre and film was far more intricate and reciprocal than deCordova makes it out to be. This was probably true in Europe as much as it was in America.

Proving that the Danish silent cinema market easily allowed for stars crossing borders, then, was the instant success of Asta Nielsen (1881–1972) in Urban Gad's (1879–1947) *Afgrunden* (1910). This was the Kosmorama company's first of only two features, but its impact is still felt today. Asta Nielsen was a rising star in the theatre, debuting at Dagmarteatret in 1902 and then leaving to tour Norway and Sweden extensively. It was there that she developed and perfected a knack for comic parts, before coming back and settling in Det ny Teater in 1908.[37] She must have met Urban Gad at Det ny Teater, since he became a stage director there in 1909. Gad went on to make a number of successful pictures with Nielsen in Denmark for several companies, but most of their cinematic collaborations took place in Germany. It was in Berlin that the pair, who were married from 1912 to 1915, got a great offer and shot no fewer than thirty-one pictures.[38] Asta Nielsen was, by all accounts, a picture personality *and* a movie star. Mottram claimed that the success of *Afgrunden* convinced "Danish theater people that film was a legitimate medium," because "as in America, established Danish stage artists would have nothing to do with the cinema. It was the younger stage people, without reputations, who were willing to work in film, and such was the group that made *Afgrunden*."[39] As I have established, however, this was simply not true. Asserting as much without proper research negates the fluidity and processes between the two media, and wrongly pushes the cliché that there existed a widespread animosity between the two media that succeeded in keeping their personnel separate from one another.

Danish film giant Nordisk kept up good working relations with very famous theatre actors before *Afgrunden* became a hit for Kosmorama. As we have seen, it released *Tyven* five months before *Afgrunden* and sent out an internal memo to their foreign offices to promote the theatre artists that they employed before *Afgrunden* was even released in Denmark.[40] If this seems cutting it close to *Afgrunden*, it is important to emphasize the sheer international magnitude and professionalism of Nordisk once again. *Afgrunden* was indeed a hit, but my research shows that it was only picked up in France in 1911, where it was known as *L'Abîme* or *L'Abime*, and in the United States in 1912, where it was known as *Woman Always Pays*, and where Nielsen's name was consequently misspelled as "Neilsen." In France, *Ciné-Journal* mentioned *Afgrunden* on 11 March 1911 to indicate that it had been playing to full

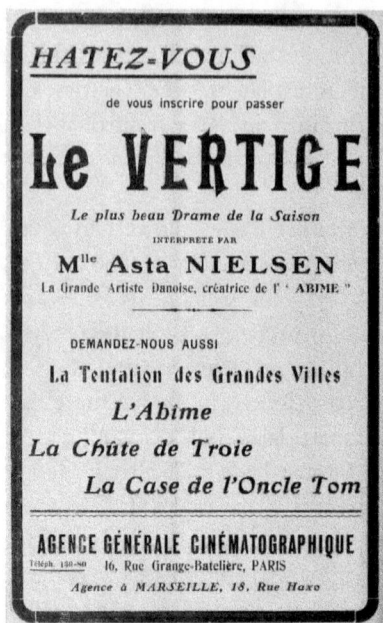

Figure 2.9 "Le Vertige," *Ciné-Journal* 4, 142 (13 May 1911), 20 (MHDL).

Figure 2.10 H.F.H., "The Asta Neilsen (sic) Pictures," *The Moving Picture World* 11, 12 (23 March 1912), 1055 (MHDL).

houses at the Cinéma-Palace theatre for a record four weeks.[41] It did not pick up Nielsen's name, however, until distribution company Agence Générale Cinématographique placed an ad in *Ciné-Journal* promoting her film *Le Vertige* (*Heisses Blut*; Urban Gad, 1911) as the "best drama of the season – starring Mademoiselle Asta Nielsen – the great Danish artist, creator of *Afgrunden*" (Figure 2.9).[42] The ad also promoted the Agence's similar titles *La Tentation des Grandes Villes* (Nordisk's 1911 *Ved Fængslets Port*, or *Temptations of a Great City*, by August Blom), *L'Abîme* (*Afgrunden*), *La Chûte de Troie* (Itala's 1911 *La caduta di Troia* by Luigi Romano Borgnetto and the great Giovanni Pastrone), and *La Case de l'Oncle Tom* (most likely Vitagraph's 1910 *Uncle Tom's Cabin* by J. Stuart Blackton).

A profile in *Moving Picture World* followed on 23 March 1912, in which Nielsen was mistakenly labeled the "German Bernhardt" (Figure 2.10). The article is an interesting one because it dives headlong into the subject of stage versus screen:

> The year of 1912 seems destined to be a memorable one in the history of motion pictures. It is probable that within the year all barriers between the legitimate stage and the photo-drama will have been let down and the motion

picture will be found occupying its rightful and destined place as one of the fine arts. This state of affairs will, of course, be brought about by precedent. It is quite necessary that the motion picture shall be taken up by the acknowledged heads of the dramatic profession before it can be fully endorsed and recognized in a formal way. [. . .] The first of these precedents, which for some time have existed only as prophesies, have already appeared in the early months of this year. France has seen the handwriting on the wall and its greatest actress, Sarah Bernhardt, has transferred her art from the speaking stage to that of the more universal photoplay. In England Sir Herbert [Beerbohm] Tree has recognized the photgraphic [sic] medium as the most universal and permanent vehicle for the dramatic art.[43]

Given the developments brought about by the European art film wave in 1908, and the close working relationship that existed between the two media in some countries, the author seems intent on overstating the barrier that existed between the two. Nevertheless, it had been a popular discursive issue to take up in film and theatre journals since 1907–8. It reflected both the need for cultural affirmation as well as medium specificity. The article most likely refers to Sarah Bernhardt's appearance in the Le Film d'Art production *La Dame aux Camélias* (André Calmettes, Louis Mercanton & Henri Pouctal, 1912) and Herbert Beerbohm Tree's *Henry VIII* (William Barker and Herbert Beerbohm Tree for Barker Motion Photography, 1911). In terms of precedents, Bernhardt had already made an important statement by appearing in Clément Maurice's experimental sound picture *Le duel d'Hamlet* (1900) for Phono Cinéma Théâtre. Her appearance made her one of the first to talk on film, albeit via synchronized phonograph, and this for an audience of millions since it was shown in Paris at the 1900 Exposition Universelle, or world's fair. For Le Film d'Art, Bernhardt had also already appeared in the 1908 *Tosca* by André Calmettes. Herbert Beerbohm Tree, then, had already starred in Shakespeare's *King John* (1899), which he directed alongside Walter Pfeffer Dando and W.K.L. Dickson for the British Mutoscope & Biograph Company. He and Charles Urban had also shot *The Tempest* for the Urban Trading Company in 1905. Change had therefore been more gradual and, as John Collick notes, short features of famous people had also become a popular sub-genre of early cinema, and Bernhardt and Beerbohm Tree were definitely in a class of their own.[44] Asta Nielsen was on par with Bernhardt and Beerbohm Tree about as much as she was German, but she was undeniably one of the first movie stars.

In the national and international transmedia strategies plotted at Nordisk, we see that little time was lost between internal decisions and outward communication. Nordisk had appointed Ingvald C. Oes to represent their American counterpart the Great Northern Film Company, and he

maintained a close line of communication with trade journals. Interviewed by way of introduction in 1908, Oes was dubbed a "pleasant and cultured gentleman" in *Moving Picture World*. When asked about the company's staff of actors he stated that the "artistical and dramatic side of the operations are led by artists of high standing, assisted by a staff of actors of recognized ability."[45] Oes also gave an interview to both *Moving Picture World* and *Moving Picture News* on 23 September 1911, after he had returned to the States from a short trip to Europe, and he was clearly out to promote Nordisk's close relationship with the theatre industry and provided the American trade press with his insight into the European film culture.[46] The interview in *Moving Picture News* was an extensive one and it was followed by a two-page spread showcasing "some of the celebrated actors from the Denmark theatres who have helped to make the Great Northern films famous"[47] (Figure 2.11). The interviewer noted that the Great Northern employed not just a stock company, but rather the finest "actors and actresses that Europe can boast, some from the royal theatre itself," but Oes divulged that it was not easy to engage the artists:

> We got one of the best authors in Denmark to write a scenario, then we interested the actors and actresses to the extent that they consented, as a favor, to pose for this one picture. The result was that they were so pleased with themselves in the picture [. . .] that they were willing to continue the work, and now almost the entire profession is available in Denmark for service at the moving picture studios. Some of those who come from the royal theater are paid as high as 15,000 a year for their services, and others are paid as much as 100 a day.[48]

Oes also spoke of the beautiful European picture theatres, Nordisk's popularity in Germany and, more importantly, pointed out that there were two directors in Nordisk's employ, naming August Blom and Eduard Schnedler-Sørensen (mistakenly called Schnedler Petersen). He did so at a time when, in Europe and America, the director generally went uncredited. Oes further strengthened the American view of Europe as an artistic Valhalla by stating that manufacturers were better off destroying flawed films than staking their reputation on them in the critical European film market, because the "standard of the moving picture in Europe [is] kept on an elevated plane, as are all things connected with art."[49] Oes's statement on the company attracting famous actors is typical of the pioneering image that Nordisk wanted to propagate. In reality, things grew more organically, and the high volume of theatre actors working in the Danish film industry demonstrated that theatrical management generally did not take issue with this, especially not in the off-season.

Behind the Velvet Curtain: The Cultural Communion between Stage and Screen 73

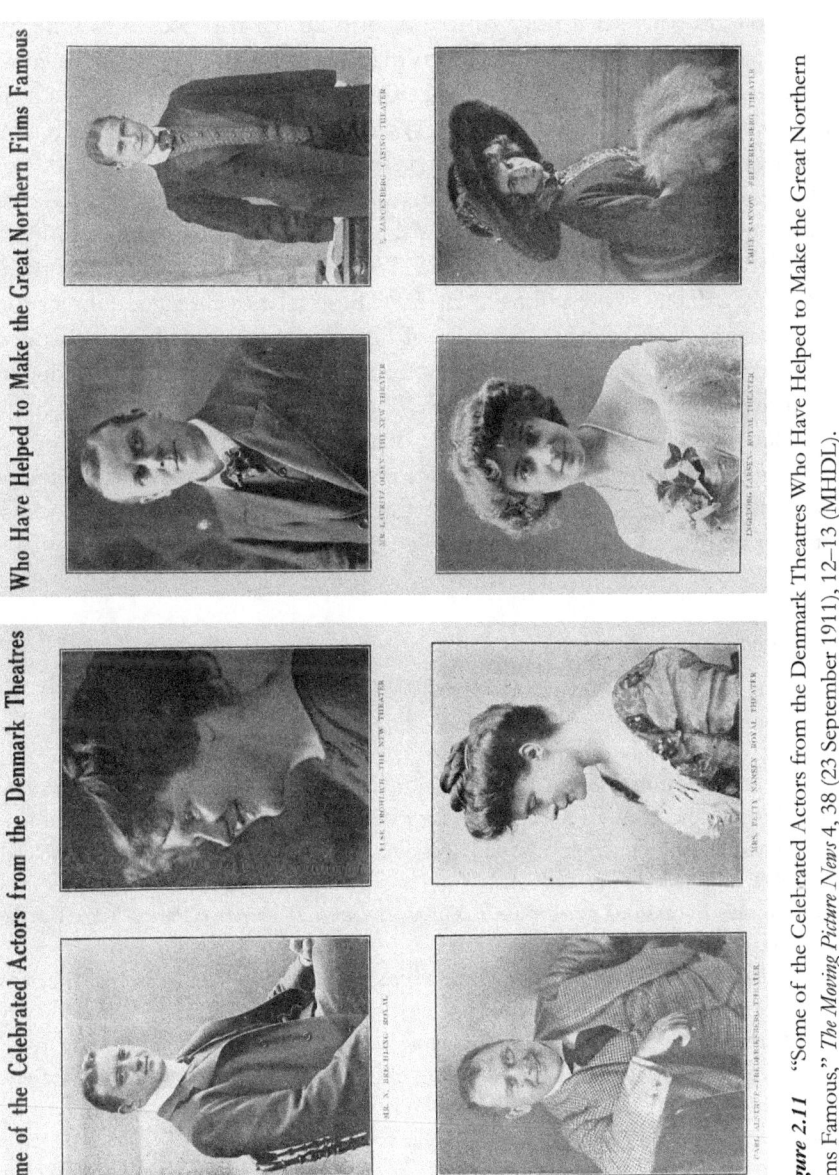

Figure 2.11 "Some of the Celebrated Actors from the Denmark Theatres Who Have Helped to Make the Great Northern Films Famous," *The Moving Picture News* 4, 38 (23 September 1911), 12–13 (MHDL).

One consequence of companies trading on well-known names, or of the entire star system, was that well-known actors' wages skyrocketed. Engberg's research gives us an insight into the wages at Nordisk in 1911, showing that the standard daily actor wage of five Danish kroner had become a thing of the past. Chief director August Blom made DKK 666,6 per month against Eduard Schnedler-Sørensen's DKK 300. A lesser-known actress such as daredevil Emilie Sannom (1886–1931) would take home around DKK 250 per month against theatre royalty Augusta Blad's (1871–1953) DKK 700 per film, in a context where multiple films were being shot per month. One of the most famous Danish superstars, Valdemar Psilander, was reportedly paid DKK 100 for a fifty-day contract in 1911, but as his fame rose his fee went up to DKK 250,000 for ten films in 1916.[50] These salaries are a good indication of what was at stake in the business of film, and it was usually the seasoned and well-known theatre actors who were able to demand these wages due to their name recognition and experience. The following chapter's case on Betty Nansen will clearly show, moreover, that the stage context from whence these well-trained actors and actresses emerged was not at all that different from that of the silver screen, with plays containing highly similar plots, subject matter, and ditto middle-class environments.

Notes

1. Anon., s.n., *Filmen* 1, 1 (15 October 1912), 3. (Author's translation).
2. Anon., s.n., 3. (Author's translation).
3. Anon., "Stumper og strimler," *Filmen* 1, 1 (15 October 1912), 18.
4. Bernard Bastide, "Léonce Perret, maître des lumières et des ombres" in Bernard Bastide and Jean A. Gili (eds.), *Léonce Perret* (Paris: Association française de recherche sur l'histoire du cinéma, 2003), 12.
5. Bastide "Léonce Perret," 14.
6. Francis Lacassin, *Louis Feuillade: Maître des lions et des vampires* (Paris: Pierre Bordas and fils, 1995), 46–7.
7. According to Ron Mottram, Danish director Benjamin Christensen also briefly worked at Folketeatret, so the two must have known each other. Unfortunately, Christensen suffered from an incurable nervous disorder that affected his voice. This had caused him to fail as an opera student at Det kongelige Teater and ruined his acting voice as well. He then worked as a French wine wholesaler for a few years before entering the silent cinematic acting world in 1911 at the Dansk Biografkompagni. See Ron Mottram, *The Danish Cinema before Dreyer* (Metuchen and London: The Scarecrow Press, 1988), 110.
8. Robert Neiiendam, "Rasmussen, Holger," *Dansk Biografisk Leksikon (3rd edition)* (Copenhagen: Gyldendal online, 1979–84) <http://denstoredanske.dk/Dansk

_Biografisk_Leksikon/Kunst_og_kultur/Teater_og_film/Skuespiller/Holger_Rasmussen> (last accessed 15 February 2015).
9. Marguerite Engberg, *Dansk Stumfilm: De store År I–II* (Copenhagen: Rhodos, 1977), 264.
10. Robert Neiiendam, "Nielsen, Martinius," *Dansk Biografisk Leksikon (3rd edition)* (Copenhagen: Gyldendal online, 1979–84) <http://denstoredanske.dk/index.php?sideId=295007> (last accessed 15 February 2015); Robert Neiiendam, "Nielsen, Oda," *Dansk Biografisk Leksikon (3rd edition)* (Copenhagen: Gyldendal online, 1979–84) <http://denstoredanske.dk/Dansk_Biografisk_Leksikon/Kunst_og_kultur/Teater_og_film/Skuespiller/Oda_Nielsen> (last accessed 15 February 2015).
11. Engberg, *Dansk Stumfilm,* 265.
12. Read all about the plagiarism scandal and its consequences for Nordisk and Fotorama in Marguerite Engberg, "Plagiarism, and the Birth of the Danish Multi-Reel Film" in Lisbeth Richter Larsen and Dan Nissen (eds.), *100 Years of Nordisk Film* (Copenhagen: Danish Film Institute, 2006), 72–9.
13. Elisabeth Schøyen, *Den hvide Slavinde – Det XX Aarhundredes Skændsel* (Aarhus: Alb. Bayer, 1905).
14. Gunnar Sandfeld, *Thalia i Provinsen: Dansk Provinsteater 1870–1920* (Copenhagen: Nyt Nordisk Forlag Arnold Busck, 1968), 278.
15. Engberg, *Dansk Stumfilm,* 216.
16. Sandfeld, *Thalia i Provinsen,* 375–6; Robert Neiiendam, "Jacobsen, Jacob," *Dansk Biografisk Leksikon (3rd edition)* (Copenhagen: Gyldendal online, 1979–84) <http://denstoredanske.dk/index.php?sideId=291899> (last accessed 15 February 2015).
17. Robert Neiiendam, "Rindom, Ellen," *Dansk Biografisk Leksikon (3rd edition)* (Copenhagen: Gyldendal online, 1979–84) <http://denstoredanske.dk/index.php?sideId=296409> (last accessed 15 February 2015).
18. Marvin Carlson, "The development of the American theatre program" in Ron Engle, and Tice L. Miller (eds.), *The American Stage* (Cambridge and New York: Cambridge University Press, 1993), 102.
19. Carlson, "The development of the American theatre program," 103.
20. Jonathan Wolfe, "New York Today: The Future of Playbill," *New York Times* (20 April 2018) <https://www.nytimes.com/2018/04/20/nyregion/new-york-today-the-future-of-playbill.html?searchResultPosition=1> (last accessed 15 December 2018).
21. Karen Krogh, "Sonne, Petrine," *Dansk Biografisk Leksikon (3rd edition)* (Copenhagen: Gyldendal online, 1979–84) <http://denstoredanske.dk/index.php?sideId=297642> (last accessed 15 February 2015).
22. Martin Dyrbye, "Pio, Elith" in Scavenius, Alette (ed.), *Gyldendals Teaterleksikon* (Copenhagen: Gyldendal online, 2007) <http://denstoredanske.dk/Gyldendals_Teaterleksikon/Dansk_1840–1950/Elith_Pio> (last accessed 15 February 2015).

23. Anon., "A Woman of the People," *Moving Picture World* 4, 26 (26 June 1909), 892.
24. Anon., "A Woman of the People," *Moving Picture World* 4, 26 (26 June 1909), 871–2.
25. Mark B. Sandberg, "Pocket Movies: Souvenir Cinema Programmes and the Danish Silent Cinema," *Film History: an International Journal* 13, 1 (2001), 7–8.
26. Sandfeld, *Thalia i Provinsen,* 274–5.
27. Michael, R. Booth, "Nineteenth-Century Theatre" in John Russell Brown (ed.), *The Oxford Illustrated History of the Theatre* (Oxford and New York: Oxford University Press, 2001), 329.
28. Marvin Carlson, *The French Stage in the Nineteenth Century* (Metuchen: The Scarecrow Press, 1972), 1–2.
29. In the case of Sarah Bernhardt, intermedial analyses were not fully made until Victoria Duckett's thorough undertaking, *Seeing Sarah Bernhardt: Performance and Silent Film* (Chicago: University of Illinois Press, 2015). For a broader international overview of actresses between stage and screen, see also Victoria Duckett and Vito Adriaensens' (eds.) special issue "The Actress-Manager and Early Film," *Nineteenth Century Theatre and Film* 45, 1 (May 2018).
30. Lenard R. Berlanstein, *Daughters of Eve: A Cultural History of French Theater Women from the Old Regime to the Fin-de-Siècle* (Cambridge MA and London: Harvard University Press, 2001), 30–1.
31. John Stokes, *The French Actress and her English Audience* (Cambridge: Cambridge University Press, 2005).
32. John Stokes, "Sarah Bernhardt," in John Stokes, Michael R. Booth, and Susan Bassnett, *Bernhardt, Terry, Duse: The Actress in her Time* (Cambridge & New York: Cambridge University Press, 1988), 13.
33. Kela Kvam, *Betty Nansen: Masken og Mennesket* (Copenhagen: Gyldendal, 1997), 162–3.
34. Engberg, *Dansk Stumfilm*, 317. (Author's translation).
35. Engberg, "Plagiarism and the Birth of the Danish Multi-Reel Film," 79.
36. Richard deCordova, *Picture Personalities: The Emergence of the Star System in America* (Urbana and Chicago: University of Illinois Press, 2001), 50–1.
37. Olaf Fønss, *Danske Skuespillerinder: Erindringer og Interviews* (Copenhagen: Nutids Verlag, 1930), 117–18.
38. Engberg, *Dansk Stumfilm*, 270–3; Marguerite Engberg, "Gad, Urban," *Dansk Biografisk Leksikon (3rd edition)* (Copenhagen: Gyldendal online, 1979–84) <http://denstoredanske.dk/Dansk_Biografisk_Leksikon/Kunst_og_kultur/Teater_og_film/Filminstrukt%C3%B8r/Urban_Gad> (last accessed 15 February 2015).
39. Mottram, *The Danish Cinema before Dreyer*, 81.
40. Engberg, *Dansk Stumfilm*, 263.
41. Anon., "L'Abime," *Ciné-Journal* 4, 133 (11 March 1911), 6.
42. By comparing the advertising still present in Agence Générale Cinématographique's ad for *Le Vertige* in *Ciné-Journal* of 27 May 1911 to those available at the Danish Film Institute this seems to be Urban Gad's *Heisses Blut*, made for

Deutsche Bioscop in 1911 and released in Denmark as *Det hede Blod*. Anon., "Le Vertige," *Ciné-Journal* 4, 142 (13 May 1911), 20. (Author's translation).
43. H.F.H., "The Asta Neilsen [*sic*] Pictures," *Moving Picture World* 11, 12 (23 March 1913), 1054.
44. John Collick, *Shakespeare, Cinema and Society* (Manchester and New York: Manchester University Press, 1989), 70.
45. Anon., Ingvald C. Oes- Of the Great Northern Film Company," *Moving Picture World* 2, 13 (28 March 1908), 261.
46. Anon., "Oes returns," *Moving Picture World* 9, 11 (23 September 1911), 882.; Anon., "Interesting facts from abroad, gleaned from an interview with Mr. I.C. Oes, manager of the Great Northern," *Moving Picture News* 4, 38 (23 September 1911), 11.
47. Anon., "Interesting facts," 12–13.
48. Anon., "Interesting facts," 11.
49. ibid.
50. Engberg, *Dansk Stumfilm*, 317–18.

CHAPTER THREE

An Actress for Our Age: Betty Nansen, Modern Media Icon

Betty Nansen's prominence might not be as grand as that of another Danish stage actress who crossed over into film, Asta Nielsen, and yet one could argue that Nansen takes up a more important rung on the cultural ladder. Blessed with piercing "Bette Davis eyes," Nansen started out as Betty Müller at Casino Teatret in Copenhagen, where she burst onto the stage at twenty years old in 1893, portraying the titular role of Victorien Sardou's *Dora* (1877) (Figure 3.1). When she married Peter Nansen, star reporter of the newspaper *Politiken*, in 1896, she took on her husband's name and moved from the Casino to the royal stage at Det kongelige Teater. This was followed by stints at Dagmarteatret, Folketeatret, and back to Det kongelige Teater, before putting her stage career on hold from 1910 to 1916 to pursue international movie stardom. Nansen appeared in over eighty theatrical lead roles in Copenhagen between 1893 and 1910, many more if we include her

Figure 3.1 Betty Nansen as Victorien Sardou's *Dora* (Casino Theatre, 1893). Theatre Production Still (KB).

appearances in other Nordic countries, and was additionally active as a co-director and stage manager. She was a muse for the great dramatists of her day, such as Hermann Sudermann, Henrik Ibsen, Holger Drachmann, and Bjørnstjerne Bjørnson, almost all of whom died around the time she put her stage career on hiatus for film.[1]

Nansen's cultural status earned almost unheard-of production deals with the Nordisk Films Kompagni and with William Fox in the United States. Her agency as an actress-manager was even greater when she returned to the stage after her film career, starting her very own Betty Nansen Teatret. She managed it from 1917 until her death in 1943 and was lauded for the continuous reinvention of both her theatre and her own roles. With Betty Nansen, this chapter provides a representative case study for the cultural communion between stage and screen in Europe. It will explore what exactly might have made a transmedial Scandinavian context unique; how Nansen managed to trade on her cultural capital for a unique production deal that launched an international career; how the legitimate stage's star system in Denmark accommodated this in Nansen's case; and why Nansen's role as a figure of the Scandinavian Modern Breakthrough movement in the arts should be key to our understanding of the conglomeration of the arts and of modernism in 1910s Europe. While the 1920s is generally seen as the period in which American film companies courted forward-thinking European directors to bank on their artistic merit and creativity, Betty Nansen presents an important exception to this period of international artistic courtship.

Word of Nansen's talent had reached across the Atlantic by 1903, with *The New York Times* announcing her performance in Sir Arthur Wing Pinero's play *Iris* (1901) at Folketeatret in Copenhagen.[2] The announcement foreshadowed the queen's welcome that Nansen would receive setting foot on American soil in 1914. It was Nordisk, however, that was able to seduce her to the medium of film first. Nansen made ten films for Nordisk, the bulk of which were released in 1913–14: *Prinsesse Elena* (Holger-Madsen, 1913), *Bristet Lykke* (August Blom, 1913), *Hammerslaget* (Robert Dinesen, 1914), *Eventyrersken* (August Blom, 1914), *Under Skæbnens Hjul* (Holger-Madsen, 1914), *Af Elskovs Naade?* (August Blom, 1914), *Moderen* (Robert Dinesen, 1914), *Revolutionsbryllup* (August Blom, 1915), *Sønnen* (August Blom, 1916), and *En ensom Kvinde* (August Blom, 1917). Nansen also made five pictures for the Fox Film Corporation in Fort Lee, New Jersey, before a wave of Scandinavian talent rolled into Hollywood in the 1920s with directors such as Benjamin Christensen and Victor Sjöström, and actors like Greta Garbo and Lars Hanson.[3] Nansen's films for Fox were: *The Celebrated Scandal* (J. Gordon Edwards and James Durkin, 1915), *Anna Karenina* (J. Gordon Edwards, 1915), *A Woman's Resurrection* (J. Gordon Edwards, 1915), *Should*

a Mother Tell? (J. Gordon Edwards, 1915), and *The Song of Hate* (J. Gordon Edwards, 1915).

Betty Nansen's artistic renown in 1910 prompted Nordisk to offer her a deal alongside famed German dancer Rita Sacchetto. Both women were stars as well as stage managers. The deals for Nansen and Sacchetto resembled the future production-unit subsidiaries that were set up for stars in the United States, such as the Mary Pickford Artcraft Pictures label that was established in 1916 under Famous Players-Lasky. As Kia Afra notes, these subsidiaries allowed the stars greater flexibility in choosing their content and who they wanted to work with, bigger budgets, and a much bigger stake in the profits.[4] Nansen and Sacchetto were marketed together by Nordisk's transatlantic branch, the Great Northern Film Company, as "stars of international fame" in a "series of photo-dramas known as our 'preferred feature attractions'."[5]

It is hardly surprising that Nansen is still considered to be one of the women to change Danish culture.[6] Analogous to Sarah Bernhardt's entry into film, Nansen did not have to start out in pictures anonymously. She transitioned fluidly between stage and screen, and the Betty Nansen Teatret is still the only legitimate Danish theatre ever to be named after a person.

MODERNISM, FEMINISM, SCANDINAVISM

Until the mid-nineteenth century, the fates of Denmark, Sweden, and Norway were bound together through monarchical rule and geographical conflict. Culturally, this carried into the beginning of the twentieth century, reflecting a "pan-Scandinavian" unity that was a key part of nineteenth-century Scandinavian nationalism.[7] This was true for the stage as well, where Scandinavia as a region had become associated with playwrights who ushered in modernity for the world stage, most notably via the Norwegians Bjørnstjerne Bjørnson and Henrik Ibsen, the Swede August Strindberg, and the Dane Holger Drachmann. These figures answered Danish scholar Georg Brandes's 1871 call for a "Modern Breakthrough" in Scandinavian literature, an impassioned plea for writers to start tackling contemporary issues.[8]

It was Henrik Ibsen's name that carried the torch for the international Scandinavia craze. Ibsen revolutionized the stage by doing away with conventions, choosing prose over verse, and discussing issues such as "women's rights, venereal disease, incest, and the corruption and hypocrisy of good society."[9] Furthermore, his creation of a female character who dared go against the traditional norms of family, *A Doll's House*'s Nora Helmer (*Et dukkehjem*), almost single-handedly spearheaded the late nineteenth century's progressive female role when it premiered at Det kongelige Teater in Copenhagen on 21 December 1879. Betty *Hennings* was the first Nora,

though the part is sometimes mistakenly attributed to the then six-year-old Betty Nansen.[10] *A Doll's House* was an international hit, but, as Narve Fulsås and Tore Rem point out, the original ending that has Nora slam the door on her family was perhaps only accepted in Scandinavia. Elsewhere, audiences often instead saw Nora collapse in front of her children after an argument with Torvald, negating the agency that she enacts in Ibsen's original ending.[11] Theatre historian Callie Jeanne Herzog argues that after Nora, Ibsen's peers had "no choice but to carefully examine their depiction of women and of women's social and sexual relations," although one could argue that this examination has been taken up at a rather leisurely pace.[12]

Linda Haverty Rugg has pointed out that the "woman question" that dominated the late-nineteenth-century Scandinavian drama of Ibsen and Strindberg was inherited by a range of Scandinavian filmmakers. These leading women, according to Haverty Rugg, often played the role of the woman who had been "tortured" by fate or was in the middle of a moral conflict.[13] We will see that this type holds up for a large number of Betty Nansen's film roles, beginning with her 1913 debut in *Prinsesse Elena*. In this role, Nansen's character sacrifices herself so that her lover can be free.

It was against the backdrop of this "woman question" that Nansen got her start at the Casino theatre in Copenhagen in 1893, starring as the titular *Dora* in Victorien Sardou's eponymous play (1877). At the centre of this Modern Breakthrough stood Copenhagen's Det kongelige Teater, where Ibsen premiered *A Doll's House* in 1879 and where Betty Nansen moved in 1896 after three years with the Casino. In her opening play, Nansen portrayed Martha in Ibsen's *The Pillars of Society* (*Samfundets Støtter*, 1877).[14] Like in England and France, the monopoly of the royal theatres in Copenhagen and Stockholm was challenged by the emergence of smaller private theatres such as the Casino (founded in 1848) and the Folketeatret (founded in 1857), both of which competed for a share of the market by daring to be innovative.[15]

The willful men and women who became a part of this wave of innovation towards the end of the nineteenth century were chronicled in a new monthly from 1901 onwards called *Teatret: Illustreret Maanedsskrift for Teater og Skuespilkunst* (*The Theatre: Illustrated Monthly for Theatre and the Dramatic Arts*).[16] The journal's first issue (1901–2) demonstrated that the same topics that had been at stake in the 1870s and 1880s were still at play on the Scandinavian stage. It profiled twice as many women as men, with "first Nora" and *grande dame* Betty Hennings receiving double honors.[17] One of its main critical pieces was on recent Ibsen adaptations.[18] It also showed a general preoccupation with plays staged by the most prestigious theatre, Det kongelige Teater.[19]

In this first issue, Betty Nansen received a six-page spread and contributed her own autobiographical piece on growing up as a "theatre brat." The

theatre critic who profiled Nansen was poet and playwright Sophus Michaëlis. Michaëlis went on to write some of Nordisk's 1910s masterpieces; his play *Revolutionsbryllup* was adapted to star Betty Nansen in 1915.[20] Michaëlis did not shy away from superlatives, describing Nansen in 1902 as an actress who "infused the Danish dramatic arts with something strong and new and radiant, something so festive that it has created a myth, something so strong that it has killed tradition."[21]

The writer described Nansen as a radical figure and as a part of a younger generation that broke with tradition and any nostalgia for the Golden Age of Danish theatre, which is personified by Michaëlis in the figure of Johanne Luise Heiberg (1812–90).[22] Heiberg was a star of Det kongelige Teater and she was notoriously against the emancipation of women. As Busk-Jensen asserts, Heiberg's ideas belonged to the Romantic generation that preceded the so-called Modern Breakthrough. This generation had a pointed lack of "interest for a possible sexual dimension in content."[23] Michaëlis saw Nansen as Heiberg's antithesis and regarded the modern Danish drama as necessarily feminist. Nansen, he explains, "created the woman of our time, rich and noble and liberated [. . .] With her, the female ideal in the Danish cultural landscape has shifted, like the art of the stage today."[24]

When dissecting Nansen's career up to his writing in 1902, Michaëlis concluded that she was only "half developed" when she played the glossy title roles in Victorien Sardou's *Dora* and Alexandre Dumas *fils*'s *Camille* (*Kameliadamen*) at the Casino between 1893 and 1896. In these performances, he argued, she was clearly talented and insightful but lacking the instrumentation to take on such formidable roles. At Det kongelige Teater she was part of the ensemble from 1896 to 1899 and not featured in any major roles but playing smaller parts safely and adding "simple and soulful harmonies" to her characters, like those in the "paintings of [Vilhelm] Hammershøj" – erased by the great distance between her and the audience. It was not until Nansen started at Dagmarteatret in 1899, Michaëlis goes on, that she was in an environment that allowed her rare abilities to mature. This context allowed "her art [to] amazingly unfold itself into full bloom."[25] Some of the roles she chose as a star actress included that of the titular prostitute-turned-entertainer *Zaza* in 1899 (Pierre Berton and Charles Simon, 1898); as well as her 1901 Tora in Bjørnstjerne Bjørnson's *Paul Lange og Tora Parsberg* (1898), a play about a real-life suicide of which the themes and characters "are pursued with immense power to a tragic end" (Figure 3.2).[26] In *Paul Lange og Tora Parsberg*, lead character Tora is in love with a kind-hearted but misguided progressive politician who ends up killing himself at the moment that she is about to declare her love for him and his cause. The role was described in the 1900s as being "representative of the courageous women who have grown tired of

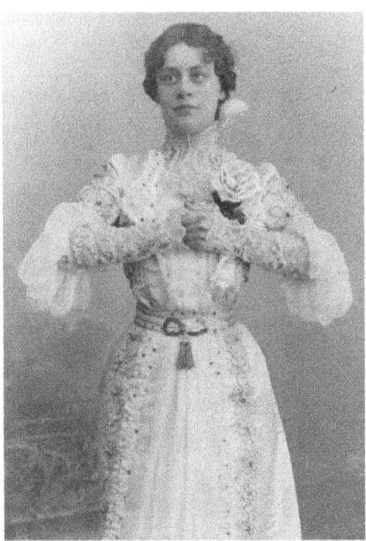

Figure 3.2 Betty Nansen as Tora in Bjørnstjerne Bjørnson's *Paul Lange og Tora Parsberg* (Dagmarteatret, 1901). Theatre Production Still (KB).

silent hopes and silent tears [. . .] a born fighter [who] loses because the man by her side is not brave and strong enough."[27]

In 1902, Nansen's professional success led to inquiries into her personal life and she was given the opportunity to create her own narrative in the aforementioned first issue of *Teatret*. Her real life mirrored – or was marketed to mirror – the modern women that she played on the stage and would go on to play in film, and this public relation strategy of making an actor's life "coincide" with their most popular roles would go on to be employed to great success in the film industry.[28] Nansen asserted herself as a modern woman through her close friendship with Sophus Michaëlis's wife, the feminist Karin Michaëlis. She was the author of the influential and bestselling *Den farlige Alder* (*The Dangerous Age*; 1910), in which the forty-two-year-old protagonist Elsie Lindtner chronicles her love life after her divorce. As stated by *The New York Times* (whose nuanced opinion it was that the book should be retitled *The Impenitent Confessions of a Perverted Soul*), the book's author becomes "the most talked-about woman in Europe."[29] Together, Michaëlis and Nansen wrote an epistolary novel on the love life of middle-aged women, entitled *Kvindehjerter* (*Women's Hearts*). *Kvindehjerter* celebrated female independence, and a woman's right to choose what she wanted to do was propagated for all matters of the heart.[30] The book was mirrored in real life by Karin Michaëlis divorcing her husband in 1911 and Betty Nansen divorcing hers in 1912.[31]

PROTEAN THESPIAN, NOVICE MANAGER

Teatret remained invested in Betty Nansen and continued to herald her as a luminary and a stand-in for the modern woman even as she became one of the *grandes dames* of Danish theatre. After Nansen was able to choose her roles at Dagmarteatret, another major step was assuming a joint actress-management position at the Folketeatret in 1903. At the Folketeatret she became co-director of the theatre at the age of thirty. The term "co-director" was used interchangeably with "manager" and the male star was her co-director/co-manager. From the information that is available, her male co-director seemed to be quite absent in the decision-making process. It was Nansen who selected the plays and the roles, and Nansen who decided how they would be performed. There remained a separate financial director of the theatre as well. Critics were respectful of Nansen's management, observing that it would be an injustice to claim that her first season co-directing the Folketeatret was without any artistic merit. It was possible that they were partially responding to the public pushback against having a woman at the helm, but at any rate it was clear that Nansen was responsible for some of the "richest performances" of the season. For example, she portrayed the undercover Russian nihilist and terrorist Helene in a stage adaptation of Richard Henry Savage's inflammatory 1891 novel *Nihilister* (*My Official Wife*, 1903). More importantly, Nansen's presence brought in new faces to complement the "old Folketeatret regulars."[32]

Nansen's management skills were seldom discussed by contemporaries. Critics instead focused on her performances. Nansen seems to have consistently chosen her roles in favor of progressive women. She famously played, for example, Cyprienne in Victorien Sardou and Émile de Najac's 1880 *Divorçons!* (*Lad os skilles, Let's Get Divorced*; 1906), a woman who divorces after falling for another man but wants to go back after she falls out of love with her paramour. Critics even claimed that Nansen was "cheating" by choosing this part, because she was better suited for the character than any other Danish actresses.[33] She embodied the part as the

> actress of our age [. . .] the beautiful woman of our time on the stage, in the same way that Ms [Johanne Luise] Heiberg aptly portrayed the saccharine cake-characters of Romanticism [. . .] For Sardou, *Let's Get Divorced* is a bad play, but Cyprienne can be performed as a contemporary person. And Betty Nansen *is* modern![34]

The few comments about her managerial skills were made after her tenure at Folketeatret, just prior to her becoming a feature performer at Det kongelige Teater from 1907 to 1910. Nansen's management at Folketeatret was seen by

some critics as ultimately too bold. The new direction that Nansen adopted yielded a new audience and was meant to prove that the theatre could keep up with progressive changes in the literary scene. This was accomplished, for example, by what critics perceived to be Nansen's novel interpretation of Marguerite Gautier in Dumas *fils*'s *Camille*, staged in 1903. Reviewers noted that the emotional changes that Nansen was able to project in Marguerite's disposition when she is forced to leave Armand were subtle, acted through Nansen's "soulful eyes." When at last Marguerite "gives in to the misery," Nansen did not go for the usual theatrical rattle of death, but acted it with "hesitation, affirmation, and flashes of hot and cold running through her body." Nansen's Marguerite died in bed and not, as Norwegian critics noted, standing up like Sarah Bernhardt does in Paris.[35]

Folketeatret was reprimanded for allowing Nansen to perform in so many roles and for spreading her too thin. Most likely, however, it was Nansen's own decision to both perform as much as she did and manage a theatre on top of that. At its core, critics did not see any change to Folketeatret, which returned to its "old ways and old audience" after Nansen left.[36] There must have been a broader discontent at Folketeatret, as Nansen's departure prompted a general exodus. Because of this, seasoned actor-manager Martinius Nielsen was scheduled to take over.[37]

Herman Bang – the Danish author, critic, and key intellectual of the Modern Breakthrough – also weighed in on Betty Nansen in 1910. As Hubert van den Berg points out, the tail end of the Modern Breakthrough overlapped with the writings of the historical avant-garde in the early twentieth century, and Bang remained an influential voice.[38] In his treatise on influential European actors, *Masker og Mennesker* (*People and Masks*; 1910), Herman Bang placed Betty Nansen on the same level as Austrian actress Charlotte Wolter, Sarah Bernhardt, Eleonora Duse, and Gabrielle Réjane. Bang emphasized Nansen's great adaptability and capacity for change and considered Nansen a mistress of reinvention. When Nansen took on co-managerial duties at Folketeatret, Bang concurred with other critics that her double duty as actress-manager started effacing her talents on the stage.

> Nansen became the theatre's manager. But Ms Nansen had a [rival]. As manager she relinquished her claim to being an actress, she stripped the management of its prima donna [...] she had to share her theatre with a prima donna [...] Betty Nansen herself. Perhaps she did not know it yet.[39]

In Bang's opinion, Nansen made a comeback by playing older characters more rooted in real life; or what he deemed "ugly" roles. These were important to Bang because they symbolized a veracity he had not seen performed by other actresses. Nansen exhibited an authenticity that brought modern

playwrights to life. Bang was particularly taken by Nansen's performance of the titular *Agnete*, Amalie Skram's 1893 play about a divorced woman who has an amoral compulsion for stealing. The Norwegian Amalie Skram was the most prominent female author of the Modern Breakthrough alongside the Finnish Minna Canth, and both were feminists who regarded women as essentially oppressed.[40] Herman Bang helped popularize modern feminist authors such as Amalie Skram, but he also realized that there was a generational rift between prominent actors. In the same treatise on influential European actors that Nansen is featured in, Bang speaks about Eleonora Duse as an example of an actress who did not, according to him, display any interest in these "new" female roles and could therefore not be considered a modern actress.

Bang, already writing retrospectively in 1910, might have foreseen that Nansen would reinvent herself at least two more times. First on film, and second by returning to stage management in a spectacular fashion. On 5 March 1910, Betty Nansen reprised her role of Tora in Bjørnstjerne Bjørnson's *Paul Lange og Tora Parsberg* (1898) at Det kongelige Teater. *Teatret* deemed Nansen's performance of the role at Dagmarteatret in 1901 so well known that little could be added at this point; indeed, it seemed stronger on the smaller stage.[41] If the play was not especially notable for its performance, it was for being Nansen's last stage role. For almost seven years she would go on to have a career on film and her performances were seen around the world.

The Polar Bear

The year 1910 was the year of the Danish feature film, spurred on by the success of Urban Gad's *Afgrunden* with Asta Nielsen. By 1910, theatre trade journals in Denmark had also entered into the European debate that raged on whether film was an art form, and how it stood up to the stage – as was discussed in more detail in chapter one.[42] Still a theatre monthly first, *Teatret* was prompted to include film by actors like Nansen moving between stage and screen. In its wake followed *Masken: Ugeblad for Teater, Koncert og Forlystelser* (*The Mask: Weekly for Theatre, Concerts, and Entertainment*), founded in 1910 as a theatre journal but more interdisciplinary than *Teatret*. Similarly, *Filmen*, which we discussed earlier, was founded in 1912 as the first trade journal for film in Denmark. These journals were important because they helped create an intermedial star system for actors who chose to combine stage and screen. A glance at *Teatret* in the 1910s reveals that almost all of Nordisk's screen actors and directors had been or were active on the stage, as exemplified in the previous chapter. As Kim Toft Hansen has demonstrated, the intermediality of this artistic milieu was such that it was the theatre journal *Teatret* that was

responsible for jumpstarting the "first Danish film debate," and not a film journal. *Teatret* did this by allowing luminaries to send in their thoughts on the medium of film.[43] Nansen's continued presence in these journals during her film career helped her transition back into theatre in 1916.

Theatre critics were generally respectful about the medium of film. For one of *Teatret*'s contributors in January 1912, the "silent theatre" of film could not yet be a form of art because it lacked a crucial ingredient: life. This referred to the lack of spoken dialogue and realistic color. Luckily for Nansen, her eyes were her most applauded instruments. Nansen also recognized that film's "silent theatre" could help her craft reach audience numbers that were unattainable on the stage. Films were supposedly also deemed too sensational in content for some opponents of the medium, but as one of *Teatret*'s film proponents stated: "if you want to put yourself above moving pictures, be sure to take into account the powerful influences the medium has already exerted on thousands of minds."[44] Nordisk's chief director August Blom concurred. He hinted that sensational films were needed to sell tickets and, in turn, produce more artistic content, quipping that "cinema is like the theatre, you can't pay your staff with ideals."[45]

According to Kela Kvam, Betty Nansen evaluated her career and made "persistent efforts to lay the groundwork" for world fame because of her impending divorce. Nansen recognized film and the subversion of language that its silence offered as a way to transcend the limits of the stage.[46] The exact details of her deal with Nordisk are unclear. From the roles and the branding on surviving Danish film programs – Nansen's name is featured in large letters on every page – it is clear that Nordisk must have afforded Nansen an unprecedented amount of creative control.

Her name was advertised internationally as early as 1911, as part of Nordisk's aggressive overseas promotion. Nansen's first film at Nordisk, *Prinsesse Elena* (Figure 3.3) was not released until two years after publicity had circulated in *The Moving Picture News*, so Nordisk did its best to build Nansen up in that period. Thorsen notes that Nordisk was no stranger to advance advertising. Additionally, Nansen is said by Thorsen to have shot all of her films with Nordisk before the outbreak of the First World War, when she had her contract voided for her move to Fox. Nansen thought that a move to the United States would be her best shot at international stardom, which turned out to be prophetic.[47] The two-page spread in *The Moving Picture News* touted *Some of the Celebrated Actors from the Denmark Theatres Who Have helped to Make the Great Northern Films Famous* and listed four actors and four actresses alongside their theatrical affiliations.[48] As noted earlier, Nansen's skill on the stage had already been reported in the United States as early as 1903. Even if Nansen was not appearing in Nordisk's films yet, dropping her name would

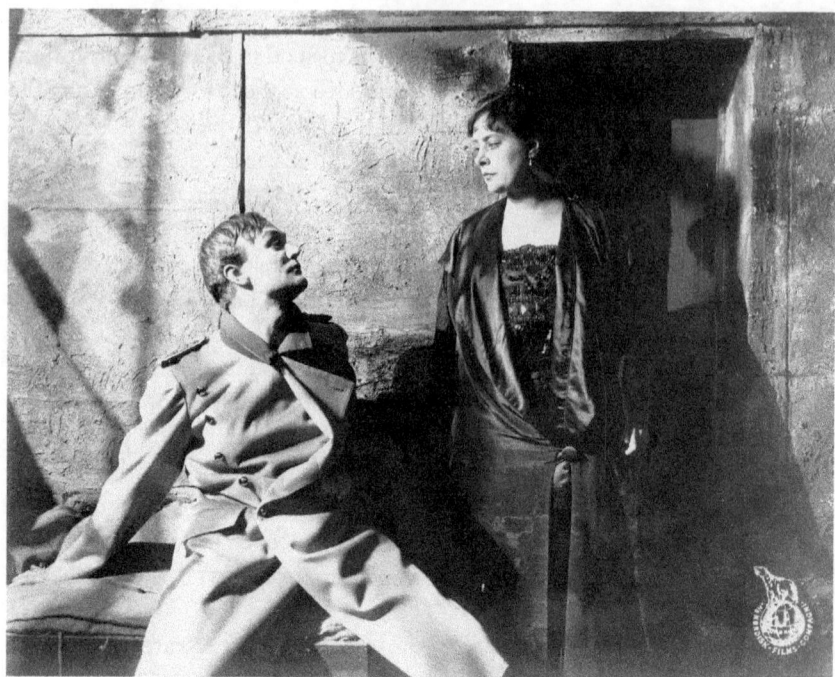

Figure 3.3 Betty Nansen as *Prinsesse Elena* (*Princess Elena's Prisoner*; Holger-Madsen, 1913, Nordisk Films Kompagni). Film Production Still (DFI).

likely assist in boosting attendance by stage-savvy audiences, and the general readership of *The New York Times*.

Nordisk's New York representative, Ingvald C. Oes, described the process of courting theatrical stars as one in which very quickly "almost the entire profession is available in Denmark for service at the moving picture studios."[49] The combination of an exponentially larger audience for artists with increased earnings must have influenced Nansen's decision to enter into the film business as well. This was in 1911, before most studios had implemented the idea of putting "famous players" in "famous plays." Furthermore, Nordisk would start crediting actors in their art films from 1909 onwards in their elaborate printed film programs.[50]

Betty Nansen's engagement in film saw her remain engaged to modern, feminist content. Indeed, it was the daughter of Amalie Skram – Johanne Skram-Knudsen – who was hired to write Nansen's *Prinsesse Elena*, which premiered in Copenhagen on 20 November 1913. By prompting Nordisk to hire Skram-Knudsen, Nansen set into motion a demand for modern female Danish writers in Scandinavia, preceded by the more prolific screenwriter Harriet Bloch. As Johanna Forsman and Kjell Sundstedt assert, the popularity

of Danish melodrama in Sweden also led the major Swedish players to hire female screenwriters out of Denmark.[51] Skram-Knudsen wrote screenplays for Victor Sjöström's *Gatans barn* (*Children of the Street*; 1914) and Mauritz Stiller's *När konstnärer älska* (*Artists in Love*; 1914).[52] Skram-Nudsen's husband, Poul Knudsen, was also a feminist and wrote the 1916 *Sønnen*. Other notable collaborations include feminist author Edith Rode writing the 1917 *En ensom Kvinde* for Nansen at Nordisk.[53]

Prinsesse Elena is the dramatic tale of a princess (Betty Nansen) who falls in love with a captive enemy officer and ultimately sacrifices her life for his freedom. The film afforded Nansen scenes in which she could fully explore a female character who was torn between familial and patriotic loyalty and love. As with many of her stage characters, Princess Elena is a sacrificial woman, and the film dramatizes her demise as a self-inflicted one. For critics at *The Motion Picture News*, Nansen was "a mental actress of the caliber of Mrs. [Minnie Maddern] Fiske." The film was also highly commended for its photography, which was "so true and at the same time so artistic," and the journal was sure that U.S. audiences would take well to Betty Nansen.[54]

The praise for the film's photography refers to the Rembrandt-like chiaroscuro style of lighting that was persistent across Nordisk's art films. *Prinsesse Elena*'s director, Holger-Madsen, and its cinematographer, Marius Clausen, were responsible for some of Nordisk's most pictorial scenes. In the final scene of the film, for example, which starts with a long shot of Elena entering her captured lover's prison cell, diegetic light streams in from the prison cell's high window. The light casts ominous shadows and bathes Nansen's entrance in darkness as her lover goes up to embrace her. When we cut in closer to a medium shot, the light illuminates her wide eyes as she carefully guides her imprisoned lover onto the bed and into the shadows, reversing roles. When he starts sobbing and turns away, Nansen very deliberately pulls a knife from her clothing and lays it down on the bed next to her. From her entrance, which displays an air of coldness and intensity in performance, the play of the light, and the revelation of the knife (Figure 3.4), a spectator might believe Nansen will kill her lover. Instead, she proposes a suicide pact so they can be together forever. Her lover would rather live and serve his country, however, and she realizes that he doesn't love her in the same way that she loves him. In the absence of a guard, she frees him and remains in the cell. Alone on the bed she gazes intently toward the camera, the light catching her face as her head tilts up slightly. She slowly uncovers her left arm and retrieves the knife, but the deed itself is cleverly hidden in a series of cuts to simultaneous actions. When we return to her cell she is already dying.

Unlike American studios in the 1910s, Nordisk invested less in close-ups, instead preferring to let scenes play out in medium or long shot, allowing the

Figure 3.4 Chiaroscuro in *Prinsesse Elena* (*Princess Elena's Prisoner*, Holger-Madsen, 1913, Nordisk Films Kompagni). Digital Film Grab (DFI).

actors to use their entire bodies. Nansen's emotive eyes are not diminished by this lack of close-ups. Sometimes they feel even more emphasized because of the relative stillness of the rest of her body. This aesthetic approach will be discussed further in the next two chapters.

In Denmark, Betty Nansen's films were immediately seen for what they really were: a package deal. This is a deal with an actor for a set number of films, with a clearly negotiated amount of creative control, and a fixed amount of revenue, all regardless of how the first film performs when it comes out. Nansen was afforded extraordinary creative control and the films were shot back-to-back to take up as little of her time as possible. She chose not only the content but presumably also the writers and supporting cast members. As such, these films were treated more as an oeuvre – or a series – than as individual films. Nansen moved to the United States in 1914 to work for Fox, so her Nordisk films must have been shot between 1910 and 1913.

Nansen remained topical in the theatrical press as well, and this continued coverage and focus on the minutiae of her craft – which had always been present in reviews of Nansen's stage work – helped keep her stage career alive. Nansen was, for instance, on the cover of *Teatret*'s August 1913 issue, in which she was profiled by Axel Garde. An author and *Teatret* regular, Garde

also wrote the film *Moderen* (1914) for Nansen. To Garde, artists like Duse, Bernhardt, and Nansen transcended the category of "theatre performers," because "the artists do not present us with theatrical characters, they present us with ourselves."[55] According to Garde, Nansen particularly captures the loneliness that we all experience in our modern lives on film by

> lifting her eyelids that seem so big and heavy because her eyes are so overwhelmingly teeming with life [. . .] You could take a cross-section of her roles and in all of them you would find that moment where she, without gestures or words, just with her face, with her smile, with the look in her eyes, would tell you everything about her character, would bring it to life.[56]

Garde was a typical Scandinavian critic of the day in that he could appreciate both stage and screen. He crossed media boundaries indiscriminately in his writings at *Teatret* and perhaps this also made him a true modernist. The journal *Filmen* was more pragmatic and simply labelled Betty Nansen "a new movie star." If it was too hard for sceptics to believe that there was yet again "a new star up in cinematic heaven," *Filmen* pointed out that it was not just anyone:

> This excellent actress has always had the ability to transform herself, so why wouldn't she also find her way around the film's technique? [Betty Nansen] is said to have contributed something new toward the new art [. . .] and it is true [. . .] we are all ready to believe that film is a big step closer to perfection.[57]

THE FOX

The first Scandinavian in film to be compared to Sarah Bernhardt was Asta Nielsen, often mistakenly labelled the "German Bernhardt."[58] It is more truthful, however, given her stage career, to promote Nansen as the "Bernhardt of Scandinavia" or the "Bernhardt of the North," as indeed she was.[59] There was a quick turnaround between Nansen's Nordisk series, released on the American market in 1913 and 1914, and her appointment at the Fox Film Corporation. This turnaround flooded American journals with Nansen news but meant that less attention was being paid to the films themselves. It was William Fox who had courted Nansen based on her stage acclaim and her Nordisk films, and it was he who announced that Fox's Nansen series would start in 1915. Fox heralded the Danish actress as "the greatest tragedienne in the world," the "inspiration of the immortal Ibsen," and the "idol of Northern Europe," and the event as the "first time in the history of pictures that a great European star was imported to appear in American-made film."[60]

Nansen's arrival was hyped for other reasons as well: she was a protégé of the then recently deceased Ibsen and had been willed manuscripts by him

that she was bringing with her to the United States.[61] Nansen was rumored to have been carrying forty-five trunks with over $50,000 worth of stage costumes, and the Danish Consul General had a Christmas tree erected in her honor.[62] Notables such as Columbia University's Professor of Dramatic Literature Brander Matthews and actress and suffragette Mary Shaw wanted to pay their respects to Ibsen through her.[63]

William Fox had been quite impressed by Nansen's roles in the big-budget Nordisk films that he saw and was hoping to hire his very own Bernhardt. He offered Nansen a salary of $25,000 per year and the chance to direct a film, or the type of money and agency that would appeal to an actress-manager who was already a star of the stage and the screen.[64] Reading this move as part of her self-proclaimed quest for world fame, it seems a logical next step. Unfortunately for Nansen, however, the deal would not lead to a Hollywood career, and as far as we know she did not get to direct a film, but this was due to reasons outside of her control. Her deal with Fox and the subsequent output seems to have been as minutely controlled by her as her Nordisk films, with roles written expressly for her, or at the very least selected by her. *The Celebrated Scandal* (J. Gordon Edwards and James Durkin, 1915), *Anna Karenina* (J. Gordon Edwards, 1915), *A Woman's Resurrection* (J. Gordon Edwards, 1915), *Should a Mother Tell?* (J. Gordon Edwards, 1915), and *The Song of Hate* (J. Gordon Edwards, 1915) were all well received, but they did not match up to the success of other films of the time, and all of Nansen's films for Fox are now considered lost.

The most notable competition in 1915 came from Fox itself. Theda Bara's performance as the vamp in *A Fool There Was* (Frank Powell, 1915) made Bara the studio's focal point over Nansen.[65] It is difficult to determine with certainty whether it was solely an unfortunate coincidence for Nansen that Theda Bara became an overnight sensation at Fox in 1915, and whether this reoriented their promotional department fully toward Bara, but it does appear that way. Nansen's films for Nordisk received far more coverage in American film journals than her American films would. A statistical comparison of American film journals between the coverage of Nansen's first film for Fox, *The Celebrated Scandal* (Figure 3.5), and Theda Bara's *A Fool There Was* reveals that the latter received no less than ten times more coverage.[66] Weighing Betty Nansen's path to stardom to that of Theda Bara is interesting and not dissimilar to a comparison between Betty Nansen and Asta Nielsen, revealing the instantaneous power of international moving picture fame. Asta Nielsen and Theda Bara did not have a career as actress-managers, and they certainly did not have the agency and cultural capital that Nansen had to wield in Denmark, first, and then in the United States. The difference in their trajectories demonstrates that aggressive advertising and a studio-built persona could

An Actress for Our Age: Betty Nansen, Modern Media Icon 93

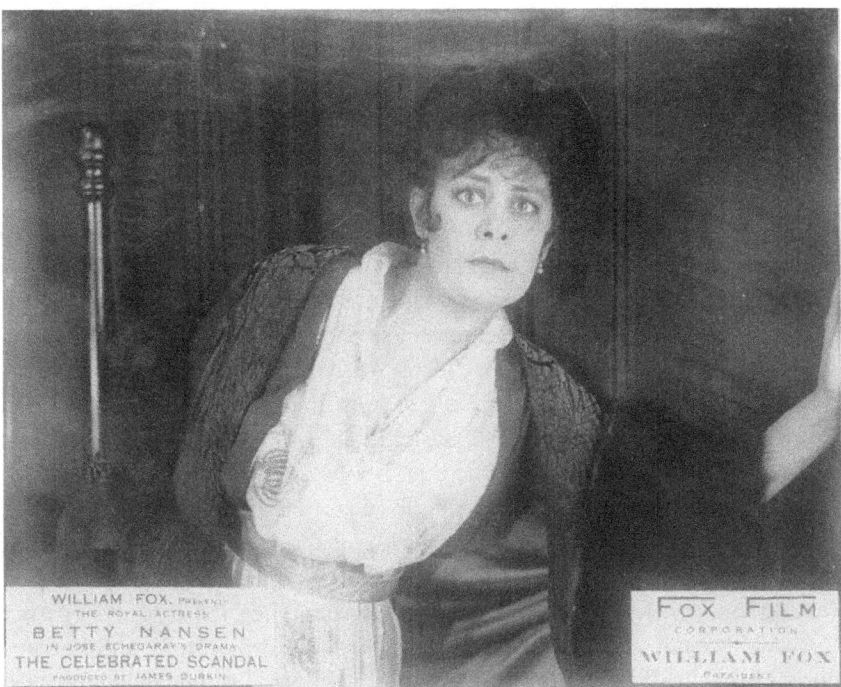

Figure 3.5 Betty Nansen in *The Celebrated Scandal* (J. Gordon Edwards and James Durkin, 1915, Fox). Film Production Still (KB).

guarantee overnight stardom. Born Theodosia Goodman, Bara muddled around on the New York stage as Theodosia de Coppet until Frank Powell transformed her name and image for the lead in *A Fool There Was*. This created what Richard Koszarski has called the "first great fabricated star" of the screen.[67] Bara's initial contract was for $75 per week, while Nansen was hired for close to $900 per week.

The discrepancy in media coverage hurt Nansen's films, which received almost no in-depth reviews when they came out. It is clear in hindsight that Nansen's deal at Fox was very similar to her deal at Nordisk. She would spend little time producing these films, since she arrived in New York in December 1914 and went back to Scandinavia in July 1915. She was paid royally and was offered maximum creative input, with the chance to direct (though she is not credited for it). It also looks she received her own production unit, since key Fox director J. Gordon Edwards helmed all of her films. We can assume that she was able to choose her own roles, since she appeared almost entirely as strong, independent, but deeply tragic women born from the imaginations of great modern authors. The femme fatale Teodora in the adaptation of Nobel Prize-winning author José Echegaray's *El gran Galeoto*

(1881), or *The Celebrated Scandal*; the tragic lead in an eponymous adaptation of Tolstoy's *Anna Karenina* (1877); the possibly even more tragic, murderous, and maltreated maid Katusha Maslova in Tolstoy's *Resurrection* (1899), retitled *A Woman's Resurrection*; and the assertive but unfortunate Floria Tosca in Victorien Sardou's *La Tosca* (1887), adapted expressly for Bernhardt and retitled *The Song of Hate*.

The only original story Nansen starred in was *Should a Mother Tell?*, commissioned from writer and future star director, Rex Ingram. It stars Nansen as Marie Baudin, another sacrificial woman. She is torn this time between the happiness of her teen daughter and saving the life of an innocent man, and the film is set against the backdrop of the French Revolution. *Should a Mother Tell?* is possibly the Nansen-Fox film that received most attention. Rex Ingram was singled out for his skillful copying of the "new" methods of French authors such as Eugène Sue, Émile Zola, Alexandre Dumas *père*, Eugène Scribe, and Victorien Sardou, for a story that never loses its "Gallic atmosphere" and reaches its climax "with all the mechanical perfection of [great French] plays."[68] Nansen "could not be improved upon" in a part that seems a perfect fit both for her personality and "the resources of her histronic [sic] art and amply emotional powers." Furthermore, and perhaps contradictory to what we consider to be "histrionic" acting today, Nansen seems to have successfully adapted to the nuances of film acting and the possibilities afforded by audiences clearly seeing her face, as she was especially commended for her "reserve powers and almost entire absence of gestures."[69] Local Fox ads play up Nansen's onscreen naturalism, inviting viewers to come and see "The Nansen Eye, The Nansen Tear, The Nansen Smile."[70]

Krefft notes that Nansen's demise at Fox might have something to do with the fact that she was not interested in promoting herself.[71] There was certainly not a lack of media coverage in general, however, because reporting on Nansen focused on the private as well as the personal: Nansen taking out insurance on her Ibsen manuscripts, wearing a supposedly solid golden gown, and mistakenly ending up in downtown Brooklyn one day.[72] Nansen told reporters she liked America very much and stayed at the Plaza Hotel in New York during production.[73] These stories were orchestrated, but Nansen was not the "it" girl that Theda Bara had become overnight. In Denmark, *Filmen* cast a critical eye on the amount of American praise that was heaped on Nansen, stating that while Nansen

> has already been recognised [in Scandinavia] as a really significant artist. But compared to the newest American additions to [Nansen's] artistic persona, one is almost reminded of the old adage: a prophet is not without honor except in his hometown.[74]

In May 1916, *Filmen* reported that Nansen was still producing films in the United States and giving "three interviews a day," but this seems inaccurate.[75] *The Motion Picture News* reported Nansen sailing to Copenhagen as early as 23 July 1915, to embark upon a theatrical tour of northern European countries that were not affected by the war.[76] This was confirmed by several film journal "oracles" who responded to people asking about Nansen's whereabouts and when they would see her in new films.[77] *Teatret*, too, noted in September 1916 that Betty Nansen was returning to Copenhagen and would be starring in a play written for her by author Sven Lange at the Alexandra theatre.[78] From the timing between Nansen's continued media coverage for her films and the Sven Lange play it appears that Nansen deliberately planned a grand return.

Nansen looked back at her time on film with mixed feelings in the trade journal *Filmen*: positive feelings about the medium, but negative ones about some of the personnel's motives. First and foremost, she expressed disgust for actors who "took the [film] fame and the money" and then refused to talk about their time in such a "lowbrow" medium, because she considered film to be one of the most powerful "disseminators of culture" of her time. Nansen was generally proud of all those actors in "whose footsteps she followed" and declared that she was "proud to admit that she admired them and learned from them." To act for the camera, Nansen quickly adapted. She shared her experiences openly, stating that she learned to activate her emotions at the right time, because it was impossible to "keep one's ears perked up" for the months that it takes to make a picture in America, the hours that you spend on costumes, and then still to be ready when they call "action" and you have "half a minute to demonstrate that your heart is filled with joy or with sorrow and distress!" Nansen was aware of film's potential and considered film acting a serious craft, since one film could reach more audience members than any play could. She thought film acting should challenge actors to demonstrate the full range of their emotions on the screen. But, she offered, if you "are one of those actors that is thinking about what to put on his sandwich for lunch while you roll your eyes in front of the camera, don't bother."[79]

BACK TO THE FUTURE: THE BETTY NANSEN THEATRE

The main focus of this chapter has been Betty Nansen's career between theatre and film, which has hopefully revealed Nansen to be an interdisciplinary actress, a powerful manager of her own career, and a key figure of the Modern Breakthrough. When Betty Nansen returned to Copenhagen from New York at age forty-two in 1915, she had enjoyed both a stage career that spanned almost twenty years and a film career that would play out over five years. She did not consider stopping either. In 1917, Nansen bought

a Copenhagen theatre and named it the Betty Nansen Teatret. She put in another twenty-six years as director, manager, and actress, until her death on 15 March 1943. The theatre was a place for Nansen to keep reinventing herself and the Scandinavian stage. Historians have even labeled Betty Nansen Teatret an avant-garde venture.

Before establishing her theatre, however, Nansen took to the stage in a new Sven Lange play, *Leonora Karoly*. This opened at Alexandrateatret on 10 November 1916. The films Nansen made for Nordisk and Fox were still being exhibited worldwide, so for many her return to the theatre came as a shock. "Now what?" *Teatret* asked itself on the last day of Nansen's run in *Leonora Karoly*, "will someone be able to keep Nansen home with the promise of a literary repertoire, an artistic ensemble, or other incentives? Or must Ms. Nansen be chased back into the desert of film?" The critic recalled the first night of the play's run, at which the otherwise courteous Danish audience was jittery. The perception was that Nansen's move to film in Denmark and the United States was an abandonment of theatre altogether. But "anger, unrest, or whatever it was," it came flooding out in a

> stormy, energetic applause for Ms. Nansen. She just needed to show them herself that [. . .] the lightning that was intended for her should go ahead and crash down and hit someone else. Apparently, the audience's lightning can only strike those that are not protected by talent [. . .] her talent was still there, glossy and radiant.[80]

But more importantly, the critic asked, "now what?" At the start of the 1917–18 season, the Betty Nansen Teatret opened its doors (Figure 3.6). Nansen bought the theatre for DKK 200,000, setting her own name above the entrance in the most powerful assertion of agency for an actress-manager, who was now also the owner and proprietor. Kvam called it a "primadonna theatre," since Nansen was its "absolute ruler;" she selected the repertoire, directed almost all plays, and took on most of the main female leads, often presenting ten productions in an eight-month season. Since it was a private theatre, it was her responsibility to keep it financially viable, running the theatre's administration on top of everything else she was doing.[81] In many ways it was a logical move for the ever ambitious Nansen.

As *Teatret* put it, "Ms. Nansen will now rule and try to win back her past audience." It took more than her first performance, however, which was an adaptation of Gaston Arman de Caillavet and Robert de Flers's 1907 comedy *L'Éventail* (*The Fan, Viften*). *Teatret*'s reaction seemed to be railing more against Nansen's newfound cultural capital than begrudging her performance. They saw not the Betty Nansen that they knew, who had once played Tora Parsberg and Agnete, but "a lady with brilliant diamonds on

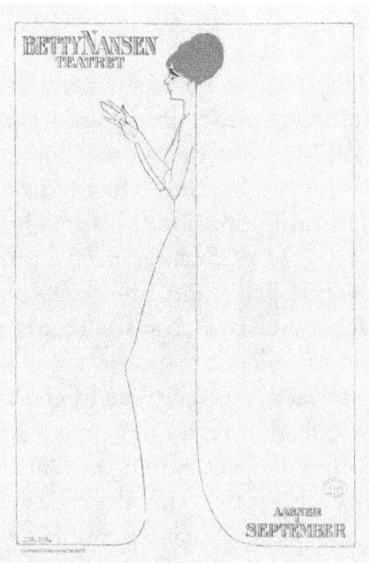

Figure 3.6 Betty Nansen Teatret aabner i September (*The Betty Nansen Theatre Opens in September*, 1917). Theatre Poster (KB).

her gold bag" as opposed to the soul of that character.[82] Their chief critic hoped to see Nansen "cut deeper" soon, and it did not take long for her to deliver. Nansen's repertoire became a combination of her own classic performances that she kept reinventing, such as Amalie Skram's *Agnete* and Ibsen's *Hedda Gabler*, and venturing into uncharted territory by bringing plays such as Maurice Maeterlinck's surreal *Le Bourgmestre de Stilmonde* (1919) in the year that it was published. The decision to stage a play with such innovative sensibilities was clear evidence of Nansen's vision to keep her theatre modern and progressive. The Maeterlinck play portrays the atrocities of German occupation in Belgium during the First World War, so staging it in a country that had generally remained on close terms with Germany was something Nansen would have carefully considered.

Both the continuous reinvention of her trademark roles as well as her more cutting-edge new work were favorably received. For instance, when Ibsen's Hedda had become a vamp in the 1920s, Nansen was praised for her 1924 production in which she showed that "the mask of the temptress might well conceal [. . .] a poor woman whose aberrations are due to her spiritual impoverishment and loneliness."[83] Almost a decade later, Betty Nansen's 1932 production and direction of Kaj Munk's *Ordet* (*The Word*, 1925) in her "avant-garde playhouse [. . .] did much to secure Munk's position as this period's most incendiary new dramatist."[84] Munk's *Ordet* has now become

synonymous with post-war modernism in cinema, through Carl Theodor Dreyer's eponymous 1955 adaptation.[85]

As Kvam notes, Betty Nansen quickly transformed her theatre into the "Little Temple of Art." Kvam reads three distinct phases of management into her time there: 1917–25 saw the theatre dominated by Scandinavian drama, doubling down on the big three, Ibsen, Strindberg, and Bjørnson; the 1928 staging of German Expressionist playwright Ernst Toller's *Hoppla, wir Leben!* (*Hoppla, Such is Life!* 1925) announced a phase marked by socially conscious and controversial plays; and from 1939 until her death in 1943, occupied by German forces, the Betty Nansen Teatret staged pacifist plays by Scandinavian authors.[86]

Betty Nansen transformed and reinvented herself many times over the course of her interdisciplinary career. She remained the post-Ibsen female and feminist on stage. In retrospect, turning to film after a rich stage career and a place at Det kongelige Teater seems a very deliberate move on the part of Nansen. It allowed her to remain in control of her career, experiment with a new medium, and provided her with a salary that could not be matched on the stage. When she returned to Copenhagen after her tenure at Fox in New York, she was intent on achieving total artistic and financial control. She invested her screen dividends in a unique venture that only someone like Sarah Bernhardt had achieved in France, the creation of a theatre in her own name. It was a private theatre, so the state would not have had any stake in it. As author Hans Brix put it in his obituary written in the prominent Danish newspaper *Berlingske Aftenavis*,

> She was the captain, and the ship was hers [. . .] They were not going to take that braided cap away from her, and she was allowed to wear it till the end.[87]

NOTES

All translations are the author's.

1. Kela Kvam, *Betty Nansen: Masken og Mennesket* (Copenhagen: Gyldendal, 1997), 269–71.
2. Anon, "Transatlantic Topics," *The New York Times* 53, 16,793 (1 November 1903), 24.
3. This was especially true of German and Swedish talent. Graham Petrie, *Hollywood Destinies: European Directors in America, 1922–1931* (Detroit: Wayne State University Press, 2002).
4. Kia Afra, *The Hollywood Trust: Trade Associations and the Rise of the Studio System* (Lanham: Rowman & Littlefield, 2016), 67.
5. Anon., "Critical Eyes," *The Moving Picture World* 19, 7 (14 February 1914), 845.

6. Maria Helleberg, *Kvinden der forandrede Danmark* (Copenhagen: Lindhardt og Ringhof, 2015), 261.
7. Mary Hilson, "Denmark, Norway, and Sweden," in Timothy Baycroft and Mark Hewitson (eds.), *What is a Nation? Europe 1789–1914* (Oxford and New York: Oxford University Press, 2006), 194.
8. Leonardo Lisi, "Scandinavia," in Pericles Lewis (ed.), *The Cambridge Companion to European Modernism* (Cambridge and New York: Cambridge University Press, 2011), 193.
9. Lisi, "Scandinavia," 194.
10. The premiere part is mistakenly attributed to Betty Nansen in Kristin Ørjasæter, "Mother, wife and role model: A contextual perspective on feminism in *A Doll's House*," *Ibsen Studies* 5, 1 (2005), 30.
11. Narve Fulsås and Tore Rem, *Ibsen, Scandinavia and the Making of a World Drama* (Cambridge and New York: Cambridge University Press, 2018), 117.
12. Herzog sees "Nora's sisters" in Ibsen's own Hedvig in *The Wild Duck* (*Vildanden*, 1884), and *Hedda Gabler* (1891); August Strindberg's *Miss Julie* (*Fröken Julie*, 1888), and Laura in *The Father* (*Fadren*, 1887); George Bernard Shaw's *Candida* (1898); and (of course) Eugene O'Neill's *Anna Christie* (1921). Callie Jeanne Herzog, *Nora's Sisters: Female Characters in the Plays of Ibsen, Strindberg, Shaw, and O'Neill* (Urbana: University of Illinois at Urbana-Champaign, 1982), 208. PhD dissertation.
13. Linda Haverty Rugg, "A Tradition of Torturing Women," in Mette Hjort and Ursula Lindqvist (eds.), *A Companion to Nordic Cinema* (Chichester: John Wiley & Sons, 2016), 352.
14. Kvam, *Betty Nansen*, 269.
15. Frederick J. Marker and Lise-Lone Marker, *A History of Scandinavian Theatre* (Cambridge and New York: Cambridge University Press, 1996), 96.
16. Running from 1901 until 1931, *Teatret: Illustreret Maanedsskrift for Teater og Skuespilkunst* became *the* journal for theatre and film in the silent era, as it overlapped with the start and development of film production in Denmark.
17. Otto Borchsenius, "Fru Hennings i Berlin," *Teatret: Illustreret Maanedsskrift for Teater og Skuespilkunst* 1 (1901–2), 29–31; and Otto Borchsenius, "Betty Hennings," *Teatret: Illustreret Maanedsskrift for Teater og Skuespilkunst* 1 (1901–2), 75–80.
18. Thomas P. Krag, "Ibsen-Fortolkning paa Scenen," *Teatret: Illustreret Maanedsskrift for Teater og Skuespilkunst* 1 (1901–2), 56–9.
19. The preoccupation with Det kongelige Teater can be seen in *Teatret*'s reviews, as for instance in the four-page review of its 1902 staging of *Hedda Gabler* (Henrik Ibsen, 1891). Johannes V. Jensen, "Teaterindtryk fra Januar 1902: Hedda Gabler," *Teatret: Illustreret Maanedsskrift for Teater og Skuespilkunst* 1 (1901–2), 60–3.
20. In addition to the multiple adaptations of Sophus Michaëlis's play *A Revolutionary Wedding*, Michaëlis also co-wrote a number of Nordisk films that preached pacifism and democracy as solutions to war and revolution. These are: *Peace on*

Earth (*Pax æterna*; Holger-Madsen, 1917), *A Trip to Mars* (*Himmelskibet*; 1918), and *A Friend of the People* (*Folkets Ven*; Holger-Madsen, 1918).
21. Sophus Michaëlis, "Betty Nansen," *Teatret: Illustreret Maanedsskrift for Teater og Skuespilkunst* 1 (1901–2), 33.
22. Michaëlis, "Betty Nansen," 33.
23. Lise Busk-Jensen, "Heiberg's View of Female Authors," in Jon Stewart (ed.), *Johan Ludvig Heiberg: Philosopher, Littérateur, Dramaturge, and Political Thinker* (Copenhagen: Museum Tusculaneum Press, 2008), 471.
24. Michaëlis, "Betty Nansen," 33.
25. Michaëlis, "Betty Nansen," 35.
26. Brian W. Downs, *Modern Norwegian Literature 1860–1918* (Cambridge and New York: Cambridge University Press, 2010), 36.
27. Bernard Stahl, "Björnson and his Woman Types," *The Independent* 68, 3,205 (5 May 1910), 968–9.
28. Betty Nansen, "Et Teaterbarn (Indtryk fra de yngste Aar)," *Teatret: Illustreret Maanedsskrift for Teater og Skuespilkunst* 1 (1901–2), 40.
29. Anon., "Laying Bare a Woman's Soul: 'The Dangerous Age,' Europe's Literary Sensation, Has Been Translated into English," *The New York Times* 60, 19,580 (3 September 1911), 530.
30. Karin Michaëlis and Betty Nansen, *Kvindehjerter* (Copenhagen: Gyldendal, 1910). At the time, Betty Nansen's husband Peter Nansen was an influential editor at the Gyldendal publishing house, which was the most important in Denmark.
31. Nansen married the actor Henrik Bentzon, who was twenty years her junior, after her divorced husband died in 1918. Birgit S. Nielsen, *Karin Michaëlis: En europæisk humanist* (Copenhagen: Museum Tusculaneum Press, 2004), 28.
32. Albert Gnudtzmann, "Teaterindtryk fra Maj 1904," *Teatret: Illustreret Maanedsskrift for Teater og Skuespilkunst* 3 (1903–4), 97.
33. Harald Raage, "Betty Nansen," *Teatret: Illustreret Maanedsskrift for Teater og Skuespilkunst* 5 (1905–6), 106.
34. Harald Raage, "Betty Nansen," 108–10.
35. L.B., "Theaterbrev fra Kjøbenhavn," *Urd* 7, 2 (10 January 1903), 20.
36. Jonathan, "Fra Galleriet," *Det ny Aarhundrede* 2, 2 (April–October 1905), 226.
37. Martinius Nielsen went on to direct more than 15 feature films for Nordisk between 1914 and 1923 and, like Nansen, was a personal friend to Henrik Ibsen. Georg Bröchur, "My Memoirs of Henrik Ibsen," *The Mask* 14, 1 (January–March 1928), 8.
38. Herman Bang and Georg Brandes's writings can, for instance, be found in the early volumes of the influential art journal *Der Sturm*. Hubert van den Berg, "The Early Twentieth Century Avant-Garde and the Nordic Countries: An Introductory Tour d'Horizon," in Hubert van den Berg et al. (eds.), *A Cultural History of the Avant-Garde in the Nordic Countries 1900–1925* (Amsterdam and New York: Rodopi, 2012), 48.
39. Herman Bang, *Masker og Mennesker* (Copenhagen and Oslo: Nordisk Forlag, 1910), 199.

40. Jan Sjåvik, *Historical Dictionary of Scandinavian Literature and Theater* (Lanham: The Scarecrow Press, 2006), 66–7.
41. Carl Behrens, "Gammelt og nyt," *Teatret: Illustreret Maanedsskrift for Teater og Skuespilkunst* 9 (1909–10), 92.
42. For national responses on the question of film as art, see especially: Richard Abel, *French Film Theory and Criticism: a History/Anthology 1907–1939* (Princeton: Princeton University Press, 1988); Anton Kaes, Nicholas Baer, and Michael Cowan (eds.), *The Promise of Cinema: German Film Theory 1907–1933* (Oakland: University of California Press, 2016); and Francesco Casetti, Silvio Alovisio, and Luca Mazzei (eds.), *Early Film Theories in Italy, 1896–1922* (Amsterdam: Amsterdam University Press, 2017).
43. Kim Toft Hansen, "Taming the Cowboy: Early Danish Film Theory, 1910–1940," *Historical Journal of Film, Radio, and Television* 36, 2 (2016), 159.
44. Sven Lauw, "Den Stumme Kunst," *Teatret: Illustreret Maanedsskrift for Teater og Skuespilkunst* 11, 7 (January 1912), 55.
45. August Blom, "Instruktør ved Nordisk Films Co., August Blom," *Teatret: Illustreret Maanedsskrift for Teater og Skuespilkunst* 11, 7 (January 1912), 56.
46. Kela Kvam, "Betty Nansen. A Unique Figure in Danish Theatre," *Nordic Theatre Studies Yearbook* 1 (1988), 72.
47. Isak Thorsen, *Nordisk Films Kompagni 1906–1924: The Rise and Fall of the Polar Bear* (New Barnet: John Libbey Publishing, 2017), 125 and 128.
48. Anon., "Some of the Celebrated Actors from the Denmark Theatres Who Have Helped to Make the Great Northern Films Famous," *The Moving Picture News* 4, 38 (23 September 1911), 12–13.
49. Anon., "Interesting Facts from Abroad, Gleaned from an Interview with Mr. I.C. Oes, Manager of The Great Northern," *The Moving Picture News* 4, 38 (23 September 1911), 11.
50. Vito Adriaensens, "'Kunst og Kino': The Art of Early Danish Drama," *Kosmorama* 259 (2015).
51. Johanna Forsman and Kjell Sundstedt, "Sweden," in Jill Nelmes and Jule Selbo (eds.), *Women Screenwriters: An International Guide* (London: Palgrave Macmillan, 2015), 551.
52. Lars Åhlander, *Svensk filmografi 1: 1897–1919* (Stockholm: Swedish Film Institute, 1977), 247–9.
53. Edith Rode's work was fraught with the tension between what men expected of women and what women needed for themselves, and at a later age Rode was one of the first to chronicle Danish women's history. Kristine Anderson, "Edith Rode," in Katharina M. Wilson and Paul and June Schlueter (eds.), *Women Writers of Great Britain and Europe: An Encyclopedia* (London and New York: Routledge, 2013), 393.
54. T.B., "Princess Elena's Prisoner," *The Motion Picture News* 8, 23 (13 December 1913), 43. Minnie Maddern was one of the most important actors of the early twentieth century, evolved into an actress-manager, and became known for popularizing Ibsen in the United States. Julie Holledge, Jonathan Bollen, Frode

Helland, and Joanna Tompkins, *A Global Doll's House: Ibsen and Distant Visions* (London: Palgrave Macmillan, 2016), 39.
55. Axel Garde, "Betty Nansen," *Teatret: Illustreret Maanedsskrift for Teater og Skuespilkunst* 12, 19 (August 1913), 146.
56. Axel Garde, "Betty Nansen," 147–8. First part of quote until [. . .] from p. 147.
57. Anon., "En ny filmsstjerne," *Filmen* 1, 22 (1 September 1913), 288.
58. Nielsen was probably mistakenly labelled the "German Bernhardt" because she made almost all of her films in Germany. E.g. Anon., "Miss Asta Nielsen," *The Moving Picture News* 5, 13 (30 March 1912), 52.
59. Respectively in Anon., "New Great Northern Favorite," *The Moving Picture News* 8, 11 (13 September 1913), 15; and Ingvald C. Oes, "The Exclusive Program," *The Motion Picture News* 8, 16 (25 October 1913), 35.
60. Anon., "William Fox Announces," *Moving Picture World* 22, 13 (26 December 1914), 1868–9.
61. Anon., "Notes Written on the Screen," *The New York Times* 64, 20,784 (20 December 1914), 8.
62. News of the trunks came from Anon, "Betty Nansen to Pose for Fox Pictures Here," *The Motion Picture News* 10, 25 (26 December 1914), 28; the honorary Christmas tree was reported in Anon., "Danish Actress Arrives," *The New York Times* 64, 20,791 (27 December 1914), 13.
63. Anon., "Betty Nansen Coming to America," *Moving Picture World* 23, 1 (2 January 1915), 79.
64. Vanda Krefft, *The Man Who Made the Movies: The Meteoric Rise and Tragic Fall of William Fox* (New York: Harper Collins, 2017), 132.
65. Gaylyn Studlar, "Theda Bara: Orientalism, Sexual Anarchy, and the Jewish Star," in Jennifer M. Bean (ed.), *Flickers of Desire: Movie Stars of the 1910s* (New Brunswick and London: Rutgers University Press, 2011), 114.
66. Statistical comparison achieved via the Media History Digital Library's Project Arclight (search.projectarclight.org) with the search terms "the celebrated scandal" versus "a fool there was." Project Arclight allows for a graphical comparison of terms across the Media History Digital Library's c. two-million-page collection.
67. Richard Koszarski, *An Evening's Entertainment: The Age of the Silent Feature Picture, 1915–1928* (Berkeley and London: University of California Press, 1994), 274.
68. Edward Weitzel, "Should a Mother Tell?," *Moving Picture World* 25, 3 (17 July 1915), 506.
69. Edward Weitzel, "Should a Mother Tell?," 507.
70. Anon., "The Regent Theatre – Fountain and Hamilton Streets," *The Allentown Morning Call* 50, 120 (20 May 1915), 10.
71. Krefft, *The Man Who Made the Movies*, 139.
72. Respectively in Anon., "Brevities of the Business," *Motography* 13, 2 (9 January 1915), 63; Anon., "Betty Nansen's Golden Gown," *Motography* 13, 3 (16 January 1915), 96; and Anon., "How Betty Nansen Went to Brooklyn," *The New York Times* 64, 20,805 (10 January 1915), 7.

73. Anon., "Betty Nansen Likes America," *Moving Picture World* 23, 3 (16 January 1915), 377.
74. The "old adage" is a biblical reference, repeated throughout the New Testament, for instance in Mark 6:4, Luke 4:24, and Matthew 13:57. Anon., "Fru Nansen i Amerika," *Filmen* 3, 11 (15 March 1915), 98.
75. Anon., "Betty Nansen," *Filmen* 4, 14 (1 May 1916), 128.
76. Anon., "Betty Nansen Sails for Home," *The Motion Picture News* 12, 3 (24 July 1915), 63.
77. E.g. in Anon., "The Picture Oracle: Questions and Answers about the Screen," *Picture-Play Magazine* 5, 2 (October 1916), 306. The "picture oracle" prophesied that there might still be a chance of Nansen returning to America; but a few months later in Anon., "The Picture Oracle: Questions and Answers about the Screen," *Picture-Play Magazine* 5, 5 (January 1917), 306, the same oracle was less careful and confirmed that Nansen sailed back to Denmark after her stint at Fox.
78. Anon., "Alexandra Teatret," *Teatret: Illustreret Maanedsskrift for Teater og Skuespilkunst* 15, 20 (September 1916), 158.
79. Betty Nansen, "Fru Nansen udtaler sig," *Filmen* 5, 23 (15 September 1917), 255.
80. Haagen Falkenfleth, "Det gærer og syder –," *Teatret: Illustreret Maanedsskrift for Teater og Skuespilkunst* 16, 5 (December 1916), 34.
81. Kvam, "Betty Nansen. A Unique Figure in Danish Theatre," 72–3.
82. Anon., "Betty Nansen Teatret," *Teatret: Illustreret Maanedsskrift for Teater og Skuespilkunst* 17, 1 (October 1917), 6. *L'Éventail* was a thinly veiled play on Oscar Wilde's *Lady Windermere's Fan, A Play About a Good Woman* (1892), tackling the subject of alleged infidelity with intrigue set in motion by a mere misplaced fan.
83. Frederick J. Marker and Lise-Lone Marker, *Ibsen's Lively Art: A Performance Study of the Major Plays* (Cambridge and New York: Cambridge University Press, 2005), 172.
84. Marker and Marker, *A History of Scandinavian Theatre*, 263.
85. Dreyer saw the play when it was performed at the Betty Nansen Teatret in 1932 and immediately contacted Munk to buy the rights, but Munk wanted more for it than the Betty Nansen Teatret had cost in its entirety, so Dreyer waited. Jan Wahl, *Carl Theodor Dreyer and Ordet: My Summer with the Danish Filmmaker* (Lexington: The University Press of Kentucky, 2012), 13.
86. Kvam, "Betty Nansen. A Unique Figure in Danish Theatre," 72–4.
87. Kvam, "Betty Nansen. A Unique Figure in Danish Theatre," 78 (from Betty Nansen's obituary by Hans Brix in *Berlingske Aftenavis*).

CHAPTER FOUR

In Another Light: Academic Painting, Pictorial Photography, Bourgeois Cinema

This chapter will discuss the common ground that exists between nineteenth- and early-twentieth-century academic painting, pictorial photography, and early European cinema. It suggests a continuation of a certain style, or a set of visual strategies, from the former through to the latter, and it examines the apparent persistence of the popular over the new. As the following chapter's case study on Victor Sjöström's 1922 *Vem dömer* (*Mortal Clay* / *Love's Crucible*) will demonstrate, these strategies were still very much in place in the early 1920s, but first we build on the preceding analyses of the European art film and its corresponding evolution, starting from the shift that took place around 1910–11. This is when the multi-reel film fast gained ground, historical settings made way for more contemporary fare, and the proliferation of the art film had strongly diluted its meaning. This made it hard to distinguish between "regular" dramatic fiction films and "art" films. These films opted to present the middle-class audiences that they had been courting since 1906–8 with enticing mirror images, reflecting not only the values, but also the visual style that these audiences were most familiar with.

I believe that this shift can best be described as a melodramatic amplification of daily life that doubled as a form of "social realism." We can recognize the same narrative and visual shift in the nineteenth-century revival of genre painting. This form of figurative and socially realist academic art was quickly, but lastingly, considered regressive kitsch in art historical circles when retroactively compared to the onset of the avant-garde from the end of the nineteenth century onwards, with styles such as Impressionism, Symbolism, Expressionism, and Cubism taking hold. The art of the academies and the salons was very popular with the middle classes, however, and it took until after the First World War for modernist art to catch on in a bigger way. Art historian Aleksa Čelebonović has aptly dissected this academic style as "Bourgeois Realism."[1] I borrow this term to demonstrate that dramatic European feature films strongly echoed the work of academic painters such as Jean Béraud (1849–1935), Solomon Joseph Solomon (1860–1927), Wilhelm Bendz (1804–32), and John Henry Frederick Bacon (1868–1914), among others, in their preoccupation with middle-class subject matter; their intense

narrativity in the staging of key moments; their shared motifs; and what we have come to know in film studies as "pictorial" lighting.

The painterly magic that reproduced the dramatic effects of light and shadow was picked up by another mechanical medium before it found its way into cinema, namely the fledgling practice of photography. "Pictorialism" became the umbrella name for the late nineteenth-century movement that strove to legitimize the medium of photography as an art form by associating heavily with the principles and aesthetics of painting, hence its name. It was the main mode of artistic discourse in photography into the twentieth century and it was exemplified by the writings of Henry Peach Robinson (1830–1901), Peter Henry Emerson (1856–1936), Robert Demachy (1859–1936), and Alfred Stieglitz (1864–1946), among many others.[2] This chapter will draw a parallel between the struggle for artistic recognition in photography and cinema, both of which I argue turned to popular artistic motifs, compositions, and strategies from nineteenth-century academic painting. In this manner, the term "pictorial" and its application in early cinema will be grounded art historically by drawing a line from painting to photography to cinema, and I will closely analyze how key art historical concepts such as Bourgeois Realism and Pictorialism defined the main artistic and discursive mode of the dramatic European feature film in the 1910s and early 1920s, arguing for the inherent intermediality of art historical concepts and motifs.

A Tableau Aesthetic

In his 1911 editorial "Le Triomphe du Cinématographe," or "the triumph of the cinema," *Ciné-Journal*'s Georges Dureau noted that larger cities in France had become the main exhibition venues for cinema because it had "won over the elegant people of urban France."[3] Dureau was explicitly talking about the contrary Parisians, who in his view would logically oppose what the rest of France had long come to accept as fact, namely that cinema was the "real deal" and here to stay. Not anymore by 1911, Dureau believed, and as we know it is around this date that the middle-class subject matter of dramatic films rose exponentially. In Denmark, this subject matter was most represented on the silver screen with 32 per cent in 1910, counted next to films dealing with the upper class, the lower class, and class conflicts, before skyrocketing to a whopping 60 per cent in 1911, and remaining more or less constant between 50 and 60 per cent up to 1914.[4] The French context does not appear to have been much different in this respect, since we have seen that Gaumont set a new course after audiences complained that their initially serious "*scènes de la vie*" were boring and contained dull characters, causing Gaumont to resort to popular dramatic fare set in middle-class households.

This shift in content did not mean, however, that Gaumont sacrificed its artistic mise-en-scène. European production companies had started developing a unique visual strategy that was well under way around 1910–11, which is referred to by David Bordwell as a "tableau aesthetic." This intricate, long-take aesthetic was an intelligent interplay of visual depth, lighting, and staging performance, which often yielded spectacular effects in both interior and exterior shots. "Tableau" stands for "picture" in the painterly sense, referring to the mostly static frame in which the events unfurled in European cinema. Bordwell considers the action playing out in a "single orienting view" in Europe to be a viable alternative to the much more editing-oriented American cinema, where actions would be more quickly broken up in a continuity of different shots.[5] "Tableau" can also refer to "tableaux vivants," or "living pictures," a stage form with a long history that was immensely popular at the end of the nineteenth century and saw solo artists or troupes recreating statues and paintings on the stage, bronzing and whitewashing themselves and holding static poses for extended periods of time. More generally, as well, "tableaux vivants" have come to signify moments on stage or on the screen in which the action is frozen at important narrative or emotional moments for dramatic effect.

Analyzing Gaumont's Louis Feuillade as a fine example of what could be achieved by employing a mise-en-scène-based style that worked *with* and *within* the frame rather than deconstructing it, Bordwell saw brilliant examples of intelligent staging in European cinema but puts his problem-solution model at work by asking himself the question of what European filmmakers sought to gain by playing down editing? Echoing Charlie Keil, perhaps, Bordwell sees Feuillade's generation as an intermediary between cinema pioneers such as Georges Méliès and Auguste and Louis Lumière and a newer generation of filmmakers who took to the American style such as Abel Gance, Marcel L'Herbier, Lev Kuleshov, and Carl Theodor Dreyer (in some of his work). With this idea in mind, however, "playing down" editing doesn't seem correctly worded. Rather, it seems that European directors of Feuillade's generation lingered more strongly on the possibilities of what could be done within the frame, taking this a step further than their predecessors' flat sets and clothesline staging to explore the photographic and optical possibilities of the medium. Relating this tactic to a production context, Bordwell argues that,

> [Feuillade's] pressurized production routines seem to have favored a technique far more straightforward than that developed by his contemporaries; he is, we might say, the Howard Hawks of the 1910s, exploiting current conventions of staging with an almost diagrammatic sobriety. His straight lines, uniform illumination, and sparsely decorated sets make his assured choreography of bodies in space all the more vivid.[6]

At the same time, Bordwell concedes that directors are concerned with directing the viewer's attention, giving them cues as to important narrative information. Given that Bordwell and others recognize the intricacy with which European directors played out visual cues in the frame by way of looks, gestures, positions, lighting, depth, plays between fore- and background, and so on, one would not be inclined to call this strategy "more straightforward" than that of the cues provided by editing. As Bordwell himself indicates, "in Feuillade's day it was not enough to direct the spectator's eye; one had to do so gracefully. Directors were expected to display a skill in pictorial composition – not least in order to help raise the cultural prestige of the cinema."[7] Both a mise-en-scène- and an editing-based approach were, furthermore, operational within this pressurized production context, but it was standardized and optimized sooner in Europe than it was in America.

The main production mode for Nordisk, as it must have been for many studios in this period, involved shooting a number of L-shaped sets at an angle. This way, two sides were covered, and depth was created through the bent of the L. We can deduce this from Nordisk president Ole Olsen's description and photo of the Valby studio practice in his autobiography (Figure 4.1).[8] In a 1913 piece in contemporary Danish theatre journal *Masken* on Asta Nielsen and Urban Gad's "arbejdsvilkaar og gager," or "working conditions and salaries," during their Berlin adventure, a photograph indicates that they used the same L-set studio approach (Figure 4.2).[9] These sets were characteristically dressed up in a bourgeois interior of the time, with "*portières*," or door curtains that served as entrances, exits, and markers of screen depth. These *portières* were all the rage in nineteenth- and early-twentieth-century home decoration.

Figure 4.1 L-shaped set at Nordisk's Valby studio c. 1912 from Ole Olsen, *Filmens Eventyr og Mit Eget (Film's Adventure and My Own*; Copenhagen: Jespersen & Pios Verlag, 1940), 128b.

Figure 4.2 Asta Nielsen and Urban Gad's Berlin Studio c. 1913 from Paul Sarauw, "Levende billeder. Danske instruktører i Berlin. Arbejdsvilkaar og Gager." *Masken* 3, 32 (11 May 1913), 210 (DFI).

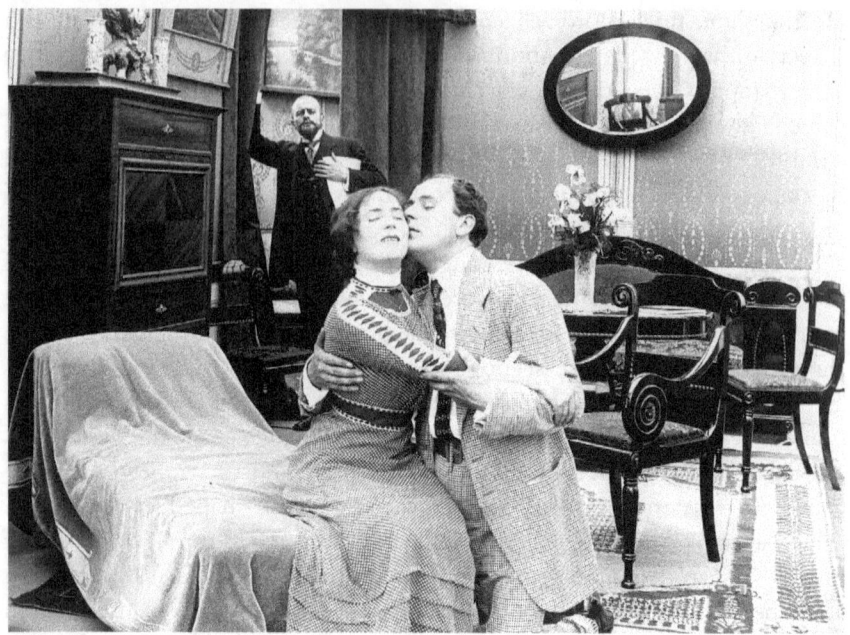

Figure 4.3 *Onkel og Nevø* (*Uncle and Nephew*; August Blom, 1912, Nordisk Films Kompagni). Film Production Still (DFI).

At Nordisk, these depth markers were part and parcel of the company aesthetic, which often hinged strongly on the interplay between fore- and background, perhaps to the point where it must have looked like a puppet-show game for audiences, spurring them on to yell: "watch out, your other suitor is behind you!" This can be seen in August Blom's 1912 *Onkel og Nevø*, for instance (Figure 4.3), starring theatrical greats Adam Poulsen, Clara Wieth (Pontoppidan), and Valdemar Psilander. Notice also the presence of the ubiquitous mirror here, doubling part of the playing field. Mirrors often act as important visual cues in early European cinema. Since this was a time when film companies still churned out films at an unbelievable pace, their sets were almost always recycled. This can lead to confusing situations when cross-cutting between different homes with very similar interiors, or when watching multiple Nordisk films in one sitting, and it also demonstrates the eminence of certain props made by the prop department (Figure 4.4).[10] One unidentified painting is particularly worn out in Nordisk's oeuvre (Figure 4.5 – right above the head of the male protagonist).

Writing about the achievements of Nordisk, Bordwell adds on to this by stating that the "international 'theatrical' style of the 1910s was far more complex than many historians allowed. As an aesthetic system it was based

In Another Light: Academic Painting, Pictorial Photography, Bourgeois Cinema 109

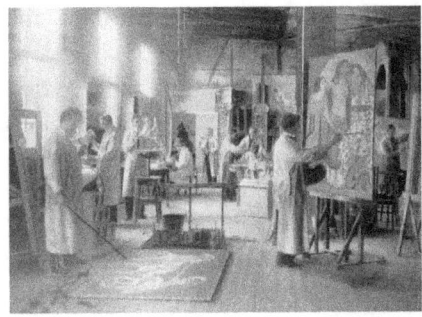

Figure 4.4 Nordisk's prop department at Valby c. 1908–12 from Ole Olsen, *Filmens Eventyr og Mit Eget* (*Film's Adventure and My Own*; Copenhagen: Jespersen & Pios Verlag, 1940), 88b.

Figure 4.5 Vigorously reused prop painting in *En Lektion* (*The Aviator and the Journalist's Wife*; August Blom, 1911, Nordisk Films Kompagni). Film Production Still (DFI).

on the idea of the shot as a rich totality."[11] Here again, Bordwell expertly vivisects the aesthetic at play via a rich descriptive analysis. Of particular interest to scholars of this period seems to be the year 1913, to which several special issues have been devoted.[12] The year 1913 feels like a breakthrough for European cinema, with a plethora of interesting films coming out, such as *L'Enfant de Paris* (*The Child of Paris* – France; Léonce Perret), *Ingeborg Holm* (Sweden; Victor Sjöström), *Atlantis* (Denmark; August Blom), *Sumerki zhenskoi dushi* (*Twilight of a Woman's Soul* – Russia; Yevgeni Bauer), *Ma l'amor mio non muore* (*Love Everlasting* – Italy; Mario Caserini), *Der Student von Prag* (*The Student of Prague* – Germany; Stellan Rye) as well as the *Fantômas* series (France; Louis Feuillade). Scholars such as David Bordwell, Casper Tybjerg, Yuri Tsivian, and Ben Brewster and Lea Jacobs have already elaborately described the functional staging of the tableau aesthetic. Brewster and Jacobs additionally provide a valuable theatrical framework in which we can better understand the workings of this style.[13] I will trace its origins and influences in light of a broader cultural context that encompasses several image-based media. An important part of that context, as well as of cinema's shift to bourgeois melodrama, was an emphasis on realism.

BOURGEOIS REALISM

Cinema "is not yet an art," the previously discussed Ricciotto Canudo argued, "because it lacks the freedom of choice peculiar to plastic interpretation, conditioned as it is to being the copy of a subject, the condition that prevents photography from becoming an art."[14] Much like the nineteenth- and early-twentieth-century critical view of photography, the medium of cinema had a

hard time getting away from the paradox of realism: cinema was too real and therefore not real enough. It suffered from what was perceived to be the same flaw as photography. It merely copied and registered reality via a mechanical device, the camera, and could therefore not be regarded as a form of art. As was part and parcel of the art film strategy, the forces behind the medium reacted by emphasizing how much film was like other arts, and appropriated their narrative and visual strategies. Towards the end of the 1910s, and especially in the 1920s, however, filmmakers took these objections to heart and invested in optical and editing techniques that were purely cinematic, or medium specific. Erika Balsom sees this idea of an artistic synthesis of reality on a spectrum from high to low definition. She posits that writers such as Canudo actually argued that cinema would be

> elevated to the status of art by foregoing the ability to automatically produce a high-definition image and instead employing filmic techniques that will lower definition, weaken the iconic likeness to the referent, and emphasize departures from physical reality.[15]

When one looks at cinema's "sister arts," one recognizes that both theatre and painting had been subject to a push for realist strategies since the 1840s. Theatre treaded into Naturalism – and sometimes hyperrealism – at the fin de siècle. This was due to the impact of the epic realistic spectacles presented by the European touring company of Georg II, the Duke of Saxe-Meiningen (1826–1914), between 1874 and 1890. The direction also owed a debt to directors such as the French André Antoine (1858–1943) and Broadway's David Belasco (1853–1931), who was insistent on replicating life's most minute details down to cooking real dishes on stage.[16] Nineteenth-century painting saw a revival of the popular seventeenth-century "genre painting," or realistic depictions of domesticity and everyday life. This was spurred on by a renewed interest in Flemish-Dutch masters such as Rembrandt and focused on the rising new middle-class artistic patrons of the bourgeoisie.[17] The popular success of genre painting in the academies, at the salons, and in people's homes led to an adaptation in photography as well, with photographers carefully recreating the artifice and aesthetics that painters adopted to record quotidian life.[18]

Art historian Petra ten-Doesschate Chu states that "Realism" in nineteenth-century European painting was simply "artistic engagement with the ordinary, contemporary life," out of which a multitude of different realist schools and artists grew.[19] It is important here that we identify the artistic mainstream and recognize its popularity throughout the early twentieth century, in spite of today's vehement focus on avant-garde art movements such as Impressionism and Expressionism. This bias towards modernism is one that

theatre historians seem to share. Philip Hook and Mark Poltimore argue that the emergence of a new middle-class patronage – "the class of people who had money and the inclination to spend it on pictures" – demanded a new type of painting for which the market was quite large, since European tastes were remarkably uniform; William Thackeray described these pictures in 1843 as dealing with "subjects far less exalted; a gentle sentiment, an agreeable, quiet incident, a tea-table tragedy, or a bread-and-butter idyll," as opposed to the glorified mythological heroism of the Romantics.[20]

This was genre painting. Scenes preoccupied with the depiction of trivial everyday occurrences in what French critic Barbier also called the "vaudeville of High Art," diverse enough in their interpretation to create subcategories of pictures solely featuring children, animals, nudes, historical events, fairy tales, or orientalist exotica.[21] The realist aspect of genre painting thus lay largely in its choice of subject matter, and also in the "truthful" depiction thereof. Following Ruskin, "truthful" referred to painting things "as they probably did look and happen, and not as by rules of art," while others saw it as eschewing the colorful and emotional excesses of romanticism. Hook and Poltimore rightly point out that the "romantic" did often manifest itself in the "manipulation of subject matter to elicit maximum emotional response," since artists were keen on getting "the best of both worlds" by marrying the two approaches.[22]

Genre painting went by several other monikers, such as "petit genre," and was – and still is – also pejoratively referred to as "kitsch" or "art pompier."[23] It is often mentioned in the same breath as academic painting or salon painting. The most appropriate appellation is perhaps that given by art historian Aleksa Čelebonović, who opted to designate these nineteenth-century slices of life "Bourgeois Realism." Dating from the 1970s, Čelebonović's work preceded many of those focusing on nineteenth-century genre painting, as the output of these artists was deemed substandard for a long time. He situates Bourgeois Realism from c. 1860 up until the period of the First World War and accounts for its unpopularity aesthetically, stating that

> even at its best moments, Bourgeois Realism looks like retrogression in relation to the schools which immediately preceded it: Neoclassicism, Romanticism, [. . .] Courbet's realism in its early stages [. . .], Impressionism [and] indeed the work of Cézanne or Van Gogh.[24]

This polarizing view is in accordance with ideas spread by influential theorists such as Clement Greenberg, who pitted the avant-garde against an artistic rear-guard, or *"arrière-garde."* Greenberg believed this rear-guard to be made up of popular commercial artworks that were mechanical variations on the same theme, "debased and academicized simulacra of genuine culture [. . .]

mechanical and operate[d] by formulas."²⁵ Greenberg's ideas were originally published in 1939 and echo Walter Benjamin's 1936 *The Work of Art in the Age of Mechanical Reproduction*. Both authors were not only engaging with the historical avant-garde aesthetically, but were also propagating a Marxist reading of popular art – i.e. formulaic and (mechanically) reproducible – as consumerist fare that was more easily susceptible to politicization, not to be reductive of the richness of Benjamin's work. Political context or not, however, Greenberg's adage "all kitsch is academic; and conversely, all that's academic is kitsch" contributed to the already widespread misconception of academicism.²⁶ Firstly, an actual definition for the term was nonexistent, so that its vagueness pervaded in its attribution to very different artists. Secondly, as art historian Paul Barlow notes, it very quickly became an obstinate cliché for twentieth-century commentators to use the term as a yardstick synonymous with "bad" or "anti-art" from the nineteenth century, "associated with the mechanization of culture and the repressive authority of social institutions" against which the avant-garde "heroically" rebelled.²⁷

These institutions were the national art academies, both public and private, from where the term was derived. L'Académie des Beaux-Arts in Paris dates back to the mid-seventeenth century and was one of the most influential and prestigious in Europe, even boasting an Italian subsidiary entitled L'Académie de France à Rome.²⁸ Fourteen of the academy's forty chairs were devoted to painting, and some of its most famous nineteenth-century members included Pierre-Paul Prud'hon (1758–1823), Jean-Auguste-Dominique Ingres (1780–1867), Eugène Delacroix (1798–1863), Alexandre Cabanel (1823–89), Jean-Léon Gérôme (1824–1904), and William-Adolphe Bouguereau (1825–1905).²⁹ In the seventeenth century, l'Académie started organizing exhibitions of their artists, which were dubbed the "Salons" after the "*salon carré*," or "square lounge," hall in the Louvre where the works were put on display. The synonymous discursive relationship between "salon painting" and "academic art" is therefore understandable. As art historian Norbert Wolf rightly indicates, however, this did not have to be the case, since the Salons proliferated and evolved into judged competitions with an international scope quite quickly, accepting works from artists who were not necessarily attached to academic institutions.³⁰ What's more, there were also the infamous, but equally official, Salons des Refusés from 1863 onwards, organized by artists whose work did not fit into the mould of the official salons.

L'Académie des Beaux-Arts was followed in importance by other European institutions such as the Royal Academy of Arts, or R.A., in London. The R.A. was modeled after its French precursor and boasted artists such as J.M.W. Turner (1775–1851), David Wilkie (1785–1841), Dutch-born Lawrence Alma-Tadema (1836–1912), Augustus Leopold Egg (1816–63),

William Powell Frith (1819–1909), John Everett Millais (1829–96), and American John Singer Sargent (1856–1925).[31] Then there was Die Akademie der Bildenden Künste in Munich, home to the late-nineteenth-century Münchner Schule or "Munich School," with representatives like Carl Theodor von Piloty (1826–86), Wilhelm von Diez (1839–1907), Eduard Kurzbauer (1840–79), Hans Makart (1840–84), Gabriel von Max (1840–1915), and later also key members of the German avant-garde such as Wassily Kandinsky (1866–1944) and Paul Klee (1879–1940).[32] This was followed by schools such as Det Kongelige Danske Kunstakademi in Copenhagen.[33] The nineteenth century was Danish painting's Golden Age, with artists such as Christoffer Wilhelm Eckersberg (1783–1853), who studied extensively in Paris and Rome, as one did. Rome also became home base to influential Danish sculptor Bertel Thorvaldsen (1770–1844). These grand artists' reputations turned Copenhagen into one of Europe's art centers, alongside the likes of Wilhelm Bendz, Constantin Hansen (1804–1880), Christen Købke (1810–48), Wilhelm Marstrand (1810–73), and Julius Exner (1825–1910).[34]

One can tell by looking at the range of artists represented that the members of the academies were by no means a homogeneous group. It must be noted that the many academies, and especially the most influential ones, did in fact teach according to a systematic set of rules and traditions. They had the power to dictate popular taste through the commodification of works presented at the Salons. Cardoso Denis and Trodd note that it was this idea of "art as a system" rather than "art as a process" that was critiqued by avant-garde proponents as the epitome of bourgeois taste, but that academicism should be considered "more of a loose network of similar institutions and procedures all drawing upon a common tradition than a unified system based upon a single model or answering to a central authority."[35]

In light of such problematic terminology, Čelebonović's decision to choose "Bourgeois Realism" seems quite apt. It plays on the art historical resurgence of genre painting in a new and ever-expanding context of middle-class patrons without implying an institutional alliance per se, although in most cases a synonymous use was certainly justifiable. One thing that was not up for debate was the popularity of this type of genre painting at the time, and Čelebonović notes

> it is not difficult to understand why [Bourgeois Realism] was so highly appreciated by the people of the time, for it provided them with a clearly recognizable picture of themselves. [. . .] [Bourgeois Realism was] the most precise reflection of middle-class society at the very height of its prosperity.[36]

At the 1878 world exposition, Naturalist Émile Zola said that these genre scenes were devoid of any artistic value and provided mere entertainment

for the French bourgeoisie, but while one can concede that the latter is at least partly true, there is no reason why "artistic" should stand opposed to "popular."[37] This opposition is a poignant one, since it is still always at the forefront of discussions surrounding both art and cinema.

Stylistically, Čelebonović sees Bourgeois Realism as an amalgam of Neoclassicism, Romanticism, and photography that remained faithful to "a workmanlike attention to detail [. . .] directed more to the cognitive than to the sensory faculties of the spectator." The nineteenth-century spectator, he argues, was primarily interested in the subject and wanted artistic skill to serve a concisely told story rich with symbolic moral value "based on a narrative content worthy of the novelists of the day."[38] Čelebonović points out that the fairly simple compositions of the style contrast with the complex dramatic narrativity of the scenes, and cites Ilya Repin's (1840–1930) *They Had Given up Waiting for Him* (aka *They Did Not Expect Him*, c. 1884–8; Figure 4.6) as an example of such a loaded picture – one also discussed compositionally by David Bordwell with regard to the European tableau aesthetic.[39] Repin's work is part of a series that comments upon a very specific social and political context – that of exile and homecoming in Tsarist Russia – but at the same time manages to transcend those national

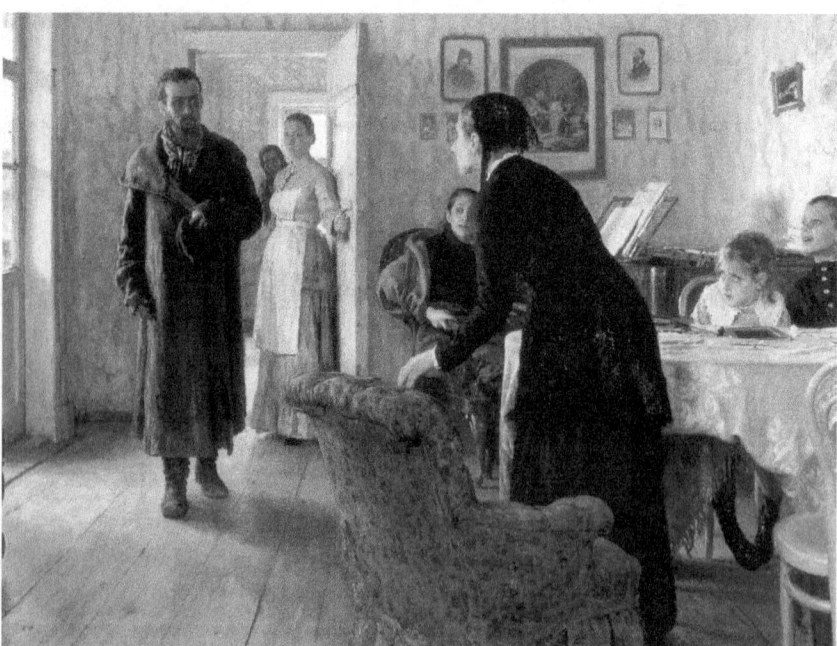

Figure 4.6 *They Had Given up Waiting for Him* (*They Did Not Expect Him*, Ilya Repin, c. 1884–8). Painting, oil on canvas. State Tretyakov Gallery, Moscow (WC).

boundaries to express a particular narrative and emotion in a style that was widely prevalent.

Consider also John Henry Frederick Bacon's 1889 *Never more to hear that silent voice, Her smile to meet no more* (Figure 4.7), with its grief-stricken protagonist fading from the window's cast light into the dark shadows – or his 1898 *The Ring*, with its soon-to-be-wed melancholy woman by the window; Jean Béraud's 1880 *A Parisian Ball* (Figure 4.8), with its multitude of middle-class conversational moments staggered in depth through lighting and diagonal angle; and Wilhelm Bendz's 1832 *Artists in Finck's Coffee House in Munich* (Figure 4.9), with its stark clair-obscur, or chiaroscuro, ambiance, and attention to detail. Immediately apparent in these depictions is their staged narrativity in a middle-class environment, their use of a prominent foreground with different planes of action to create diagonal depth and divide up the frame, and the presence of "natural" (i.e. naturally motivated) and "source" (i.e. emanating from an apparently visible source) lighting. One continues to see echoes of this approach in later "modernist" work, for instance in the oeuvres of the Dane Vilhelm Hammershøi (who studied at the Danish Academy) and the American Edward Hopper (who was taught at the New York School of Art and Design).

The use of diegetic light in these works creates different patches of emphasis in the frame, sets a certain mood, and is part and parcel of art-historical motifs such as the woman-at-the-window and the dramatic use of clair-obscur. All of the above equally holds true for theatrical and cinematic production stills in the early twentieth century, which were meant to display key narrative moments in a dramatic but decodable fashion. Furthermore, these compositions also strongly echo their aforementioned seventeenth-century Dutch genre counterparts, most famously represented by Johannes Vermeer (1632–75) and Rembrandt van Rijn (c. 1606–69), who similarly traded on decodable realism with a strong narrative bent.

Rembrandt, Vermeer, and their successors achieved this by creating a depth-infused tension between fore- and background, by employing "natural" lighting patterns and chiaroscuro, and by subdividing the canvas, often via frames within the frame. This is how they constructed intricately narrative works that allowed for multiple readings and could be quite immersive and engaging to viewers. As Hollander has noted, artists such as Vermeer, de Hooch, Rembrandt, and Nicolaes Maes "ingeniously manipulated the space within their pictures" by creating different areas for their figures to inhabit; these scenes-within-scenes were introduced by devices such as "archways, open doors, pulled-back curtains [. . .] or appear within the frames of mirrors and pictures on walls." This "entrance for the eyes," as Hollander has called it, became a formula by the middle of the seventeenth

116 *Velvet Curtains and Gilded Frames*

Figure 4.7 *Never more to hear that silent voice, Her smile to meet no more* (John Henry Frederick Bacon, 1889). Painting, oil on canvas. Private Collection (WC).

Figure 4.8 *A Parisian Ball* (*Scène de Bal*; Jean Béraud, 1880). Painting, oil on canvas. Jean-François Heim Gallery, Basel (HG).

Figure 4.9 *Artists in Finck's Coffee House in Munich* (*Kunstnere i Fincks Kaffehus i München*; Wilhelm Bendz, 1832). Painting, oil on canvas. Thorvaldsen Museum, Copenhagen (WC).

century. This formula relied heavily on the use of perspective, depth, and aperture framing in interiors, and also integrated religious allegories into secular spaces.[40]

Telling examples include Pieter de Hooch's (1629–84) *Woman Lacing Her Bodice Beside a Cradle* (c. 1661–3) (Figure 4.10), the lighting of which eerily draws a little girl to the door in Poltergeist fashion *avant la lettre*. Jan Steen's (1626–79) *Easy Come, Easy Go* (c. 1661) (Figure 4.11) boasts a very deep background and four simultaneous actions. And Rembrandt's exquisite *Old Man in an Interior with Winding Staircase* (c. 1632) (Figure 4.12) is the epitome of (single) source-lit chiaroscuro with its intelligently chosen arching subdivision of the frame. Lene Bøgh Rønberg studied the correspondences between seventeenth-century Dutch genre painting and nineteenth-century Danish genre painting and noted that critics invoked the terms "genre painting" and "Netherlandish images" to describe the "new" wave of artistic realism in the nineteenth century. She also demonstrates the two eras' shared representational strategies in the depiction of everyday bourgeois home life and its underlying implication of moral values.[41]

Researching the shared aesthetic parameters and motifs between Bourgeois Realism in painting and cinema, one is immediately struck by the similarities in the portrayal of social and family life, most notably in interior scenes. In the case of the type of films we are discussing, these interior studio scenes often made up most of the films. The scenes were mostly staged in long take and long shot, with different planes of action playing out at the same time, utilizing the optical depth, interior elements such as *portières*, and lighting, to subdivide the screen and apply varying kinds of focus for the viewer's eyes. The result was a frame packed full of narrative and aesthetic information, very much like its pictorial counterparts.

Compare, for instance, Solomon Joseph Solomon's 1884 *A Conversation Piece* (Figure 4.13) with production stills from August Blom's 1911 *Den hvide Slavehandels sidste Offer* (*The White Slave Trade's Last Victim* or *In The Hands of Impostors no.2*) (Figure 4.14) and *Den farlige Alder* (*The Dangerous Age* or *The Price of Beauty*; August Blom, 1911) (Figure 4.15). In *A Conversation Piece*, Solomon provides the audience with a drawing room setting of a casual affair in which a couple is foregrounded to highlight their intimate relationship, while the background is occupied with two to three more planes of action: a woman, possibly the mistress of the house, playing piano; an older man, possibly the master of the house, leaning on a table where a servant is seated and looking at the piano playing; and another servant, this could be on the same plane but possibly also one deeper into the frame, who seems to be lighting the lamp. We can see that the spatial set-up is the same as in the production stills from both *Den hvide Slavehandels sidste Offer* and *Den farlige Alder*, with

Figure 4.10 Woman Lacing Her Bodice Beside a Cradle (*Interieur met vrouw zittend naast een wieg*; Pieter de Hooch, c. 1661–3). Painting, oil on canvas. Gemäldegalerie, Berlin (WC).

Figure 4.11 Easy Come, Easy Go (*Soo gewonne, soo verteert*; Jan Steen, c. 1661). Painting, oil on canvas. Museum Boijmans van Beuningen, Rotterdam (WC).

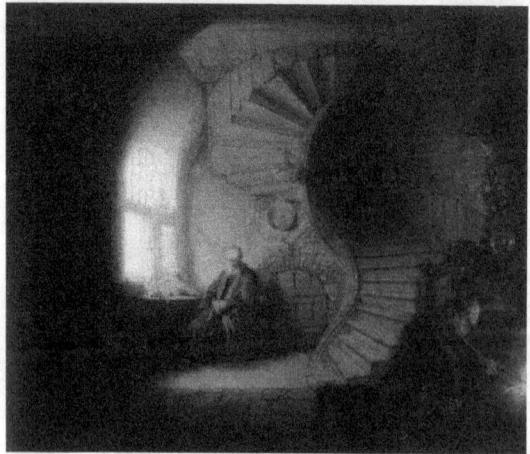

Figure 4.12 Old Man in an Interior with Winding Staircase (*Mediterende filosoof*; Rembrandt, c. 1632). Painting, oil on canvas. The Louvre, Paris (WC).

In Another Light: Academic Painting, Pictorial Photography, Bourgeois Cinema 119

Figure 4.13 A Conversation Piece (Solomon Joseph Solomon, 1884). Painting, oil on canvas. Leighton House Museum, London (WC).

Figure 4.14 Den hvide Slavehandels sidste Offer (*In The Hands of Impostors no. 2*; August Blom, 1911, Nordisk Films Kompagni). Film Production Still (DFI).

Figure 4.15 Den farlige Alder (*The Price of Beauty*; August Blom, 1911, Nordisk Films Kompagni). Film Production Still (DFI)

the prominent foreground taken at a slightly canted instead of frontal angle to create diagonal depth and interplay with the other planes of action. This set-up was a mainstay of the bourgeois realist European cinema of the 1910s, quickly evolving into more elaborately staged and lit forms.

The impressive depth of field and detail that was allowed in European films of the 1910s was made possible not just by the study of the "old masters." It was further made possible by the advances in artificial lighting and the international switch to panchromatic film stock. As Charles O'Brien notes, this stock was sensitive to "yellow, green, and ultramarine portions of the light spectrum, rather than to blue alone," yielding a "detailed, sculpted image noticeably superior to ordinary black-and-white."[42] The stock allowed cinematographers to register more gradations between highlights and shadows, which, as Patrick Keating asserts, "can produce a more compelling impression of depth."[43] Generally speaking, this approach stands in contrast to what is known as the 1920s "soft style" of cinematography, in which lens and light diffusion produce a much softer and more unfocused image.[44] When we tie this in with Balsom's understanding of artfulness in cinema, we can say that these techniques lowered the definition of the image to emphasize the departure from reality and increase the level of artistic and medium-specific synthesis.[45]

As production stills, 4.14 and 4.15 represent important narrative moments frozen at the height of a certain dramatic action – tableaux vivants if you will. They do not represent the flow of action from one situation and one positioning to another. In still 4.14 from *Den hvide Slavehandels sidste Offer*, main character Edith von Felsen (Clara Wieth) has no clue yet that she has been duped by a gang of human traffickers. She is being seduced on the foreground by the count, who wants to own her. Another interested customer, known as Mr. Bright (Otto Lagoni), the solitary mustachioed man background left, sternly looks on. The other two prominent figures on the foreground left seem to be engaged in a secretive conversation, and are, in fact, part of the gang of human traffickers masquerading as friends of Edith's aunt. Notice also the curtained door in the background, that aforementioned staple of early European cinema that served to create depth in the frame and was often utilized for important background action and aperture framing. More examples of this abound at Nordisk, as can be evidenced from Figure 2.8 and the following production stills from twelve films made between 1910 and 1914 (Figures 4.16–4.27).

In Another Light: Academic Painting, Pictorial Photography, Bourgeois Cinema 121

Figure 4.16 *Diamantbedrageren* (*The Diamond Swindler*; Unknown, 1910, Nordisk Films Kompagni). Film Production Still (DFI).

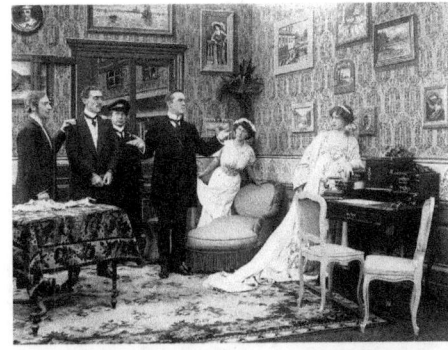

Figure 4.17 *Gadeoriginalen* (*A Dream with a Lesson*; August Blom, 1911, Nordisk Films Kompagni). Film Production Still (DFI).

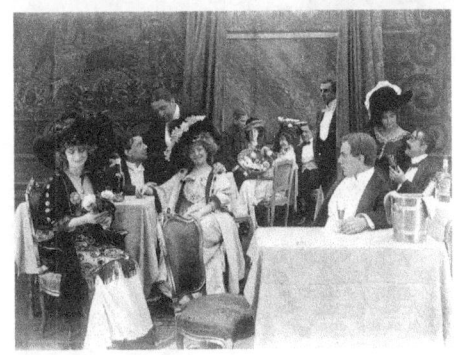

Figure 4.18 *Sønnen fra Rullekælderen* (*The Adopted Son*; Unknown, 1911, Nordisk Films Kompagni). Film Production Still (DFI).

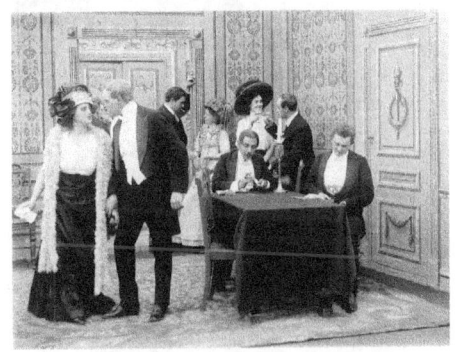

Figure 4.19 *Det bødes der for* (*Love and Money*; August Blom, 1911, Nordisk Films Kompagni). Film Production Still (DFI).

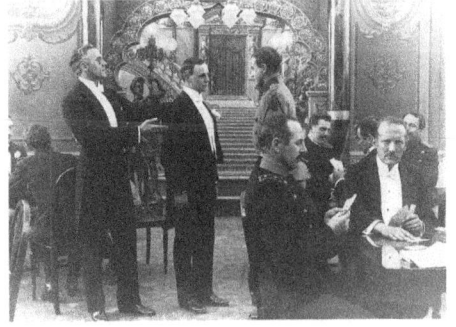

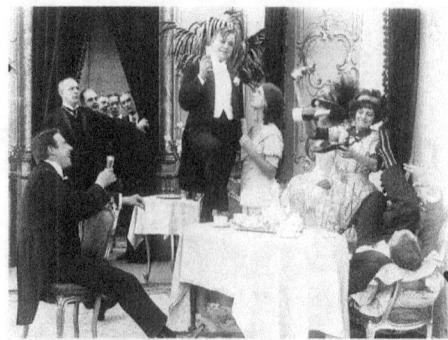

Figure 4.20 *Kærlighedens Styrke* (*The Power of Love*; August Blom, 1911, Nordisk Films Kompagni). Film Production Still (DFI).

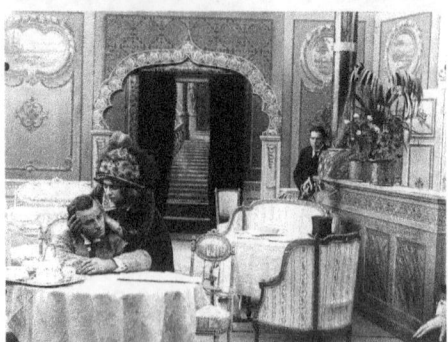

Figure 4.21 *Dyrekøbt Glimmer* (*When Passion Blinds Honesty*; Urban Gad, 1911, Nordisk Films Kompagni). Film Production Still (DFI).

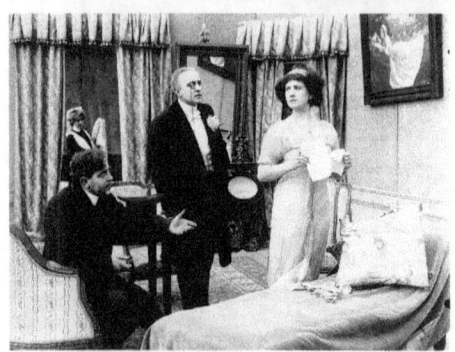

Figure 4.22 *Kærlighed og Venskab* (*Love and Friendship*; Eduard Schnedler-Sørensen, 1912, Nordisk Films Kompagni). Film Production Still (DFI).

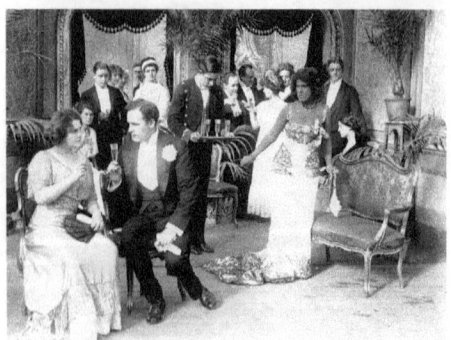

Figure 4.23 *Tropisk Kærlighed* (*Love in the Tropics*; August Blom, 1912, Nordisk Films Kompagni). Film Production Still (DFI).

Figure 4.24 Det gamle Købmandshus (*Midsummer-tide*; August Blom, 1912, Nordisk Films Kompagni). Film Production Still (DFI).

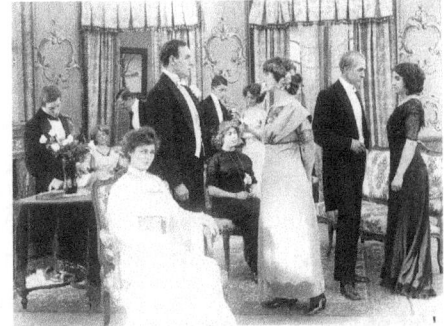

Figure 4.25 Guvernørens Datter (*The Governor's Daughter*; August Blom, 1912, Nordisk Films Kompagni). Film Production Still (DFI).

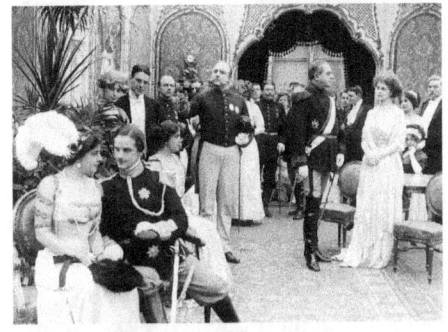

Figure 4.26 Den tredie Magt (*The Stolen Treaty*; August Blom, 1913, Nordisk Films Kompagni). Film Production Still (DFI).

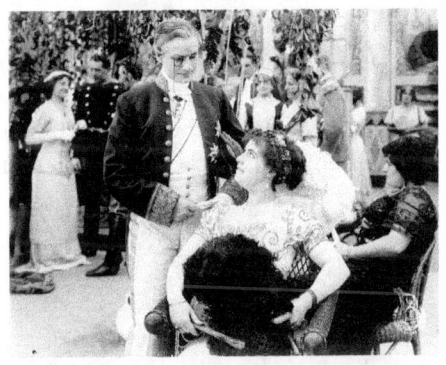

Figure 4.27 Et Kærlighedsoffer (*I Will Avenge*; Robert Dinesen, 1914, Nordisk Films Kompagni). Film Production Still (DFI).

Pictorialism

This framing and staging went hand in hand with another important aspect of Solomon Joseph Solomon's (Figure 4.13) work as a representative of Bourgeois Realism in relation to the silver screen, namely his work with light and shadow. Though subtle in his approach, Solomon works with the effect of source lighting quite deftly to strengthen the realistic aspect of his piece. He adds reflections, light patches, and shadows to create a heightened "pictorial" lighting scheme that sets the foreground apart from the background and produces delicate nuances in emotion. The atmospheric red owl lamp stands out, glowing crimson against the darker part of the frame that is the foreground right. The white light of the lamp in the background centre shines brightly and is located adjacently from the left part of the frame, which is more evenly lit. Beautiful examples of these lighting effects in painting include the aforementioned John Henry Frederick Bacon's *The Ring*, which combines low-key lighting from small source lights and a fireplace with the popular natural lighting of the woman-at-the-window motif.[46] Augustus Leopold Egg's (1816–63) *Past and Present* triptych (1858), then, depicts the highly dramatic and violent disintegration of a Victorian family against the beaming light of the moon, which plays an important aesthetic and sentimental role (Figures 4.28–4.30). With its strong colors, heavy reliance on motifs, and amplification of the narrative, Egg's work demonstrates the continuing legacy of Romanticism. His dramatic compositions make use of (single-source) low-key lighting, often in the guise of moonlight; substantial depth in the frame; and compositional arches and frames within the frame to further amplify the tangible narrative intensity of the whole.

Similar dramatic lighting effects were part and parcel of European cinema of the 1910s and 1920s, both in interiors and in atmospheric exterior shots, and filmmakers started integrating these as early as 1908.[47] Atmospheric exteriors were in effect even earlier in non-fiction travelogues. As Jennifer Lynn Peterson has noted, analogous with the landscape-oriented notion of the "picturesque," there was a long tradition in the visualization of exteriors that emphasized lighting and composition, especially against-the-day lighting in the form of sunsets or sunrises.[48] Evidence for an early use of such effects can be demonstrated by one of two Nordisk films: *Fiskerliv i Norden* (Viggo Larsen, 1906) or *Ved Havet* (Ole Olsen, 1909). These two fishermen tales only survive in a Swedish distribution copy in which the two were cut together, but what remains contains two beautiful tinted atmospheric inserts of a moonlit and sunset seascape (Figures 4.31 and 4.32), though it is unclear in which of the two these are featured, if not in both. This seascape motif was exceedingly popular in both painting and photography. At the Second Exhibition of

In Another Light: Academic Painting, Pictorial Photography, Bourgeois Cinema 125

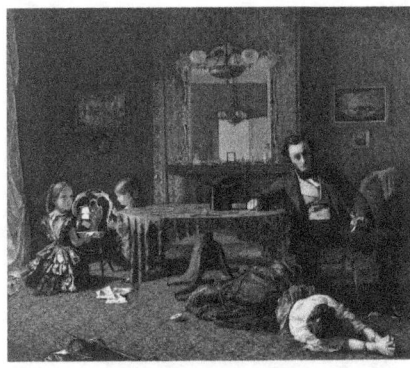

Figure 4.28 *Past and Present, No.1* (Augustus Leopold Egg, 1858). Painting, oil on canvas. Tate Gallery, London (WC).

Figure 4.29 *Past and Present No.2* (Augustus Leopold Egg, 1858). Painting, oil on canvas. Tate Gallery, London (WC).

Figure 4.30 *Past and Present No.3* (Augustus Leopold Egg, 1858). Painting, oil on canvas. Tate Gallery, London (WC).

Figure 4.31 *Fiskerliv i Norden / Ved Havet* (*Fishermen's Life in the North / By the Sea*; Viggo Larsen / Ole Olsen, 1906/9, Nordisk Films Kompagni). Digital Film Grab (DFI).

Figure 4.32 *Fiskerliv i Norden / Ved Havet* (*Fishermen's Life in the North / By the Sea*; Viggo Larsen / Ole Olsen, 1906/9, Nordisk Films Kompagni). Digital Film Grab (DFI).

Figure 4.33 Le Tic (*The Twitch*; Étienne Arnaud, 1908, Gaumont). Digital Film Grab (IA).

Figure 4.34 La Fille de Jephté (*The Vow; or, Jephthah's Daughter*; Léonce Perret 1910, Gaumont). Digital Film Grab (GPA).

the Paris Photo Club, for instance, the popularity of the seascape silhouette motif was exemplified by, among others, the salon's Baron Nathaniel de Rothschild's *Dans le Golfe de Smyrne*, Arthur G. da Cunha's *Étretat*, and Maurice Bucquet's *Machine Arrière*.[49]

In film, we see the seascape as a semantic motif early on, for instance, in the 1908 comic Gaumont romp *Le Tic* (*The Twitch*; Étienne Arnaud), which opens with a shot of the sun glistening on the Seine while boats pass, and was shot from under a bridge or using a mask to create an artistic arch in the frame (Figure 4.33); and Gaumont's historical art film *La Fille de Jephté* (Léonce Perret, 1910) (Figure 4.34), which was shot fully *en plein-air* and features a semi-silhouetted boat on a lake with the sun setting behind the mountains in the background. In the 1910s, this type of lighting was unmistakably linked to the bourgeois melodramas of companies such as Gaumont and Nordisk. This entailed source lighting effects, the use of chiaroscuro and contre-jour, and motifs such as the woman at the window, the silhouette, the frame-in-frame open-door shot, and the moon- or sunlit seascape. It is no coincidence, then, that this type of lighting is referred to by scholars as "pictorial," or "painterly." In fact, low-key lighting effects first became known as "Rembrandt" and "Lasky lighting" in America around 1915, a term supposedly introduced by Cecil B. DeMille while at the Jesse L. Lasky Feature Play Company.[50]

As Keating correctly points out, however, "Rembrandt lighting" was already widely applied in nineteenth-century photography, with Pictorialist pioneer Henry Peach Robinson adapting it in his 1891 book, *The Studio, and What to Do in it*.[51] The popularity of Rembrandt has to be seen in the larger context of what was essentially a nineteenth-century revival of genre painting after the example of the famous seventeenth-century Dutch Masters. Alison

McQueen notes that France witnessed a true "cult of Rembrandt" in the second half of the nineteenth century. This cult saw Rembrandt's artistic persona reinvented to fit many different aesthetic and political purposes, and it resulted in leading artists such as Jean-Léon Gérôme making good use of the Dutchman's chiaroscuro techniques.[52] These lighting effects became staples of Bourgeois Realist painting in the nineteenth century.

More importantly for our case, however, is that they were also appropriated by an artistic movement that hoped to elevate the artistic status and legitimacy of the medium of photography by associating with, and deriving its name from, painting. Pictorialism is generally recognized as finding its origin in the works of Englishman Henry Peach Robinson, who published his groundbreaking *Pictorial Effect in Photography – Being Hints on Composition and Chiaroscuro for Photographers* in 1869. He was known for his dramatically narrative photographs that usually combined multiple negatives into one print, such as the 1858 *Fading Away* (Figure 4.35). We find an illustrated guide to "Rembrandt lighting" in Henry Peach Robinson's *Pictorial Effect in Photography*, and many other photography manuals followed up on this well into the twentieth century, rendering the technique of "Rembrandt lighting" essential and commonplace. In J.B. Schriever's 1908 *Complete Self-Instructing Library of Practical Photography*, for instance, at least thirty pages are devoted to an instruction in "Rembrandt lighting."[53]

Figure 4.35 *Fading Away* (Henry Peach Robinson, 1858). Photograph, albumen silver print from glass negatives. The Royal Photographic Society at the National Media Museum, Bradford (WC).

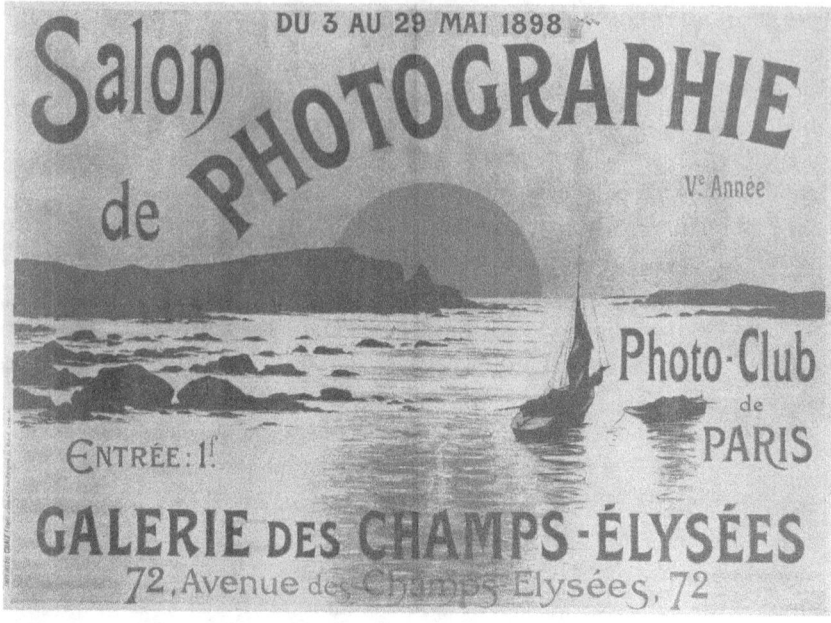

Figure 4.36 *Salon de Photographie – Photo-Club de Paris* (1898). Lithographic print (Private Collection) (WC).

As Margaret F. Harker notes, photography was first seen as a process for documentation and a "servant of Fine Art [...] providing artists with aides-mémoires for the construction of their paintings and subsequently with reproductions of these works;" it was Henry Peach Robinson who fought to elevate the medium by applying the traditions of painting to it.[54] Pictorialism can be understood as an international aesthetic movement for the advancement of artistic photography, *creating* images, rather than merely *recording* them. For this it looked to popular painterly motifs and tropes of the time. Photography was cinema's antecedent vis-à-vis the "medium as art" debate, similarly struggling with artistic legitimization because of its mechanical mediation of reality. The photographers of the movement thus reworked a photograph using filters, composites, dyes, negative manipulation and combination, and so on, to create a texture similar to that of paintings.

Much like the visual arts academies, photographers organized themselves in groups and held international Salons (Figure 4.36), the main European groups being the Linked Ring Society in Great Britain, the Photo Club de Paris in France, the Wiener Kamera-Klub in Austria, Gesellschaft zur Förderung der Amateur-Photographie zu Hamburg in Germany, and the Cercle Artistique de Bruxelles in Belgium. Through the numerous journals and salons, the Pictorialists became a legitimate international movement,

with their American counterpart being Alfred Stieglitz and Edward Steichen's Photo Secession. In Europe, driving forces behind the debate on which direction the movement was headed were Brits Henry Peach Robinson and Peter Henry Emerson, and Frenchmen Constant Puyo and Robert Demachy.[55] The movement firmly rooted itself in pictorial tradition and sought to uphold reigning values and stylistic strategies, with painters such as Rembrandt, Corot, Millet, and Whistler being key influences. As Kristina Lowis notes,

> Lacking academic training, [the Pictorialists] strove to assimilate the characteristics of recognized paintings and the laws and rules governing art. [...] Pictorial iconography, with a few (notably American) exceptions, was not a matter for argument. The great majority of art photography's theorists saw their aesthetics as affirming culturally accepted values.[56]

Henry Peach Robinson conveniently summarized these intentions as the application of "pictorial effect" in his eponymous book, creating a manual for amateurs and artists alike that disseminated "guiding laws in composition and chiaro-oscuro [Robinson's spelling] which must, in all forms of art, be the basis of pictorial effect."[57] Interestingly, Peach Robinson's focus on "effect" leads one to interpret his views on art as being quite Romantic. He believed that "every scene worth painting must have something of the sublime, the beautiful or the picturesque," and he found photography especially well equipped to represent the latter.[58] Though picturesque means painterly, or after a painting, as much as pictorial does, it is used more commonly to refer to landscapes and is also a loaded aesthetic notion that – much like the sublime – was part and parcel of eighteenth-century Romantic sensibilities. William Gilpin, one of the originators of the term, defined both "effect" and the "picturesque" in his 1768 *An Essay upon Prints, containing Remarks upon the Principles of Picturesque Beauty*, describing the former as arising "chiefly from the management of light" and the latter simply as expressing "that peculiar kind of beauty, which is agreeable in a picture."[59] One can see that, true to the times, Gilpin's definitions remain rather vague, but coupled to the work of painters such as J.M.W. Turner (1775–1851), Caspar David Friedrich (1774–1840), or Eugène Delacroix (1798–1863), we understand Romantic art as striving to appeal to our emotions in quite a visceral sense, presenting us with unbridled heroism, powerful scenes of commanding nature, and allegorical mysticism.

Though he left the intellectual elaboration of these key notions to others, Gilpin did share a focus with Peach Robinson in that both were proponents of a systematic approach to art as a means of obtaining what they considered to be the correct way of representation. Peach Robinson countered the view of photography as a medium that could only literally reproduce the world head-on in his work, arguing that photography was more than capable of

transfiguring its subjects by a poetic treatment, not only in its use of different lenses and dyes, but mostly through a careful study of pictorial principles that will result in an original style "sufficient to stamp the impress of the author on certain works [. . .] as paintings are ascribed to their various authors."[60] To do so, Peach Robinson proposes "hints" on, among others, balance, unity, composition, variety and repetition, portraiture, backgrounds, as well as a great many on chiaroscuro. He does this while consistently invoking the work of famous Flemish and Dutch painters such as the Dutch Antoon Van Dyck (1599–1641), Aelbert Cuyp (1620–91), and, of course, Rembrandt. As Jessica S. McDonald notes, Peach Robinson had actually trained as a painter, and his imitation of academic painting carried through in his method of making composite studio photographs, which combined parts of different negatives into a narrative whole.[61]

However influential Peach Robinson's views were, he also met with opposition within Pictorialism from artists such as Peter Henry Emerson. Emerson propagated a naturalistic vision above darkroom compositions and sought to profile photography as an independent art form rather than an imitation of painting.[62] Generally speaking, however, the Pictorialist assimilation of nineteenth-century painting resulted in the transference of key art-historical motifs. Most of these were dominated by their great attention to (low-key) lighting, for, as Peach Robinson already asserted:

> how many of the deservedly esteemed productions of the Flemish and Dutch schools would be thrown aside, as intolerable and disgusting, were it not for the beautiful effects of their judicious distribution of lights and shades.[63]

Cinematographers and directors would have doubtlessly picked up on these popular artistic notions through photography or through the trades. For example, *Moving Picture World* writer Thomas Bedding, a Brit who was a Fellow of the Royal Photographic Society (F.R.P.S.), advised in 1909 that "Pictorial photography of the stationary kind is best done en plein air."[64] Bedding also advocated for the use of chiaroscuro in the moving image but cautioned those attempting it, stating that "unless the [camera] operator has a mastery of pictorial effect, he should adopt a conventional method of lighting. That is to say, the sun should be behind the camera."[65] Under his pseudonym, Lux Graphicus, Bedding emerged even further as a stickler for the rules of pictorialism, believing the style to be the future of American film if U.S. filmmakers wished to compete with the films of Europe in 1910:

> a photograph, whether it is a stationary or moving photograph may be either purely photographic, that is, a mechanical transcript of the original, or it may be pictorial. There is no reason why every picture that is made should not be pictorial. Again, I say, as I have said over and over again, very few

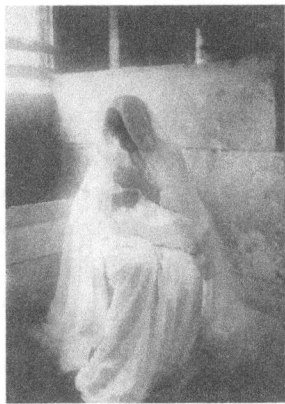

Figure 4.37 The Manger (Gertrude Käsebier, 1899). Photograph, platinum print. The Museum of Modern Art, New York (WC).

Figure 4.38 Den hvide Slavehandels sidste Offer (*In the Hands of Impostors no. 2*; August Blom, 1911, Nordisk Films Kompagni). Film Production Still (DFI).

>moving pictures are pictorial, in that they mostly violate some or many of the rules of composition [. . .] It is necessary, nay imperative, in the interests of the business that the vital importance of pictorialism in the moving picture should confront us all at this moment [. . .] the French, Italian, German [probably mislabeled: Danish][66] moving pictures are undeniably pictorial – almost without exception. [. . .] The British pictures are not pictorial [. . .] the American pictures are here and there pictorial, and that is all.[67]

The gospel of Pictorialism was aided in its diffusion by the fact that Gaumont and Nordisk worked with fixed director-unit systems in the early 1910s, so it makes sense that their bourgeois melodramas showed a high sense of visual congruency. Looking at some of these motifs in detail, let us compare, first, the woman-by-the-window motif, as seen in, for instance, Gertrude Käsebier's *The Manger* (1899) (Figure 4.37) and August Blom's *Den hvide Slavehandels sidste Offer* (1911) (Figure 4.38). The same contemplative motif can for example also be seen in Louis Feuillade's *La Tare* (1911) and *La Hantise* (by lamplight; 1912), and judging from my research in the DFI stills archive also in Nordisk's *Folkets Vilje* (Eduard Schnedler-Sørensen, 1911), *Gennem Kamp til Sejr* (Urban Gad, 1911), *Det bødes der for* (August Blom, 1911), *Dødens Brud* (by the fireplace; August Blom, 1912), *Hjærternes Kamp* (August Blom, 1912), *Bagtalelsens Gift* (Valdemar Hansen, 1912), *Det berygtede Hus* (Urban Gad, 1912), *Prinsesse Elena* (Holger-Madsen, 1913), *Atlantis* (August Blom, 1913), and *Skæbnens Veje* (Holger-Madsen, 1913), among many others.

Thomas P. Campbell describes this contemplative person-by-the-window motif as "a metaphor for unfulfilled longing by embracing both the very close and the faraway, [an] intangible mood [captured by artists in] pictures of hushed, spare rooms with contemplative figures."[68] The source light falling in through the window is meant to represent the only light in the room in order to create a natural ambiance. In Käsebier's case, the evening light floods the window with a slight overexposure, while wrapping the woman and her child in a soft shadow on one side. In the production still from *Den hvide Slavehandels sidste Offer*, Clara Wieth is bathed in moonlight, overexposing her worried figure and casting a shadow on the bed as she leans back.

Secondly, there is the silhouette, with its rich history and immense popularity as a portrait form in the eighteenth and nineteenth century; Hans Christian Andersen was, for instance, known for his cut-out silhouettes. The silhouette eagerly found its way into photography and cinema, the two media most well equipped to deal with the subtle nuances and splendor of contre-jour lighting. In Robert Demachy's 1907 *Mont St. Michel* (Figure 4.39) we can feel the rich texture created by the diffused light emanating from behind the silhouetted mill, making the figure in the foreground seep away into near abstraction. Viewing Demachy's mills, one cannot help but take Alfred Machin's wonderfully tinted and toned *De Molens die juichen en weenen* (*The Mills in Joy and Sorrow*; 1912) (Figure 4.40) and Benjamin Christensen's silhouetted masterpiece *Det hemmelighedsfulde X* (*The Mysterious X*; 1914) (Figure 4.41) as cinematic counter-examples.

Alfred Machin's mill and foreground figure resemble Robert Demachy's most compositionally, with its low angle leaving room in the frame for a beautiful cloudy sky. Benjamin Christensen's composition is so formalized – especially with its binocular camera mask – that it verges on abstraction and perhaps bears more resemblance to the silhouette cut-outs of Hans Christian Andersen. Between the popular picturesque seascape of A. Rutot's *Clair de lune sur la mer* (1896) (Figure 4.42) and Léonce Perret's *Le Roman d'un mousse* (*The Curse of Greed*; 1913) (Figure 4.43), we can additionally see a very clear one-on-one relationship. The moon and the setting sunshine bright in the centre of a large, cloudy sky, creating a glistening streak on the water against which the two little boats are beautifully silhouetted as they drift gently onwards. A similar exercise, furthermore, could be made with the interior source lighting motif – usually a "fireside reminiscences" moment – and with the use of camera mask framings, utilizing either natural surroundings such as bridges and cave mouths, or an actual camera matte.

Academic painting, pictorial photography, and early European cinema were engaged in a rich intermedial relationship. Through shared art-historical

Figure 4.39 Mont St. Michel (Robert Demachy, 1907). Photograph, autotype (halftone) from Franz Goerke (ed.), *Die Kunst in der Photographie* (Halle: Verlag von Wilhelm Knapp, 1907) (PS).

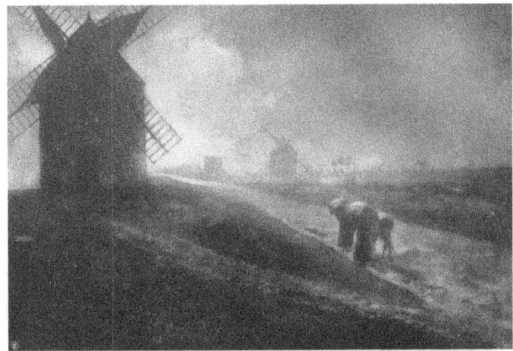

Figure 4.40 De molens die juichen en weenen (*The Mills in Joy and Sorrow*; Alfred Machin, 1912). Two-frame photograph (EYE).

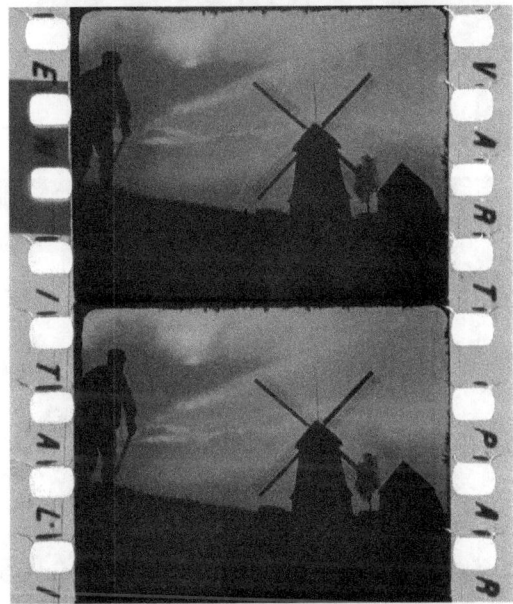

Figure 4.41 Det hemmelighedsfulde X (*Sealed Orders*; Benjamin Christensen, 1914, Dansk Biograf Compagni). Digital Film Grab (DFI).

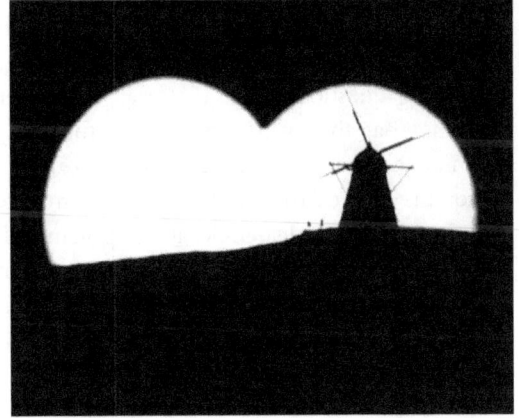

Figure 4.42 *Clair de lune sur la mer* (A. Rutot, 1896), photogravure from *Troisième Exposition d'Art Photographique* (Paris: Photo-Club de Paris, 1896), 46 (PS).

Figure 4.43 *Le Roman d'un mousse* (*The Curse of Greed*; Léonce Perret, 1913, Gaumont). Digital Film Grab (IA).

strategies, validation issues, and misconceptions, all of these media existed in the same cultural realm. Photography historian Michel Poivert has raised the interesting question of the Pictorialists' conservative adherence to tradition, claiming that they went against the modern and were as such somewhat of an anachronism; or, as he puts it, "out of step with their times."[69] This critique is part of the modernist bias similarly held against academic genre painting. In Pictorialist circles it was polemically dealt with and, as asserted by Poivert, eventually led to a rift between more modernist-inclined (American) artists and the traditional (European) Pictorialists.[70] Broadly speaking, artistic avant-garde experiments had started halfway through the nineteenth century, gaining a lot of momentum by the fin de siècle. Since both Bourgeois Realist painting and Pictorial photography were part of popular nineteenth-century

middle-class culture, cinema's appropriation of these prevalent genre tropes made it similarly embedded in a rather traditional context. A number of historians and scholars also consider the pre-World War One period part of what is called the "long nineteenth century" (1789–1914). On the stage, too, the popular artistic mode was that of realism in the shape of the popular melodrama. There were key bonding factors between Bourgeois Realist painting, Pictorialist photography, and early European cinema, or, as Martin Meisel has put it: "the construction of meaning in art through shared expressive and narrative conventions is never a closed system, but rather an expanding universe of discourse [. . .] using a recognizable vocabulary."[71] Looking forward outside the period that this book has most focused on until this point (1908–14) and into the late 1910s and 1920s, one sees that filmmakers continue to be a clear part of this intermedial universe. They worked in the same tradition and with the same tools, so as to be recognized by audiences and artists alike. In the following chapter, we will demonstrate that Victor Sjöström is one of these filmmakers, through careful analysis of his 1922 film *Vem dömer*.

NOTES

1. Aleksa Čelebonović, *The Heyday of Salon Painting: Masterpieces of Bourgeois Realism* (London: Thames & Hudson, 1974).
2. Cf. Henry Peach Robinson, *Pictorial Effect in Photography: Being Hints on Composition and Chiaro-Oscuro for Photographers* (Philadelphia: Edward L. Wilson, 1881) and *The Elements of a Pictorial Photograph* (Bradford: The Country Press, 1896). Peter Henry Emerson, *Naturalistic Photography for Students of the Art* (London: Sampson Low, Marston, Searle & Rivington, 1889). Robert Demachy, "La recherche d'art en photographie," *L'Art décoratif* 4, 45 (June 1902), 117–24 and Robert Demachy and Constant Puyo, *Les procédés d'art en photographie* (Paris: Photo Club de Paris, 1906). Alfred Stieglitz is most notable for his photography journal *Camera Work* (1903–17), which contained most of his thoughts on the medium, but see also Dorothy Norman, *From the Writings and Conversations of Alfred Stieglitz* (New York: Twice A Year Press, 1938).
3. Georges Dureau, quoted in Richard Abel, *The Ciné Goes to Town: French Cinema 1896–1914* (Berkeley & Los Angeles: University of California Press, 1998), 33.
4. Marguerite Engberg, *Dansk Stumfilm: De store År I–II* (Copenhagen: Rhodos, 1977), 421–3.
5. David Bordwell, *Figures Traced in Light: On Cinematic Staging* (Berkeley & Los Angeles: University of California Press, 2005), 46–7.
6. Bordwell, *Figures Traced in Light*, 48.
7. Bordwell, *Figures Traced in Light*, 49.
8. Ole Olsen, *Filmens Eventyr og Mit Eget* (Copenhagen: Jespersen and Pios Verlag, 1940), 128b.

9. Paul Sarauw, "Levende billeder. Danske instruktører i Berlin. Arbejdsvilkaar og Gager," *Masken* 3, 32 (11 May 1913), 210.
10. Olsen, *Filmens Eventyr,* 88b.
11. David Bordwell, "Nordisk and the Tableau Aesthetic" in Lisbeth Richter Larsen and Dan Nissen (eds.), *100 Years of Nordisk Film* (Copenhagen: Danish Film Institute, 2006), 81.
12. E.g., Thierry Lefebvre and Laurent Mannoni (eds.), "L'Année 1913 en France," *1895 – Revue d'Histoire du Cinéma* (Hors série, 1993); Peter Lehman (ed.), "Il Cinema Nel 1913/The Year 1913," *Griffithiana – La Rivista Della Cineteca Del Friuli/Journal of Film History* 50 (Special Issue, May 1994).
13. Bordwell, *Figures Traced in Light,* Ch. 2 deals entirely with French director Louis Feuillade (43–82); Bordwell, "Nordisk and the Tableau Aesthetic," deals with the style of Danish film company Nordisk. He has also blogged about the "tableau style" of staging in different national contexts at <http://www.davidbordwell.net/blog/category/tableau-staging/> (last accessed 15 February 2015). Casper Tybjerg, *An Art of Silence and Light: The Development of the Danish Film Drama to 1920* (Copenhagen: University of Copenhagen, Doctoral Dissertation, 1996); Yuri Tsivian, *Early Cinema in Russia and its Cultural Reception* (London and New York: Routledge, 1994); Ben Brewster and Lea Jacobs, *Theatre to Cinema: Stage Pictorialism and the Early Feature Film* (Oxford & New York: Oxford University Press, 1997).
14. Ricciotto Canudo, "The Birth of a Sixth Art" in Richard Abel (ed.), *French Film Theory and Criticism: A History/Anthology 1907–1939 – Volume I: 1907–1929* (Princeton: Princeton University Press, 1993), 62.
15. Erika Balsom, "One Hundred Years of Low Definition," in Martine Beugnet, Allan Cameron, and Arild Fetveit (eds.), *Indefinite Visions: Cinema and the Attractions of Uncertainty* (Edinburgh: Edinburgh University Press, 2017), 80.
16. Georg II, the Duke of Saxe-Meiningen insisted on historical authenticity and rehearsed his actors for months. Bruce McConachie, "Theatre and performance in modern media cultures," in Phillip B. Zarrilli, Bruce McConachie, Gary Jay Williams, Carol Fisher Sorgenfrei, *Theatre Histories: An Introduction* (Second Edition) (New York and London: Routledge, 2010), 312. A notable occurrence on Broadway was David Belasco's insistence that real pancakes be cooked in the Child's Restaurant he had reproduced for his 1912 *The Governor's Lady*. Chris Salter, "Participation, Interaction, Atmosphere, Projection: New Forms of Technological Agency and Behavior in Recent Scenographic Practice," in Arnold Aronson (ed.), The Routledge Companion to Scenography (London: Routledge, 2017), 177. See also: Philip Beitchman, *The Theatre of Naturalism: Disappearing Act* (New York: Peter Lang, 2011).
17. Cf. Colin B. Bailey (ed.), *The Age of Watteau, Chardin and Fragonard: Masterpieces of French Genre Painting* (New Haven and London: Yale University Press, 2003); Rosalind P. Gray, *Russian Genre Painting in the Nineteenth Century* (Oxford and New York: Oxford University Press, 2000); Lee M. Edwards (ed.), *Domestic Bliss: Family Life in American Painting 1840–1910* (New York: The Hudson River Museum, 1986).

18. Stephen Petersen, "Genre," in John Hannavy (ed.), *Encyclopedia of Nineteenth-Century Photography, Volume 1 A–I Index* (New York and London: Routledge, 2008), 575–7.
19. Petra ten-Doesschate Chu, *Nineteenth-Century European Art* (New York: Abrams, 2003), 257.
20. Philip Hook and Mark Poltimore, *Popular 19th Century Painting: A Dictionary of European Genre Painters* (Woodbridge: Antique Collectors' Club, 1986), 12.
21. Hook and Poltimore, *Popular 19th Century Painting*, 13.
22. Hook and Poltimore, *Popular 19th Century Painting*, 19.
23. "Art Pompier" literally translates to "fireman art" and refers to the shiny firemen helmets of the time, since they corresponded with those of Greco-Roman soldiers in neoclassical genre pieces that were popular at the academies. Furthermore, "pompier" closely resembles the French "pompeux," meaning pompous.
24. Čelebonović, *The Heyday of Salon Painting*, 24.
25. Clement Greenberg, "Avant-Carde and Kitsch" in Sally Everett (ed.), *Art Theory and Criticism: An Anthology of Formalist, Avant-Garde, Contextualist and Post-Modernist Thought* (Jefferson: McFarland & Company, 1991), 32.
26. ibid.
27. Paul Barlow, "Fear and loathing of the academic, or just what is it that makes the avant-garde so different, so appealing?" in Rafael Cardoso Denis and Colin Trodd (eds.), *Art and the Academy in the Nineteenth Century* (Manchester: Manchester University Press, 2000), 15.
28. The French L'Académie des Beaux-Arts in Paris was created in 1816 by merging L'Académie de Peinture et de Sculpture (founded 1648), L'Académie de Musique (founded 1669), and L'Académie d'Architecture (founded 1671). Its Italian counterpart, L'Académie de France à Rome, was founded in 1666 to accommodate the winners of the Prix de Rome, a three-to-five-year scholarship for promising young students at the Palazzo Mancini in Rome. Interestingly, L'Académie des Beaux-Arts also has a section for cinema, which was added in 1985, and one for photography, which was only added in 2005.
29. Geraldine Norman, *Nineteenth-Century Painters and Painting: A Dictionary* (Berkeley & Los Angeles: University of California Press, 1977), 88.
30. Norbert Wolf, *The Art of the Salon: The Triumph of 19th-Century Painting* (Munich, London and New York: Prestel, 2012), 49.
31. The Royal Academy of Arts was founded in 1768.
32. Die Akademie der Bildenden Künste in Munich was founded in 1770 but only received its "academy" moniker officially in 1808.
33. Det Kongelige Danske Kunstakademi was founded in 1754 as Det Kongelige Danske Skildre-, Billedhugger- og Bygnings-Academie i København.
34. Kasper Monrad (ed.), *The Golden Age of Danish Painting* (New York: Hudson Hills Press, 1993), 11.
35. Rafael Cardoso Denis and Colin Trodd (eds.), *Art and the Academy in the Nineteenth Century* (Manchester: Manchester University Press, 2000), 6.
36. Čelebonović, *The Heyday of Salon Painting*, 13 and 24.

37. Wolf, *The Art of the Salon*, 179.
38. Čelebonović, *The Heyday of Salon Painting*, 36–7.
39. David Bordwell, *On the History of Film Style* (Cambridge, MA and London: Harvard University Press, 1997), 195.
40. Martha Hollander, *An Entrance for the Eyes: Space and Meaning in Seventeenth-Century Dutch Art* (Berkeley: University of California Press, 2002), 1–2.
41. Lene Bøgh Rønberg, "Bourgeois Home Life in the Two Golden Ages: Influences and Correspondences" in Kasper Monrad, Ragni Linnet, and Lene Bøgh Rønberg (eds.), *Two Golden Ages: Masterpieces of Dutch and Danish Painting* (Zwolle & Copenhagen: Rijksmuseum Amsterdam and Statens Museum for Kunst, 2001), 74.
42. Charles O'Brien, "Film Colour and National Cinema Before WWI: Pathécolor in the United States and Great Britain," in Frank Kessler and Nanna Verhoeff (eds.), *Networks of Entertainment: Early Film Distribution 1895–1915* (New Barnet: John Libbey, 2007), 33.
43. Patrick Keating, *Hollywood Lighting from the Silent Era to Film Noir* (New York: Columbia University Press, 2010), 84.
44. Christopher Beach, *A Hidden History of Film Style: Cinematographers, Directors, and the Collaborative Process* (Oakland: University of California Press, 2015), 51.
45. Balsom, "One Hundred Years of Low Definition," 80.
46. For a good overview, cf. Sabine Rewald, *Rooms With a View: The Open Window in the 19th Century* (New York: Metropolitan Museum of Art, 2011).
47. In exteriors, these are commonly referred to as "atmospheric inserts" per Barry Salt, *Film Style & Technology: History & Analysis* (London: Starword, 1992), 139.
48. Jennifer Lynn Peterson, *Education in the School of Dreams: Travelogues and Early Nonfiction Film* (Durham & London: Duke University Press, 2013), 35.
49. *Deuxième Exposition d'Art Photographique* (Paris: Photo-Club de Paris, 1895). Planches VI (de Rothschild), XVII (da Cunha), and XXXVI (Bucquet).
50. Sumiko Higashi, *Cecil B. DeMille and American Culture: the Silent Era* (Berkeley & Los Angeles: University of California Press, 1994), 3.
51. Keating, *Hollywood Lighting from the Silent Era to Film Noir*, 31.
52. Alison McQueen, *The Rise of the Cult of Rembrandt: Reinventing an Old Master in Nineteenth-Century France* (Amsterdam: Amsterdam University Press, 2003), 155.
53. James Boniface Schriever (ed.), *Complete Self-Instructing Library of Practical Photography, Volume VIII Studio Portraiture Part II Studio System* (Scranton, PA: American School of Art and Photography, 1908).
54. Margaret F. Harker, "Henry Peach Robinson: The Grammar of Art," in Mike Weaver (ed.), *British Photography in the Nineteenth Century: the Fine Art Tradition* (Cambridge and New York: Cambridge University Press, 1989), 133.
55. Patrick Daum, Francis Ribemont, and Phillip Prodger (eds.), *Impressionist Camera: Pictorial Photography in Europe, 1888–1918* (London & New York: Merrell, 2006).
56. Kristina Lowis, "European Pictorial Aesthetics," in Patrick Daum, Francis Ribemont and Phillip Prodger (eds.), *Impressionist Camera: Pictorial Photography in Europe, 1888–1918* (London and New York: Merrell, 2006), 48.

57. Henry Peach Robinson, *Pictorial Effect in Photography: Being Hints on Composition and Chiaro-Oscuro for Photographers* (Philadelphia: Edward L. Wilson, 1881), v.
58. Peach Robinson, *Pictorial Effect in Photography*, 6.
59. William Gilpin, *An Essay upon Prints, containing Remarks upon the Principles of Picturesque Beauty* (London: J. Robson, 1768), 2.
60. Peach Robinson, *Pictorial Effect in Photography*, 5.
61. Jessica S. McDonald, "Readings in the History of Pictorialism," in Alison Nordström (ed.), *Truth Beauty: Pictorialism and the Photograph as Art, 1845–1945* (Vancouver: Douglas and McIntyre, 2008), 116.
62. Emerson, *Naturalistic Photography for Students of the Art*.
63. Peach Robinson, *Pictorial Effect in Photography*, 123.
64. Thomas Bedding, "The Modern Way in Moving Picture Making – Chapter III: The Studio," *Moving Picture World* 4, 13 (27 March 1909), 360.
65. Thomas Bedding, "The Modern Way in Moving Picture Making – Chapter XI: Photographing Outdoor Subjects," *Moving Picture World* 4, 21 (22 May 1909), 666.
66. It is more likely that the author means "Danish" as opposed to "German." This was a common mistake in 1910 because of the confusion around Nordisk. It would additionally make sense because the German Autorenfilme did not start making waves until 1913.
67. Lux Graphicus, "On the Screen," *Moving Picture World* 7, 5 (30 July 1910), 241.
68. Thomas P. Campbell, "Director's Foreword," in Sabine Rewald, *Rooms with a View: The Open Window in the 19th Century* (New York: Metropolitan Museum of Art, 2011), viii.
69. Michel Poivert, "An Avant-Garde Without Combat: The French Anti-Modernists and the Pre-Modernism of the American Photo-Secession," in Patrick Daum, Francis Ribemont and Phillip Prodger (eds.), *Impressionist Camera: Pictorial Photography in Europe, 1888–1918* (London and New York: Merrell, 2006), 32.
70. This argument forms the entire basis of Poivert's piece "An Avant-Garde Without Combat," 31–46.
71. Martin Meisel, *Realizations: Narrative, Pictorial and Theatrical Arts in Nineteenth-Century England* (Princeton: Princeton University Press, 1983), 11.

CHAPTER FIVE

Old Masters Endure: Victor Sjöström's Netherlandish Tableaux

When this chapter's case study, *Vem dömer*, hit the silver screen in 1922, Swedish cinema was in the middle of a cinematic Golden Age led by Victor Sjöström, Mauritz Stiller, and the production company they worked for, Charles Magnusson's AB Svenska Biografteatern (also known as Svenska Bio and Swedish Biograph).[1] This Swedish Golden Age was kicked off by *Terje Vigen* (*A Man There Was*; Victor Sjöström, 1917) and ended with the exodus of Victor Sjöström, Mauritz Stiller, and star actors Lars Hanson and Greta Garbo, who were courted by Hollywood in 1923 and 1924.[2] Both Denmark and Sweden were neutral during the First World War, allowing them to continue to foster their film industry to a degree that the previously world-dominant French could not. Swedish production companies like Svenska Bio took over the torch from the Danish Nordisk Films Kompagni in the late 1910s, providing a continuation and refinement of the Bourgeois Realist visual strategies and influences we have discussed in previous chapters. Steve Neale points to A.W. Sandberg's 1926 *Klovnen* (*The Clown*) as an example of this long-take tableau aesthetic persisting in Scandinavia until the mid-1920s; in this case in a Danish Nordisk film with a famous Swedish lead in Gösta Ekman.[3]

This chapter closely reads another Gösta Ekman film, directed by Victor Sjöström, produced by the successor of Svenska Bio, and released in 1922. The film was made and released almost a decade after the suggested peak of European pictorial filmmaking in 1913, but we see that it engages equally – if not even more deeply – with aesthetic tropes of the nineteenth-century Rembrandt revival in academic painting, Pictorialist photography, and theatrical performance. In his previous work, Sjöström always invested heavily in framing, lighting, and performance to begin with. His *Ingeborg Holm* (1913), for instance, also earns him a spot in the hallowed halls of the 1913 club. It seems, however, as if Sjöström made use of *Vem dömer*'s period setting to amplify these parameters, adding an extra layer of cinematic texture *between* shots through what we will coin the "Scandinavian dissolve."

Vem dömer was released internationally as *Mortal Clay* and *Love's Crucible* and became part and parcel of a Swedish invasion that had been widely reported

on internationally since at least 1919. Sjöström led the way with *Tösen från Stormyrtorpet* (*The Girl from the Marsh Croft*; 1917), which was released to great enthusiasm in the United States to become "the first photoplay of importance to come over" from a country that has "more telephones per capita than any other," in a sign of Sweden's great scientific wealth and progress.[4] The film was supposedly "the first Swedish photoplay to be shown in New York City," where its "many beautiful scenes [and] splendid acting" were celebrated with applause at its Carnegie Hall screening, according to D.W. Griffith's journalist spouse, Linda A. Griffith.[5]

This chapter also considers the international significance of *Vem dömer*, arguing that it has academically been overlooked within the oeuvre of Victor Sjöström and as the key part of the Swedish Golden Age that it is. This first becomes apparent through the deployment of the film's key tropes and stylistic markers. They focus on the self-reflexive thematization of art through its characterization of the relationship between artist and model, and its representation of the Sacred Image. Secondly, the film's North American distribution through Little Theatre Films presented a watershed moment in the artistic alliance between theatre and a new wave of art films. And finally, it is *Vem dömer*'s highly overt and referential rejuvenation of the Old Masters that sets it apart from others, which is achieved through the clever use of space and light, as well as through the circularity of the narrative in motifs, gestures, and tableaux vivants.

The praises of Swedish cinema in general, and of Sjöström in particular, had first been sung by the French. Gaumont had been the distributor of Svenska Bio's films in France. This meant that Gaumont's filmmakers had private access to Svenska Bio's films for their own viewing and inspiration, creating an important relationship of influence between the two countries. As Peter Decherney has demonstrated in the more extreme example of Edwin Porter and Thomas Edison's dupes and remakes, access to foreign prints in this period should not be underestimated.[6]

It was Impressionist filmmaker Louis Delluc who sang the Swedes' praises more publicly, devoting an entire issue of his film magazine, *Cinéa*, to the talents of Swedish directors in 1921. The cover of the magazine (Figure 5.1) is graced with an image of Victor Sjöström standing on top of a mountain as escaped thief Berg-Ejvind in *Berg-Ejvind och hans hustru* (*The Outlaw and His Wife*; Victor Sjöström, 1918). This image is accompanied by the announcement that "there is a country where they make beautiful films, where they don't like bad films, where they don't imitate American films: it is Sweden."[7] The issue describes the merits of a handpicked selection of twenty-nine films "to review and to view" from *Balettprimadonnan* (*Wolo Czawienko*; Mauritz Stiller, 1916) to *Körkarlen* (*The Phantom Carriage*; Victor Sjöström, 1921),

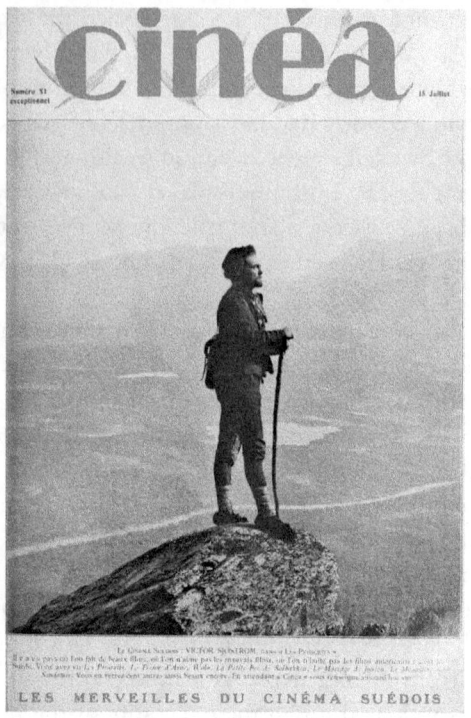

Figure 5.1 Victor Sjöström on the cover of *Cinéa*. "Les Merveilles du Cinéma Suédois," *Cinéa* 11 (special issue) (15 July 1921), cover. Production still from *Berg-Ejvind och hans hustru* (*The Outlaw and His Wife*; Victor Sjöström, 1918) (MHDL).

almost all of them films that are now (or should be) considered a part of the pantheon of early European cinema.[8] Though *Vem dömer* had yet to be released, the issue does provide illustrated caricatures of its principals: director Victor Sjöström (Figure 5.2), lead actress Jenny Hasselqvist (Figure 5.3), and male lead Gösta Ekman (Figure 5.4). Sjöström was the only figure to get a full-page spread, in which the success of his films in France, Germany, and the U.K. is emphasized. The piece paints the director as a Swedish national poet "preaching in the new temple of the people: the cinema" and as "a man of thought [who] will experience great victories in the battle that is being fought for the cinematographic Art."[9]

In the United States, then, New York was still very much the barometer for cultural success, in spite of the film industry's move west to Los Angeles. *The New York Times* opined in 1922 that "in view of the substantial work they have done, the Swedish picture makers seem to have been rather carelessly neglected by Broadway," noting that New York may see *Vem dömer* soon because of the praise it received upon its premiere in London, and because

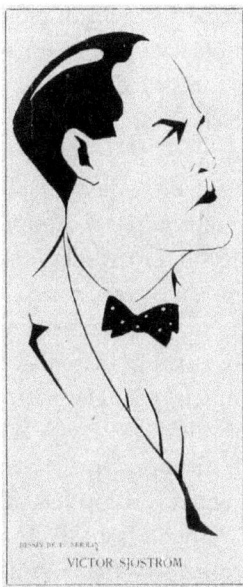 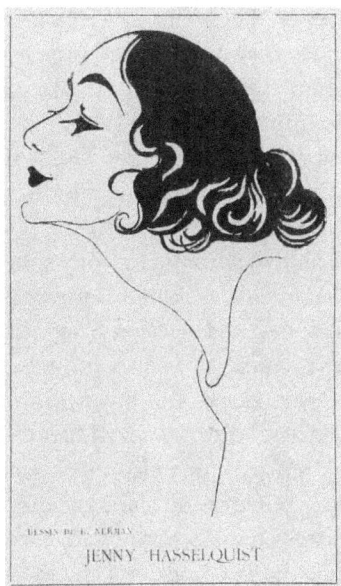 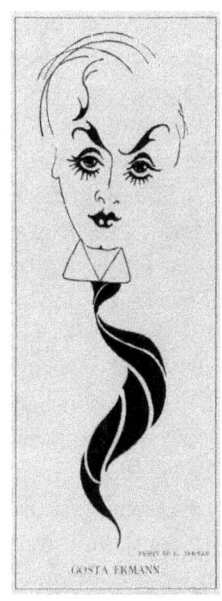

Figure 5.2 Caricature of Victor Sjöström. E. Nerman, "Victor Sjostrom [sic]," *Cinéa* 11 (special issue) (15 July 1921), 21 (MHDL).

Figure 5.3 Caricature of Jenny Hasselqvist. E. Nerman, "Jenny Hasselquist [sic]," *Cinéa* 11 (special issue) (15 July 1921), 7 (MHDL).

Figure 5.4 Caricature of Gösta Ekman. E. Nerman, "Gosta Ekmann [sic]," *Cinéa* 11 (special issue) (15 July 1921), 10 (MHDL).

Körkarlen had recently paved the way (running for three weeks at the Criterion Theatre).[10] Historically and academically, however, *Körkarlen*'s critical and financial success has achieved the opposite, pushing *Vem dömer* into relative obscurity. It has not helped that Ingmar Bergman quoted *Körkarlen* to have been a major influence on his work, but the trained eye will see that Bergman might have learned and borrowed a thing or two from *Vem dömer* as well – if not more.[11] The film continues to occupy a somewhat unfortunate space in Sjöström's career. Its release came after the international success of *Körkarlen*, right before his move to Hollywood, and has generally been perceived as an attempt to "repeat the commercial export success of" Sjöström's other religious period drama, *Klostret i Sendomir* (*The Monastery of Sendomir*, 1920).[12]

Indeed, the plot and setting of the two films are rather alike: both deal with a marriage between an older man and a younger woman that is violently broken off due to an affair with a younger man. The films share an emphasis on religion and morality, moreover, and *Klostret i Sendomir*'s seventeenth-century Gothic Warsawian sets and costumes are not unlike *Vem dömer*'s

fifteenth-century Florence. The story for *Vem dömer* came from an original script by Sjöström's close friend and famed novelist and playwright, Hjalmar Bergman, who joined him in Hollywood in 1923 to work for Samuel Goldwyn. Bergman mocked Sjöström for changing his name to "Seastrom," jesting that he would then proceed to call himself "the Duke of Florence."[13]

The plot of *Vem dömer* revolves around a noble young lady named Ursula (Jenny Hasselqvist) who is forced to marry the older sculptor Master Anton (Ivan Hedqvist) but is in love with the mayor's son, Bertram (Gösta Ekman). The clandestine love between Ursula and Bertram is kept alive in the form of a shared book of poems, stolen glances on balconies, and secret meetings, but the doomed twosome is found out soon enough. Consumed by hatred for her forced husband, Ursula decides to buy poison from a monk. The monk perceives the purchase to be a Romeo-and-Juliet type of suicide pact with her lover, and so the monk replaces the poison – elegantly transported inside of a ring – with an innocuous powder and alerts the mayor. The revelation sets off an angry mob that storms Ursula's house with torches. When Master Anton tries to confront Ursula, he becomes unwell, and when he sees that Ursula is about to poison him, he dies of a heart attack. Ursula is now tasked with having to prove her innocence, and it is only through penance and a trial by fire that she can convince the community of her innocence and come clean with her intentions proper.

Art, Artist, Idol

Variety received *Vem dömer* as a masterpiece "from a stage manager's point of view," stating that every little detail of the film had been carefully worked out, and noting that Swedish Bio would do for the film world what the productions of [John] Hare, [George] Alexander, and [Henry] Irving had done for the legitimate stage.[14] The National Board of Review's Frances Taylor Patterson concurred, and lauded the "splendid composition [. . .], incomparable loveliness of its lighting scenes, [and] architectural magnificence."[15] *Vem dömer*'s connection to the art of the legitimate stage went beyond the aforementioned analogy, however, for the National Board of Review also played an important part in the film's introduction into the American market by partnering with the cinema component of the Little Theatre movement, Little Theatre Films, Inc.

The Little Theatre was a progressive national movement that grew from amateur theatres' dissatisfaction with the lurid melodramas and crass commercialism of the professional circuit. These theatres organized themselves in the 1910s around dramatists such as Percy MacKaye, and associated heavily with the art theatre movement and the wave of modernist formalists coming

out of Europe, the latter of which Kenneth Macgowan so eloquently grouped and dubbed "New Stagecraft."[16] As such, these smaller theatre groups were modernist, anti-commercial, and inspired by the loftier institutions such as the Moscow Art Theatre, the Freie Bühne, and the Théâtre Libre, and recognized dramatists such as Edward Gordon Craig, Max Reinhardt, and Adolphe Appia. The movement spawned, for instance, Eugene O'Neill's Provincetown Players.[17]

While the Little Theatre movement's interest in *Vem dömer* might seem like a trivial distribution matter from the outset, it was actuality an integral part of America's film history. After the First World War, American production and distribution companies were struck by the popularity and artistic nature of the fare that was coming out of countries such as Germany, Sweden, and Denmark, and started importing films *and* their creative leads. On top of Sjöström and Stiller, the most notable directors to be courted successfully were Ernst Lubitsch, F.W. Murnau, Paul Leni, and Benjamin Christensen. This was seen as a way to "lend a touch of class" to Hollywood and is still a tried and true strategy to inject artistic renown into a commercial studio context.[18] In essence, this created a second (or third) wave of art films meant to legitimize the cinema as an independent art form. The European directors' welcome in Hollywood had worn out towards the end of the 1920s, however. They had to contend with both the executives who had invited the directors to produce their vision – which was not actually what the executives wanted; as well as with the critics who made "artistic" ring synonymous with "arrogant."[19] Very few of these actors and directors ended up staying, and fewer still went on to have a successful career in the United States.[20]

Though film production companies had sought out collaborations and associations with the stage in pursuit of "Art" with a capital "A" many times before, the Little Theatre movement's decision to consider the medium of film a part of its artistic mission was exceptional. It marks one of the only times, I believe, that this ever happened (Figure 5.5). According to the Little Theatre's president, Curtis Melnitz, the decision had everything to do with the fact that there was a shared and "discriminating audience [. . .] waiting for such a movement as this" that had already sustained the Little Theatre movement.[21] To make this unique collaboration work, the Little Theatre stocked its advisory board with many film notables, such as Maurice Tourneur, Rex Ingram, Erich von Stroheim, Mary Pickford, Douglas Fairbanks, and Charlie Chaplin. They chose *Vem dömer* as its first of twenty-five pictures to be distributed and Victor Sjöström even became a member of their advisory board before the film's release.[22]

Tony Guzman has noted that Little Theatre Films never really got off the ground – as opposed to its stage-bound parent company – and has argued

November 3, 1923

Page 1031

Is There an Undiscovered Picture Audience?

Little Theatre Films, Inc., with That as Its Object, Includes Foremost Artists and Officials

By HELEN V. SWENSON

AN innovation in the releasing of motion pictures has been instituted by Little Theatre Films, Incorporated. The stated aim of this organization is "to provide through existing little theatre groups, university dramatic societies and women's clubs a direct release for those artistic films which cannot find a place in the commercial theatre."

They go further in their statement, with the explanation that they will "appeal to the minority in America—to the same audience that has made possible the little theatre movement, which has rendered such magnificent service to the art of the theatre.

"We believe that a discriminating audience is waiting for such a movement as this, and that the minority to which we shall appeal is large enough to make our plan practical."

It was the firm belief of Curtis Melnitz, the president and organizer of this concern, that a large audience could be found among the more intelligent groups of society for pictures of the better sort.

WITH this aim in view, he organized his company, and as proof of the fact that he is not merely an idealist he is now presenting to the public a picture called "Mortal Clay."

Co-operating in this scheme is the National Board of Review, which states in its publication Exceptional Photoplays: "'Mortal Clay' is a Swedish picture of a medieval story of great power, beautifully handled, and noteworthy for its spiritual substance."

It was directed by Victor Seastrom, the great Swedish director, who is now working for Goldwyn in Hollywood. Mr. Seastrom is believed by many to be one of the greatest directors living, and in "Mortal Clay," as well as in those productions which he is at present

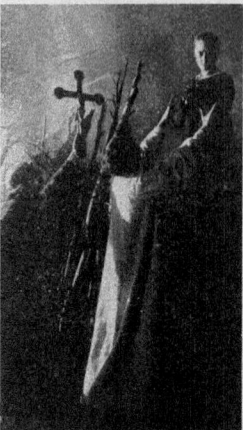

working on for Goldwyn, he has put his very best.

AS evidence of the fact that those connected with motion pictures are not lacking in vision, we find on the advisory board such names as Mary Pickford, Douglas Fairbanks and Charlie Chaplin, the latter stating in connection with the picture:

"I consider 'Mortal Clay' a most beautifully prepared and executed work of art—an inspiration to all lovers of beauty, and a vehicle that should ele-

"Mortal Clay," which was directed by Victor Seastrom, now engaged by Goldwyn, is the first picture which Little Theatre Films, Inc., is endeavoring to release through Little theatre groups

vate the whole standard of motion pictures. Mr. Seastrom is a true artist."

Rex Ingram of Metro has given a lot of his time and attention to the movement, and has shown his remarkable clear-sightedness in working for the organization as much as he could.

THE directors who have appeared on the advisory board are William De Mille of Paramount, Rex Ingram of Metro, Maurice Tourneur of First National Bob Wagner and Erich Von Stroheim. To them a great deal of credit is due for the initial success of the venture.

In the list of those who have expressed their belief in the picture appear such names as Rupert Hughes of Goldwyn; Ernst Lubitsch, who directed Mary Pickford's latest picture, "Rosita"; Matt Moore, who is starring in First National's "Thundergate"; Fred Niblo of Metro; Anna Q. Nilsson, who appeared in First National's "Ponjola"; Thomas G. Patten, Eileen Pringle, Edna Purviance, star in United Artists' "A Woman of Paris"; Joseph Schildkraut, and Daniel Frohman.

Great credit is due to all of those behind this movement for their foresight in sponsoring this new venture. Although for many years, there has been agitation for the institution of a non-commercial movie theatre, this is the first practical step in that direction.

Exhibitors are handicapped in the selection of their programs by the fact that they must appeal to a varied audience. They dare not display a picture which the majority of their patrons would not understand.

On the other hand, it is just as true that there is a large audience of intelligent persons who are qualified to appreciate good pictures, just as they are able to judge the value of good books, good architecture, and good plays.

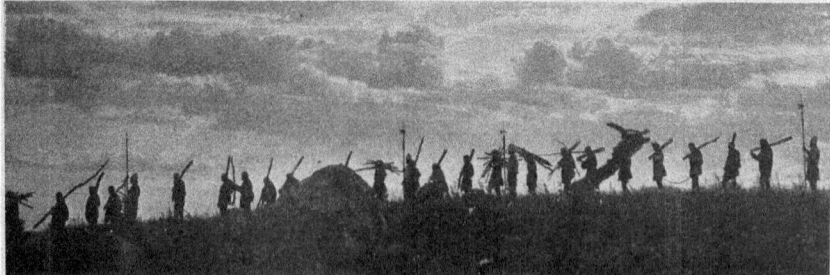

Figure 5.5 Little Theatre Films presents *Vem dömer*. Helen V. Swenson, "Is There an Undiscovered Picture Audience?" *Exhibitors Trade Review* 14, 23 (3 November 1923), 1031 (MHDL).

that *Vem dömer* was a sensible and inexpensive choice because American film distributors had first passed on it in 1922. This was before it had been announced that Sjöström was being brought over to Hollywood by Samuel Goldwyn.[23] The actual release and follow-up to *Vem dömer* might be a testament to this, as it was noted to appear on screens in the final week of June 1923.[24] In January 1924, Little Theatre Films president Curtis Melnitz quit.[25] Charlie Chaplin, at least, considered *Vem dömer* to be:

> a most beautifully prepared and executed work of art – an inspiration to all lovers of beauty, and a vehicle that should elevate the whole standard of motion pictures. Mr. Seastrom is a true artist.[26]

On top of the promotion (and distribution) of *Vem dömer* as a work of art, the trade journals also focused on the figure of Victor Sjöström himself. They characterized the director as a mythical and aloof European artist, almost to the point of caricature. He was described as a strong, tall man with "Nordic blue" eyes – "the blue of the winter sea" – and prophesied him to be "the greatest director in motion pictures."[27] The biggest compliment that any artistically minded director such as Sjöström could possibly be paid was perhaps that he was said to be difficult to interview on several occasions (Figure 5.6). One reporter eloquently described him as a man who performs "entrechats of irony before a back-drop of impenetrable gloom."[28]

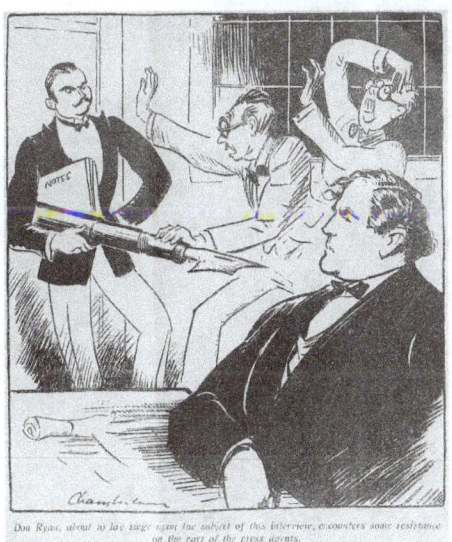

Figure 5.6 Don Ryan attempting to interview Victor Sjöström. K.R. Chamberlain, "Don Ryan, about to lay siege upon the subject of this interview, encounters some resistance on the part of the press agents," *Picture-Play Magazine* 20, 1 (March 1924), 23 (MHDL).

This characterization and, to a certain degree, antagonization of the figure of the artist is mirrored in *Vem dömer*'s sculptor, Master Anton. The forced marriage that Ursula undergoes in effect subjugates her to him, underscoring the literal meaning of his title "Master." As Susan Felleman notes, this is a reiteration of the "ancient and mythic scenario of genius and muse, of master and subject," and, one might add, of artist and model, performed by the usual "couple of older man and younger woman."[29] It comes as no surprise, then, that Anton's first act of married life is to substantiate that subjugation by forcefully turning Ursula into his model, clearly without her consent. Ursula is posed on her knees on a wooden pedestal, looking straight ahead with her hands in a praying position, clad in lace and pearls and wearing a tall crown. Ursula's pose is that of the popular religious Renaissance motif of the Virgin in Prayer, and more specifically the Coronation of the Virgin, which was highly popular in thirteenth-century Italy.[30] The statuary equation between Ursula and the Virgin Mary – the most portrayed holy figure – also places Ursula on a metaphoric pedestal as the "good woman," as an ideal woman full of virtue.[31] When Ursula starts to falter in keeping her pose, then, this can be read as commentary that reveals her "mere" human nature. It is not only her pose but also her morality that is slipping, because she is having an affair as a married woman (Figure 5.7).

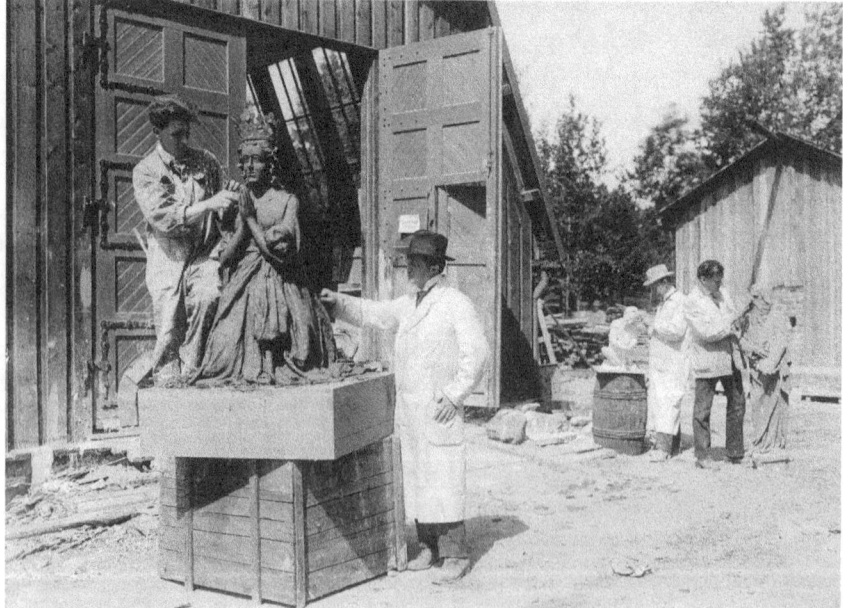

Figure 5.7 The art department working on the Ursula sculpture – in the Coronation of the Virgin pose. *Vem dömer* (Victor Sjöström, 1922). Production still (SFI).

Only Anton's assistant takes note that Ursula breaks her pose and comes to her aid, since the sculptor seems to be entirely immersed in his work. He chisels away at her clay double, lovingly caressing its chin at one point, unaware of Ursula's internal and external struggle. For all the saturnine, hedonistic, and abject qualities ordinarily lent to the character of the artist, however, Master Anton is not all that bad in *Vem dömer*.[32] Though the details of the forced marriage are unclear, Anton is otherwise a cuckolded and clueless husband who appears to succumb to a broken heart when he sees that Ursula is trying to poison him with the powder that was initially reserved for her Shakespearian suicide pact with Bertram. Both Ursula's model pose and Anton's dying pose are closely embedded in the circularity of visual motifs in *Vem dömer*, a point to which we will return. Ursula's pose is tied to another religious tale of statuary as well, namely the fourteenth-century Dutch poem *Beatrijs* (*Beatrice*; c. 1374). This is the story of a nun who elopes with a man and whose place in the convent is taken by a statue of the Virgin Mary come to life, preserving her spot and her reputation for when she returns down and out fourteen years later.[33] The legend of Beatrice became popular again in the 1910s and 1920s through Karl Volmöller and Max Reinhardt's play *Das Mirakel* (1911) and its subsequent film adaptation(s) (e.g. Michel Carré's 1912 *The Miracle*).

Animated and agitated sculptors and statuary made up an important slice not only of late-nineteenth and early-twentieth century performance culture, but also of early cinema, for instance in the films of Georges Méliès and the Saturn Film Company.[34] This was true for Scandinavia, as well, for instance in Urban Gad's *Die ewige Nacht* (*The Eternal Night*; 1916), with Asta Nielsen as a blind model; and in Robert Dinesen's *Djævelens Datter* (*The Devil's Daughter*; 1913) and *Den sidste Nat* (*The Last Night*; 1915).[35] This list also includes Marian apparitions, such as in *Le Noël de Monsieur le curé* (*The Parish Priest's Christmas*; Alice Guy, 1906). For Ursula, however, statuary magic is dispensed not by the Virgin Mary, in spite of the overt overtures that she seems to make to her, but from a statue of Christ Crucified that bookends the film (Figure 5.8).

The statue of Christ adorns the local church and is the first and last thing we see in the film. Christ is pivotal to the narrative and to the title. "*Vem dömer*" literally translates to "who judges," implicating that only Christ can judge, and perhaps not the community that tries to lynch Ursula. The statue thus comments on the actions of the female protagonist and judges her morality, but it does so not merely by acting as a bookend. In the beginning of the film, Ursula prays for deliverance from her marriage in the form of death. The statue delivers what Ursula prays for, not in the form of her death but that of Anton's. Even when the monk who sold Ursula the false poison testifies that she could not have killed him, however, there is a severe distrust

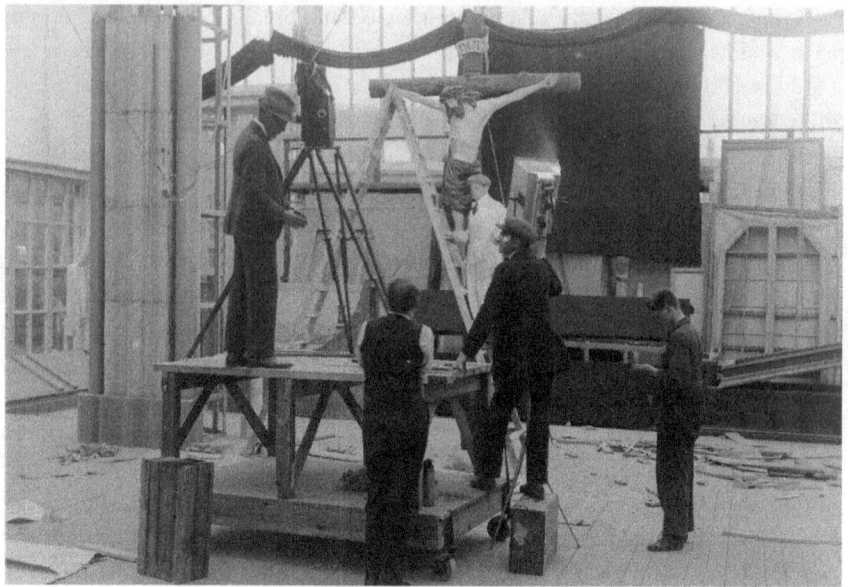

Figure 5.8 Christ, ready for his close-up. *Vem dömer* (Victor Sjöström, 1922). Production still (SFI).

from within the community. The statue of Christ reacts to these events by bleeding from its crown of thorns while the sculptor's two assistants mourn by his casket. The community wrongly perceives this miracle as a sign of Ursula's guilt and so they wield torches to her house, screaming to "Burn the Witch!" Her lover Bertram decides to take her place when she refuses the bishop's proposition of proving her innocence through a "trial by fire," but she realizes the gravity of what she was going to do to Anton and takes Bertram's place at the stake at the last minute. The statue of Christ Crucified is set up outside by the stake and transforms into Anton's ghost before Ursula's eyes, guiding her through the fire and vindicating her in front of the villagers' eyes (Figures 5.9 and 5.10).

Sjöström's intent visualization of the statue of Christ Crucified, shown to possess mystical powers, combined with Ursula's dependence on it, leads to a fetishization and idolization of Christ Crucified that did not sit well with American critics – the same critics who felt that Ursula's religious vindication was unjust. A critic for *Variety* saw the film in London and contacted the censors to question them about this. S/he felt that the story was without a moral – the murderer is reunited with her lover, after all – and was surprised that the "scenes of the [Sacred] Image, such as the wounds bleeding until the guilty poisoner had expiated his or her sin, were passed."[36] The censor replied that s/he did not object to the "figure of Christ in itself but only to His

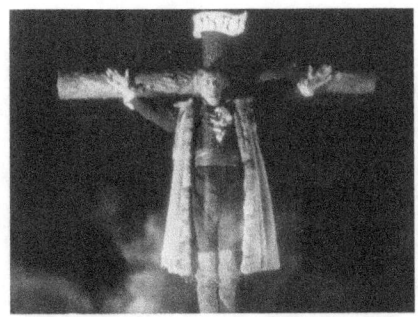 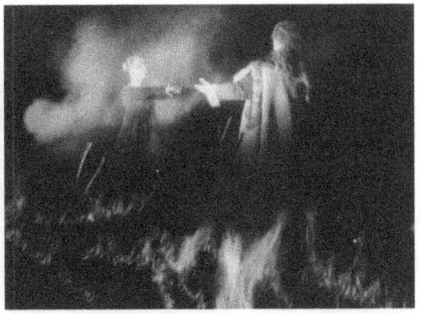

Figure 5.9 Christ Crucified transformed into the ghost of Master Anton. *Vem dömer* (Victor Sjöström, 1922). Digital film grab (SFI).

Figure 5.10 Ursula, guided through the fire. *Vem dömer* (Victor Sjöström, 1922). Digital film grab (SFI).

impersonation by an actor."[37] While this resolution seems to be a religious one, Tom Milne points out that it is striking that the film refuses to "dissociate the flesh and the spirit in its symbolism."[38]

It is quite possible that these criticisms led to the film being recut when it was released in the United States. The film's censored recutting for the American market itself is supported by two ads that freelance editor Lesley Mason took out to boast about his work on *Mortal Clay*.[39] Furthermore, *Pictures and the Picturegoer* also noted that *Vem dömer* had undergone a metamorphosis on the American screen compared to how it was released in Sweden:

> In Sweden, the heroine was a murderess – in America she became an innocent young thing wrongfully accused, and the sun made a halo of her vindicated curls before the final "fade-out." Consequently, as this picture was distinguished by qualities that were altered beyond recognition in America, that country wanted the producer.[40]

If Victor Sjöström had not already experienced the practice of his films being recut for foreign markets first-hand, he was about to. The production of his first American feature for Goldwyn was an adaptation of Hall Caine's 1921 bestseller *The Master of Man: The Story of Sin*, once again a female-centred story of crime and redemption. It was adapted as *Name the Man* (1924), starring Mae Busch and Conrad Nagel. As Bengt Forslund notes, the production started off with a screenplay that was too long and ended up being cut down from Sjöström's perceived twelve acts to eight acts. Nevertheless, the film was a huge hit.[41]

CIRCULAR FRAMES AND PASSIONATE TABLEAUX

The presence of Anton's ghost in the narrative of *Vem dömer* would not have come as a surprise to those familiar with the work of Sjöström, or with Swedish culture more broadly. By then, ghosts had dominated the supernatural stories of Nobel Prize-winning Selma Lagerlöf, and a lot of Lagerlöf's mystical elements certainly echo throughout Hjalmar Bergman's *Vem dömer* script. Svenska Bio had already bought the rights to all of Selma Lagerlöf's work prior to 1919 and it first started adapting her work to the screen in 1917.[42] This led to such haunting films as, for instance, *Ingmarssönerna* (*Dawn of Love*; Victor Sjöström, 1919), which deals with an arranged marriage and consultations with the deceased in heaven; *Herr Arnes pengar* (*Sir Arne's Treasure*; Mauritz Stiller, 1919), filled with ghosts, omens, curses, and the "hand of God;" and, of course, *Körkarlen* (*The Phantom Carriage*; Victor Sjöström, 1921), in which souls are collected and ghosts haunt past, present, and future.

In all of these films, ghosts are manifestations of lives lost, of characters that were first alive and then shuffled off this mortal coil. The visualization of these specters through masterful superimpositions was undoubtedly an important part of why these films were lauded critically, and many of these critics saw the cinema as *the* medium to represent the supernatural. German author Friedrich Freksa, for instance, observed in 1916 that

> like living ghosts, the cinema can conjure up events of a grotesque and magical kind, which never take place in life and could never appear on the stage. This clearly marks the territory that could become meaningful for the art of cinema.[43]

In 1923, our aforementioned Italian theorist Ricciotto Canudo similarly posited that "cinema permits, and must further develop, the extraordinary and striking faculty of representing immateriality."[44] The emphasis on past lives in the work of Selma Lagerlöf famously made the author turn to flashbacks that thoroughly shaped the structure of her stories, and these structures were consequently adapted to film, long before they became a staple of film noir narratives in the 1940s. We can identify flashbacks in *Ingmarssönerna* and *Herr Arnes pengar*, and in *Körkarlen* we even get flashbacks within flashbacks that were found to be "curiously original in construction."[45] *Klostret i Sendomir*, adapted from a story by Romantic Austrian author Franz Grillparzer, is also shaped by flashbacks. French film writer Georges Sadoul has gone on record saying that Sjöström and his cinematographer Julius Jaenzon's (also J. Julius) advanced visualization of flashbacks and spectral imagery was still being discussed in Paris around 1945 as an example to aspire to.[46]

Vem dömer's structure is similarly haunted, but instead of flashbacks it is

crafted into a circle on a visual and narrative level, effectuating repetition and reenactment through visual motifs, superimpositions, and cross-dissolves. As Maureen Turim sees it, in *Körkarlen*, the "memory of the past links the supernatural, the morality tale, and the dream state."[47] The same can be said of *Vem dömer*, although the dream state corresponds more with a vexation on past events that makes our protagonist Ursula have visions and perform reenactments. The most prominent circularity to the story is the aforementioned bookending by the statue of Christ Crucified. What is more, we find Ursula praying to the statue in the opening scene, going into the church alone to pray for her deliverance through death; as well as in the final scene, thankful for her vindication after her trial by fire. Her own pose (kneeling, praying, staring intently ahead) and that of the crucified Christ (upright and arms splayed wide open) are performed and reenacted multiple times throughout the narrative.

The wedding scene that follows holds the first instance in which both poses are mirrored. When Anton wants to go in for a hug after their marriage is officiated, he opens his arms wide and artificially slows down his actions to create a tableau vivant moment. He moves ever so slightly closer to Ursula, who is looking at him and holding her hands together (Figure 5.11). Though perhaps a subtle gesture, the subsequent iris-out to black is followed by an iris-in to the statue of Christ Crucified, unmistakably shot in the same position and from the same angle. This reciprocation of Anton's pose in statuary form is not just a visual motif, but also a foreshadowing of the metamorphosis that the Christ Crucified statue will undergo as it turns into Anton's specter in the end. Sjöström unfolds this visual reciprocity even further in the following shot, when we see that Anton is working on the sculpture of Ursula in her

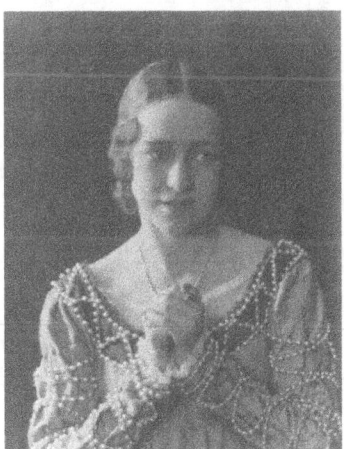

Figure 5.11 Ursula, pious in her wedding gown. *Vem dömer* (Victor Sjöström, 1922). Film production still (SFI).

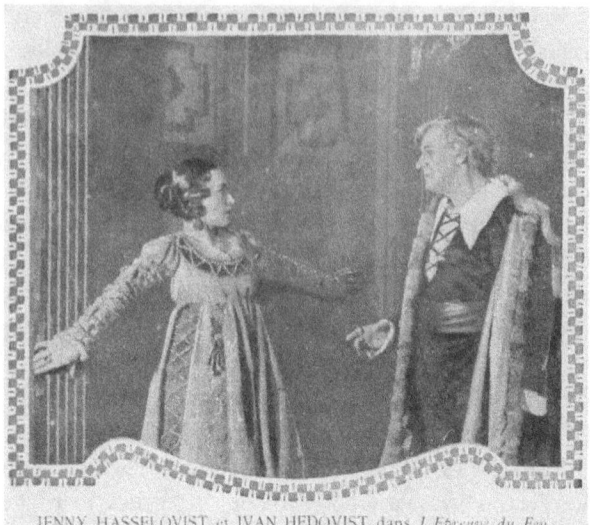 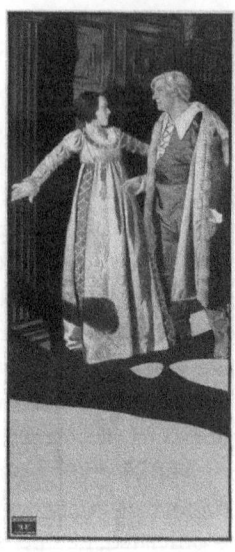

Figure 5.12 Jenny Hasselqvist and Ivan Hedqvist in a key pose in *Vem dömer* (Victor Sjöström, 1922). Production still. Lionel Landry, "L'Epreuve du Feu." *Cinéa* 2, 81 (15 December 1922), 16 (MHDL).

Figure 5.13 The same key pose as painted advertising for *Vem dömer* (Victor Sjöström, 1922). (SFI).

praying position (known as the Coronation of the Virgin motif), quite literally molding her human form into this pose.

Just as Ursula is forced into her submissive pose by way of a clay proxy, Anton is forced into his pose by Ursula's affair with Bertram. When Ursula is meeting with her love interest, the sculptor seems to have a premonition that this is going on through Victor Sjöström's clever crosscutting between the two actions. Sweating profusely, Anton grabs at his heart and leans on his statue. When his two assistants grab hold of him he pushes them away and holds his arms wide open for a few seconds. At this point, the sculptor looks to have suffered a stroke and, significantly, this is also how he will die later in the film. When Anton goes back to the house after learning that Ursula and Bertram have devised a suicide pact, he first tries to strangle Ursula and then gain entry to the room that Bertram is in. Ursula bars the door with her arms splayed wide, assuming Anton's death pose in an image that also featured heavily in the advertising for the film (Figures 5.12 and 5.13). The pose forces Anton back as he reaches for his heart again, stumbling to grab onto a mantle in front of a mirror. He begs Ursula for water, but spies in the mirror that she is poisoning his drink with the powder that the monk has given her – and which the spectator knows to be harmless. In an almost supernatural fashion,

Figure 5.14 Assembling the stake. *Vem dömer* (Victor Sjöström, 1922). Film production still (SFI).

Figure 5.15 The Dance of Death in *Det sjunde inseglet* (*The Seventh Seal*, Ingmar Bergman, 1957). Film production still (SFI).

invisible forces seem to drive Anton's arms open and force him back against the wall. A single light illuminates the sculptor's face and torso in the same way that the statue of Christ Crucified is lit, and the camera pushes forward to a medium close-up as we watch the life drain out of Anton's eyes.

Between Ursula's lover Bertram's arrest and his imminent demise at the stake, Sjöström crosscuts between: on the one hand, the community coming together to build the stake in an impressively pictorial sequence that no doubt inspired Ingmar Bergman for his famous horizon scene in *Det sjunde inseglet* (*The Seventh Seal*, 1957) (compare Figure 5.14 to 5.15); and, on the other hand, Ursula and the monk, who are isolated in the room Anton died in, trying to piece together what happened and reenacting it in the process. Taking a step back, it is important to frame Anton's visual equation with Christ's death as a reenactment in and of itself. As Candida R. Moss has noted, the bodily and cultic reenactment of Christ at the cross dates back to the reign of Marcus Aurelius, including in the liturgical codification of a pose known as "Orans" (Figure 5.16).[48] In the Middle Ages and the Renaissance, then, the Passion of the Christ became an important part of performance culture through Passion Plays and tableaux vivants.[49]

Anton seems compelled to take on the Orans posture when dying, and Ursula reenacts it to come to terms with her responsibility for his death. When she takes on his final pose, Ursula commands Anton's specter and literally loses herself in the celluloid for a few beats through a measured lap dissolve. It is not until Ursula is standing before the mirror and sees the reflection of the monk pouring a glass of water that she realizes Anton saw her mixing in the supposed poison. This last-minute realization of her implicit responsibility triggers a sincere emotional reaction. It coerces her to take on Anton's

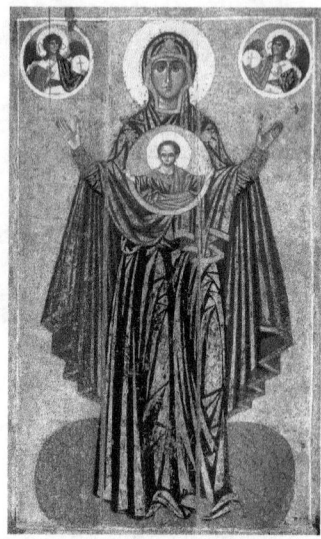

Figure 5.16 Orans posture. Thirteenth-century icon of Our Lady of the Sign from Yaroslavl. Kiev School, c. 1114. Tretiakov Gallery, Moscow (WC).

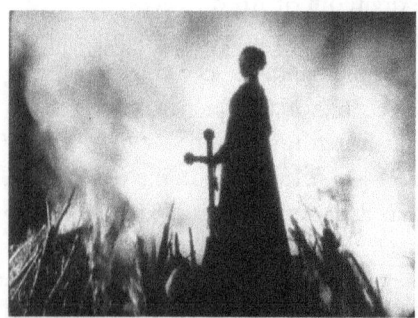 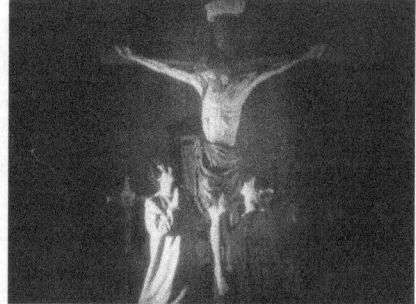

Figure 5.17 Ursula at the stake. *Vem dömer* (Victor Sjöström, 1922). Digital film grab (SFI).

Figure 5.18 Ursula and Bertram kneeling before the statue of Christ Crucified. *Vem dömer* (Victor Sjöström, 1922). Digital film grab (SFI).

final pose, which is staged by Sjöström with the same intensity, lighting, and push in from the camera. The next time we see Ursula, she has shown up at the stake as a mythical figure, silhouetted in contre-jour and surrounded by fire and smoke (Figure 5.17). She is guided through the fire by Christ in the form of Anton's ghost and closes out the film in her initial kneeling position by the statue of Christ Crucified (Figure 5.18).

OLD MASTERS ANEW: A SCANDINAVIAN DISSOLVE

It is clear that Sjöström was well versed in the subject matter and iconography of *Vem dömer*'s Renaissance setting. In its scenography and cinematography, too, the film seeks to reference and rejuvenate the "Old Masters." In doing so, Sjöström was building on the European tradition of Pictorialist filmmaking that we have discussed at length in the previous chapter and that was still going strong. Alongside France and Italy, Sweden and Denmark had a big stake in this aesthetic approach, exporting it internationally. This tableau style was effectuated by what was referred to in Sjöström's and others' work as "Netherlandish" images – to borrow Bøgh Rønberg's term once more – composed of the by now familiar chiaroscuro "Rembrandt" lighting and a long-take mise-en-scène that employed deep staging and aperture framing.[50]

Contemporary film journals likewise invoked the Old Masters to speak about the medium of film as an art. They most often referred to Rembrandt, Rubens, and Velázquez, which betrayed a predilection for seventeenth-century artists that must have featured in the minds of filmmakers as well, most of whom came from a background in visual and performing arts at this time. As journalist Marjorie Mayne noted in 1924, Victor Sjöström and his fellow directors must have undoubtedly gone to museums as well to be inspired for their films:

> It is certain that the Old Masters inspire the New. For composition, for lighting effects, for draperies, costumes and types, [they] translate what they find into celluloid, using their own medium of light and shade [. . .]. [T]he best of them hail from the Old World: Seastrom, Stroheim, Ingram, Lubitsch, Gance, Pearson [. . .] And the director went to the picture galleries for his data. Victor Seastrom re-incarnated Renaissance art in *Love's Crucible*, scene after scene of which remains an unforgettable memory.[51]

Viewing *Vem dömer* as if it were a moving painting is indeed an effective strategy for analyzing the film. Indeed this holds true by extension for the whole strand of European cinema of the 1910s and early-to-mid-1920s that we have been discussing. As Martha Hollander has noted in her analysis of seventeenth-century Dutch and Flemish art, artists such as Jan Vermeer, Pieter de Hooch, Rembrandt and Nicolaes Maes "ingenuously manipulated the space within their pictures" by creating different areas for their figures to inhabit; these scenes-within-scenes were introduced by devices such as "archways, open doors, pulled-back curtains [. . .] or appear within the frames of mirrors and pictures on walls."[52] This "entrance for the eyes," as Hollander has called it, became a formula that banked heavily on the use of perspective, depth, and aperture framing in interiors by the middle of the century, and

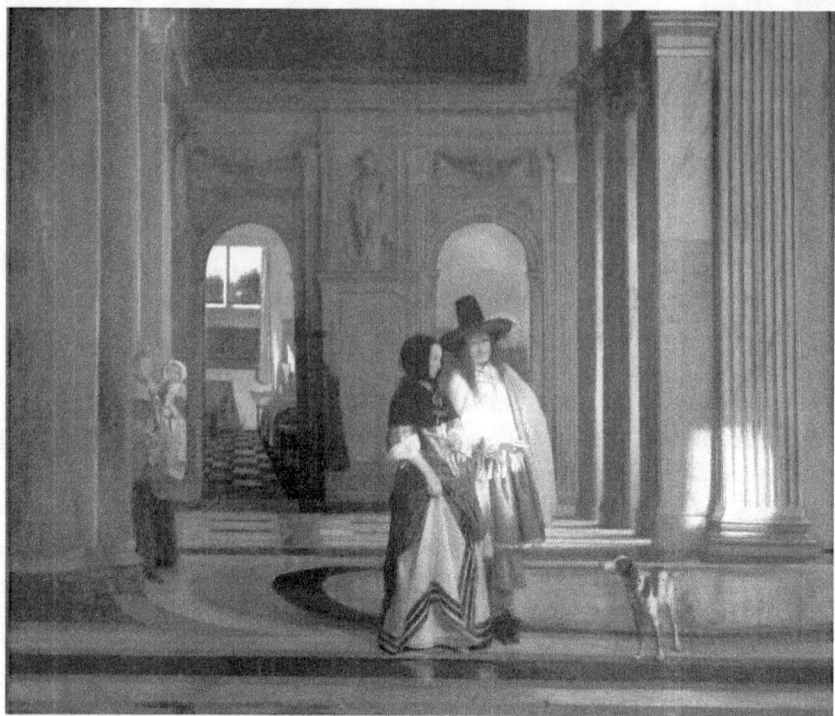

Figure 5.19 *Een stel wandelt door het Stadhuis van Amsterdam* (*A Couple Walking in the Citizens' Hall of Amsterdam Town Hall*; Pieter de Hooch, c. 1663–5). Painting, oil on canvas. Musée des Beaux-Arts, Strasbourg (WC).

which also integrated religious allegories into secular spaces.[53] A marvelous instance of a painting that exemplifies this "entrance for the eyes" is Pieter de Hooch's *Een stel wandelt door het Stadhuis van Amsterdam* (*A Couple Walking in the Citizens' Hall of Amsterdam Town Hall*, c. 1663–5) (Figure 5.19), which reads as a number of subdivided narratives that stand in close relation to one another to create a whole.

In *Vem dömer*, one scene where this approach is formidably illustrated sees Bertram moping on a street corner after being told by his father, the mayor, that he is not to see Ursula anymore. Staged on the foreground, Bertram and the right wall of the street corner act as a *repoussoir* that creates extra depth in the left side of the frame. The left side of the frame is further subdivided into a middle ground and a deep background. On the far left is the middle ground that holds a torch and a door, and to its right we find an arch that frames the action in the deep background (Figure 5.20). Interestingly, when Sjöström cuts closer on the axis, as Bertram's father comes by to offer some consoling words, we see that the two actresses in the deep background

Figure 5.20 Sjöström's subdivision of the frame – 1. establishing shot. *Vem dömer* (Victor Sjöström, 1922). Digital Film Grab (SFI).

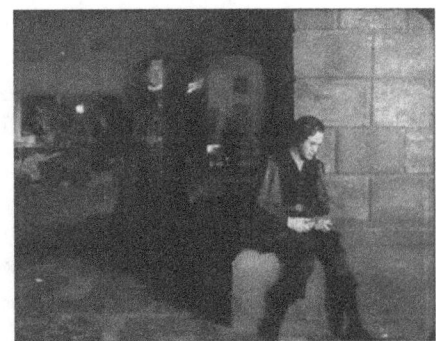

Figure 5.21 Sjöström's subdivision of the frame – 2. cut closer on the axis. *Vem dömer* (Victor Sjöström, 1922). Digital Film Grab (SFI).

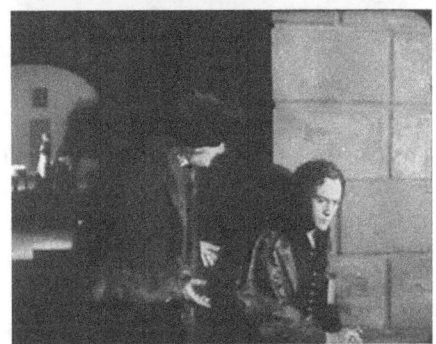

Figure 5.22 Sjöström's subdivision of the frame – 3. re-establishing shot. *Vem dömer* (Victor Sjöström, 1922). Digital Film Grab (SFI).

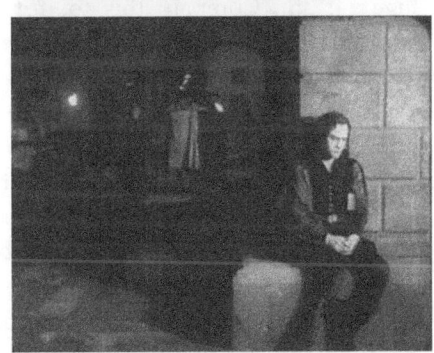

Figure 5.23 Sjöström's subdivision of the frame – 4. final reframing. *Vem dömer* (Victor Sjöström, 1922). Digital Film Grab (SFI).

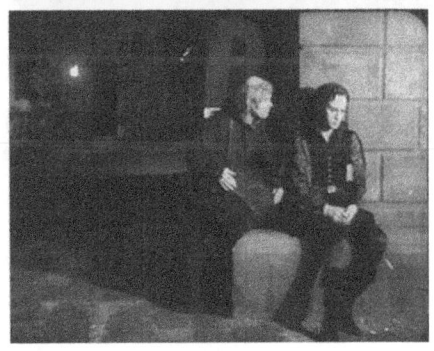

remain deliberately frozen to effectuate a tableau vivant (Figure 5.21). They resume their action only after Anton has joined the conversation in the foreground. He dismisses Bertram with a wave of his hand and walks off and away through the arch with his friend, the mayor, trading places with the monk who will sell Ursula the fake poison (Figure 5.22). The camera tilts down slightly to reframe the action when the monk reaches the foreground and the lighting once again emphasizes the different frames-in-frame and zones of depth in Sjöström's minute composition (Figure 5.23). With minimal editing but maximal staging, Sjöström manages to create complex relationships that play out between most of the key players in his film.

This is far from the only scene that is played out in this referential way. This can be evidenced, for instance, in the iconic, repeated shot of Ursula entering and leaving the church (Figure 5.24). The pillars, the lighting, and the floor tiles are used to frame Ursula in line with the Statue of Christ Crucified, creating a visual analogy on what is a set built from scratch. We see it also in the deep-focus composition with aperture framing that has the monk leaving Ursula's room after his sale of poison, as well as Ursula subsequently letting Bertram in that same room but from another door; or in Ursula's and the monk's grieving by Master Anton's bed after his death, with each character occupying a particular place in the subdivided screen (Figure 5.25). Compare this to, for instance, Nicolaes Maes's curtained trompe l'oeuil painting *Afluisterend dienstmeisje naast een half weggeschoven gordijn* (*Eavesdropper with a Scolding Woman*; c. 1655) (Figure 5.26) and Samuel van Hoogstraten's *De Pantoffels* (*The Slippers*; 1660) (Figure 5.27). On the whole, as Astrid Söderbergh Widding has noted, Swedish and Danish cinema had a predilection for using scenic space and frame-in-frame devices in interesting ways in the silent period.[54] This seems to be particularly true for period pieces. Three Danish Nordisk films from the first part of the 1920s come to mind: the very first silver screen rendition of the much adapted, seventeenth-century-set Danish classic written by Steen Steensen Blicher, *Præsten i Vejlby* (*The Hand of Fate*; August Blom, 1922); the unsung masterpiece *Lasse Månsson fra Skaane* (*Struggling Hearts*; A.W. Sandberg, 1923), which takes place in 1658; and *Fra Piazza del Popolo* (*Mists of the Past*; A.W. Sandberg, 1925), in which we are transported to 1820s Denmark and Rome.

On a final note, I would like to point to Sjöström's and his cinematographer Julius Jaenzon's use of the languid cross-dissolve as a scene transition in *Vem dömer*, which Florin has called "transformatory devices."[55] I propose we start calling this effect the "Scandinavian dissolve," in honor of the Swedish and Danish directors such as Sjöström, Stiller, and Dreyer who seemed to have pioneered and perfected this particular brand of deliberately delayed dissolve from the late 1910s throughout the 1920s. The transitional device

Figure 5.24 Ursula's tightly framed position on the church set. *Vem dömer* (Victor Sjöström, 1922). Film production still (SFI).

Figure 5.25 Ursula and the monk grieving in a subdivided frame. *Vem dömer* (Victor Sjöström, 1922). Film production still (SFI).

Figure 5.26 *Afluisterend dienstmeisje naast een half weggeschoven gordijn* (*Eavesdropper with a Scolding Woman*; Nicolaes Maes, c. 1655). Painting, oil on panel and mixed media. Private Collection (WC).

Figure 5.27 *De pantoffels* (*The Slippers*; Samuel van Hoogstraten, c. 1660). Painting, oil on canvas. The Louvre, Paris (WC).

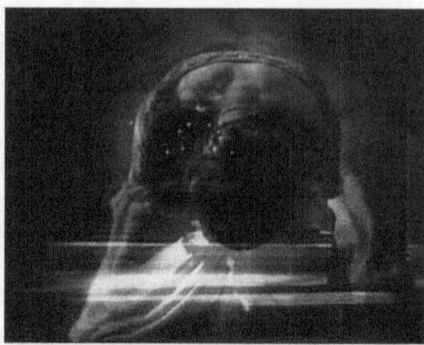

Figure 5.28 Ursula caught in a Scandinavian dissolve. *Vem dömer* (*Love's Crucible*; Victor Sjöström, 1922). Digital film grab (SFI).

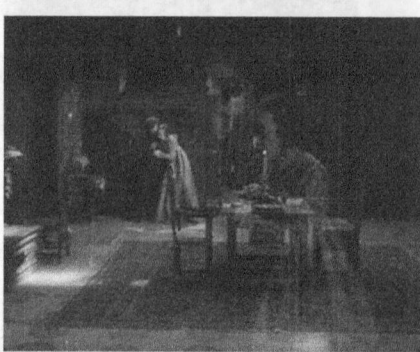

Figure 5.29 Ursula caught in a Scandinavian dissolve. *Vem dömer* (*Love's Crucible*; Victor Sjöström, 1922). Digital film grab (SFI).

Figure 5.30 Ursula caught in a Scandinavian dissolve. *Vem dömer* (*Love's Crucible*; Victor Sjöström, 1922). Digital film grab (SFI).

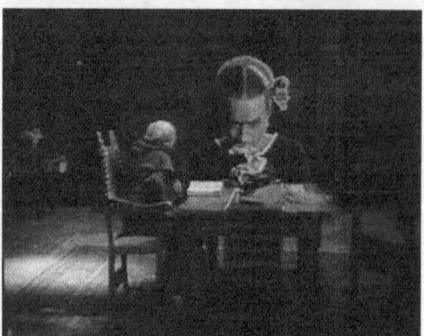

Figure 5.31 Ursula caught in a Scandinavian dissolve. *Vem dömer* (*Love's Crucible*; Victor Sjöström, 1922). Digital film grab (SFI).

seems to have faded out in the sound era. These Scandinavian dissolves work as complements to the subdivision of the frame, doubling up the image to create exquisitely composed frames-*on*-frames. These doubled-up frames generate a spectral iconography that is highly particular, in keeping with the literary tradition of Lagerlöf, and also seemingly in tune with modernist modes of photography, which skewed towards embracing the optical possibilities of the medium in the same way that cinema would. In *Vem dömer*, Sjöström technically uses Scandinavian dissolves to move further and closer on the axis, to create shot-reverse shots, and simply to replace hard cuts, but their real power lies in the systematic nature with which they make Ursula bleed into and haunt every frame (Figures 5.28–5.31).

Notes

1. AB Svenska Biografteatern operated from 1907 until 1919, when it merged with Filmindustri AB Skandia and became Svensk Filmindustri AB. To the outside world, the company would remain known as Swedish Biograph. Charles Magnusson continued to run the company until 1928, and it still exists today. John Fullerton, "Svenska Biografteatern" in Richard Abel (ed.), *Encyclopedia of Early Cinema* (London and New York: Routledge, 2005), 890–1.
2. Anders Marklund, "The Golden Age and Late Silent Cinema: Introduction" in Mariah Larsson and Anders Marklund (eds.), *Swedish Film: An Introduction and Reader* (Lund: Nordic Academic Press, 2010), 72–5.
3. Steve Neale, "Introduction 2: The Long Take – Concepts, Practices, Technologies, and Histories," in John Gibbs and Douglas Pye (eds.), *The Long Take: Critical Approaches* (London: Palgrave Macmillan, 2017), 31.
4. Anon., "Reids and Rawlinsons of Sweden," *Photoplay* 17, 1 (December 1919), 32.
5. Linda A. Griffith, "Comments and Criticisms of a Free-Lance," *Film Fun* 31, 363 (July 1919), 6–7.
6. The Edison company famously duped, or copied, many foreign negatives that they distributed, passing them off as their own product. If a particular popular print was not in their realm, Edwin Porter would often remake it. Peter Decherney, *Hollywood's Copyright Wars: From Edison to the Internet* (New York: Columbia University Press, 2013), 64.
7. Anon., "Les Merveilles du Cinéma Suédois," *Cinéa* 11 (special issue) (15 July 1921), cover. Author's translation.
8. Anon., "Les Films Suédois à Revoir et à Voir," *Cinéa* 11 (special issue) (15 July 1921), 5.
9. R.L.C., "Victor Sjostrom [sic]," *Cinéa* 11 (special issue) (15 July 1921), 21. Author's translation.
10. Anon., "Picture Plays and People," *The New York Times* 71, 23,549 (16 July 1922), 3.

11. Ingmar Bergman and Marianne Ruuth (transl.), *Images: My Life in Film* (New York: Arcade Publishing, 1994), 24.
12. Bo Florin, *Transition and Transformation: Victor Sjöström in Hollywood 1923–1930* (Amsterdam: Amsterdam University Press, 2012), 23.
13. Erik Hj. Linder, Marna Feldt and Carmen Sandström-Smith (transl.), "Hjalmar Bergman in Hollywood: A Sad Chapter" in Nils Y. Wessell (ed.), *The American-Swedish '72* (Philadelphia: American Swedish Historical Foundation, 1972), 49.
14. Gore, "Love's Crucible," *Variety* 67, 6 (30 June 1922), 33.
15. Frances Taylor Patterson also started teaching screenwriting at Columbia University in the late 1920s. Frances Taylor Patterson, "The Swedish Photoplays," *Exceptional Photoplays* 3, 2 (December 1922), 4.
16. Don B. Wilmeth, "1865–1915" in Barry B. Witham, (ed.), *Theatre in the United States: A Documentary History. Volume I: 1750–1915 – Theatre in the Colonies and United States* (Cambridge and New York: Cambridge University Press, 1996), 309.
17. Dorothy Chansky, *Composing Ourselves: The Little Theatre Movement and the American Audience* (Carbondale: Southern Illinois University Press, 2004), 4.
18. Lucy Fischer, *American Cinema of the 1920s: Themes and Variations* (New Brunswick and London: Rutgers University Press, 2009), 7.
19. Graham Petrie, *Hollywood Destinies: European Directors in America, 1922–1931* (Revised Edition) (Detroit: Wayne State University Press, 2002), 21.
20. Apart from Petrie (2002), see also: Harry Waldman, *Hollywood and the Foreign Touch: A Dictionary of Foreign Filmmakers and their Films From America, 1910–1995* (Lanham and London: The Scarecrow Press, 1996) and Larry Langman, *Destination Hollywood: The Influence of Europeans on American Filmmaking* (Jefferson and London: McFarland & Company, 2000).
21. Curtis Melnitz quoted in Helen V. Swenson, "Is There an Undiscovered Picture Audience?," *Exhibitors Trade Review* 14, 23 (3 November 1923), 1031.
22. Anon., "Organization of Little Theatre: Advisory Board Completed with Addition of Several Names," *Exhibitors Trade Review* 14, 9 (28 July 1923), 379.
23. Tony Guzman, "The Little Theatre Movement: The Institutionalization of the European Art Film in America," *Film History: an International Journal* 17, 2/3 (2005), 265.
24. Anon., "Little Theatre's Initial Picture," *Exhibitors Trade Review* 14, 4 (23 June 1923), 154.
25. Anon., "Curtis Melnitz Quits Little Theatre Films," *Exhibitors Herald* 18, 3 (12 January 1924), 24.
26. Chaplin, Charles quoted in Helen V. Swenson, "Is There an Undiscovered Picture Audience?," *Exhibitors Trade Review* 14, 23 (3 November 1923), 1031.
27. Constance Palmer Littlefield, "New Hope for the American Photoplay: Victor Seastrom Talks about Our Motion Pictures," *Screenland* 8, 1 (October 1923), 83.
28. Don Ryan, "Entrechats of Irony: A somewhat futile attempt to interview Victor Seastrom," *Picture-Play Magazine* 20, 1 (March 1924), 23.
29. Susan Felleman, *Art in the Cinematic Imagination* (Austin: University of Texas Press, 2006), 157.

30. Lilian H. Zirpolo, *The A to Z of Renaissance Art* (Lanham, Toronto, and Plymouth: The Scarecrow Press, 2009), 110.
31. Christa Grössinger, *Picturing Women in Late Medieval and Renaissance Art* (Manchester and New York: Manchester University Press, 1997), 20.
32. Margot and Rudolf Wittkower, *Born Under Saturn: The Character and Conduct of Artists – A Documented History from Antiquity to the French Revolution* (New York: New York Review of Books, 2007).
33. Colette M. van Kerckvoorde, *An Introduction to Middle Dutch* (Berlin and New York: Mouton de Gruyter, 1993), 180.
34. Vito Adriaensens and Steven Jacobs, "The Sculptor's Dream: Tableaux Vivants and Living Statues in the Films of Méliès and Saturn," *Early Popular Visual Culture* 13, 1 (2015), 45–7.
35. Vito Adriaensens, "Die ewige Nacht" in Steven Jacobs, Susan Felleman, Vito Adriaensens, and Lisa Colpaert, *Screening Statues: Sculpture and Cinema* (Edinburgh: Edinburgh University Press, 2017), 181.
36. Gore, "Love's Crucible," *Variety* 67, 6 (30 June 1922), 33.
37. T.P. O'Connor quoted in Gore, "Love's Crucible," *Variety* 67, 6 (30 June 1922), 33.
38. Tom Milne, "Vem Dömer? (Love's Crucible)," *Monthly Film Bulletin* 45, 528 (January 1978), 15.
39. Lesley Mason, "'Mortal Clay' Will Be the Talk of the Season," *The Film Daily* 21, 78 (18 September 1922), 3 and Lesley Mason, "Don't Take MY Word for It!," in Joseph Dannenberg, *Film Year Book 1922–1923* (New York and Hollywood: Wid's Films and Film Folks, Inc., 1923), 124.
40. Anon., "The Sombreness of Seastrom," *Pictures and the Picturegoer* 10, 57 (September 1925), 46.
41. Bengt Forslund and Peter Cowie (transl.), *Victor Sjöström: His Life and His Work*. New York: Zoetrope, 1988), 183.
42. Tytti Soila, "Sweden," in Tytti Soila, Astrid Söderbergh Widding, and Gunnar Iversen, *Nordic National Cinemas* (London and New York: Routledge, 1998), 160.
43. Friedrich Freksa and Eric Ames (transl.), "Theater, Pantomime, and Cinema," in Anton Kaes, Nicholas Baer and Michael Cowan (eds.), *The Promise of Cinema: German Film Theory, 1907–1933* (Oakland: University of California Press, 2016), 114. First published as Friedrick Freksa, "Theater, Pantomime und Kino," *Dramaturgische Blätter* 6 (April 1916), 125–30.
44. Ricciotto Canudo quoted in Murray Leeder (ed.), *Cinematic Ghosts: Haunting and Spectrality from Silent Cinema to the Digital Era* (New York and London: Bloomsbury, 2015), 6.
45. Gladys Bollman, "Reviews of Films," *Educational Film Magazine* 5, 4 (April 1921), 20.
46. Forslund, *Victor Sjöström*, 53.
47. Maureen Turim, *Flashbacks in Film: Memory & History* (New York and London: Routledge, 1989), 96.

48. Candida R. Moss, *The Other Christs: Imitating Jesus in Ancient Christian Ideologies of Martyrdom* (Oxford and New York: Oxford University Press, 2010), 65.
49. Gerard Nijsten, "Feasts and Public Spectacle: Late Medieval Drama and Performance in the Low Countries," in Alan E. Knight (ed). *The Stage as Mirror: Civic Theatre in Late Medieval Europe* (Cambridge: D.S. Brewer, 1997), 107–44.
50. This term was used throughout art history and in the nineteenth century to refer specifically to seventeenth-century Dutch painting. Lene Bøgh Rønberg, "Bourgeois Home Life in the Two Golden Ages: Influences and Correspondences" in Kasper Monrad, Ragni Linnet, and Lene Bøgh Rønberg (eds.), *Two Golden Ages: Masterpieces of Dutch and Danish Painting* (Zwolle and Copenhagen: Rijksmuseum Amsterdam and Statens Museum for Kunst, 2001), 74.
51. Marjorie Mayne, "The New Masters," *Pictures and the Picturegoer* 7, 37 (January 1924), 41 and 44.
52. Martha Hollander, *An Entrance for the Eyes: Space and Meaning in Seventeenth-Century Dutch Art* (Berkeley, Los Angeles, and London: University of California Press, 2002), 1–2.
53. Hollander, *An Entrance for the Eyes*, 3.
54. Astrid Söderbergh Widding, "Towards Classical Narration? Georg af Klercker in Context," in John Fullerton and Jan Olsson (eds.), *Nordic Explorations: Film Before 1930* (Sydney: John Libbey, 1999), 187–203.
55. Bo Florin, *Transition and Transformation*, 21.

CONCLUSION

Towards a Cultural Poetics of Early European Cinema

> The moving picture is scarcely twenty-five years old. Born of a matchless technical invention, it demands to-day, with the unrelieved arrogance of the proverbial upstart, complete recognition in the society of the arts. There, in the company of the established arts, it finds illustrious companions each of whom looks back upon a proud tradition of hundreds and hundreds of years. The old arts, however, are reluctant about admitting the moving picture to their family.[1]

When German writer Walter Bloem looked at the place of film as an art form in 1922, he offered up a surprisingly insightful and frank analysis. Far less flowery than his French-Italian counterpart Ricciotto Canudo, and prone to fewer maxims, Bloem was under no illusions about the artistic nature of cinema. He had seen the medium thrust itself onto the world stage and develop into an undeniable player in the cultural and artistic field in record time, buoyed by masses that connected with its ability to create immersive and cathartic emotional experiences. There was no doubt in Bloem's mind about cinema's place among the arts, but he recognized that it was a commercial medium at heart and that films born from strictly artistic considerations would not make for a sustainable model. This had been evidenced by French production company Le Film d'Art, after all. Like this very book, Bloem considered what "artistic progress" in cinema actually looked like, then, when weighed against evolutions in visual arts and taking mass commercialism into account.

Velvet Curtains and Gilded Frames has looked at the place of European cinema between 1908 and 1914 from several different perspectives, briefly looking ahead to the late 1910s and early 1920s. The end goal has always been to better understand the driving cultural and artistic forces at play behind this formative period in film history. From a historiographical standpoint, researching this subject means coping with the loss of a large percentage of celluloid and revisiting the primary materials that remain. Luckily, due to the high demand for films, European studios standardized production early on and cranked out films at a furious pace, allowing a fair sample to stand the test of time. Furthermore, surviving stills, programs, screenplays, advertising,

newspaper reviews, journals, and autobiographies form an equally important part of the primary research material, a good deal of which lies virtually untouched in archives in libraries, or has only recently been made available to the scientific community through large-scale digitization efforts, such as the Media History Digital Library and the Bibliothèque nationale de France's Gallica, following a push in the field of digital humanities. When it comes to film archives, the digitization and accessibility efforts made by the Danish Film Institute and the Eye Film Museum have stood out tremendously. Visiting a lot of these sources for the first time, reassessing earlier claims in secondary studies, and cutting through language and medium barriers, I argue strongly in favor of an intermedial, new historicist approach towards early European cinema in order to answer how the makeup of this relatively new art form related to society. This inquiry has led to my proposal of a "cultural poetics," following Greenblatt, that views the dramatic fiction film in early European cinema as an exponent of Bourgeois Realism, one of the main artistic modes of the long nineteenth century.

Providing a theoretical framework to work with, as well as against, I have used the introduction to this book to first analyze concrete examples of relatively recent calls for papers from European conferences on the historiography of cinema and new media. The ubiquity of their themes, which have returned to us in cycles across every decade since at least the 1970s, proves that the issues we are dealing with when writing film history remain topical and largely the same. The international aspirations and global market positions of this book's main film company case studies, Gaumont and Nordisk, are invoked to explain why they prove excellent representatives for the whole of European cinema. Where quite a bit of excellent secondary research exists on Gaumont in French and English, I made use of the well-preserved primary archival source materials for Nordisk at the Danish Film Institute and the sparse secondary material, though growing, which was mostly in Danish. These two companies were also representative of European trends in that both produced explicitly "artistic" series in the wake of the "*film d'art*" phenomenon. This move was meant to elevate the status of their output and draw in new middle- and upper-class audiences. Though a national context is certainly unavoidable when researching the specificities of these cases, I plead for an overarching "European" class view in this book. Silent films traveled freely between countries, European film companies set out to make universally viewable output that was not country-specific, the *film d'art* phenomenon was transnational, and both content and style were aimed at reeling in middle- and upper-class audiences. The compounding effects of these targeted efforts trump impetuses of nationally specific cultures. Films of which the sensibilities and storylines would only be understood in Denmark

were not commercially viable enough to consider. To this we can couple the continuation and persistence of artistic strategies that were popular in Europe, viewing its cultural context not as a modern(ist) one – following the challenge of the "modernity thesis" by such scholars as David Bordwell and Charlie Keil – but as a long nineteenth century in which popular, more classic modes, persisted over "new" styles that had very slowly been gaining acceptance within visual arts.

The first chapter proper tracks the rhetorical and productional "birth of a sixth art." It describes the history of the art film in Europe, elaborating on the pioneering role of Le Film d'Art, the company, and its relationship to larger companies at the time. I argue that there are two distinct phases to be discerned in the evolution of the art film. Phase one is characterized by a dominance of popular classics: biblical, mythological, literary, theatrical or operatic subject matter, mostly with a historical bent, and around 1908–9, with precedents dating back to 1905. Phase two displays a shift towards more contemporary environments and towards stories with a melodramatic bent – including many adaptations of more contemporary popular classics – starting around 1910–11. This evolution and shift in emphasis in the art film is analyzed at both main case companies to demonstrate the common ground that they share, and to point out where they display singularities. The companies' bold promotional statements did not mean that everyone suddenly deemed film an art, however, since this was very much up for debate. The film-as-art debate was very present in contemporary journals, and authors were particularly concerned with medium specificity, weighing film critically against performing and visual arts, and realism. They considered the (im)possibility of mediating reality via a mechanical device; the very issue that, according to some, prevented photography from being considered a legitimate art form. This is followed by a close reading of the work of Ricciotto Canudo, who, as one of the first film theoreticians, embodies the general discursive concerns of the moment, and writes exhaustively of intermediality, medium specificity, and realism. At the same time, Canudo characterizes the contradictory qualities of the early-twentieth-century intellectual, combining anachronistically Romantic ideas with Futurist tendencies.

The next chapter serves to make explicit the connection between early European cinema and the theatre, the cultural communion between stage and screen. This relationship is often acknowledged as being present, or written about as being a difficult one in the silent era, but very seldom explored in depth or supported by solid research. My investigation follows the work done by scholars such as Brewster and Jacobs, David Mayer, Christine Gledhill, Jon Burrows, and Victoria Duckett. Focusing mostly on the situation at Nordisk, I first demonstrate that there was a high degree of intermedial actorial and

directorial activity, as personnel switched fluidly and often between the stage and the screen and back, the two thus clearly sharing a performative context. Subsequently the chapter delves into the two media's mutual marketing strategies, proving that cinema took over the theatre's promotional tactics to attract audiences and imbue themselves with the latter's prestige. Film production companies worked with printed programs, started crediting actors, and exploited their films' connections to the stage in trade journals. These strategies led directly to the creation of a cinematic star system, a system that was already in place in the theatre. Here too, I argue, one can see that the relationship between film and theatre is a transmedial and international phenomenon, with early film advertising mostly certifying the artistic (i.e. theatrical) nature of their talent, and European companies marketing their product in Europe and abroad. Future research will have to fully confirm my hypothesis that the popular theatre skewed towards social (melo)dramas that were geared towards the middle classes, nuancing the influence that Naturalism had on middle-class melodramas, and certifying that newer performance styles only properly made their introduction in European cinema by the end of the 1910s, after the Great War.

A case study on Danish superstar of the stage and screen, Betty Nansen, follows in chapter three. Focusing on Nansen, this chapter takes a more in-depth approach to demonstrate that fully investigating a singular context lays bare even deeper connections between the two media, one that transcends international borders at that. The French legend Sarah Bernhardt may have been seen to give birth to the notion of "famous players in famous plays" when she starred as Queen Elizabeth I in *Les amours de la reine Élisabeth* (Henri Desfontaines and Louis Mercanton, 1912), but in Denmark, the influential Nordisk Films Kompagni had already invested far more extensively in marketing the appeal of theatrical stars that crossed over into the realm of film by this time. I trace how Nordic drama was marketed internationally by analyzing the trajectory of one of the most important, yet undervalued, actresses of the time, Betty Nansen, who was also known as the Bernhardt of Scandinavia. Nansen was the model for the new "post-Ibsen" female in Scandinavian society, both on and off the stage. She was additionally a key example of how theatre and film uniquely managed to bridge the gap in Denmark. Betty Nansen's stage and screen work reinforced each other, from the Danish Royal Theatre to the American Fox Film Corporation, and to managing her own theatre in Copenhagen, the still extant Betty Nansen Teatret.

We move from the stage to the frame in chapter four. Here we take on the relationship between nineteenth- and early-twentieth-century academic painting, Pictorialist photography, and early European cinema, analyzing their shared visual contexts. The chapter first explores the reigning aesthetic of early

European feature-length cinema, in what David Bordwell has referred to as a "tableau aesthetic," to define its characteristics. I plead for the recognition that the mise-en-scène-based long-take aesthetic of early European cinema was not a mere phase in an evolutionary model preceding a "classical style." Rather, it should be seen as a viable alternative style that still exists today, and that used different visual parameters to help bring a narrative across to audiences. Moreover, even though it knew a relatively brief evolution, it grew quite accomplished from 1911 onwards. I subsequently see a logical continuation between nineteenth-century academic art and early European cinema through what I propose is a shared context of Bourgeois Realism. In painting, like on the stage, popular classic content persisted over the new. Avant-gardist artistic modes had started coming on strong in visual arts since the 1880s, but had yet to find their way into most bourgeois homes – or, for that matter, onto the silver screen, where the Russian Montage movement, the French Impressionists, and the German Expressionists, among others, would be active by the very end of the 1910s and throughout the 1920s and 1930s. An investigation of photographic Pictorialism, then, reveals a shared quest for artistic legitimacy and cultural capital. Photography and film fought to get rid of the bias towards their mechanical paint brushes by associating heavily with the art of painting; hence the aptly named movement of Pictorialism. Delving into the visual particularities and popular teachings of Pictorialism, I demonstrate that their strategies were strongly related to those employed in academic painting, and that, in turn, these were the same popular motifs and techniques that early European cinema employed, such as the ubiquitous use of chiaroscuro in lighting.

This book's final chapter speaks to the enduring legacy of the Old Masters, who were often invoked by film companies and filmmakers when discussing and marketing their artistic approach, most notably the figure of Rembrandt. The cue that had been taken from academic painting, Pictorialist photography, and popular stage melodramas was not abandoned moving into the 1920s. Filmmakers like the Swede Victor Sjöström, who is the subject of this chapter, are good examples of artists who can be counted to engage with a Bourgeois Realist approach in the 1910s and continued to do so in the 1920s, even if newer strategies and influences were also seeping into their work. Since Sweden and Denmark both practiced neutrality during the First World War, this allowed them a continued focus on their film industry to a degree that the previously world-dominant French could not. Film production companies like Svenska Bio took over the torch from the Danish Nordisk Films Kompagni in the late 1910s, providing a continuation and refinement of the Bourgeois Realist visual strategies and influences we have been discussing. Victor Sjöström's *Vem dömer* (1922) is an underrated and understudied gem,

which makes it a perfect case study for this chapter. With a focus on art, cinematography that channels the Old Masters in a highly referential way, and an interesting narrative structure, this Renaissance-set period piece has all the trappings of a Swedish Golden Age masterpiece. The film's Netherlandish tableaux may have an optical twist suited to the 1920s in their languid lap-dissolve transitions, but its roots are firmly planted in the 1910s.

I am convinced that the field of film and media studies would benefit enormously from a further investigation of the manifold relationships between the medium of film and painting, theatre, and photography. There remains a lot of common ground to cover, and more intricate nuances and relationships to work out, and that holds true for the rich and fascinating period of the 1910s and 1920s as for no other. This is research that I will continue to pursue, striving for a broader cultural poetics of early cinema and its different key periods, dispelling myths, and building on frameworks established for the reader in this book. Hopefully, this book's foundations, which look to be anchored firmly in a historical context, will withstand the future of intermedial and interdisciplinary research. Wölfflin's initial provocation of suggesting a "history of art without names" comes back into play here. It gave way to a more nuanced reformulation that put the concepts of "vision" and "form" at the heart of visual history, superseding a necessarily fraught nationalized and narrow conception led by connoisseurship. While I believe very strongly in the necessity of context, the idea of recognizing and developing a supra-national and exchangeable set of formalist strategies is at the very core of the success of the European film companies and films that are discussed in this book, and of the power of silent cinema more broadly. We should also reconsider the forcefulness to the end of this period with the arrival of sound here – cinema's first death. The musings of a theorist like Canudo in 1908 looked forward to the day that cinema would act as a form of Esperanto, a universal visual language that would be understood by all. By the late 1920s, the unrivaled visuality, color, texture, and sparing use of intertitles in cinema brought those musings into the domain of reality. Walter Bloem foresaw in the early 1920s that man might, against their better judgement, decide to enter the sound film arena. For Bloem, this loss of medium specificity would doom cinema to become a pale imitation of the theatre, and would chip away at its universally shared set of visual parameters.

> If it accepts it, one of the most beautiful, and one of the most recent, messengers of peace known to the human family will have been lost. For the film speaks to-day the silent language of the emotions, that language which is understood by all peoples and races wherever they may live; it speaks the reconciliatory language of the human heart.[2]

NOTES

1. Walter S. Bloem and Allen W. Porterfield (transl.), *The Soul of the Moving Picture* (New York: E.P. Dutton & Company, 1924), 1. Originally published in German as *Seele des Lichtspiels: Ein Bekenntnis zum Film* (Leipzig und Zürich: Grethlein & Co., 1922). For more on the complicated legacy of Bloem, who took a notoriously hard 180-degree turn in his moral and philosophical beliefs in the 1930s, see Rodler F. Morris, *From Weimar Philosemite to Nazi Apologist: The Case of Walter Bloem* (Lewiston, Queenston, and Lampeter: The Edwin Mellen Press, 1988).
2. ibid, 14.

Bibliography

Abel, Richard (ed.), *French Film Theory and Criticism: A History/Anthology 1907–1939 – Volume I: 1907–1929* (Princeton: Princeton University Press, 1993).

Abel, Richard, *The Ciné Goes to Town: French Cinema 1896–1914 (updated and expanded edition)* (Berkeley and Los Angeles: University of California Press, 1998).

Abel, Richard, "History Can Work for You, You Know How to Use it," *Cinema Journal* 44, 1 (2004), 107–12.

Adriaensens, Vito, "Albert 'Cap' Capellani," in Stefan Franck (ed.), *To Dazzle the Eye and Stir the Heart: the Red Lantern, Nazimova and the Boxer Rebellion* (Brussels: Cinémathèque Royale de Belgique, 2012), 27–34.

Adriaensens, Vito, "Die ewige Nacht" in Steven Jacobs, Susan Felleman, Vito Adriaensens, and Lisa Colpaert, *Screening Statues: Sculpture and Cinema* (Edinburgh: Edinburgh University Press, 2017), 181.

Adriaensens, Vito, "A Swedish Renaissance: Art and Passion in Victor Sjöström's 'Vem dömer' (1922)," *Kosmorama* 269 (2017). https://www.kosmorama.org/en/kosmorama/artikler/swedish-renaissance-art-and-passion-victor-sjostroms-vem-domer-1922.

Adriaensens, Vito, "'Kunst og Kino': The Art of Early Danish Drama," *Kosmorama* 259 (2015). https://www.kosmorama.org/en/kosmorama/artikler/kunst-og-kino-art-early-danish-cinema.

Adriaensens, Vito, "Malerei in Bewegung: Bürgerlicher Realismus und Piktoralismus im europäischen Kino (1908–1914)," in Jörg Schweinitz and Daniel Wiegand (eds.), *Film Bild Kunst: Visuelle Ästhetik des vorklassischen Stummfilms* (Marburg: Schüren Verlag, 2016), 151–75.

Adriaensens, Vito, "The Bernhardt of Scandinavia: Betty Nansen's Modern Breakthrough," *Nineteenth Century Theatre and Film* 45, 1 (2018), 56–80.

Adriaensens, Vito and Steven Jacobs, "The Sculptor's Dream: Tableaux Vivants and Living Statues in the Films of Méliès and Saturn," *Early Popular Visual Culture* 13, 1 (2015), 41–65.

Afra, Kia, *The Hollywood Trust: Trade Associations and the Rise of the Studio System* (Lanham: Rowman & Littlefield, 2016).

Allen, Robert C., "Historiography and the Teaching of Film History," *Film & History – An Interdisciplinary Journal of Film and Television Studies* 10, 2 (1980), 1–6.

Allen, Robert C., "From Exhibition to Reception: Reflections on the Audience in Film History," *Screen* 31, 4 (1990), 347–56.

Allen, Robert C. and Douglas Gomery, *Film History: Theory and Practice* (New York: McGraw Hill, 1985).

Altenloh, Emilie, *Zur Soziologie des Kino: die Kino-Unternehmung und die Sozialen Schichten ihrer Besucher* (Jena: Eugen Diederichs, 1914).

Altman, Charles F., "Towards a Historiography of American Film," *Cinema Journal* 16, 2 (1977), 1–25.

Anderson, Kristine, "Edith Rode," in Katharina M. Wilson and Paul and June Schlueter (eds.), *Women Writers of Great Britain and Europe: An Encyclopedia* (London and New York: Routledge, 2013), 393–4.
Andreasen, Uffe, "Louis "v. Kohl," *Dansk Biografisk Leksikon (3rd edition)* (Copenhagen: Gyldendal online). http://denstoredanske.dk/index.php?sideId=298832.
Ankersmit, Frank R., *Sublime Historical Experience* (Stanford: Stanford University Press, 2005).
Anon., s.n., *Filmen* 1, 1 (15 October 1912), 3.
Anon., "A History of Cinema Without Names: A Research Project" Call for Papers (2014), *XXII Udine International Film Studies Conference*, Udine (18–20 March 2015).
Anon., "Alexandra Teatret," *Teatret: Illustreret Maanedsskrift for Teater og Skuespilkunst* 15, 20 (September 1916), 158.
Anon., "A Woman of the People," *Moving Picture World* 4, 26 (26 June 1909), 892.
Anon., "A Woman of the People," *Moving Picture World* 4, 26 (26 June 1909), 871–2.
Anon., "Betty Nansen," *Filmen* 4, 14 (1 May 1916), 128.
Anon., "Betty Nansen Coming to America," *Moving Picture World* 23, 1 (2 January 1915), 79.
Anon., "Betty Nansen Likes America," *Moving Picture World* 23, 3 (16 January 1915), 377.
Anon., "Betty Nansen Sails for Home," *Motion Picture News* 12, 3 (24 July 1915), 63.
Anon., "Betty Nansen's Golden Gown," *Motography* 13, 3 (16 January 1915), 96.
Anon., "Betty Nansen Teatret," *Teatret: Illustreret Maanedsskrift for Teater og Skuespilkunst* 17, 1 (October 1917), 6.
Anon., "Betty Nansen to Pose for Fox Pictures Here," *Motion Picture News* 10, 25 (26 December 1914), 28.
Anon., "Brevities of the Business," *Motography* 13, 2 (9 January 1915), 63.
Anon., "Critical Eyes," *Moving Picture World* 19, 7 (14 February 1914), 845.
Anon., "Curtis Melnitz Quits Little Theatre Films," *Exhibitors Herald* 18, 3 (12 January 1924), 24.
Anon., "Danish Actress Arrives," *The New York Times* 64, 20,791 (27 December 1914), 13.
Anon., *Deuxième Exposition d'Art Photographique* (Paris: Photo-Club de Paris, 1895).
Anon., "En ny filmsstjerne," *Filmen* 1, 22 (1 September 1913), 288.
Anon., "Fru Nansen i Amerika," *Filmen* 3, 11 (15 March 1915), 98.
Anon., "How Betty Nansen Went to Brooklyn," *The New York Times* 64, 20,805 (10 January 1915), 7.
Anon., "Ingvald C. Oes – Of the Great Northern Film Company," *Moving Picture World* 2, 13 (28 March 1908), 261.
Anon., "Interesting facts from abroad, gleaned from an interview with Mr. I.C. Oes, manager of the Great Northern," *The Moving Picture News* 4, 38 (23 September 1911), 11.
Anon., "L'Abime," *Ciné-Journal* 4, 133 (11 March 1911), 6.
Anon., "Laying Bare a Woman's Soul: 'The Dangerous Age,' Europe's Literary Sensation, Has Been Translated into English," *The New York Times* 60, 19,580 (3 September 1911), 530.
Anon., "Les Films Suédois à Revoir et à Voir," *Cinéa* 11 (special issue) (15 July 1921), 5.
Anon., "Les Merveilles du Cinéma Suédois," *Cinéa* 11 (special issue) (15 July 1921), cover.
Anon., "Le Théatro-Film," *Ciné-Journal* 2, 46 (4–10 July 1909), 5–6.
Anon., "Le Vertige," *Ciné-Journal* 4, 142 (13 May 1911), 20.
Anon., "Le Vertige," *Ciné-Journal* 4, 144 (27 May 1911), 18.
Anon., "Little Theatre's Initial Picture," *Exhibitors Trade Review* 14, 4 (23 June 1923), 154.
Anon., "Lux – Un Drame dans une Carrière," *Ciné-Journal* 1, 4 (8 September 1908), 6.
Anon., "Miss Asta Nielsen," *The Moving Picture News* 5, 13 (30 March 1912), 52.
Anon., "New Great Northern Favorite," *The Moving Picture News* 8, 11 (13 September 1913), 15.

Anon., "Norden – Danmark," *Biografteaterbladet – Danmark, Norge, Sverige* 1 (January 1911), 7–8.
Anon., "Notes Written on the Screen," *The New York Times* 64, 20,784 (20 December 1914), 8.
Anon., "Oes returns," *Moving Picture World* 9, 11 (23 September 1911), 882.
Anon., "Organization of Little Theatre: Advisory Board Completed with Addition of Several Names," *Exhibitors Trade Review* 14, 9 (28 July 1923), 379.
Anon., "Picture Plays and People," *The New York Times* 71, 23,549 (16 July 1922), 3.
Anon., "Reids and Rawlinsons of Sweden," *Photoplay* 17, 1 (December 1919), 32.
Anon., "Scènes muettes de la vie réelle," *Ciné-Journal* 3, 89 (7 May 1910), ii.
Anon., "Some of the Celebrated Actors from the Denmark Theatres Who Have Helped to Make the Great Northern Films Famous," *The Moving Picture News* 4, 38 (23 September 1911), 12–13.
Anon., "Stumper og strimler," *Filmen* 1, 1 (15 October 1912), 18.
Anon., "The Picture Oracle: Questions and Answers about the Screen," *Picture-Play Magazine* 5, 2 (October 1916), 306.
Anon., "The Picture Oracle: Questions and Answers about the Screen," *Picture-Play Magazine* 5, 5 (January 1917), 306.
Anon., "The Regent Theatre – Fountain and Hamilton Streets," *The Allentown Morning Call* 50, 120 (20 May 1915), 10.
Anon., "The Sombreness of Seastrom," *Pictures and the Picturegoer* 10, 57 (September 1925), 46.
Anon., "Transatlantic Topics," *The New York Times* 53, 16,793 (1 November 1903), 24.
Anon., "Vitagraph Co.," *Ciné-Journal* 3, 92 (28 May 1910), ii.
Anon., "What is Cinema History?" Call for Papers (2014), HoMER Network Conference, Glasgow (22–4 June 2015).
Anon., "William Fox Announces," *Moving Picture World* 22, 13 (26 December 1914), 1868–9.
Arnoldy, Édouard, *Pour une histoire culturelle de cinéma – au-devant de "scènes filmées," de "films chantants et parlants" et de comédies musicales* (Liège: Éditions du Céfal, 2004).
Askari, Kaveh, *Making Movies into Art: Picture Craft from the Magic Lantern to Early Hollywood* (London: British Film Institute, 2014).
Astaix, Kastor & Lallement, "Le Film d'Art," *Ciné-Journal* 3, 93 (4 June 1910), 7.
Åhlander, Lars, *Svensk filmografi 1: 1897–1919* (Stockholm: Swedish Film Institute, 1977).
Bailey, Colin B. (ed.), *The Age of Watteau, Chardin and Fragonard: Masterpieces of French Genre Painting* (New Haven and London: Yale University Press, 2003).
Balsom, Erika, "One Hundred Years of Low Definition," in Martine Beugnet, Allan Cameron, and Arild Fetveit (eds.), *Indefinite Visions: Cinema and the Attractions of Uncertainty* (Edinburgh: Edinburgh University Press, 2017), 73–89.
Bang, Herman, *Masker og Mennesker* (Copenhagen and Oslo: Nordisk Forlag, 1910).
Barlow, Paul, "Fear and loathing of the academic, or just what is it that makes the avant-garde so different, so appealing?" in Rafael Cardoso Denis and Colin Trodd (eds.), *Art and the Academy in the Nineteenth Century* (Manchester: Manchester University Press, 2000), 15–32.
Bastide, Bernard, "Léonce Perret, maître des lumières et des ombres" in Bernard Bastide and Jean A. Gili (eds.), *Léonce Perret* (Paris: Association française de recherche sur l'histoire du cinéma, 2003), 11–28.
Bastide, Bernard, "Les 'séries d'art' Gaumont: Des 'sujets de toute première classe'" in Alain Carou and Béatrice de Pastre (eds.), "Le Film d'art et les films d'art en Europe (1908–1911)," *1895 – Revue d'Histoire du Cinéma* 56 (Special issue, December 2008), 305–26.
Beach, Christopher, *A Hidden History of Film Style: Cinematographers, Directors, and the Collaborative Process* (Oakland: University of California Press, 2015).

Beckert, Sven, "Institution-building and Class Formation: How Nineteenth-century Bourgeois Organized," in Graeme Morton, Boudien de Vries and R.J. Morris (eds.), *Civil Society, Associations and Urban Places: Class, Nation and Culture in Nineteenth-Century Europe* (Aldershot: Ashgate, 2006), 17–38.

Bedding, Thomas, "The Modern Way in Moving Picture Making – Chapter III: The Studio," *Moving Picture World* 4, 13 (27 March 1909), 360.

Bedding, Thomas, "The Modern Way in Moving Picture Making – Chapter XI: Photographing Outdoor Subjects," *Moving Picture World* 4, 21 (22 May 1909), 666.

Behrens, Carl, "Gammelt og nyt," *Teatret: Illustreret Maanedsskrift for Teater og Skuespilkunst* 9 (1909–10), 92.

Beitchman, Philip, *The Theatre of Naturalism: Disappearing Act* (New York: Peter Lang, 2011).

Benoît-Lévy, Edmond, "Le Droit d'auteur cinématographique," *Phono-Ciné-Gazette* 62 (15 October 1907), 365.

Bergman, Ingmar and Marianne Ruuth (transl.), *Images: My Life in Film* (New York: Arcade Publishing, 1994).

Berlanstein, Lenard R., *Daughters of Eve: A Cultural History of French Theater Women from the Old Regime to the Fin-de-Siècle* (Cambridge, MA and London: Harvard University Press, 2001).

Bertellini, Giorgio (ed.), *Italian Silent Cinema: a Reader* (New Barnet: John Libbey & Company, 2013).

Biltereyst, Daniel, Richard Maltby, and Philippe Meers (eds.), *Cinema, Audiences and Modernity: New Perspectives on European Cinema History* (London and New York: Routledge, 2012).

Bilton, Peter (ed.), "Denmark, 1746–1889" in Laurence Senelick (ed.), *National Theatre in Northern and Eastern Europe, 1746–1900 (Theatre in Europe: a Documentary History)* (Cambridge: Cambridge University Press, 2008), 17–63.

Bloch, Marc, *Apologie pour l'histoire, ou métier d'historien* (Paris: Armand Colin, 1971).

Bloem, Walter S. and Allen W. Porterfield (transl.), *The Soul of the Moving Picture* (New York: E.P. Dutton & Company, 1924).

Blom, August, "Instruktør ved Nordisk Films Co., August Blom," *Teatret: Illustreret Maanedsskrift for Teater og Skuespilkunst* 11, 7 (January 1912), 55–6.

Blom, Ivo, "Il Fuoco or the Fatal Portrait: The XIXth Century in the Italian Silent Cinema," *Iris* 14–15 (Autumn 1992), 55–66.

Blom, Ivo, "Quo vadis? From Painting to Cinema and Everything in Between" in Leonardo Quaresima and Laura Vichi (eds.), *La decima musa. Il cinema e le altre arti/The Tenth Muse: Cinema and other arts* (Udine: Forum, 2001), 281–96.

Blom, Ivo, "Of Artists and Models: Italian Silent Cinema between Narrative Convention and Artistic Practice" in Ágnes Pethő (ed.), *The Cinema of Sensations* (Newcastle upon Tyne: Cambridge Scholars Publishing, 2015), 121–36.

Bollman, Gladys, "Reviews of Films," *Educational Film Magazine* 5, 4 (April 1921), 20–3.

Booth, Michael R., "Nineteenth-Century Theatre" in John Russell Brown (ed.), *The Oxford Illustrated History of the Theatre* (Oxford and New York: Oxford University Press, 2001), 299–340.

Borchsenius, Otto, "Fru Hennings i Berlin," *Teatret: Illustreret Maanedsskrift for Teater og Skuespilkunst* 1 (1901–2), 29–31.

Borchsenius, Otto, "Betty Hennings," *Teatret: Illustreret Maanedsskrift for Teater og Skuespilkunst* 1 (1901–2), 75–80.

Bordwell, David, "Contemporary Film Studies and the Vicissitudes of Grand Theory," in David Bordwell and Noel Carroll (eds.), *Post-Theory: Reconstructing Film Studies* (Madison: The University of Wisconsin Press, 1996), 3–36.

Bordwell, David, *Figures Traced in Light: On Cinematic Staging* (Berkeley and Los Angeles: University of California Press, 2005).

Bordwell, David, "Nordisk and the Tableau Aesthetic" in Lisbeth Richter Larsen and Dan Nissen (eds.), *100 Years of Nordisk Film* (Copenhagen: Danish Film Institute, 2006), 80–95.

Bordwell, David, *On the History of Film Style* (Cambridge, MA and London: Harvard University Press, 1997).

Bordwell, David, "The Classical Hollywood Style, 1917–1960" in David Bordwell, Janet Staiger and Kristin Thompson, *The Classical Hollywood Cinema: Film Style & Mode of Production to 1960* (London and New York: Routledge, 2005), 1–87.

Bordwell, David and Kristin Thompson, *Film History: an Introduction* (Second Edition. New York: McGraw-Hill, 2003).

Brewster, Ben and Lea Jacobs, *Theatre to Cinema: Stage Pictorialism and the Early Feature Film* (Oxford and New York: Oxford University Press, 1997).

Brown, Richard, "Trade Marks" in Richard Abel (ed.), *Encyclopedia of Early Cinema* (London and New York: Routledge, 2005), 636–7.

Bröchur, Georg, "My Memoirs of Henrik Ibsen," *The Mask* 14, 1 (January–March 1928), 8.

Burrows, Jon, *Legitimate Cinema: Theatre Stars in Silent British Films 1908–1918* (Exeter: Exeter University Press, 2003).

Busk-Jensen, Lise, "Heiberg's View of Female Authors," in Jon Stewart (ed.), *Johan Ludvig Heiberg: Philosopher, Littérateur, Dramaturge, and Political Thinker* (Copenhagen: Museum Tusculaneum Press, 2008), 527–48.

Butsch, Richard, *The Making of American Audiences: From Stage to Television, 1750–1990* (Cambridge and New York: Cambridge University Press, 2000).

Bøgh Rønberg, Lene, "Bourgeois Home Life in the Two Golden Ages: Influences and Correspondences" in Kasper Monrad, Ragni Linnet, and Lene Bøgh Rønberg (eds.), *Two Golden Ages: Masterpieces of Dutch and Danish Painting* (Zwolle and Copenhagen: Rijksmuseum Amsterdam and Statens Museum for Kunst, 2001), 72–141.

Campbell, Thomas P., "Director's Foreword" in Sabine Rewald, *Rooms with a View: The Open Window in the 19th Century* (New York: Metropolitan Museum of Art, 2011), viii.

Canudo, Ricciotto, "Manifeste des Sept Arts," *Gazette des sept arts* no. 2 (23 January 1923), 2.

Canudo, Ricciotto, "The Birth of a Sixth Art" in Richard Abel (ed.), *French Film Theory and Criticism: A History/Anthology 1907–1939 – Volume I: 1907–1929* (Princeton: Princeton University Press, 1993), 58–66.

Canudo, Ricciotto, *L'Usine aux Images (édition intégrale établie par Jean-Paul Morel)* (Paris: Nouvelles Éditions Séguier & Arte Éditions, 1995).

Capitaine, Jean-Louis, *Les premières feuilles de la marguerite: Affiches Gaumont, 1905–1914* (Paris: Gallimard, 1994).

Cardoso Denis, Rafael and Colin Trodd (eds.), *Art and the Academy in the Nineteenth Century* (Manchester: Manchester University Press, 2000).

Carlson, Marvin, *The French Stage in the Nineteenth Century* (Metuchen: The Scarecrow Press, 1972).

Carlson, Marvin, "The development of the American theatre program" in Ron Engle, and Tice L. Miller (eds.), *The American Stage* (Cambridge and New York: Cambridge University Press, 1993), 101–14.

Carou, Alain, "Le Film d'Art ou la difficile invention d'une literature pour l'écran (1908–1909)" in Alain Carou and Béatrice de Pastre (eds.), "Le Film d'art et les films d'art en Europe (1908–1911)," *1895 – Revue d'Histoire du Cinéma* 56 (Special issue, December 2008), 9–38.

Carou, Alain and Béatrice de Pastre (eds.), "Le Film d'art et les films d'art en Europe (1908–1911)," *1895 – Revue d'Histoire du Cinéma* 56 (Special issue, December 2008).

Carou, Alain and Laurent Le Forestier (eds.), *Louis Feuillade: Retour aux sources – Correspondances et archives* (Paris: Revue de l'Association française de recherché sur l'histoire du cinéma and Gaumont, 2007).

Carr, Edward Hallett, *What is History?* (London: Macmillan, 1961).

Casetti, Francesco, Silvio Alovisio, and Luca Mazzei (eds.), *Early Film Theories in Italy, 1896–1922* (Amsterdam: Amsterdam University Press, 2017).

Čelebonović, Aleksa, *The Heyday of Salon Painting: Masterpieces of Bourgeois Realism* (London: Thames & Hudson, 1974).

Chamberlain, K.R., "Don Ryan, about to lay siege upon the subject of this interview, encounters some resistance on the part of the press agents," *Picture-Play Magazine* 20, 1 (March 1924), 23.

Champreux, Jacques and Alain Carou (eds.), "Louis Feuillade," *1895 – Revue d'Histoire du Cinéma* (Hors série, October 2000).

Chansky, Dorothy, *Composing Ourselves: The Little Theatre Movement and the American Audience* (Carbondale: Southern Illinois University Press, 2004).

Cohen, Sande, *History Out of Joint: Essays on the Use and Abuse of History* (Baltimore: Johns Hopkins University Press, 2006).

Collick, John, *Shakespeare, Cinema and Society* (Manchester and New York: Manchester University Press, 1989).

Compagnon, Antoine, *Le démon de la théorie: littérature et sens commun* (Paris: Éditions du Seuil, 1998).

Crafton, Donald, "Foreword" in Angela Dalle Vacche (ed.), *The Visual Turn: Classical Film Theory and Art History* (New Brunswick and London: Rutgers University Press, 2003), ix–xii.

d'Hugues, Philippe, "Louis Feuillade le précurseur" in Philippe d'Hugues and Dominique Muller (eds.), *Gaumont: 90 ans de cinéma* (Paris: Editions Ramsay and La Cinémathèque Française, 1986), 46–52.

d'Hugues, Philippe and Dominique Muller (eds.), *Gaumont: 90 ans de cinéma* (Paris: Editions Ramsay & La Cinémathèque Française, 1986).

Dalle Vacche, Angela (ed.), *The Visual Turn: Classical Film Theory and Art History* (New Brunswick and London: Rutgers University Press, 2003).

Dalle Vacche, Angela, *Diva: Defiance and Passion in Early Italian Cinema* (Austin: University of Texas Press, 2008).

Dalle Vacche, Angela (ed.), *Film, Art, New Media: Museum without Walls?* (Basingstoke and New York: Palgrave Macmillan, 2012).

Dansen paa Koldinghus (Viggo Larsen, 1908) – Film Program. Collection of the Danish Film Institute.

Daum, Patrick, Francis Ribemont and Phillip Prodger (eds.), *Impressionist Camera: Pictorial Photography in Europe, 1888–1918* (London and New York: Merrell, 2006).

Peter Decherney, *Hollywood's Copyright Wars: From Edison to the Internet* (New York: Columbia University Press, 2013).

deCordova, Richard, *Picture Personalities: The Emergence of the Star System in America* (Urbana and Chicago: University of Illinois Press, 2001).

Demachy, Robert, "La recherche d'art en photographie," *L'Art décoratif* 4, 45 (June 1902), 117–124.

Demachy, Robert and Constant Puyo, *Les procédés d'art en photographie* (Paris: Photo Club de Paris, 1906).

Den hvide Slavehandel (Alfred Cohn, 1910) – Film Program. Collection of the Danish Film Institute.

Den hvide Slavehandel (August Blom, 1910) – Film Program. Collection of the Danish Film Institute.

Den sidste Hurdle (Einar Zangenberg, 1912) – Film Program. Collection of the Danish Film Institute.

Dotoli, Giovanni and Jean-Paul Morel, "Présentation Générale" in Ricciotto Canudo, *L'Usine aux Images (Édition intégrale établie par Jean-Paul Morel)* (Paris: Nouvelles Éditions Séguier & Arte Éditions, 1995), 7–20.

Doumic, René, "Drama Review: the Cinema Age" in Richard Abel (ed.), *French Film Theory and Criticism: A History/Anthology 1907–1939 – Volume I: 1907–1929* (Princeton: Princeton University Press, 1993), 86–9.

Duckett, Victoria, *Seeing Sarah Bernhardt: Performance and Silent Film* (Chicago IL: University of Illinois Press, 2015).

Duckett, Victoria and Vito Adriaensens (eds.), "The Actress-Manager and Early Film" (special issue), *Nineteenth Century Theatre and Film* 45, 1 (May 2018).

Dureau, Georges, "Films d'Art et 'Film d'Art,'" *Ciné-Journal* 3, 94 (11 June 1910), 3–4.

Downs, Brian W., *Modern Norwegian Literature 1860–1918* (Cambridge and New York: Cambridge University Press, 2010).

Dyrbye, Martin, "Pio, Elith" in Scavenius, Alette (ed.), *Gyldendals Teaterleksikon* (Copenhagen: Gyldendal online, 2007). http://denstoredanske.dk/index.php?sideId=429623.

Dødsspring til Hest fra Cirkuskuplen (Eduard Schnedler-Sørensen, 1912) – Film Program. Collection of the Danish Film Institute.

Edwards, Lee M. (ed.), *Domestic Bliss: Family Life in American Painting 1840–1910* (New York: The Hudson River Museum, 1986).

E.-H.-I., "Biografen og den internationale Scenekunst," *Filmen* 1, 2 (15 October 1912), 19–20.

Elsaesser, Thomas, *Weimar Cinema and After: Germany's Historical Imaginary* (London and New York: Routledge, 2000).

Emerson, Peter Henry, *Naturalistic Photography for Students of the Art* (London: Sampson Low, Marston, Searle & Rivington, 1889).

En Kvinde af Folket (Viggo Larsen, 1909) – Film Program. Collection of the Danish Film Institute.

Engberg, Marguerite, *Dansk Stumfilm: De store År I–II* (Copenhagen: Rhodos, 1977).

Engberg, Marguerite, "Gad, Urban," *Dansk Biografisk Leksikon (3rd edition)* (Copenhagen: Gyldendal online, 1979–1984). http://denstoredanske.dk/index.php?sideId=289877.

Engberg, Marguerite, "Plagiarism, and the Birth of the Danish Multi-Reel Film" in Lisbeth Richter Larsen and Dan Nissen (eds.), *100 Years of Nordisk Film* (Copenhagen: Danish Film Institute, 2006), 72–9.

Everett, Sally (ed.), *Art Theory and Criticism: An Anthology of Formalist, Avant-Garde, Contextualist and Post-Modernist Thought* (Jefferson: McFarland & Company, 1991).

Everson, William K., *American Silent Film* (New York: Da Capo Press, 1978).

Falkenfleth, Haagen, "Det gærer og syder –," *Teatret: Illustreret Maanedsskrift for Teater og Skuespilkunst* 16, 5 (December 1916), 34.

Felleman, Susan, *Art in the Cinematic Imagination* (Austin: University of Texas Press, 2006).

Felleman, Susan, *Real Objects in Unreal Situations: Modern Art in Fiction Films* (Chicago: Intellect, 2014).

Fescourt, Henri, *La foi et les montagnes; ou, Le septième art au passé* (Paris: P. Montel, 1959).

Feuillade, Louis, "Le Film Esthétique," *Ciné-Journal* 3, 92 (28 May 1910), 3.

Feuillade, Louis, "Les Scènes de la vie telle qu'elle est," *Ciné-Journal* 4, 139 (22 April 1911), 19.
Fischer, Lucy (ed.), *American Cinema of the 1920s: Themes and Variations* (New Brunswick and London: Rutgers University Press, 2009).
Florin, Bo, *Transition and Transformation: Victor Sjöström in Hollywood 1923–1930* (Amsterdam: Amsterdam University Press, 2012).
Focillon, Henri, *Vie des formes* (Paris: Ernst Leroux, 1934).
Forslund, Bengt and Peter Cowie (transl.), *Victor Sjöström: His Life and His Work* (New York: Zoetrope, 1988).
Forsman, Johanna and Kjell Sundstedt, "Sweden," in Jill Nelmes and Jule Selbo (eds.), *Women Screenwriters: An International Guide* (London: Palgrave Macmillan, 2015), 550–77.
Foucault, Michel, *L'Archéologie du savoir* (Paris: Gallimard, 1969).
Freksa, Friedrich, and Eric Ames (transl.), "Theater, Pantomime, and Cinema," in Anton Kaes, Nicholas Baer and Michael Cowan (eds.), *The Promise of Cinema: German Film Theory, 1907–1933* (Oakland: University of California Press, 2016), 110–14.
Frölich, Else, "Film," *Teatret: Illustreret Maanedsskrift for Teater og Skuespilkunst* 12, 14 (April 1913), 107–9.
Fullerton, John, "Svenska Biografteatern" in Richard Abel (ed.), *Encyclopedia of Early Cinema* (London and New York: Routledge, 2005), 890–1.
Fulsås, Narve and Tore Rem, *Ibsen, Scandinavia and the Making of a World Drama* (Cambridge and New York: Cambridge University Press, 2018).
Fønss, Olaf, *Danske Skuespillerinder: Erindringer og Interviews* (Copenhagen: Nutids Verlag, 1930).
Gaines, Jane, "Film History and the Two Presents of Feminist Film Theory," *Cinema Journal* 44, 1 (2004), 113–19.
Gaines, Jane, "What Happened to the Philosophy of Film History?" *Film History: An International Journal* 25, 1–2 (2013), 70–80.
Garde, Axel, "Betty Nansen," *Teatret: Illustreret Maanedsskrift for Teater og Skuespilkunst* 12, 19 (August 1913), 146–7.
Garncarz, Joseph, "The emergence of nationally specific film cultures in Europe, 1911–1914" in Richard Abel, Giorgio Bertellino and Rob King (eds.), *Early Cinema and the "National"* (New Barnet: John Libbey & Company, 2008), 185–94.
Gili, Jean Antoine and Eric Le Roy (eds.), "Albert Capellani: De Vincennes à Fort Lee," *1895 – Revue d'Histoire du Cinéma* 68 (Special issue, Fall 2012).
Gilpin, William, *An Essay upon Prints, containing Remarks upon the Principles of Picturesque Beauty* (London: J. Robson, 1768).
Gledhill, Christine, *Reframing British Cinema 1918–1928: Between Restraint and Passion* (London: British Film Institute, 2003).
Gnudtzmann, Albert, "Teaterindtryk fra Maj 1904," *Teatret: Illustreret Maanedsskrift for Teater og Skuespilkunst* 3 (1903–4), 97.
Goodman, Nelson, *Languages of Art: An Approach to a Theory of Symbols* (Indianapolis: Bobbs-Merrill, 1968).
Gore, "Love's Crucible," *Variety* 67, 6 (30 June 1922), 33.
Graphicus, Lux (Thomas Bedding), "On the Screen," *Moving Picture World* 7, 5 (30 July 1910), 241.
Gray, Rosalind P., *Russian Genre Painting in the Nineteenth Century* (Oxford and New York: Oxford University Press, 2000).
Greenberg, Clement, "Avant-Garde and Kitsch" in Sally Everett (ed.), *Art Theory and Criticism: An Anthology of Formalist, Avant-Garde, Contextualist and Post-Modernist Thought* (Jefferson: McFarland & Company, 1991), 26–40.

Greenblatt, Stephen, "Towards a Poetics of Culture" in H. Aram Veeser (ed.), *The New Historicism* (London and New York: Routledge, 1989), 1–14.

Grieveson, Lee, "Woof, Warp, History," *Cinema Journal* 44, 1 (2004), 119–26.

Griffin, Patrick, "Film, Document, and the Historian," *Film & History – An Interdisciplinary Journal of Film and Television Studies* 2, 2 (1972), 14–21.

Griffith, Linda A., "Comments and Criticisms of a Free-Lance," *Film Fun* 31, 363 (July 1919), 6–7.

Grössinger, Christa, *Picturing Women in Late Medieval and Renaissance Art* (Manchester and New York: Manchester University Press, 1997).

Gunning, Tom, "The Cinema of Attraction: Early Film, Its Spectator and the Avant-Garde," *Wide Angle* 8, 3–4 (1986), 63–70.

Gunning, Tom, "Early cinema as global cinema: the encyclopedic ambition" in Richard Abel, Giorgio Bertellino and Rob King (eds.), *Early Cinema and the "National"* (New Barnet: John Libbey & Company, 2008), 11–16.

Guzman, Tony, "The Little Theatre Movement: The Institutionalization of the European Art Film in America," *Film History: An International Journal* 17, 2/3 (2005), 261–84.

H.F.H., "The Asta Neilsen [sic] Pictures," *Moving Picture World* 11, 12 (23 March 1912), 1054–5.

Hamlet (August Blom, 1911) – Film Program. Collection of the Danish Film Institute.

Harker, Margaret F., "Henry Peach Robinson: The Grammar of Art" in Mike Weaver (ed.), *British Photography in the Nineteenth Century: the Fine Art Tradition* (Cambridge and New York: Cambridge University Press, 1989). 133–40.

Haugmard, Louis, "The 'Aesthetic' of the Cinematograph" in Richard Abel (ed.), *French Film Theory and Criticism: A History/Anthology 1907–1939 – Volume I: 1907–1929* (Princeton: Princeton University Press, 1993), 77–85.

Haverty Rugg, Linda, "A Tradition of Torturing Women," in Mette Hjort and Ursula Lindqvist (eds.), *A Companion to Nordic Cinema* (Chichester: John Wiley & Sons, 2016), 351–70.

Heiner, Jørgen, "Garde, Aage" in Scavenius, Alette (ed.), *Gyldendals Teaterleksikon* (Copenhagen: Gyldendal online, 2007). http://denstoredanske.dk/index.php?sideId=428152.

Helleberg, Maria, *Kvinden der forandrede Danmark* (Copenhagen: Lindhardt og Ringhof, 2015).

Heltemod Forsoner (Viggo Larsen, 1909) – Film Program. Collection of the Danish Film Institute.

Herzog, Callie Jeanne, *Nora's Sisters: Female Characters in the Plays of Ibsen, Strindberg, Shaw, and O'Neill* (Urbana: PhD dissertation, University of Illinois at Urbana-Champaign, 1982).

Higashi, Sumiko, *Cecil B. DeMille and American Culture: the Silent Era* (Berkeley and Los Angeles: University of California Press, 1994).

Higashi, Sumiko, "In Focus: Film History, or a Baedeker Guide to the Historical Turn," *Cinema Journal* 44, 1 (2004), 94–100.

Higson, Andrew, "The Concept of National Cinema," *Screen* 30, 4 (1989), 36–47.

Hilson, Mary, "Denmark, Norway, and Sweden," in Timothy Baycroft and Mark Hewitson (eds.), *What is a Nation? Europe 1789–1914* (Oxford and New York: Oxford University Press, 2006), 192–209.

Hobsbawm, Eric, *The Age of Empire: 1875–1914* (London: Abacus, 2003).

Hollander, Martha, *An Entrance for the Eyes: Space and Meaning in Seventeenth-Century Dutch Art* (Berkeley: University of California Press, 2002).

Holledge, Julie, Jonathan Bollen, Frode Helland, and Joanna Tompkins, *A Global Doll's House: Ibsen and Distant Visions* (London: Palgrave Macmillan, 2016).

Hook, Philip and Mark Poltimore, *Popular 19th Century Painting: A Dictionary of European Genre Painters* (Woodbridge: Antique Collectors' Club, 1986).

Hvem er Hun? (Holger Rasmussen, 1910) – Film Program. Collection of the Danish Film Institute.
Jacobs, Steven, *The Wrong House: The Architecture of Alfred Hitchcock* (Rotterdam: 010 Publishers, 2007).
Jacobs, Steven, *Framing Pictures: Film and the Visual Arts* (Edinburgh: Edinburgh University Press, 2011).
Jacobs, Steven and Lisa Colpaert, *The Dark Galleries: a Museum Guide to Painted Portraits in Film Noir, Gothic Melodramas and Ghost Stories of the 1940s and 1950s* (Ghent: AraMER, 2013).
Jensen, Johannes V., "Teaterindtryk fra Januar 1902: Hedda Gabler," *Teatret: Illustreret Maanedsskrift for Teater og Skuespilkunst* 1 (1901–2), 60–3.
Jonathan, "Fra Galleriet," *Det ny Aarhundrede* 2, 2 (April–October 1905), 226.
Kaes, Anton, Nicholas Baer, and Michael Cowan (eds.), *The Promise of Cinema: German Film Theory 1907–1933* (Oakland: University of California Press, 2016).
Keating, Patrick, *Hollywood Lighting from the Silent Era to Film Noir* (New York: Columbia University Press, 2010).
Keil, Charlie, *Early American Cinema in Transition: Story, Style, and Filmmaking, 1907–1913* (Madison: The University of Wisconsin Press, 2001).
Keil, Charlie, "To Here from Modernity: Style, Historiography, and Transitional Cinema" in Charlie Keil and Shelley Stamp (eds.), *American Cinema's Transitional Era: Audiences, Institutions, Practices* (Berkeley and Los Angeles: University of California Press, 2004), 51–65.
Keil, Charlie and Shelley Stamp (eds.), *American Cinema's Transitional Era: Audiences, Institutions, Practices* (Berkeley and Los Angeles: University of California Press, 2004).
Kocka, Jürgen and Allan Mitchell (eds.), *Bourgeois Society in Nineteenth-Century Europe* (Oxford: Berg, 1993).
Koszarski, Richard, *An Evening's Entertainment: The Age of the Silent Feature Picture, 1915–1928* (Berkeley and London: University of California Press, 1994).
Krag, Thomas P., "Ibsen-Fortolkning paa Scenen," *Teatret: Illustreret Maanedsskrift for Teater og Skuespilkunst* 1 (1901–2), 56–9.
Krefft, Vanda, *The Man Who Made the Movies: The Meteoric Rise and Tragic Fall of William Fox* (New York: Harper Collins, 2017).
Krogh, Karen, "Sonne, Petrine," *Dansk Biografisk Leksikon (3rd edition)* (Copenhagen: Gyldendal online, 1979–1984). http://denstoredanske.dk/index.php?sideId=297642.
Kvam, Kela, "Betty Nansen. A Unique Figure in Danish Theatre," *Nordic Theatre Studies Yearbook* 1 (1988), 69–78.
Kvam, Kela, *Betty Nansen: Masken og Mennesket* (Copenhagen: Gyldendal, 1997).
Lacassin, Francis, *Louis Feuillade* (Paris: Seghers, 1964).
Lacassin, Francis, *Louis Feuillade: Maître des lions et des vampires* (Paris: Pierre Bordas and fils, 1995).
Landry, Lionel, "L'Epreuve du Feu," *Cinéa* 2, 81 (15 December 1922), 16.
Langman, Larry, *Destination Hollywood: The Influence of Europeans on American Filmmaking* (Jefferson and London: McFarland & Company, 2000).
Larsen, Lisbeth Richter, "The Nordisk Film Collection: An Introduction," in Dan Nissen, Lisbeth Richter Larsen, Jesper Stub Johansen and Thomas C. Christensen (eds.), *Preserve Then Show* (Copenhagen: Det Danske Filminstitut, 2002), 196–206.
Lauw, Sven, "Den Stumme Kunst," *Teatret: Illustreret Maanedsskrift for Teater og Skuespilkunst* 11, 7 (January 1912), 53–5.
L.B., "Theaterbrev fra Kjøbenhavn," *Urd* 7, 2 (10 January 1903), 20.

Leeder, Murray (ed.), *Cinematic Ghosts: Haunting and Spectrality from Silent Cinema to the Digital Era* (New York and London: Bloomsbury, 2015).
Lefebvre, Thierry and Laurent Mannoni (eds.), "L'Année 1913 en France," *1895 – Revue d'Histoire du Cinéma* (Hors série, 1993).
Lehman, Peter (ed.), "Il Cinema Nel 1913/The Year 1913", *Griffithiana – La Rivista Della Cineteca Del Friuli/Journal of Film History* 50 (Special issue, May 1994).
Leteux, Christine, *Albert Capellani: Cinéaste du Romanesque* (Grandvilliers: La Tour Verte, 2013).
Linder, Erik Hj., Marna Feldt and Carmen Sandström-Smith (transl.), "Hjalmar Bergman in Hollywood: A Sad Chapter" in Nils Y. Wessell (ed.), *The American-Swedish '72* (Philadelphia: American Swedish Historical Foundation, 1972), 45–62.
Lisi, Leonardo, "Scandinavia," in Pericles Lewis (ed.), *The Cambridge Companion to European Modernism* (Cambridge and New York: Cambridge University Press, 2011), 191–203.
Littlefield, Constance Palmer, "New Hope for the American Photoplay: Victor Seastrom Talks about Our Motion Pictures," *Screenland* 8, 1 (October 1923), 62–3 and 83.
Lowis, Kristina, "European Pictorial Aesthetics" in Patrick Daum, Francis Ribemont and Phillip Prodger (eds.), *Impressionist Camera: Pictorial Photography in Europe, 1888–1918* (London and New York: Merrell, 2006), 47–64.
Löwith, Karl, *Meaning in History* (Chicago and London: The University of Chicago Press, 1949).
Magraw, Roger, *France 1815–1914: The Bourgeois Century* (Oxford and New York: Oxford University Press, 1986).
Marinetti, Filippo Tommaso, "The Futurist Manifesto" in Stanislao G. Pugliese (ed.), *Fascism, Anti-Fascism, and the Resistance in Italy – 1919 to the Present* (Lanham and Oxford: Rowman and Littlefield Publishers, 2004), 25–9.
Marinetti, Filippo Tommaso, "Manifesto of Futurism" in John Pollard, *The Fascist Experience in Italy* (London and New York: Routledge, 2005), 15–16.
Marker, Frederick J. and Lise-Lone Marker, *A History of Scandinavian Theatre* (Cambridge and New York: Cambridge University Press, 1996).
Marker, Frederick J. and Lise-Lone Marker, *Ibsen's Lively Art: A Performance Study of the Major Plays* (Cambridge and New York: Cambridge University Press, 2005).
Marklund, Anders, "The Golden Age and Late Silent Cinema: Introduction" in Mariah Larsson and Anders Marklund (eds.), *Swedish Film: An Introduction and Reader* (Lund: Nordic Academic Press, 2010), 72–5.
Mason, Lesley, "Don't Take MY Word for It!," in Joseph Dannenberg, *Film Year Book 1922–1923* (New York and Hollywood: Wid's Films and Film Folks, Inc., 1923), 124.
Mason, Lesley, "'Mortal Clay' Will Be The Talk of the Season," *The Film Daily* 21, 78 (18 September 1922), 3.
Mayer, David, *Stagestruck Filmmaker: D.W. Griffith and the American Theatre* (Iowa City: University of Iowa Press, 2009).
Mayne, Marjorie, "The New Masters," *Pictures and the Picturegoer* 7, 37 (January 1924), 41–4.
McConachie, Bruce, "Theatre and performance in modern media cultures," in Phillip B. Zarrilli, Bruce McConachie, Gary Jay Williams, Carol Fisher Sorgenfrei, *Theatre Histories: An Introduction* (Second Edition) (New York and London: Routledge, 2010), 299–326.
McDonald, Jessica S., "Readings in the History of Pictorialism" in Alison Nordström (ed.), *Truth Beauty: Pictorialism and the Photograph as Art, 1845–1945* (Vancouver: Douglas and McIntyre, 2008), 113–29.
McQueen, Alison, *The Rise of the Cult of Rembrandt: Reinventing an Old Master in Nineteenth-Century France* (Amsterdam: Amsterdam University Press, 2003).

Meisel, Martin, *Realizations: Narrative, Pictorial and Theatrical Arts in Nineteenth-Century England* (Princeton: Princeton University Press, 1983).
Michaëlis, Karen and Betty Nansen, *Kvindehjerter* (Copenhagen: Gyldendal, 1910).
Michaëlis, Sophus, "Betty Nansen," *Teatret: Illustreret Maanedsskrift for Teater og Skuespilkunst* 1 (1901–2), 33.
Milne, Tom, "Vem Dömer? (Love's Crucible)," *Monthly Film Bulletin* 45, 528 (January 1978), 15.
Monrad, Kasper, "The Copenhagen School of Painting" in Kasper Monrad (ed.), *The Golden Age of Danish Painting* (New York: Hudson Hills Press, 1993), 11–19.
Monrad, Kasper (ed.), *The Golden Age of Danish Painting* (New York: Hudson Hills Press, 1993).
Monrad, Kasper, Ragni Linnet and Lene Bøgh Rønberg (eds.), *Two Golden Ages: Masterpieces of Dutch and Danish Painting* (Zwolle and Copenhagen: Rijksmuseum Amsterdam and Statens Museum for Kunst, 2001).
Morfinisten – Film Program (Louis von Kohl, 1911). Danish Film Institute.
Morris, Rodler F., *From Weimar Philosemite to Nazi Apologist: The Case of Walter Bloem* (Lewiston, Queenston, and Lampeter: The Edwin Mellen Press, 1988).
Moss, Candida R., *The Other Christs: Imitating Jesus in Ancient Christian Ideologies of Martyrdom* (Oxford and New York: Oxford University Press, 2010).
Mottram, Ron, *The Danish Cinema Before Dreyer* (Metuchen and London: The Scarecrow Press, 1988).
Musser, Charles, "Historiographic Method and the Study of Early Cinema," *Cinema Journal* 44, 1 (2004), 101–7.
Nansen, Betty, "Et Teaterbarn (Indtryk fra de yngste Aar)," *Teatret: Illustreret Maanedsskrift for Teater og Skuespilkunst* 1 (1901–2), 40.
Nansen, Betty, "Fru Nansen udtaler sig," *Filmen* 5, 23 (15 September 1917), 255.
Neale, Steve, "Introduction 2: The Long Take – Concepts, Practices, Technologies, and Histories," in John Gibbs and Douglas Pye (eds.), *The Long Take: Critical Approaches* (London: Palgrave Macmillan, 2017), 27–42.
Neiiendam, Robert, "Jacobsen, Jacob," *Dansk Biografisk Leksikon (3rd edition)* (Copenhagen: Gyldendal online, 1979–84). http://denstoredanske.dk/index.php?sideId=291899.
Neiiendam, Robert, "Nielsen, Martinius," *Dansk Biografisk Leksikon (3rd edition)* (Copenhagen: Gyldendal online, 1979–1984). http://denstoredanske.dk/index.php?sideId=295007.
Neiiendam, Robert, "Nielsen, Oda," *Dansk Biografisk Leksikon (3rd edition)* (Copenhagen: Gyldendal online, 1979–1984). http://denstoredanske.dk/index.php?sideId=295032.
Neiiendam, Robert, "Rasmussen, Holger," *Dansk Biografisk Leksikon (3rd edition)* (Copenhagen: Gyldendal online, 1979–84). http://denstoredanske.dk/index.php?sideId=296179.
Neiiendam, Robert, "Rindom, Ellen," *Dansk Biografisk Leksikon (3rd edition)* (Copenhagen: Gyldendal online, 1979–84). http://denstoredanske.dk/index.php?sideId=296409.
Nerman, E., "Gosta Ekmann [sic]," *Cinéa* 11 (special issue) (15 July 1921), 10.
Nerman, E., "Jenny Hasselquist [sic]," *Cinéa* 11 (special issue) (15 July 1921), 7.
Nerman, E., "Victor Sjostrom [sic]," *Cinéa* 11 (special issue) (15 July 1921), 21.
Nielsen, Birgit S., *Karin Michaëlis: En europæisk humanist* (Copenhagen: Museum Tusculaneum Press, 2004).
Nijsten, Gerard, "Feasts and Public Spectacle: Late Medieval Drama and Performance in the Low Countries," in Alan E. Knight (ed.), *The Stage as Mirror: Civic Theatre in Late Medieval Europe* (Cambridge: D.S. Brewer, 1997), 107–44.
Nordström, Alison (ed.), *Truth Beauty: Pictorialism and the Photograph as Art, 1845–1945* (Vancouver: Douglas and McIntyre, 2008).

Norman, Dorothy, *From the Writings and Conversations of Alfred Stieglitz* (New York: Twice A Year Press, 1938).

Norman, Geraldine, *Nineteenth-Century Painters and Painting: A Dictionary* (Berkeley and Los Angeles: University of California Press, 1977).

O'Brien, Charles, "Film Colour and National Cinema Before WWI: Pathécolor in the United States and Great Britain," in Frank Kessler and Nanna Verhoeff (eds.), *Networks of Entertainment: Early Film Distribution 1895–1915* (New Barnet: John Libbey, 2007), 30–8.

Oes, Ingvald C., "The Exclusive Program," *The Motion Picture News* 8, 16 (25 October 1913), 35.

Olsen, Ole, *Filmens Eventyr og Mit Eget* (Copenhagen: Jespersen and Pios Verlag, 1940).

Ørjasæter, Kristin, "Mother, wife and role model: A contextual perspective on feminism in *A Doll's House*," *Ibsen Studies* 5,1 (2005), 19–47.

Panofsky, Erwin, "On Movies," *Bulletin of the Department of Art and Archaeology of Princeton University* (June 1936), 5–15.

Panofsky, Erwin, *Studien zur Ikonologie. Humanistische Themen in der Kunst der Renaissance* (Cologne: Dumont, 1980).

Patterson, Frances Taylor, "The Swedish Photoplays," *Exceptional Photoplays* 3, 2 (December 1922), 3–4.

Peach Robinson, Henry, *Pictorial Effect in Photography: Being Hints on Composition and Chiaro-Oscuro for Photographers* (Philadelphia: Edward L. Wilson, 1881).

Peach Robinson, Henry, *The Elements of a Pictorial Photograph* (Bradford: The Country Press, 1896).

Petersen, Stephen, "Genre," in John Hannavy (ed.), *Encyclopedia of Nineteenth-Century Photography, Volume 1 A-I Index* (New York and London: Routledge, 2008), 575–7.

Peterson, Jennifer Lynn, *Education in the School of Dreams: Travelogues and Early Nonfiction Film* (Durham and London: Duke University Press, 2013).

Pethő, Ágnes, *Cinema and Intermediality: The Passion for the In-Between* (Newcastle upon Tyne: Cambridge Scholars Publishing, 2011).

Petrie, Graham, *Hollywood Destinies: European Directors in America, 1922–1931* (Detroit: Wayne State University Press, 2002).

Peucker, Brigitte, *Incorporating Images: Film and the Rival Arts* (Princeton: Princeton University Press, 1995).

Peucker, Brigitte, *The Material Image: Art and the Real in Film* (Stanford: Stanford University Press, 2007).

Pevsner, Nikolaus, *Academies of Art: Past and Present* (Cambridge and New York: Cambridge University Press, 2014).

Poivert, Michel, "An Avant-Garde Without Combat: The French Anti-Modernists and the Pre-Modernism of the American Photo-Secession," in Patrick Daum, Francis Ribemont and Phillip Prodger (eds.), *Impressionist Camera: Pictorial Photography in Europe, 1888–1918* (London and New York: Merrell, 2006), 31–46.

Raage, Harald, "Betty Nansen," *Teatret: Illustreret Maanedsskrift for Teater og Skuespilkunst* 5 (1905–1906), 106–10.

Rewald, Sabine, *Rooms with a View: The Open Window in the 19th Century* (New York: Metropolitan Museum of Art, 2001).

Richter Larsen, Lisbeth and Dan Nissen (eds.), *100 Years of Nordisk Film* (Copenhagen: Danish Film Institute, 2006).

R.L.C., "Victor Sjostrom [sic]," *Cinéa* 11 (special issue) (15 July 1921), 21.

Rosenstone, Robert A., "History in Images – History in Words – Reflections on the Possibility of Really Putting History onto Film," *The American Historical Review* 93, 5 (1988), 1173–85.

Ryan, Don, "Entrechats of Irony: A somewhat futile attempt to interview Victor Seastrom," *Picture-Play Magazine* 20, 1 (March 1924), 22–4 and 108.
Salmon, Stéphanie, "Le Film d'Art et Pathé: une relation éphémère et fondatrice" in Alain Carou and Béatrice de Pastre (eds.), "Le Film d'art et les films d'art en Europe (1908–1911)," *1895 – Revue d'Histoire du Cinéma* 56 (Special issue, December 2008), 69–80.
Salt, Barry, *Film Style & Technology: History & Analysis* (London: Starword, 1992).
Salter, Chris, "Participation, Interaction, Atmosphere, Projection: New Forms of Technological Agency and Behavior in Recent Scenographic Practice," in Arnold Aronson (ed.), *The Routledge Companion to Scenography* (London: Routledge, 2017), 161–82.
Sandberg, Mark B., "Pocket Movies: Souvenir Cinema Programmes and the Danish Silent Cinema," *Film History: an International Journal* 13, 1 (2001), 6–22.
Sandberg, Mark B., "Multiple-reel/feature films: Europe" in Richard Abel (ed.), *Encyclopedia of Early Cinema* (London and New York: Routledge, 2005), 452–6.
Sandfeld, Gunnar, *Thalia i Provinsen: Dansk Provinsteater 1870–1920* (Copenhagen: Nyt Nordisk Forlag Arnold Busck, 1968).
Sarauw, Paul, "Levende billeder. Danske instruktører i Berlin. Arbejdsvilkaar og Gager," *Masken* 3, 32 (11 May 1913), 210.
Schriever, James Boniface (ed.), *Complete Self-Instructing Library of Practical Photography, Volume VIII Studio Portraiture Part II Studio System* (Scranton: American School of Art and Photography, 1908).
Schøyen, Elisabeth, *Den hvide Slavinde – Det XX Aarhundredes Skændsel* (Aarhus: Alb. Bayer, 1905).
Shepherd, David. J., *The Bible on Silent Film: Spectacle, Story and Scripture in the Early Cinema* (Cambridge and New York: Cambridge University Press, 2013).
Singer, Ben, *Melodrama and Modernity: Early Sensational Cinema and its Contexts* (New York: Columbia University Press, 2001).
Sjåvik, Jan, "*Historical Dictionary of Scandinavian Literature and Theater* (Lanham: The Scarecrow Press, 2006).
Sklar, Robert, "Does Film History Need a Crisis?," *Cinema Journal* 44, 1 (2004), 134–8.
Soila, Tytti, "Sweden," in Tytti Soila, Astrid Söderbergh Widding, and Gunnar Iversen, *Nordic National Cinemas* (London and New York: Routledge, 1998), 142–233.
Stahl, Bernard, "Björnson and his Woman Types," *The Independent* 68, 3,205 (5 May 1910), 968–9.
Staiger, Janet, "The Future of the Past," *Cinema Journal* 44, 1 (2004), 126–9.
Stokes, John, "Sarah Bernhardt" in John Stokes, Michael R. Booth and Susan Bassnett, *Bernhardt, Terry, Duse: the Actress in her Time* (Cambridge and New York: Cambridge University Press, 1988), 13–63.
Stokes, John, *The French Actress and her English Audience* (Cambridge and New York: Cambridge University Press, 2005).
Strauven, Wanda, "Futurist Poetics and the Cinematic Imagination: Marinetti's Cinema without Films" in Günter Berghaus (ed.), *Futurism and the Technological Imagination* (Amsterdam and New York: Rodopi, 2009), 201–28.
Studlar, Gaylyn, "Theda Bara: Orientalism, Sexual Anarchy, and the Jewish Star," in Jennifer M. Bean (ed.), *Flickers of Desire: Movie Stars of the 1910s* (New Brunswick and London: Rutgers University Press, 2011), 113–36.
Sutliffe, Albert, *The Americans in Paris, with Names and Addresses, Sketch of American Art, Lists of Artists and Pictures, and Miscellaneous Matter of Interest to Americans Abroad* (Paris: T. Symonds, 1887).

Swenson, Helen V., "Is There an Undiscovered Picture Audience?," *Exhibitors Trade Review* 14, 23 (3 November 1923), 1031.
Söderbergh Widding, Astrid, "Towards Classical Narration? Georg af Klercker in Context," in John Fullerton and Jan Olsson (eds.), *Nordic Explorations: Film Before 1930* (Sydney: John Libbey, 1999), 187–203.
T. B., "Princess Elena's Prisoner," *The Motion Picture News* 8, 23 (13 December 1913), 43.
ten-Doesschate Chu, Petra, *Nineteenth-Century European Art* (New York: Abrams, 2003).
Thorsen, Isak, "The Nordisk Film Collection," *Early Popular Visual Culture* 14, 3 (2016), 281–7.
Thorsen, Isak, *Nordisk Films Kompagni 1906–1924: The Rise and Fall of the Polar Bear* (New Barnet: John Libbey Publishing, 2017).
Toft Hansen, Kim, "Taming the Cowboy: Early Danish Film Theory, 1910–1940," *Historical Journal of Film, Radio, and Television* 36, 2 (2016), 156–74.
Tsivian, Yuri, *Early Cinema in Russia and its Cultural Reception* (London and New York: Routledge, 1994).
Turim, Maureen, *Flashbacks in Film: Memory & History* (New York and London: Routledge, 1989).
Tybjerg, Casper, *An Art of Silence and Light: The Development of the Danish Film Drama to 1920* (Copenhagen: University of Copenhagen, Doctoral Dissertation, 1996).
Tyven (Unknown director, 1910) – Film Program. Collection of the Danish Film Institute.
Uricchio, William and Roberta E. Pearson, *Reframing Culture: The Case of the Vitagraph Quality Films* (Princeton: Princeton University Press, 1993).
Valéry, Paul, *L'enseignement de la poétique au Collège de France* (Paris: s.n., 1937).
van den Berg, Hubert, "The Early Twentieth Century Avant-Garde and the Nordic Countries: An Introductory Tour d'Horizon," in Hubert van den Berg et al. (eds.), *A Cultural History of the Avant-Garde in the Nordic Countries 1900–1925* (Amsterdam and New York: Rodopi, 2012), 19–66.
van Kerckvoorde, Colette M., *An Introduction to Middle Dutch* (Berlin and New York: Mouton de Gruyter, 1993).
Vardac, A. Nicholas, *Stage to Screen: Theatrical Origins of Early Film from Garrick to Griffith* (Cambridge, MA: Harvard University Press, 1949).
Vogel-Jørgensen, F., "Edith Buemann," *Masken* 1, 42 (16 July 1911), 359–60.
von Kohl, Louis, "Forfatteren og Maleren Louis v. Kohl," *Teatret: Illustreret Maanedsskrift for Teater og Skuespilkunst* 11, 7 (January 1912), 55.
Wahl, Jan, *Carl Theodor Dreyer and Ordet: My Summer with the Danish Filmmaker* (Lexington: The University Press of Kentucky, 2012).
Waldman, Harry, *Hollywood and the Foreign Touch: A Dictionary of Foreign Filmmakers and their Films From America, 1910–1995* (Lanham and London: The Scarecrow Press, 1996).
Warburg, Aby with Martin Warnke and Claudia Brink (eds.), *Der Bilderatlas MNEMOSYNE* (Berlin: De Gruyter, 2000).
Weaver, Mike (ed.), *British Photography in the Nineteenth Century: The Fine Art Tradition* (Cambridge and New York: Cambridge University Press, 1989).
Weitzel, Edward, "Should a Mother Tell?" *Moving Picture World* 25, 3 (17 July 1915), 506–7.
Welle, John P., "Film on Paper: Early Italian Cinema Literature, 1907–1920," *Film History: an International Journal* 12, 3 (2000), 288–99.
White, Hayden, *Metahistory: The Historical Imagination in Nineteenth-Century Europe* (Baltimore: Johns Hopkins University Press, 1973).
White, Hayden, "Historiography and Historiophoty," *The American Historical Review* 93, 5 (1988), 1193–9.

Williams, Alan, *Republic of Images: A History of French Filmmaking* (Cambridge, MA and London: Harvard University Press, 1992).

Wilmeth, Don. B., "1865–1915" in Barry B. Witham, (ed.), *Theatre in the United States: A Documentary History. Volume I: 1750–1915 – Theatre in the Colonies and United States* (Cambridge and New York: Cambridge University Press, 1996), 169–313.

Wittkower, Margot and Rudolf, *Born Under Saturn: The Character and Conduct of Artists – A Documented History from Antiquity to the French Revolution* (New York: New York Review of Books, 2007).

Wolf, Norbert, *The Art of the Salon: The Triumph of 19th-Century Painting* (Munich, London and New York: Prestel, 2012).

Wolfe, Jonathan, "New York Today: The Future of Playbill," *New York Times* (20 April 2018) <https://www.nytimes.com/2018/04/20/nyregion/new-york-today-the-future-of-playbill.html?searchResultPosition=1> (last accessed 15 December 2018).

Wölfflin, Heinrich, *Kunstgeschichtliche Grundbegriffe: Das Problem der Stilentwicklung in der neueren Kunst* (Munich: Bruckmann, 1915).

Wölfflin, Heinrich, *Das Erklären von Kunstwerken* (Leipzig: E. A. Seemann, 1921).

Zirpolo, Lilian H., *The A to Z of Renaissance Art* (Lanham, Toronto, and Plymouth: The Scarecrow Press, 2009).

Filmography

Af Elskovs Naade? (*Was She Justified?*; August Blom, 1914)
Afgrunden (*The Abyss*; Urban Gad, 1910)
A Fool There Was (Frank Powell, 1915)
Anna Karenina (J. Gordon Edwards, 1915)
Atlantis (August Blom, 1913)
A Woman's Resurrection (J. Gordon Edwards, 1915)
Bagtalelsens Gift (*The Clown's Revenge*; Valdemar Hansen, 1912)
Balettprimadonnan (*Wolo Czawienko*; Mauritz Stiller, 1916)
Balloneksplosionen (*The Hidden Message*; Kay van der Aa Kühle, 1913)
Barrabas (Louis Feuillade, 1920)
Berg-Ejvind och hans hustru (*The Outlaw and His Wife*; Victor Sjöström, 1918)
Blade af Satans Bog (*Leaves from Satan's Book*; Carl Theodor Dreyer, 1921)
Bristet Lykke (*A Paradise Lost*; August Blom, 1913)
Bryggerens Datter (*Dagmar*; Rasmus Ottesen, 1912)
Dansen paa Koldinghus (*The Dance of Death*; Viggo Larsen, 1908)
Den Dødes Halsbaand (*The Necklace of the Dead*; August Blom, 1910)
Den farlige Alder (*The Price of Beauty*; August Blom, 1911)
Den glade Enke (*The Merry Widow*; Viggo Larsen, 1906)
Den hvide Slavehandel (*The White Slave Trade*; Alfred Cohn, 1910)
Den hvide Slavehandel (*The White Slave Trade*; August Blom, 1910)
Den hvide Slavehandels sidste Offer (*In the Hands of Impostors no. 2*; August Blom, 1911)
Den hvide Slavinde (*The White Slave*; Viggo Larsen, 1907)
Den lille Hornblæser (*The Little Hornblower*; Eduard Schnedler-Sørensen, 1909)
Den sidste Nat (*The Last Night*; Robert Dinesen, 1915)
Den tredie Magt (*The Stolen Treaty*; August Blom, 1913)
Der Student von Prag (*The Student of Prague*; Stellan Rye, 1913)
Der var Engang (*Once Upon a Time*; Viggo Larsen, 1907)
Det berygtede Hus (*The White Slave Trade III*; Urban Gad, 1912)
Det bødes der for (*Love and Money*; August Blom, 1911)
Det gamle Købmandshus (*Midsummer-tide*; August Blom, 1912)
Det hemmelighedsfulde X (*Sealed Orders, The Mysterious X*; Benjamin Christensen, 1914)
Det sjunde inseglet (*The Seventh Seal*; Ingmar Bergman, 1957)
Diamantbedrageren (*The Diamond Swindler*; Unknown, 1910)
Die ewige Nacht (*The Eternal Night*; Urban Gad, 1916)
Djævelens Datter (*The Devil's Daughter*; Robert Dinesen, 1913)
Du skal ære din Hustru (*Master of the House*; Carl Theodor Dreyer, 1925)
Dyrekøbt Glimmer (*When Passion Blinds Honesty*; Urban Gad, 1911)

Dødens Brud (August Blom, 1912)
Dødsridtet (*The Leap to Death*; Rasmus Ottesen, 1912)
En ensom Kvinde (*A Lonely Woman*; August Blom, 1917)
En Kvinde af Folket (*A Woman of the People*; Viggo Larsen, 1909)
En Lektion (*The Aviator and the Journalist's Wife*; August Blom, 1911)
Erreur Tragique (*Tragic Error*; Louis Feuillade, 1912)
Esther (Louis Feuillade, 1910)
Et Kærlighedsoffer (*I Will Avenge*; Robert Dinesen, 1914)
Eventyrersken (August Blom, 1914)
Fantômas (Louis Feuillade, 1913–1914)
Fidji-Øerne (Unknown, c. 1908)
Fiskerliv i Norden/Ved Havet (*Fishermen's Life in the North/By the Sea*; Viggo Larsen/Ole Olsen, 1906/9)
Folkets Ven (*A Friend of the People*; Holger-Madsen, 1918)
Folkets Vilje (*The King's Power*; Eduard Schnedler-Sørensen, 1911)
Fra Piazza del Popolo (*Mists of the Past*; A.W. Sandberg, 1925)
Gadeoriginalen (*A Dream with a Lesson*; August Blom, 1911)
Gatans Barn (*Children of the Street*; Victor Sjöström, 1914)
Gennem Kamp til Sejr (*Thru Trials to Victory*; Urban Gad, 1911)
Grimasse-Væddekamp (Unknown, c. 1908)
Guvernørens Datter (*The Governor's Daughter*; August Blom, 1912)
Hamlet (August Blom, 1911)
Hammerslaget (*In the Hour of Temptation*; Robert Dinesen, 1914)
Heisses Blut (*Burning Blood*; Urban Gad, 1911)
Heltemod Forsoner (*Courage Reconciled*; Viggo Larsen, 1909)
Henry VIII (William Barker and Herbert Beerbohm Tree, 1911)
Herr Arnes pengar (*Sir Arne's Treasure*; Mauritz Stiller, 1919)
Himmelskibet (*A Trip to Mars*; Holger-Madsen, 1918)
Hippomène et Atalante (Étienne Arnaud, 1910)
Hjærternes Kamp (*A High Stake*; August Blom, 1912)
Hotel Paradis (George Schnéevoigt, 1931)
Hvem er Hun? (*Madame X*; Holger Rasmussen, 1910)
Häxan (*Häxan: Witchcraft Through the Ages*; Benjamin Christensen, 1922)
Hævnens Nat (*Blind Justice*; Benjamin Christensen, 1916)
Idylle corinthienne (Louis Feuillade, 1909)
Ingeborg Holm (Victor Sjöström, 1913)
Ingmarssönerna (*Dawn of Love*; Victor Sjöström, 1919)
Judex (Louis Feuillade, 1916–18)
Judith et Holopherne (*Judith and Holofernes*; Louis Feuillade, 1909)
Kameliadamen (*The Lady with the Camellias*; Viggo Larsen, 1907)
Kean (Holger Rasmussen, 1910)
King John (Herbert Beerbohm Tree, Walter Pfeffer Dando and W.K.L. Dickson, 1899)
Klostret i Sendomir (*The Monastery of Sendomir*; Victor Sjöström, 1920)
Klovnen (*The Clown*; A.W. Sandberg, 1926)
Kærlighedens Styrke (*The Power of Love*; August Blom, 1911)
Kærlighed og Venskab (*Love and Friendship*; Eduard Schnedler-Sørensen, 1912)
Körkarlen (*The Phantom Carriage*; Victor Sjöström, 1921)
La caduta di Troia (*The Fall of Troy*; Giovanni Pastrone and Luigi Romano Borgnetto, 1911)

La Dame aux Camélias (*The Lady of the Camellias*; André Calmettes, Louis Mercanton and Henri Pouctal, 1912)
La Fille de Jephté (*The Vow; or, Jephthah's Daughter*; Léonce Perret, 1910)
La Hantise (*The Obsession*; Louis Feuillade, 1912)
La Légende de Daphné (*The Legend of Daphne*; Louis Feuillade, 1910)
La Légende de la Fileuse (*The Legend of the Spinner*; Louis Feuillade, 1908)
La Légende de Midas (*The Legend of King Midas*; Louis Feuillade, 1910)
La Légende de Narcisse (*The Legend of Narcissus*; Louis Feuillade, 1908)
De Molens die juichen en weenen (*The Mills in Joy and Sorrow*; Alfred Machin, 1912)
L'Amour et Psyché (*Love and Psyche*; Louis Feuillade, 1908)
L'Assassinat du duc de Guise (*The Assassination of the Duke of Guise*; André Calmettes and Charles Le Bargy, 1908)
Lasse Månsson fra Skaane (*Struggling Hearts*; A.W. Sandberg, 1923)
L'Assommoir (*Drink*; Albert Capellani, 1908)
La Tare (*The Defect*; Louis Feuillade, 1911)
La Tosca (Viggo Larsen, 1908)
La Tosca (André Calmettes and Charles Le Bargy, 1909)
L'Aveugle de Jérusalem (*The Blind Man of Jerusalem*; Louis Feuillade, 1909)
La Vie du Christ (*The Birth, the Life, and the Death of Christ*; Alice Guy, 1906)
Le duel d'Hamlet (*Hamlet*; Clément Maurice, 1900)
Le Festin de Balthazar (*Balthasar's Feast*; Louis Feuillade, 1910)
L'Enfant de Paris (*The Child of Paris*; Léonce Perret, 1913)
L'Enfant Prodigue (*The Prodigal Son*; Ferdinand Zecca, 1901)
Le Noël de Monsieur le curé (*The Parish Priest's Christmas*; Alice Guy, 1906)
Le Printemps (*Spring*; Louis Feuillade, 1909)
Le Roman d'un Mousse (*The Curse of Greed*; Léonce Perret, 1913)
Les amours de la reine Élisabeth (*Queen Elizabeth*; Henri Desfontaines and Louis Mercanton, 1912)
Les Aventures de Robinson Crusoé (*Robinson Crusoe*; Georges Méliès, 1902)
Les Vampires (*The Vampires*; Louis Feuillade, 1915–1916)
Le Tic (*The Twitch*; Étienne Arnaud, 1908)
Le Voile des nymphes (Louis Feuillade, 1909)
Lysistrata ou la grève des baisers (Louis Feuillade, 1910)
Ma l'amor mio non muore (*Love Everlasting*; Mario Caserini, 1913)
Moderen (*Storms of the Heart*; Robert Dinesen, 1914)
Mordets Melodi (*Melody of Murder*; Bodil Ipsen, 1944)
Morfinisten (*The Morphine Takers*; Louis von Kohl, 1911)
Name the Man (Victor Sjöström, 1924)
När konstnärer älska (*Artists in Love*; Mauritz Stiller, 1914)
Onkel og Nevo (*Uncle and Nephew*; August Blom, 1912)
Othello (Viggo Larsen, 1908)
Pax æterna (*Peace on Earth*; Holger-Madsen, 1917)
Prinsesse Elena (*Princess Elena's Prisoner*; Holger-Madsen, 1913)
Prométhée (*The Legend of Prometheus*; Louis Feuillade, 1908)
Prompte Levering (Unknown, c. 1908)
Præsidenten (*The President*; Carl Theodor Dreyer, 1919)
Præsten i Vejlby (*The Hand of Fate*; August Blom, 1922)
Revolutionsbryllup (*A Revolutionary* Wedding; August Blom, 1915)
Should a Mother Tell? (J. Gordon Edwards, 1915)

Sumerki zhenskoi dushi (*Twilight of a Woman's Soul*; Yevgeni Bauer, 1913)
Sur la barricade (*On The Barricade*; Alice Guy, 1907)
Sønnen (*Her Son*; August Blom, 1916)
Sønnen fra Rullekælderen (*The Adopted Son*; Unknown, 1911)
Terje Vigen (*A Man There Was*; Victor Sjöström, 1917)
The Celebrated Scandal (J. Gordon Edwards and James Durkin, 1915)
The Hazards of Helen (J.P. McGowan and J. Gunnis Davis, 1914–17)
The Miracle (Michel Carré, 1912)
The Perils of Pauline (Louis J. Glasnier, 1914)
The Song of Hate (J. Gordon Edwards, 1915)
The Tempest (Herbert Beerbohm Tree and Charles Urban, 1905)
Tih-Minh (Louis Feuillade, 1918)
Tosca (André Calmettes, 1908)
Tropisk Kærlighed (*Love in the Tropics*; August Blom, 1912)
Tyven (*The Thief*; Unknown, 1910)
Tösen från Stormyrtorpet (*The Girl from the Marsh Croft*; Victor Sjöström, 1917)
Uncle Tom's Cabin (J. Stuart Blackton, 1910)
Under skæbnens Hjul (*For the Sake of a Man*; Holger-Madsen, 1914)
Ved Fængslets Port (*Temptations of a Great City*; August Blom, 1911)
Vem dömer (*Love's Crucible*; Victor Sjöström, 1922)

About the Author

Vito Adriaensens is a scholar, curator, and filmmaker. He holds a PhD in Theatre Studies and Intermediality from the University of Antwerp and an MFA in Directing from the Feirstein Graduate School of Cinema at Brooklyn College. Vito was a visiting scholar at the University of Copenhagen, and has taught at Ghent University, the Université libre de Bruxelles, the University of Antwerp, the VU University in Amsterdam, and at Columbia University in New York, where he taught early cinema for more than seven years. He is currently an assistant professor at New York University's Tisch School of the Arts.

Vito was an executive committee member of Domitor, the International Society for the Study of Early Cinema, and his research focuses on the aesthetic, cultural, and art-historical interaction between film, theatre, and visual arts, with an emphasis on early cinema. He is the co-author of *Screening Statues: Sculpture and Cinema* (with Steven Jacobs, Susan Felleman, and Lisa Colpaert; Edinburgh University Press, 2017), and he is currently editing a volume on the tableau vivant and working on *From New Stagecraft to New Cinema*, a monograph that looks to redefine the evolution of cinema against developments in the historical avant-garde in visual and performing arts; and finishing a book on Benjamin Christensen's 1922 cult film *Häxan* (*Witchcraft Through the Ages*).

As a filmmaker, Vito works primarily on celluloid. His award-winning experimental films have toured festivals internationally, and he is a small gauge film instructor at Brooklyn cinema-arts non-profit Mono No Aware. Vito's first feature is the *Metamorphoses*-inspired anthology film *Ovid, New York*.

Index

AB Svenska Biografteatern (Svenska Bio), 140–1, 152, 163n, 171
academic painting, 9, 39, 104–35, 137n, 140, 170–1
Académie de France à Rome, L', 112, 137n
Académie des Beaux-Arts, L', 112, 137n
Af elskovs Naade (*Was She Justified?*; 1914), 79
Afgrunden (*The Abyss*; 1910), 36, 69–70, 86
Agnete (1893, play), 86, 96–7
Akademie der Bildenden Künste, Die (Münchner Schule; Munich, Germany), 113, 137n
Alexander, George, 144
Alexandrateatret, 95–6
Allen, Robert C., 1–2
Alma-Tadema, Lawrence, 112
Altman, Charles F. (Rick), 2
American Mutoscope and Biograph, 24, 71
Amour et Psyché, L' (*Love and Psyche*; 1908), 28
amours de la reine Élisabeth, Les (*Queen Elizabeth*; 1912), 170
Andersen, Hans Christian, 57, 132
Ankersmit, Frank R., 2
Anna Karenina (1877, novel), 94
Anna Karenina (1915), 79, 92, 94
Année terrible, L' (1872, poetry), 29
Antoine, André, 25–6, 30, 65, 110
Apollinaire, Guillaume, 44
Appia, Adolphe, 145
Arnaud, Étienne, 29, 56, 126
Arnheim, Rudolf, 11
Artcraft Pictures, 80
artists and models, 141, 144–51
Assassinat du duc de Guise, L' (*The Assassination of the Duke of Guise*; 1908), 4, 22, 26–7, 40
Assommoir, L' (*Drink*; 1908), 27
Atlantis (1913), 109, 131

Aurelius, Marcus, 155
avant-garde, 15–16, 44–8, 85, 96–7, 104, 110–13, 134
Aventures de Robinson Crusoé, Les (*Robinson Crusoe*; 1902), 27
Aveugle de Jérusalem, L' (*The Blind Man of Jerusalem*; 1909), 28

Bacon, John Henry Frederick, 104, 115–16, 124
Bagtalelsens Gift (*The Clown's Revenge*; 1912), 131
Bakst, Léon, 44
Balettprimadonnan (*Wolo Czawienko*; 1916), 141
Balloneksplosionen (*The Hidden Message*; 1913), 37
Balzac, Honoré de, 28
Bang, Herman, 85–6, 100n
Bara, Theda (Theodosia Goodman), 92–4
Barker, William, 71
Barrabas (1920), 28
Bauer, Yevgeni, 109
Beatrijs (*Beatrice*; c. 1374), 149
Bébé (Clément Mary), 28
Bedding, Thomas (Lux Graphicus), 130
Beerbohm Tree, Herbert, 71
Belasco, David, 110, 136n
Bendz, Wilhelm, 104, 113, 115–16
Benjamin, Walter, 112
Benoît-Lévy, Edmond, 25, 45
Béraud, Jean, 104, 115–16
Berg-Ejvind och hans hustru (*The Outlaw and His Wife*; 1918), 141–2
Bergman, Hjalmar, 144, 152
Bergman, Ingmar, 143, 155
Bernhardt, Sarah, 66, 68, 70–1, 76n, 80, 85, 91–2, 94, 98, 102n, 170

Bernstein, Henri, 34–5, 42, 65
Berton, Pierre , 82
berygtede Hus, Det (*The White Slave Trade III*; 1912), 131
Betty Nansen Teatret, 67, 79–80, 95–8, 170
Biografteaterbladet, 41
Biografteatret, 5
Bisson, Alexandre, 25, 67
Bjørnson, Bjørnstjerne, 79–80, 82–3, 86, 98
Blaché, Herbert, 28
Blackton, J. Stuart, 70
Blad, Augusta, 74
Blade af Satans Bog (*Leaves from Satan's Book*; 1921), 62
Blicher, Steen Steensen, 160
Bloch, Harriet, 88
Bloch, Marc, 2
Bloem, Walter, 167, 172
Blom, Agnete, 43
Blom, August, 6, 13, 36–7, 43, 56–7, 62, 62–4, 70, 72, 74, 79, 87, 108–9, 117, 119, 121–3, 131, 160
Bordwell, David, 2–3, 12, 14–16, 106–9, 108–9, 114, 136n, 169, 171
Bouguereau, William–Adolphe, 112
bourgeois realism, 8–9, 14, 16, 42, 49, 104–35, 140, 168
Bourgmestre de Stilmonde, Le (*The Burgomaster of Stilemonde*; 1919, play), 97
Bout de Zan (René Poyen), 28
Brandes, Edvard, 42
Brandes, Georg, 42, 80, 100n
Brewster, Ben, 12, 109, 169
Bristet Lykke (*A Paradise Lost*; 1913), 79
British Mutoscope & Biograph Company, 71
Bryggerens Datter (*Dagmar*; 1912), 37
Bucquet, Maurice, 126
Busch, Mae, 151
bødes der for, Det (*Love and Money*; 1911), 121, 131

Cabanel, Alexandre, 112
caduta di Troia, La (*The Fall of Troy*; 1911), 70
Caine, Hall, 151
Calmettes, André, 4, 22, 26, 37, 71
Canth, Minna, 86
Canudo, Ricciotto, 11, 22, 43–9, 109–10, 152, 167, 169, 172
Capellani, Albert, 4–5, 27
Capriciosa (1836, play), 34
Carr, E. H., 2
Carré, Michel, 149
Caserini, Mario, 109
Casino Teatret, 56, 58, 62, 78, 81, 82
Čelebonović, Aleksa, 9, 14, 104, 111, 113–14,
Celebrated Scandal, The (1915), 79, 92–4, 102n
Cercle Artistique de Bruxelles, 128
Cézanne, Paul, 111
Chagall, Marc, 44
Chamberlain, K. R., 147
Chaplin, Charles, 145, 147
Chautard, Émile, 55
chiaroscuro, 89–90, 115–17, 126–7, 129–30, 157, 171; *see also* Rembrandt lighting
Christ crucified, 149–51, 153, 155–6, 160
Christensen, Benjamin (Benjamin Christie), 6, 62, 74n, 79, 132–3, 145
Ciné-Journal, 5, 22, 29–33, 36, 39–40, 45, 69–70, 105
cine-letterati, 45
Cinéa, 141–3, 154
Cinéma-Palace (Gaumont-Palace), 24, 69
Clausen, Marius, 89
Cocteau, Jean, 44
Cohen, Sande, 2
Cohn, Alfred, 13, 38, 57–8
Comédie-Française, 22, 25, 55, 66
Compagnon, Antoine, 1
Corot, Jean-Baptiste-Camille, 129
Courbet, Gustave, 39, 111
Courteline, Georges, 25
Criterion Theatre, 143
Cubism, 45, 104
cultural poetics, 12, 167–72
Cuyp, Aelbert, 130

da Cunha, Arthur G., 126
d'Annunzio, Gabriele, 45
Dagmarteatret, 56, 62, 65, 67, 69, 78, 82–4, 86
Dame aux Camélias, La (*Camille*; *Kameliadamen*; 1848, play), 33, 82, 85
Dame aux Camélias, La (*The Lady of the Camellias*; 1912), 71
Dando, Walter Pfeffer, 71

Dansen paa Koldinghus (*The Dance of Death*; 1908), 33, 59–61
Dansen på Koldinghus (1895, play), 33, 59
Dansk Filmfabrik, 58
Dansk Kunstfilm, 7, 26, 34, 60, 63
de Caillavet, Gaston Arman, 96
de Féraudy, Maurice, 29
de Flers, Robert, 96
de Hooch, Pieter, 115, 117–18, 157–8
de Najac, Émile, 84
de Pixerécourt, René-Charles Guilbert, 66
de Rothschild, Nathaniel, 126
Déjazet (Pauline Virginie Déjazet), 66
Delacroix, Eugène, 112, 129
Delaroche, Paul, 27
Delluc, Louis, 44
Demachy, Robert, 141
DeMille, Cecil B., 126
Desclée, Aimée, 66
Desfontaines, Henri, 170
Diamantbedrageren (*The Diamond Swindler*; 1910), 121
Dickson, W. K. L., 71
Diedrich, Ellen, 58
Dinesen, Robert, 79, 123, 149
Divorçons! (1880, play), 84
Djævelens Datter (*The Devil's Daughter*; 1913), 149
Dollarprinsessen (*Die Dollarprinzessin*; 1907, operetta), 42
Dora (1877, play), 78, 81–2
Doumic, René, 47
Drachmann, Holger, 33, 59, 79, 80
Dreyer, Carl Theodor, 37, 60, 62, 98, 103n, 106, 160
Du skal ære din Hustru (*Master of the House*; 1925), 60
Duc de Guise, Le (1837, opera), 27
duel d'Hamlet, Le (*Hamlet*; 1900), 71
dukkehjem, Et (*A Doll's House*; 1879, play), 80
Dumas *fils*, Alexandre, 33, 82, 85
Dumas *père*, Alexandre, 56, 94
Dureau, Georges, 5, 39–41, 105
Durkin, James, 79, 92–3
Duse, Eleonora, 66, 85–6, 91
Dussaud, Frantz, 46
Dyrekøbt Glimmer (*When Passion Blinds Honesty*; 1911), 122

Dødens Brud (1912), 131
Dødes Halsbaand, Den (*The Necklace of the Dead*; 1910), 57
Dødsridtet (*The Leap to Death*; 1912), 37

Echegaray, José, 94
Eckersberg, Christoffer Wilhelm, 113
Edwards, J. Gordon, 79–80, 92–3
Egg, Augustus Leopold, 112, 124–5
Eisenstein, Sergei, 16
Ekman, Gösta, 140, 142–4
Emerson, Peter Henry, 105, 129–30
Enfant de Paris, L' (*The Child of Paris*; 1913), 109
Enfant Prodigue, L' (*The Prodigal Son*; 1901), 27, 29
ensom Kvinde, En (*A Lonely Woman*; 1917), 79, 89
Entretiens idéalistes, Les, 43, 45
Erreur Tragique (*Tragic Error*; 1912), 31
Esther (1910), 29, 56
Éventail, L' (*The Fan*; *Viften*; 1907, play), 96
Eventyrersken (1914), 79
Everson, William K., 6
ewige Nacht, Die (*The Eternal Night*; 1916), 149
Exner, Julius, 113
Expressionism, 9, 98, 104, 110, 171

Fairbanks, Douglas, 145
Fall, Leo, 42
Famous Players-Lasky, 40, 80, 126, 170
Fantômas (1913–14), 5, 15, 28, 31, 109
farlige Alder, Den (*The Dangerous Age*; 1910, novel), 83
farlige Alder, Den (*The Price of Beauty*; 1911), 83, 117, 119
Femme X, La (*Madame X*; 1908, play), 67
Fescourt, Henri, 28, 31
Festin de Balthazar, Le (*Balthazar's Feast*; 1910), 29
Feuillade, Louis, 4–5, 15, 28–33, 39, 56, 106–7, 109, 131, 136n
Feuillère, Edwige, 66
Fidji-Øerne (c. 1908), 59–60
Fille de Jephté, La (*The Vow; or, Jephthah's Daughter*; 1910), 29, 126

film-as-art discussion, 4–5, 7, 11–14, 22–50, 55, 60, 71–2, 86–7, 91, 94–6, 104–6, 109–10, 145–7, 157, 167–72
Film d'Art, Le, 4, 7, 22–50, 59, 66, 71, 167–9
Film d'Arte Italiana, 26
Film esthétique, Le, 5, 28, 32–3, 41
Filmen, 22, 36, 38, 55, 86, 91, 94–5
Fiske, Minnie Maddern, 89, 101n
Fiskerliv i Norden/Ved Havet (Fishermen's Life in the North/By the Sea; 1906/1909), 124–5
Focillon, Henri, 1
Folketeatret, 56, 58, 62, 67, 74, 78–9, 81, 84–5
Folkets Ven (A Friend of the People; 1918), 100n
Folkets Vilje (The King's Power; 1911), 131
Fool There Was, A (1915), 92–3, 102n
Fotorama (A/S Th. S. Hermansen), 13, 38, 57–8
Foucault, Michel, 2
Fox, William (Fox Film Corporation), 67, 79, 87, 90–6, 98, 170
Fra Piazza del Popolo (Mists of the Past; 1925), 160
Frazer, Sir James George, 49
Freie Bühne, Die, 145
Freksa, Friedrich, 152
Friedrich, Caspar David, 129
Frith, William Powell, 113
Frölich, Else, 42
Futurism, 22, 45, 48, 50, 169
Fønss, Thilda, 56

Gad, Urban, 36, 69–70, 86, 107, 122, 131, 149
Gadeoriginalen (A Dream with a Lesson; 1911), 121
Gaietés de l'escadron, Les (1886, novel), 25
gamle Købmandshus, Det (Midsummer-tide; 1912), 123
Gance, Abel, 16, 44, 106, 157
Garbo, Greta, 79, 140
Garde, Axel, 90–1
Gatans Barn (Children of the Street; 1914), 89
Gaudreault, André, 16
Gaumont, 4–5, 7, 13, 22–4, 27–33, 37–41, 45, 49, 55–6, 105–6, 126, 131, 134, 141, 168

Gennem Kamp til Sejr (Thru Trials to Victory; 1911), 131
genre painting, 8–9, 14, 104, 110–11, 113–15, 117, 126, 134–5
Georg II, Duke of Saxe-Meiningen, 110, 136n
Gérôme, Jean-Léon, 112, 127
Gesamtkunstwerk, 33–4, 49–50
Gesellschaft zur Förderung der Amateur-Photographie zu Hamburg (Germany), 128
Gilpin, William, 129
glade Enke, Den (The Merry Widow; 1906), 33
Goldwyn, Samuel, 144, 147, 151
Goodman, Nelson, 1
Gordon Craig, Edward, 145
gran Galeoto, El (The Celebrated Scandal; 1881, play), 94
Grands Films Artistiques, Les, 27–8
Greenberg, Clement, 111–12
Griffin, Patrick, 2
Griffith, D. W., 141
Griffith, Linda A., 141
Grillparzer, Franz, 152
Grimasse-Væddekamp (c. 1908), 59–60
Grünbaum, Fritz, 42
Guégan, Maurice, 24–5
Gunning, Tom, 10, 16
Guvernørens Datter (The Governor's Daughter; 1912), 123
Guy (Blaché), Alice, 27–9, 149

Hamlet (1911), 57, 63–4
Hammershøi, Vilhelm, 82, 115
Hammerslaget (In the Hour of Temptation; 1914), 79
Hansen, Constantin, 113
Hansen, Valdemar, 131
Hanson, Lars, 79, 140
Hantise, La (The Obsession; 1912), 131
Hare, John, 144
Hasselqvist, Jenny, 142–4, 154
Hatot, Georges, 27
Haugmard, Louis, 46
Hawks, Howard, 106
Hazards of Helen, The (1914–17), 16
Hedda Gabler (1891, play), 97, 99n
Hedqvist, Ivan, 144, 154

Heiberg, Johanne Luise, 82, 84
Heisses Blut (Burning Blood; 1911), 70, 76n
Helsengreen, Gunnar, 57
Heltemod Forsoner (Courage Reconciled; 1909), 63–4
hemmelighedsfulde X, Det (Sealed Orders; The Mysterious X; 1914), 132–3
Hennings, Betty, 80–1
Henry VIII (1911), 71
Herr Arnes pengar (Sir Arne's Treasure; 1919), 152
Heuzé, André, 56
Himmelskibet (A Trip to Mars; 1918), 100n
Hippomène et Atalante (1910), 29
historiography, 1–2, 5, 12, 167
Hjærternes Kamp (A High Stake; 1912), 131
Hobsbawm, Eric, 7, 9, 23
Holch, Christel, 57
Holger-Madsen, 6, 79, 88–90, 93, 131
Hopper, Edward, 115
Hoppla, wir Leben! (Hoppla, Such is Life!; 1925, play), 98
Hotel Paradis (1931), 62
Hugo, Victor, 29, 65
Hvem er Hun? (Madame X; 1910), 67
hvide Slavehandel, Den (The White Slave Trade; Alfred Cohn, 1910), 13, 38, 57–8
hvide Slavehandel, Den (The White Slave Trade; August Blom, 1910), 13, 38, 57–8
hvide Slavehandels sidste Offer, Den (In the Hands of Impostors no. 2; 1911), 117, 119–20, 131–2
hvide Slavinde – Det XX Aarhundredes Skændsel, Den (The White Slave – The Twentieth-Century's Scandal; 1905, novel), 57
hvide Slavinde, Den (The White Slave; 1907), 57
Häxan (Häxan: Witchcraft Through the Ages; 1922), 62
Hævnens Nat (Blind Justice; 1916), 62

Ibsen, Henrik, 79–81, 91–2, 94, 97–8, 99n, 100n, 102n, 170
Idylle corinthienne (1909), 28
Impressionism, 9, 42, 44, 104, 110–11, 141, 171
Ingeborg Holm (1913), 15, 109, 140
Ingmarssönerna (Dawn of Love; 1919), 15, 152
Ingram, Rex, 94, 145, 157
Ingres, Jean-Auguste-Dominique, 112

intermediality, 1–2, 10–13, 54–5, 76n, 86, 105, 132, 135, 168–9
Ipsen, Bodil, 60
Iris (1901, play), 79
Irving, Henry, 144

Jacobs, Lea, 12, 109, 169
Jacobsen, Jacob, 57
Jacobsen, Otto, 35–6, 65
Jaenzon, Julius (J. Julius), 152, 160
Joseph Solomon, Solomon, 104, 117, 119, 124
Judex (1916–18), 28
Judith et Holopherne (Judith and Holofernes; 1909), 28

Kameliadamen (The Lady with the Camellias; 1907), 33–4
Kandinsky, Wassily, 113
Käsebier, Gertrude, 131
Kean (1836, play), 56
Kean (1910), 56
Kean, Edmund, 56
Keil, Charlie, 14–16, 106, 169
King John (1899), 71
Klee, Paul, 113
Klostret i Sendomir (The Monastery of Sendomir; 1920), 143, 152
Klovnen (The Clown; 1926), 140
Knudsen, Poul, 89
kongelige Danske Kunstakademi, Det, 113, 137n
kongelige Teater, Det, 56–7, 62, 67, 74n, 78, 80–2, 84, 86, 98, 99n
Kuleshov, Lev, 106
Kurzbauer, Eduard, 113
Kvinde af Folket, En (A Woman of the People; 1909), 60–3
Kvindehjerter (Women's Hearts; 1910, novel), 83, 100n
Kærlighed og Venskab (Love and Friendship; 1912), 122
Kærlighedens Styrke (The Power of Love; 1911), 122
Kærlighedsoffer, Et (I Will Avenge; 1914), 123
Købke, Christen, 113
Körkarlen (The Phantom Carriage; 1921), 141, 143, 152–3

L-shaped sets, 107
Lacassin, Francis, 5, 28
Lagerlöf, Selma, 152, 163
Lagoni, Otto, 120
Lange, Sven, 95–6
Larsen, Viggo, 33–4, 56–7, 60–1, 64, 124–5
Lasky, Jesse L., 80, 126
Lasse Månsson fra Skaane (*Struggling Hearts*; 1923), 160
Lavedan, Henri, 22, 25
Le Bargy, Charles, 4, 22, 25–6, 37
Légende de Daphné, La (*The Legend of Daphne*; 1910), 29
Légende de la Fileuse, La (*The Legend of the Spinner*; 1908), 28
Légende de Midas, La (*The Legend of King Midas*; 1910), 28
Légende de Narcisse, La (*The Legend of Narcissus*; 1908), 28
Léger, Fernand, 16, 44
Lehár, Franz, 33
Lektion, En (*The Aviator and the Journalist's Wife*; 1911), 109
Leni, Paul, 145
Leonora Karoly (1916, play), 96
L'Herbier, Marcel, 44, 106
lille Hornblæser, Den (*The Little Hornblower*; 1909), 57
Linked Ring Society, The, 128
Little Theatre, The, 141, 144–7
Löwith, Karl, 2
Lubitsch, Ernst, 145, 157
Lugné-Poe, 65
Lumière, 23, 27, 39, 106
Lysistrata ou la grève des baisers (1910), 29

Ma l'amor mio non muore (*Love Everlasting*; 1913), 109
Macgowan, Kenneth, 145
Machin, Alfred, 132–3
MacKaye, Percy, 144
Mademoiselle Mars (Anne Françoise Hyppolyte Boutet Salvetat), 66
Maes, Nicolaes, 115, 157, 160–1
Maeterlinck, Maurice, 97
Makart, Hans, 113
Marinetti, Filippo Tommaso, 48, 50

Marstrand, Wilhelm, 113
Mason, Lesley, 151
Master of Man, The (1921), 151
Matthews, Brander, 92
Maugras, Emile, 24–5
Maurice, Clément, 71
Mayne, Marjorie, 157
Méliès, Georges, 23, 27, 106, 149
Melnitz, Curtis, 145–7
melodrama, 16, 26, 28, 31, 38, 42, 49, 57, 89, 104, 109, 126, 131, 144, 169, 170–1
Mercanton, Louis, 71, 170
Merry Widow, The (*Die lustige Witwe*; 1905, operetta), 33
Michaëlis, Karin, 83, 100n
Michaëlis, Sophus, 82–3, 99n
Millais, John Everett, 113
Millet, Jean-François, 33, 39, 129
Miracle, The (1912), 149
Mirakel, Das (1911, play), 149
Moderen (*Storms of the Heart*; 1914), 79, 91
Modern Breakthrough, 79–86, 95
Molens die juichen en weenen, De (*The Mills in Joy and Sorrow*; 1912), 132–3
Mordets Melodi (*Melody of Murder*; 1944), 62
Morfinisten (*The Morphine Takers*; 1911), 37
Moscow Art Theatre, 145
Moving Picture World, The, 22, 45, 61–3, 70–3, 130–1
Munk, Kaj, 97–8, 103n
Murnau, Friedrich Wilhelm, 145

Nagel, Conrad, 151
Name the Man (1924), 151
Nansen, Betty, 13, 55, 67, 74, 78–98, 170
National Board of Review, 144
Naturalism, 9, 42, 94, 110, 170
Neoclassicism, 111, 114, 137n
Netherlandish images, 117–18, 140–63
New Stagecraft, 25–6, 145
New York School of Art and Design, 115
Nielsen, Asta, 36, 42–3, 69–71, 78, 86, 91–2, 107, 149
Nielsen, Martinius, 56, 85, 100n
Nielsen, Oda, 35, 56, 65, 67
Nihilister (*My Official Wife*; 1903, novel), 84
Noël de Monsieur le curé, Le (*The Parish Priest's Christmas*; 1906), 149

Nordisk Films Kompagni (Great Northern Film Company), 4–7, 9, 13, 22, 26, 33–9, 42–3, 49, 54–75n, 79–80, 82, 86–93, 96, 99n, 100n, 107–9, 119–26, 131, 136n, 139n, 140, 160, 168–72
Nuovo giornale, Il, 43, 45
ny Teater, Det, 42, 62, 69
När konstnärer älska (*Artists in Love*; 1914), 89

Odéon, l', 55
Oehlenschläger, Adam, 57
Oes, Ingvald C., 71–2, 88
Old Masters, 110, 120, 126, 140–63, 171–2
Olsen, Ole, 5, 13, 33, 38, 56–7, 107, 109, 124–5
O'Neill, Eugene, 99n, 145
Onkel og Nevø (*Uncle and Nephew*; 1912), 108
Onslow, George, 27
Orans pose, 155–6
Ordet (*The Word*; 1925, play), 97–8, 103n
Othello (1908), 34
Ottesen, Rasmus, 37
Overskou, Thomas, 34

panchromatic film stock, 120
Panofsky, Erwin, 1, 11
Papini, Giovanni, 45
Passion play, 155
Pastrone, Giovanni, 70
Pathé-Frères, 4–5, 15, 23–9, 31, 33, 39–41, 45–6, 50n, 56
Paul Lange og Tora Parsberg (1898, play), 82–3, 86, 96
Pax æterna (*Peace on Earth*; 1917), 100n
Peach Robinson, Henry, 44, 105, 126–30
Perils of Pauline, The (1914), 16
Perret, Léonce, 5, 55–6, 109, 126, 132, 134
Phono Cinéma Théâtre, 71
Phono-Ciné-Gazette, 25, 45
Photo-Club de Paris, 128, 134
Picasso, Pablo, 44
Pickford, Mary, 80, 145
pictorial(ism), 33, 40, 44, 63, 89, 105–35, 140, 155, 157, 170–1
picturesque, 124–32
Pinero, Sir Arthur Wing, 79
Pio, Elith, 62
playbills, 36, 57–67; *see also* programs

plein-air photography, 126, 130
Plessy (Jeanne Sylvanie Arnould-Plessy), 66
portières, 107, 117
Pouctal, Henri, 71
Poulsen, Adam, 108
Powell, Frank, 92–3
Prinsesse Elena (*Princess Elena's Prisoner*; 1913), 79, 81, 87–90, 93, 131
Printemps, Le (*Spring*; 1909), 29
programs, 7, 27 34–7, 57–67, 87–8, 167, 170; *see also* playbills
Prométhée (*The Legend of Prometheus*; 1908), 28
Promio, Alexandre, 27
Prompte Levering (c. 1908), 59
Provincetown Players, 145
Prud'hon, Pierre-Paul, 112
Præsidenten (*The President*; 1919), 62
Præsten i Vejlby (*The Hand of Fate*; 1922), 160
Psilander, Valdemar, 74, 108
Puvis de Chavannes, Pierre, 33
Puyo, Constant, 129, 135n

Rachel (Elisabeth Félix), 66
Rasmussen, Holger, 56–7, 67
Regia Kunstfilms Kompagni, 67
Reinhardt, Max, 145, 149
Réjane, Gabrielle, 55, 66, 85
religious motifs and metaphors, 33, 46, 49, 117, 140–63
Rembrandt lighting, 89, 117, 126–7, 130, 157; *see also* chiaroscuro
Rembrandt van Rijn, 110, 115, 117–18, 126–7, 129, 130, 140, 157, 171
Renaissance, 148, 155, 157, 172
Repin, Ilya, 114
repoussoir, 158
Resurrection (1899, novel), 94
Revolutionsbryllup (*A Revolutionary Wedding*; 1915), 79, 82
Revue Mondiale, La, 28
Rindom, Svend, 58
Rode, Edith, 89, 101n
Roman d'un Mousse, Le (*The Curse of Greed*; 1913), 132, 134
Romano Borgnetto, Luigi, 70
Romanticism, 22, 50, 84, 111, 114, 124
Roose, Thorkild, 57
Rosenstone, Robert A., 2

Rostand, Edmond, 25
Royal Academy of Arts (R.A.), 112–13
Rubens, Peter Paul, 157
Ruskin, John, 111
Russian Montage Movement, 171
Rutot, Aimé, 132, 134
Ryan, Don, 147
Rye, Stellan, 109

S.C.A.G.L. (Société Cinématographique des Auteurs et Gens de Lettres), 26–8, 40
Sacchetto, Rita, 80
Sadoul, Georges, 152
St. James Theatre, 59
Salon des Refusés, 9, 112
Samfundets Støtter (*The Pillars of Society*; 1877, play), 81
Sandberg, Anders Wilhelm, 140, 160
Sannom, Emilie, 74
Sardou, Victorien, 25, 34, 66, 78, 81–2, 84, 94
Saturn Film Company, 149
Savage, Richard Henry, 84
Scandinavian dissolve, 140, 153, 155, 157–63
Scènes de la vie telle qu'elle est, 5, 28, 30–3, 49–50, 105
Schnedler-Sørensen, Eduard, 34–5, 57, 72, 74, 122, 131
Schnéevoigt, George, 62
Schriever, James Boniface, 127
Schøyen, Elisabeth, 57
Scribe, Eugène, 66, 94
Shaw, Mary, 92
Should a Mother Tell? (1915), 79–80, 92, 94,
sidste Nat, Den (*The Last Night*; 1915), 149
Simon, Charles, 82
Singer Sargent, John, 113
sjunde inseglet, Det (*The Seventh Seal*; 1957), 155
Sjöström, Victor (Victor Seastrom), 13, 15, 79, 89, 104, 109, 135, 140–63, 171
Skandinavisk-Russiske Handelshus, Det, 37
Skram, Amalie, 86, 88, 97
Skram-Knudsen, Johanne, 88–9
Solax Film Company, 28
Song of Hate, The (1915), 80, 92, 94
Sonne, Petrine, 60–2
Stampa, La, 45
Star Films, 23, 27

Steen, Jan, 117–18
Steichen, Edward, 129
Stieglitz, Alfred, 105, 129, 135n
Stiller, Mauritz, 89, 140–1, 145, 152, 160
Storm Petersen, Robert, 38
Stravinsky, Igor, 44
Strindberg, August, 80–1, 98, 99n
Student von Prag, Der (*The Student of Prague*; 1913), 109
Sudermann, Hermann, 79
Sue, Eugène, 94
Sumerki zhenskoi dushi (*Twilight of a Woman's Soul*; 1913), 109
Sur la barricade (*On The Barricade*; 1907), 29
Sutliffe, Albert, 8
Swedish Golden Age, 140–4, 172
Symbolism, 9, 39, 104
Sønnen (*Her Son*; 1916), 79, 89
Sønnen fra Rullekælderen (*The Adopted Son*; 1911), 121

tableau aesthetic (tableau style), 15, 29, 105–9, 114, 136n, 152–63
tableau vivant, 106, 120, 141, 152–63
Talma, François-Joseph, 66
Tare, La (*The Defect*; 1911), 131
Taylor Patterson, Frances, 144, 164n
Teatret: Illustreret Maanedsskrift for Teater og Skuespilkunst, 36–7, 42, 86–7, 90–1, 95–6
Tempest, The (1905), 71
Terje Vigen (*A Man There Was*; 1917), 140
Terry, Ellen, 66
Thackeray, William, 111
Thaulow, Frits, 42
Théâtre du Vaudeville, 55
Théâtre Libre, 25, 145
Théâtre Réjane, 66
Théâtre Sarah Bernhardt, 66
Théâtro-Film, 29–30, 33
Thompson, Kristin, 2, 14
Thorvaldsen, Bertel, 8, 113, 116
Tic, Le (*The Twitch*; 1908), 126
Tih-Minh (1918), 28
Tissot, James, 39
Toller, Ernst, 98
Tolstoy, Leo, 94
Tosca (1908), 71
Tosca, La (1887, play), 34, 94

Tosca, La (1908), 33–4
Tosca, La (1909), 37
Tourneur, Maurice, 50n, 55, 145
tredie Magt, Den (*The Stolen Treaty*; 1913), 123
Tropisk Kærlighed (*Love in the Tropics*; 1912), 122
Turner, J. M. W., 112, 129
Tyven (*The Thief*; 1910), 34–5, 42–3, 63, 67, 69
Tösen från Stormyrtorpet (*The Girl from the Marsh Croft*; 1917), 141

Uncle Tom's Cabin (1910), 70
Under skæbnens Hjul (*For the Sake of a Man*; 1914), 79
Urban Trading Company, 71
Urban, Charles, 71

Vampires, Les (*The Vampires*; 1915–16), 5, 28, 31
van der Aa Kühle, Kay, 37
Van Dyck, Antoon, 130
van Gogh, Vincent, 111
van Hoogstraten, Samuel, 160–1
var engang, Der (*Once Upon a Time*; 1885, play), 33
var Engang, Der (*Once Upon a Time*; 1907), 33
Ved Fængslets Port (*Temptations of a Great City*; 1911), 70
Velázquez, Diego, 157
Vem dömer (*Love's Crucible*; *Mortal Clay*; 1922), 13, 15, 104, 135, 140–63, 171

Vermeer, Johannes, 115, 157
Vie du Christ, La (*The Birth, the Life, and the Death of Christ*; 1906), 27, 29
Villefroy, E., 39
Virgin Mary motif, 148–9, 154
Voile des nymphes, Le (1909), 28
Voleur, Le (*The Thief*; 1906, play), 34, 65
Volmöller, Karl, 149
von Diez, Wilhelm, 113
von Kohl, Louis, 37
von Max, Gabriel, 113
von Piloty, Carl Theodor, 113
von Stroheim, Erich, 145, 157

Wagner, Richard, 49, 50
Warburg, Aby, 1
Whistler, James Abbott McNeill, 129
White, Hayden, 2
Wiener Kamera-Klub, 128
Wieth (Pontoppidan), Clara, 108, 120, 132
Wilkie, David, 112
Willner, Alfred Maria, 42
Wölfflin, Heinrich, 1, 2, 172
Wolter, Charlotte, 85
Woman's Resurrection, A (1915), 79, 92, 94

Yhcam, 46

Zangenberg, Einar, 56
Zaza (1898, play), 82
Zecca, Ferdinand, 4, 27, 29
Zola, Émile, 27, 30, 94, 113

EU representative:
Easy Access System Europe
Mustamäe tee 50, 10621 Tallinn, Estonia
Gpsr.requests@easproject.com

www.ingramcontent.com/pod-product-compliance
Lightning Source LLC
Chambersburg PA
CBHW071418170526
45165CB00001B/314